Postindustrial DIY

POLIS: Fordham Series in Urban Studies

Edited by Daniel J. Monti, Saint Louis University

POLIS will address the questions of what makes a good community and how urban dwellers succeed and fail to live up to the idea that people from various backgrounds and levels of society can live together effectively, if not always congenially. The series is the province of no single discipline; we are searching for authors in fields as diverse as American studies, anthropology, history, political science, sociology, and urban studies who can write for both academic and informed lay audiences. Our objective is to celebrate and critically assess the customary ways in which urbanites make the world corrigible for themselves and the other kinds of people with whom they come into contact every day.

To this end, we will publish both book-length manuscripts and a series of "digital shorts" (e-books) focusing on case studies of groups, locales, and events that provide clues as to how urban people accomplish this delicate and exciting task. We expect to publish one or two books every year and a larger number of "digital shorts." The digital shorts will be 20,000 words or fewer and have a strong narrative voice.

Postindustrial DIY

Recovering American Rust Belt Icons

DANIEL CAMPO

FORDHAM UNIVERSITY PRESS
NEW YORK 2024

Portions of this work originally appeared in the following articles written by Daniel Campo: "Iconic eyesores: Exploring Do-it-Yourself Preservation and Civic Improvement at Abandoned Train Stations in Buffalo and Detroit," *Journal of Urbanism* 7 no. 4 (2014); "Postindustrial Futures: Adaptive Reuse versus 'As Is' Preservation," *Urban Infill* 7 (2014); "Historic Preservation in an Economic Void: Reviving Buffalo's Concrete Atlantis," *Journal of Planning History* 15 no. 4 (2016); "Rustbelt Insurgency and Cultural Preservation: How Guerrilla Practices Saved the Blast Furnaces and the Automobile Factory," *Urban Design International* 25 (2020).

Fordham University Press has no responsibility for the persistence or accuracy of URLs for external or third-party Internet websites referred to in this publication and does not guarantee that any content on such websites is, or will remain, accurate or appropriate.

Fordham University Press also publishes its books in a variety of electronic formats. Some content that appears in print may not be available in electronic books.

Visit us online at www.fordhampress.com.

Library of Congress Cataloging-in-Publication Data available online at https://catalog.loc.gov.

Printed in the United States of America
26 25 24 5 4 3 2 1
First edition

CONTENTS

Prologue: A Postindustrial View from the Northeast Corridor 3

1. Recovering Postindustrial Places 25

2. Buffalo's Central Terminal 63

3. Silo City 119

4. The Carrie Blast Furnaces 177

5. The Packard Automotive Factory 231

6. Michigan Central Station 295

7. The Beginning or End of Postindustrial DIY? 361

Acknowledgments 383

Notes 385

Index 419

For Anne

Postindustrial DIY

A view from the train on the Northeast Corridor through North Philadelphia. (Author, 2021.)

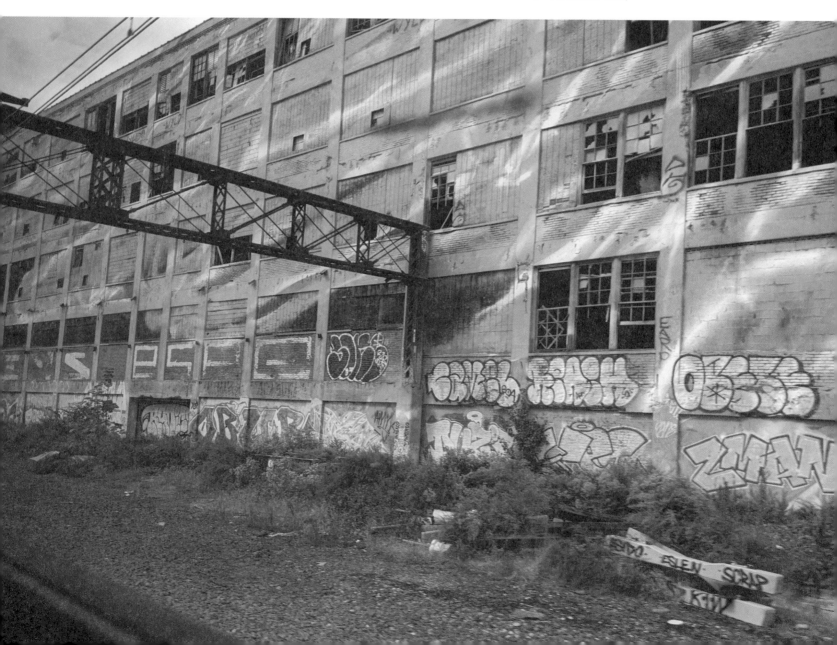

A Postindustrial View from the Northeast Corridor

I n 1999 I began regularly traveling between New York and Philadelphia by train. I was beginning my PhD at the University of Pennsylvania but frequently returned to New York, where my previous life, family, friends, and professional and personal interests still resided. As a New Yorker I knew preposterously little about Philadelphia almost until the day I moved there. I naively thought of myself as a person of the world and of cities, but as a legitimate adult had never bothered to visit the big city ninety miles southwest of New York until my initial visit to Penn. While I didn't exactly groove to my new life and city, at least not right away, I was nonetheless fascinated by it. It was, ironically, my time looking out the window on these train trips—sometimes on Amtrak but more often a SEPTA R7 commuter train (connecting with New Jersey Transit in Trenton)—that stoked my interest in Philadelphia's vast and intensely urban geography.

By the early 2000s Philadelphia had reversed its decades-long population slide and at its core was being rediscovered as an urbane metropolis, a more intimately scaled and affordable alternative to its neighbor to the north. Young, educated, and entrepreneurial people from dozens of cities, regions, and other countries flooded the city, some of them connected to the city's renowned universities, others to its arts scene or its restaurants, entertainment and nightlife venues, or commercial ventures. Some had simply been university students who stayed beyond graduation rather than moving to New York, Los Angeles, San Francisco, or anywhere else that previously offered more excitement or professional or creative opportunities or a better standard of living. Yet despite Philly's

growing vibrancy and its particular ability to be itself amid improvement and rising property values, revival had not reached all parts of the city.

The view from the train of the Northeast Corridor's long diagonal through North Philadelphia was of postindustrial deterioration—a long procession of decaying structures, sites, and neighborhoods built for or around mass production. It was unvarnished Philadelphia grit, and the demographics of most of these neighborhoods correspondingly showed continued population loss and property abandonment, even as the city's core was gaining population. This intimate, if brief view (unplanned service delays sometimes created opportunities for longer, stationary study) showed an American metropolis greatly reduced in extent and purpose: brick and concrete daylight factories, old warehouses and newer distribution terminals, refineries and tank farms, power generation facilities, Delaware River shipping terminals of various vintages, recycling and salvage sites—including one where cars were crushed—and correctional and detention centers. From my seat on the R7, I became familiar with these sites and would anticipate and quietly savor the moment they came into view: the elegant Victorian clock tower atop the former Schlichter Jute Cordage Works, momentarily appearing before a northward bend in the tracks; the ruinous Blumenthal Brothers Chocolate Works with its own diminutive tower ornamented with distinctive Arts and Crafts terracotta sign panels; the massive nineteenth-century stone fortifications of the decommissioned Holmesburg Prison, which was surprisingly difficult to see from the tracks immediately below; and the distinctive graffiti tags covering daylight factories built around North Philadelphia Station. The thousands of tattered row homes standing adjacent to vacant lots where houses once stood, punctuated by faded business districts where SEPTA trains stopped, provided continuity and rhythm to the trip. In places, the corridor itself opened up into an expansive network of tracks, yards and interlockings with old spurs trailing off into the crumbling industrial fabric or postindustrial meadows, or unceremoniously ending at crudely built parking lots.

These trips were an entrée to further investigation. What I saw from the train were the remains of the city's industrial icons, manufacturing complexes known for their products throughout the nation and world. They included Stetson, the world's largest hat factory; Disston, the world's largest saw works; the Philco Television and Radio Works; the Cramp Shipyard, one of the United States'

The Machine Shop of the former Cramp Shipyard prior to its demolition in 2007. (Author, 2005.)

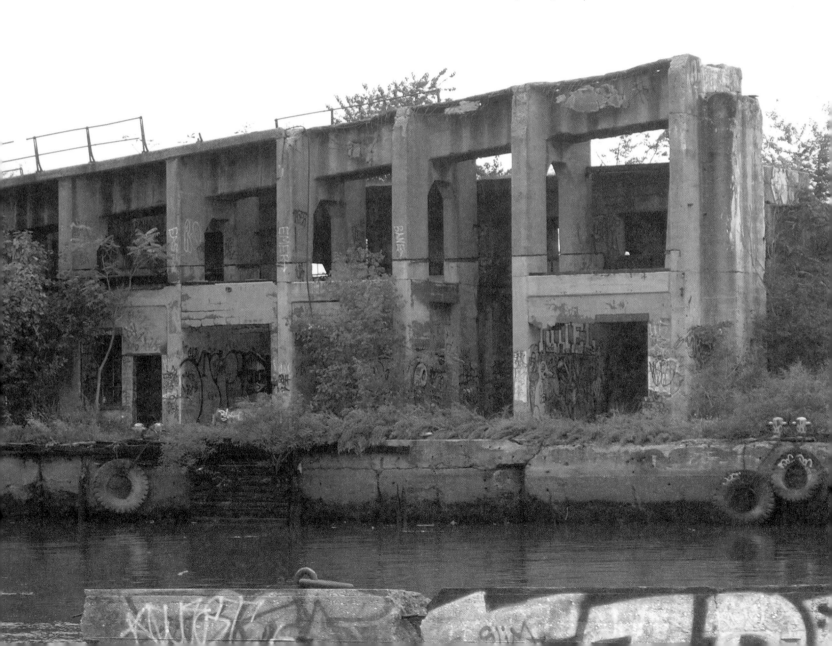

The Reading Railroad Ore Pier on Philadelphia's Delaware Riverfront. (Author, 2008.)

largest private shipyards of the nineteenth century; manufacturers of pharmaceuticals, textiles and clothing, electronics, locomotives and railcars, airplane parts, armaments, medical and scientific equipment, typesetting and photographic equipment, books, pianos, paints, petroleum and chemicals, carpets, linoleum, sugar refining, and candy. Philadelphia, the nation's first large industrial city, was once the "Workshop of the World," with wide-brim Stetsons shipped to far-flung places like Argentina and Australia; ditto for Disston saws and Philco televisions and millions of Philco radios, many of which were fitted into Detroit-made cars.[1] The more I studied these sites and visited them, the more they moved me in ways that at the time and even now, I could not entirely understand.[2]

Hidden in plain sight to the many thousands of commuters and travelers who passed them each day, these places were often of startling postindustrial beauty, architectural majesty, complex urbanity, contradiction, and mystery—and holders of a staggering amount of history. Yet many if not most SEPTA riders saw decline, a corridor of rust with a few interesting or historically evocative landmarks; on the ground, reality was more complicated. Tens of thousands of people still lived and worked in proximity to the old factories, shopped at local stores, sent their kids to nearby schools, and attended services in the corridor's old churches or other houses of worship. And at the former production sites themselves, extant buildings were often partially occupied, though with contemporary businesses that provided a fraction of the employment as the industrial concerns they succeeded, including wholesale distribution, waste transfer and recycling, and self-storage facilities, and others for vehicle repair or parking, along with a smattering of small manufacturers, offices, and social services.

Some old industrial and commercial buildings provided space for artists' live-work-display spaces, craft workshops, and music and nightlife venues. These adaptations were on the rise, part of the new Philadelphia even if they were cloaked amid the everyday fabric of the old city. As my experience and social capital grew, my travels often brought me to these spaces for art shows, concerts, festivals, and social events: the Reading Railroad's neoclassical brick office building on Spring Garden Street adjacent to the Reading's abandoned trestle (now being adapted as a linear park); the Crane Arts Building, an early-twentieth-century brick plumbing warehouse on North American

Street; the row of small industrial buildings (demolished circa 2009) south of the Benjamin Franklin Bridge approach in Old City that served as the Philadelphia Fringe Festival headquarters; and former factory buildings scattered across the neighborhoods of Northern Liberties, Fishtown, and Port Richmond, the names and addresses of which I can't recall. Outdoor spaces were also prominent parts of this postindustrial landscape and complemented interior activities, including the community-maintained Liberty Lands Park, the site of a former tannery and EPA-directed clean-up where homespun music festivals were regularly held; and the iconic ruins of the Reading Railroad Ore Pier (now known as the Graffiti Pier) on the Delaware River. Paradoxically monumental yet hidden, the pier's concrete columns supported an elevated trackway from which coal was once dumped into barges, and its adjacent forestlike upland of vestigial infrastructure provided visitors with a sublime mix of sensations and provocations. While often a quiet place to take in the river's splendor, at times it possessed an edgy social ecology, including local youth who partied, played paintball, and engaged in destructive acts.

Apart from the Ore Pier, at all these sites sweat-equity investments had created vital cultural spaces that anchored creative communities and, sometimes, contributed to neighborhood revival. The protagonists of these places—artists, building tradespeople, and cultural entrepreneurs—were helping the city forge a new postindustrial identity from its old building fabric and transition from material to cultural production in a way that did not require extensive public sector capital. And even as their existence was tenuous—many improvements may have fallen short of building, fire, and public assembly codes—these reuses contributed to the preservation of industrial structures that would have otherwise continued to decay.

These places were indeed disappearing, and not just from deterioration but from government-led or -subsidized demolition programs. A variety of initiatives were taking down industrial-era buildings, often without a strong rationale other than clearing places that represented insurance liabilities or making space for some to-be-determined new construction, a highly speculative endeavor in many cases, given locations in areas of market weakness. A Philco daylight factory, one of the city's first reinforced-concrete buildings, was demolished in 2000 by the city's bond-funded Neighborhood Transformation Initiative.[3] Twenty years later, the block-sized site was still a vacant lot.

The twenty-six-building Schmidt's Brewery complex, including its elegant Victorian administration building, was cleared in 2000–2001 by a developer who bought the property at auction with the intention of constructing a suburban-scaled shopping center (neighborhood contestation forced the developer to build the more contextually appropriate, mixed-use Piazza at Schmidt's). Along the Delaware, in 2007 the Pennsylvania Department of Transportation demolished the Cramp Shipyard Machine Shop, a stunning, block-sized single-story brick building punctuated by large vertical window bays. Even as residents and activists fought to save it and entrepreneurs put together adaptation plans, the state cleared the building to construct a new exit ramp from I-95 to facilitate trips to the planned Sugar House Casino, itself located on the grounds of the former Revere Sugar Refinery, cleared in an earlier era of demolitions during the late 1980s and early 1990s.

Among the most senseless of all early twenty-first-century Philadelphia demolitions was the 2007 clearance of the Gilbert Building, a stately nine-story office building constructed in 1910. Two blocks from Suburban Station, where I often disembarked from my journey from New York, the Gilbert sat amid a small commercial district of late-nineteenth- and early-twentieth-century structures hugging the eastern edge of North Broad Street north of City Hall. The reinforced-concrete, brick-clad Gilbert with its limestone-framed entrance had for many decades housed professional services and was listed on the National Historic Register in 1986. After a period of underutilization and then vacancy, in the early twenty-first century local arts organizations—including the cooperative Vox Populi, the Asian Arts Initiative, the Fabric Workshop, and the High Wire Gallery, along with thirty-five individual artists—took up occupancy and made sweat-equity investments to adapt their spaces, in coordination with the building's owner. Sharing a DIY ethic and the collective resolve to engage an old building with good bones, the Gilbert's arts enterprises grew and cross pollinated. A shared mission to revive the building was not necessarily what they had in mind when they signed onto the Gilbert, but the building's camaraderie was infectious. As the programs and reputations of these tenants grew, so too did the Gilbert's scene, with ever more visitors taking part in monthly art shows, performances, and happenings.

The Gilbert was like Philadelphia as a whole: intimate, old, rough around the edges, and sometimes written off or unfairly maligned, but solid and enduring. These very qualities made it appeal-

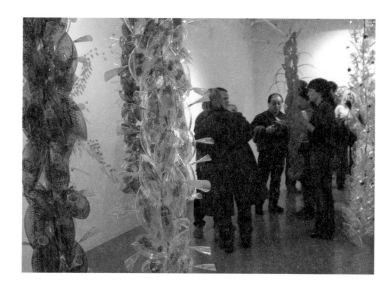

Visitors to Vox Populi enjoying Parts to the Whole, one of many art shows and events staged inside Philadelphia's Gilbert Building. Jae hi Ahn's installation is in the foreground. (Roberta Fallon, 2006.)

ing to a new generation of Philadelphians, many of whom were willing to take risks or get their hands dirty. They in turn drew visitors from ever larger circles, including those from New York, Washington, and elsewhere. Its buzz was precisely the kind that American cities began to champion in the 2000s and attempted to capture through revitalization efforts. Leaders in Rust Belt, shrinking, or legacy cities were beginning to understand that educated, entrepreneurial, and "creative class" residents were attracted to old, dense places with urbane character (what planners and architects long called "traditional urbanism") and could drive revival.[4] Yet in most American cities, Philadelphia included, creative-class initiatives and efforts to revive traditional urbanism and conserve historic buildings still took a back seat to large-scale redevelopment practices. The Gilbert retained Philadelphia authenticity, and its vitality was catalyzed not by a big real estate deal or millions of dollars in economic development subsidies, but by grassroots actions. But authenticity and sweat-equity improvements were no match for the growth machine.[5]

In the larger scheme of historic architecture, the Gilbert was not a marquee structure, and plenty of Philadelphia office buildings were taller, more palatial or sumptuously ornamented, or better exemplars of architectural style or innovation. Similarly, arts uses like those of the Gilbert in redundant commercial or industrial buildings were abundant in Philadelphia in the early twenty-first cen-

The Gilbert Building, background right, as it was being demolished in 2007. The Race Street Fire House, foreground left, was also among the buildings cleared for the Pennsylvania Convention Center expansion. (Chris Woods.)

tury, and most Gilbert tenants eventually found new digs in similar structures. But the serendipity and interplay among tenants, visitors, and the larger city had been lost, as had their location at the region's core, just steps from City Hall and the regional transit nexus located below it. It was also a reasonable walk from nearly all of Center City, and I usually went on foot to these events from my apartment a little over a mile away. That such property would be valued by the market—a market awakening to the possibility that Philadelphia itself was a tremendously undercapitalized city, and no more so than at its core—is a familiar story to any observer and most residents of early-twenty-first-century North American cities.

But the Gilbert wasn't torn down by greedy property developers. The state of Pennsylvania desired the Gilbert's site, along with those of at least fourteen other buildings, for a seven-hundred-million-dollar expansion of the already colossal Pennsylvania Convention Center (PCC). While the existing convention center was only an episodic generator of urban activity and commerce, the Pennsylvania Convention and Visitors Bureau (PCVB) and aligned growth machine agents ignored the ample evidence that these centers were bad public investments and subverted democratic processes.[6] "Bigger is Better," the PCVB said in its public relations and advertising campaigns. Sometimes hailed as the largest public works campaign in state history, a dubious honor given its inherent waste, the expansion probably cost taxpayers closer to a billion dollars, when the thirty years of city-funded subsidies were considered along with other redirected state revenue streams. The present convention center was operating at a yearly deficit of fifteen million dollars, which once expanded could balloon to twenty-one million dollars.[7] From Governor Ed Rendell on down, the bevy of state agencies, public authorities, consultants, allied development interests, and some media were oblivious to or had entirely ignored what was already happening along North Broad Street and at the Gilbert. When confronted, state leaders could only meekly argue that the convention center would lose its business to cities with larger facilities, even as academic studies suggested otherwise. As a PCVB representative told me over the phone for a story I was writing for the *Philadelphia City Paper*, before the Gilbert came down, "We know we have to expand it now, because the second it is done it will already be too small."[8] When pressed about the lack of transparency, ballooning costs, and the project's displacements, the representative admitted that the project had flaws but

rationalized that public approvals and funding were in place and legal challenges had been mostly settled. It was too late to stop now. Perfect was the enemy of the good.

And after the expanded PCC opened in late 2009, with its glassy airport terminal-like entrance on Broad Street where some of the city's most distinctive commercial buildings once stood, the market for convention space remained flat and the newly expanded center remained mostly empty, most of the time. The PCVB lashed out at the unions and, in a familiar trope, blamed the high-cost, inflexible work rules and seeming indifference of union labor for scaring away large trade shows and meetings. It was the recession and the union's fault—and some argued that even now that the convention center spanned some three giant blocks, decking over the streets in between, it still wasn't large enough. Prior to the use of eminent domain to take title to twenty-seven underlying properties and the resulting demolition of at least fifteen buildings, several of architectural distinction, demand for space along North Broad had been on the rise.[9] Building owners and their tenants had already begun to make modest investments in their spaces, and some had greater rehabilitation plans.[10] Activity was returning to one of Philadelphia's traditional sites of commerce and consumption, helping North Broad regain some of its foot traffic and verve.

The Gilbert's demolition and the clearance of a large city block occurred at a time when Philadelphia leadership, long a step behind what was happening on the ground, was waking up to the possibility that the city's revival was built in part on arts and creative economy actors and organizations that valued modest-sized spaces in old buildings and neighborhoods. As the *New York Times* opined, Philadelphia was the "sixth borough," or a grittier, cooler, lower-cost version of what Brooklyn once was.[11] The Gilbert was a rising star in the constellation of Philadelphia arts—and its protagonists and patrons were part of a community well connected to established Philadelphia cultural institutions, including museums, galleries, and university arts programs. Yet city and state leaders could neither see nor understand this vitality—or had grossly underestimated it. Nor did they have real concern that the buildings they planned to (and eventually did) bring down were part of the city's architectural heritage, and that some were National Register–listed or –eligible. The state and the many boosters who had been co-opted into supporting the expansion showed no concern about destroying North Broad Street's design characteristics with all its accumulated complexity,

intricacies, meanings and uses, even as they trumpeted the expanded convention center's ability to complement the Pennsylvania Academy of Fine Arts across the street and other tourist attractions. Better to replace it all with a single monolithic building whose form and scale were far more appropriate for an airport than a historic quarter. And thus, an enduring, durable, and at times delightful city block was lost to irrational public development practices.

Of course, Philadelphia was not the sole perpetrator in the destruction of iconic buildings that could be retained and reused and contribute to revitalization efforts. Nor was it the only city where DIY and sweat-equity investments were destroyed in the process. Such development initiatives were common across the United States in the 2000s. At the other end of my Northeast Corridor train trips, industrial era buildings were coming down with abandon. New York City was experiencing yet another real estate boom, and the economic fallout of 9/11 and the Great Recession caused only brief slowdowns in a decades-long run of escalating property values, fueled by speculative development practices and city policies designed to encourage property investment at whatever cost. With high costs and fierce competition for sites, developers and city leaders were eager to push new development beyond Manhattan and the clutch of established Brooklyn neighborhoods already deemed market worthy.

In Brooklyn, much of the development activity and speculation targeted the constellation of rapidly gentrifying working-class neighborhoods along its waterfront, which through the 1990s was the borough's Rust Belt. In the neighborhoods of Greenpoint and Williamsburg at the borough's northern tip, industrial icons fell and towers rose in their place. Development displaced residents, businesses, and creative endeavors, particularly along the blocks adjacent to the East River with their fabulous, if undercapitalized views of the river, its bridges, and the Manhattan skyline. The inauguration of Mayor Michael Bloomberg in 2002, and his administration's sweeping rezoning program, greatly accelerated what was already happening on the ground in North Brooklyn. The administration's 180-plus-block Greenpoint and Williamsburg waterfront rezoning initiative, announced in 2003 and passed by the city council in 2005, encouraged speculative activity, as did smaller rezonings and city-aided real estate ventures before and after 2005. I had in fact contributed to these efforts in the late 1990s as a planner working in the Brooklyn Borough Office of the New York City Department of City Planning, though the most consequential municipal actions would

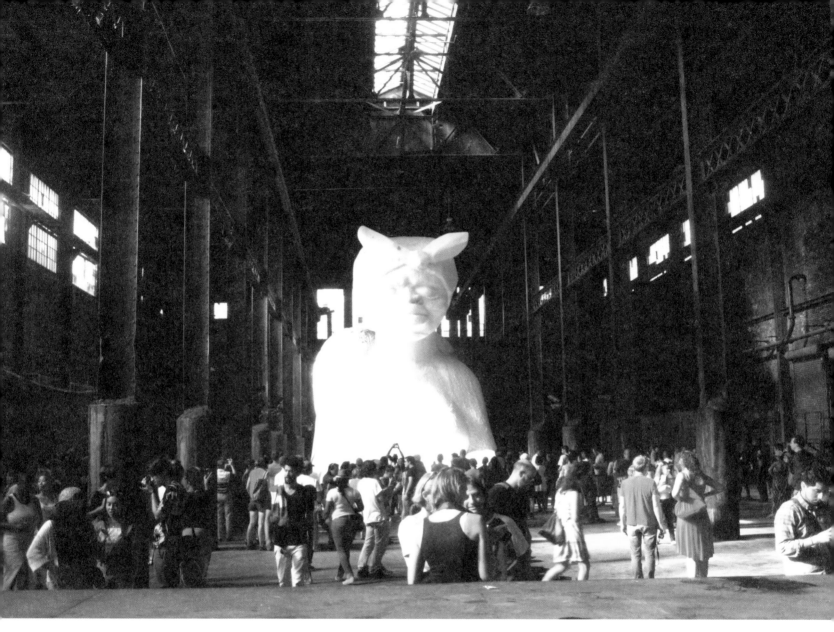

Kara Walker's A Subtlety, or the Marvelous Sugar Baby inside the now-demolished Raw Sugar Warehouse at the Domino Sugar Refinery on the North Brooklyn waterfront. (Author, 2014.)

come during Bloomberg's twelve-year reign. In 2007, as the Gilbert was being brought down in Philadelphia, the National Trust for Historic Preservation placed "Brooklyn's Industrial Waterfront" on its list of America's eleven most-endangered historic places, but it was already too late.[12] Historic preservation advocacy was no match for a hot real estate market, global investors, and politicians eager to leave their mark on the city.

The casualties of these development initiatives included many occupied (or partially occupied) landmark buildings and those of landmark potential, including some that housed arts and music uses, small businesses, and legacy manufacturers. Other casualties were sites of established transgressive, guerrilla, or informal activity, including the vacant piers and waterfront spaces, which had been appropriated by local pleasure seekers who fished, walked their dogs, watched the sunset, practiced music, socialized, or communed with nature. Then there were those buildings whose familiar presence provided residents with a sense of orientation, belonging, historic continuity, or architectural delight. Notable demolitions included the BMT Power Station (2000), the central building of the Schaeffer Brewery (2001), and the Old Dutch Mustard Company factory (2006). One of the largest buildings of the American Manufacturing Company complex (later called Greenpoint Terminal Market) was destroyed by arson in 2006. The Rosenwach Water Tank Factory, damaged by a fire in 2009, was eventually sold to developers who demolished it a few years later and built a slab hotel on its site. And while the core building of Brooklyn's iconic Domino Sugar Refinery complex (the world's largest sugar refinery when it was built) was preserved, it was only in fact its skin, with a new building constructed inside its 1884 Romanesque façade. Meanwhile, in 2014–2015, the project's developer, Two Trees, demolished all of Domino's twenty other buildings and replaced them with several luxe apartment towers aimed at the global 1 percent, which also contain some affordable units. Two Trees also constructed Domino Park, designed by notable landscape architecture firm James Corner Field Operations, with some of the refinery's salvaged machinery artfully scattered about. Among the lost buildings was the stunning Raw Sugar Warehouse, with its massive garage door openings onto the river and its movable gantry, which entered the broader public consciousness as the site of Kara Walker's 2014 installation, *A Subtlety, or the Marvelous Sugar Baby*.[13]

(Why couldn't Two Trees, known for its successful preservation of industrial buildings in Brooklyn's Dumbo district, leave this warehouse in place for future arts programs and simply build the towers around them?) And while not directly facilitated by city government, in 2016 the Brooklyn Navy Yard Development Corporation demolished the Yard's Admiral's Row of Greek Revival and Italianate town houses to build a supermarket.

Even as clearance was pervasive, some iconic buildings were preserved, but at great expense for high-income-generating uses, mostly as residential apartments. They included Cass Gilbert's 1913 Austin Nichols Warehouse, a block-sized, seven-story Egyptian Revival building—a concrete behemoth with vertical slat windows and a ground-floor railroad atrium once connected to float bridges that delivered rail cars to and from barges that plied the harbor. Like Austin Nichols, the ten-story Gretsch Musical Instrument Factory on Broadway was converted into luxury condominiums, as were some of the buildings of the Eberhard-Faber Pencil Factory in Greenpoint.

Such was the price of progress. In New York, publicly facilitated development practices were always rationalized as providing affordable housing and new parks in neighborhoods starved for them, not unlike the way such practices are rationalized in Rust Belt cities around job creation and blight removal. Indeed, the decade after the 2005 waterfront rezoning saw a great expansion of park and public leisure spaces, though the affordable housing has been more limited and truly affordable units remained largely elusive in an environment of speculation. Yet despite all the development activity, displacement, and escalating property values, Greenpoint and Williamsburg did not immediately lose all their compelling postindustrial character. Some galleries, artist lofts, and music and entertainment spaces survived, joined by adventurously designed restaurants and retail, craft manufacturing and design, media, and fashion concerns, all of which valued authentic industrial interiors. Many of the restaurants, performance venues, and arts endeavors have since closed or moved, but some persisted and new ones opened—in some cases, serving as eye candy to sell the expensive real estate above or around them or that would ultimately replace them. But the area's unique flavor was receding, and its arts scene was moving farther east to the neighborhoods of East Williamsburg, Bushwick and Ridgewood, Queens. Additionally, Williamsburg's most distinctive

Brooklyn's Accidental Playground on the East River. (Author, 2001.)

public space, the appropriated railroad piers and former waterfront railroad yard that had evolved into a people's park, was reclaimed at great expense by the city, state, and development interests. The waterfront eventually gained officially designated parks, but North Brooklyn's accidental commons, where the cultural and countercultural freely mixed among diverse visitors, was lost.

The demise of Williamsburg's free spirited, DIY waterfront, which I studied during my years at Penn and wrote about in *The Accidental Playground*, was inevitable.[14] The hungry city was waking up, and no under-the-radar expanse of anarchic space with amazing views would be allowed to lay fallow. There was no way to reconcile this outsider waterfront activity with the conventions, practices, and laws of urban development in the city. Nonetheless, I wondered what would happen if such spaces were allowed to grow organically, perhaps with gentle assistance from the government. What would they eventually become, and could development practices be tamed to accommodate such places? Similarly, I thought about buildings like the Gilbert. Were there other distinctive, yet faded industrial-era buildings where DIY and arts activities could grow and become fully legitimate? The preservation of such buildings in the United States has always been problematic, and where successful, the results were almost always upper-market uses. Was it possible to stabilize rather than preserve iconic buildings and landscapes and allow for grassroots tenancies or, alternatively, keep stabilized ruins available for wide-ranging itinerant use? Could the problem of preserving an iconic building or site—one of great collective value even as its condition might be poor—be reconceptualized to be more like an enlarged DIY house renovation? Could it be a collective project where local resources, knowledge, talent, and passion trump developers and deep-pocketed investors, conventional preservation incentives, and painstaking architectural practices?

At a time when interest in DIY building practices and the traditional architecture and urbanism of American cities was coalescing, drawing more participants and catalyzing restorative activity and economy, there seemed to be no place where such activities were allowed to endure and grow. In a strong market like Brooklyn, sweat-equity practices were being cannibalized or eliminated by the development initiatives they spawned, while in a middle or emerging market like Philadelphia, they were being destroyed both by rising demand and the often contradictory rationale that the city's economic weakness demanded sweeping public sector intervention. Of course, DIY pos-

sessed its own contradictions: was it even possible for such activities and places to endure or enjoy some permanence without becoming professionalized or co-opted by conventional development? And the mobility of many activities and the craftiness of their agents contradicted arguments about the need to preserve such places. While the Gilbert's serendipitous scene was impossible to re-create, its former arts constituents did find spaces in other buildings and have continued to stage their programs and build their organizations. The Brooklyn waterfront was lost for its unusual constituencies, but most of its practitioners of music, art, performance, and skateboarding found other venues while nearby residents now enjoy parts of this same waterfront as fully developed park spaces. Why should we worry about losing such activities when they will just move to the next neighborhood?

Of course, even in very large cities like New York, industrial fabric is finite, as are ungentrified neighborhoods. Given the appetite of city leadership to build affordable housing—even if it means destroying or pricing out more affordable housing in the process—it is conceivable that one day there will be no more artist lofts or anarchic spaces available for appropriation along the waterfront or elsewhere. New York's industrial icons were disappearing, often being replaced by global architectural products aimed at the 1 percent and investor class that could just as easily have been built in Beijing or Dubai. In addition to its genericism, erasure of history, and sometimes overwhelming scale, the new construction also failed to generate the kind of energy and messy, ad hoc diversity of the old, lightly improved buildings and underutilized spaces. Housing advocates and local community development corporations often cheered the new development, frequently after having been offered a carrot of a small number of affordable housing units as part of the mix, a commitment to local hiring, or funding contributions to organizational projects. But the new buildings were often reviled by established residents of these neighborhoods while scholars have criticized city policies that encourage or subsidize these redevelopment practices for exacerbating inequality and destroying the intricate resident diversity of these former working-class neighborhoods.[15] Yet real estate interests are among the most active contributors to the campaigns of local politicians and most effective agents in gaining the ear of the mayor, governor, or local council member. And while the arts and artists have recently been recast from victims to agents of neighborhood gentrification

and displacement, city policies and growth coalition actors are far more powerful. They sweep away more incremental forms of neighborhood change and the not always easy, but generally copacetic coexistence between artists and working-class or long-tenured populations.[16]

I tried to maintain some scholarly remove from the events that I watched unfold in New York and Philadelphia, but it was hard not to feel that public policies were betraying these cities' built heritage, distinctive cultures, and identities. In Philadelphia in particular, watching those buildings come down on North Broad Street and the convention center rise in their place, I felt like part of my own soul was crushed and that public sector urban planning and development practices had been corrupted beyond the point of redemption. Intellectually and emotionally, I had to find new grounds for discovery, observation, and experiment. Cities further down the economic food chain might still provide the postindustrial opportunities that were vanishing in Brooklyn and Philadelphia.

Long before I had published *The Accidental Playground* or my experiential ode to Philadelphia's historic industrial fabric, I visited Detroit.[17] While my maiden trip in 2003 and subsequent forays in 2005 and 2006 were purely speculative, in the Motor City I found a postindustrial landscape where I imagined some version of my proposed natural experiments could happen. Additionally, it wasn't too hard to find iconic industrial sites—the city was full of them, though many were teetering on the brink of erasure. And city leaders demonstrated even greater apathy toward industrial-era landmarks than their colleagues in New York and Philadelphia. If they could only find the money to tear all these sites down.

While there was no gazing out the window of a commuter train in Detroit, the windshield of a rental car provided a more than adequate view of the city's vast deindustrialized landscape. The patchwork of vacancy-laden neighborhoods punctuated by abandoned industrial, commercial, and civic landmarks—old automobile factories, empty downtown skyscrapers, shuttered schools and hospitals, the overgrown parks no longer maintained by city government, and thousands of miles crumbling roadways—offered seemingly endless provocations. Visiting the city's deteriorating monuments, including the Michigan Central Station, the Packard Automobile Factory, the Book-Cadillac Hotel, and

many less prominent sites, I felt a contradictory mix of emotions: sadness, titillation, outrage, and an optimism that an alternative future could begin here. I was sympathetic to the hundreds of thousands of Detroiters of little wealth or resources, who lacked substantial opportunity or mobility, and those whose day-to-day reality often vacillated between desperation and making do. I experienced acute awareness of my privilege of being an educated, middle-class, mobile, white visitor in a city of rampant poverty and misfortune that by the millennium had lost over 50 percent of its 1950 peak population and was over 80 percent Black. My Detroit research inquiries sometimes generated scorn or laughter, and a few times I was told bluntly to go back to where I came from or to study some other city. I had endured outright hostility in my Philadelphia field research, but in Detroit I was a total outsider. Even in the presence of Detroit architects or planners, the act of observing informal practices at abandoned sites often felt compromised and, sometimes, vaguely exploitive. I needed to see sites in other Rust Belt cities before I could even understand what exactly I was looking at or for.

I would eventually find my way to Buffalo and Pittsburgh, both of which possessed their own tortured narratives of postindustrial decline, but also iconic sites that provided the setting and inspiration for subprofessional urban development and spatial practices. And while I also made trips seeking interesting postindustrial recovery projects in Chicago, Cleveland, Flint, Milwaukee, Paterson, Rochester, St. Louis, and Youngstown, I knew I had to limit the number of sites for longer-term study. Not wanting to merely repeat the research of *The Accidental Playground* in a less populated environment, I limited my selections to large, iconic sites that still possessed buildings in major cities, ones that could be resurrected through traditional historic preservation practices and adaptive reuse, rather than mostly cleared landscapes like the former waterfront railroad yard and piers that I had studied in Brooklyn. I also eliminated from consideration those sites that had been adapted mainly as artist lofts, as their presence is still quite ubiquitous. I was seeking sites that possessed broader collective meaning and architectural distinctiveness and prominence.

Eventually I settled on five sites for detailed study and serial visitation: two in Detroit, two in Buffalo, and one at the edge of Pittsburgh. At each of these places, I found abandoned industrial-era icons with enduring structures—though often in poor condition—being appropriated, ad-

opted, preserved, restored, or used by a range of protagonists in a larger environment of decline. Though of vastly different typologies, they possessed similar narratives and were each natural experiments in the potential and limits of appropriation and DIY. What was the value of these activities, and could they last and grow, given both the continued decline and nascent rediscovery of these three cities? I observed and chronicled the story of these places for over twelve years seeking these answers.

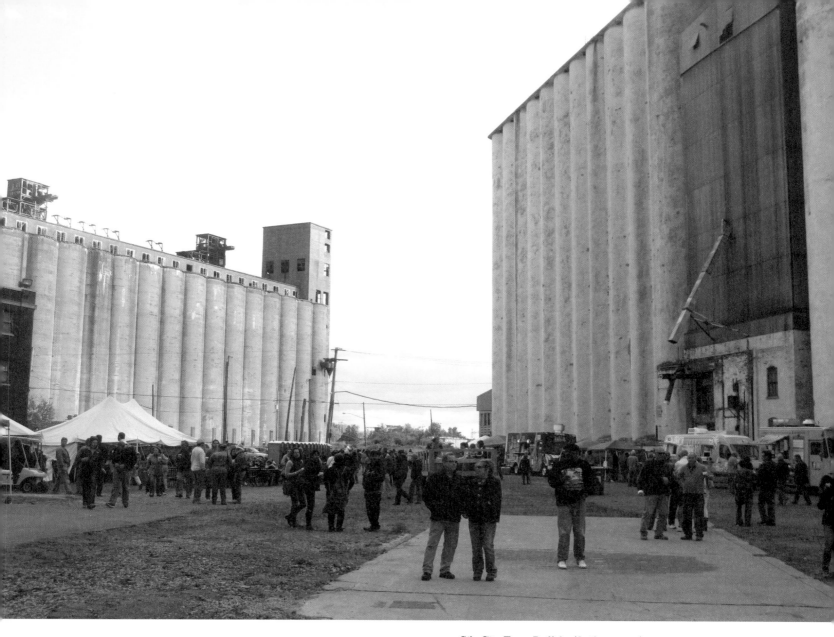

Silo City Taps, Buffalo. (Author, 2014.)

Recovering Postindustrial Places

D own the dusty pavement of Buffalo's Childs Street, my rental car rumbled across a series of old freight tracks, well-receded into the roadbed, and the street gave way to a large, asymmetrical opening surrounded by four towering concrete grain elevators. Pulling into a gravel parking area and hopping out into the unusually cold September air, a buzz of excitement came over me: I had arrived at Silo City. To my right, a small work crew was assembling a stage for Silo City Taps, a beer and music festival to be held the next day. The stage was an improvised affair consisting of two-by-fours, plywood, and steel beams harvested from the Perot Malting Elevator immediately behind it, supported by piles of railroad ties at its corners. The beams taken from Perot were part of a small railroad shed that once projected out into this accidental courtyard framed by Silo City's grain elevators, which also include the American and Marine A and the rehabilitated, then-in-use Lake and Rail, which was visually, but not by ownership, part of Silo City at that time.

As I had discovered on previous visits, this scruffy courtyard possesses a kind of magic. It is where historic industrial architecture and the serpentine geography of the Buffalo River come together under an ever-changing sky, creating a space that is intimate and often serene, even as the elevators themselves are giants that dominate the landscape. Icons of the region, these concrete structures made Buffalo the largest grain port in the world for much of the twentieth century. It's easy to understand why this place has become both a local gathering spot and a pilgrimage site

for modern architecture enthusiasts, even as the courtyard itself is accidental: the elevators themselves were all built independently by different corporate entities on discrete riverfront property plots.

The Perot, constructed in two sections in 1907 and 1933, and idle since 1993, is the most diminutive of the four elevators. Yet its ninety-foot concrete silos, which have a 500,000-bushel storage capacity (a fraction of the 4.1-million-bushel volume of the adjacent Lake and Rail), still towered over the stage below. The Perot's architectural vitality comes from the vertical thrust of its concrete silos, the elegance of its efficient geometry and repetition of forms, its substantially intact internal equipment and viaduct connections to the adjacent American (this is how it received its grain via lake boat). It once was the city's largest malting house, which for decades produced the malted barley that went into Genesee Beer and others.[1] While removing seemingly ancillary parts like the train shed does not substantially reduce Perot's historic integrity, such practices are generally at odds with the Secretary of the Interior's Standards for the Treatment of Historic Properties.[2] Though the US National Park Service had deemed it eligible for the National Register of Historic Places in 1991, Perot has not been designated. Even if it had, the shed may have been considered a "noncontributing" structure. Moreover, a Historic Register listing cannot stop a private owner from using their own resources to demolish a structure "contributing" to a historic designation anyway—and does not ultimately stop governments or their agents either. Such is the arcane and seemingly arbitrary nature of historic preservation in the United States.[3]

The next day, several hundred attendees—undeterred by the mid-September chill—drank craft beers, ate the specialties served by food trucks, and explored this campus of grain elevators tucked into this Buffalo River oxbow while local bands blasted away from the stage completed a day earlier. Most who were taking in the performances weren't thinking much about historic designations and were likely unaware of what might have been lost in the construction of the stage—and, even if they knew, would have still been wowed by the unusual festival grounds and the grain elevators around them. Behind the elevators, some gathered along the riverfront landing, which separated Perot from the American and was topped by two sets of railroad tracks. On those tracks rested a formerly movable "marine tower" of paint-flecked and rusted panels of corrugated steel, itself taller

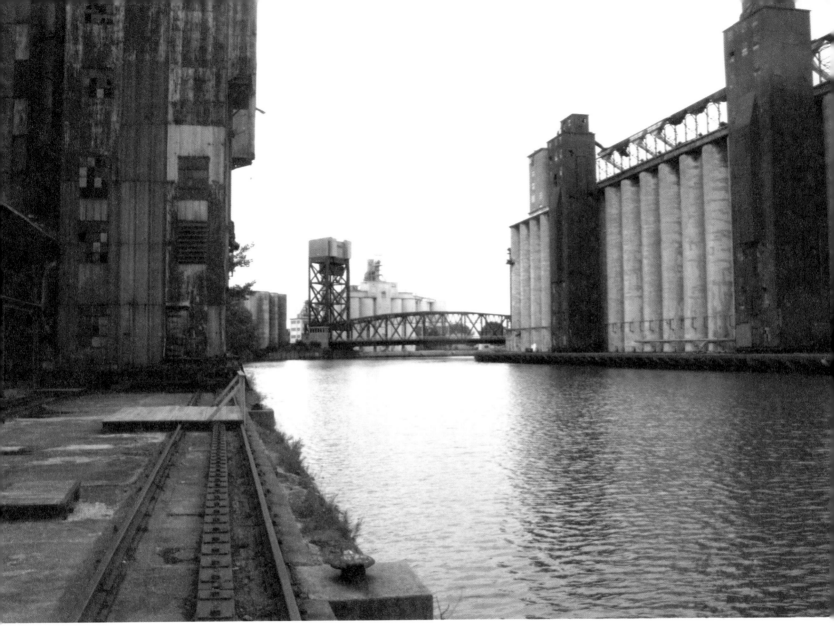

Perspective of the Buffalo River's Elevator Alley from the wharf between the American and Perot Malting grain elevators. (Author, 2014.)

than the silos of either grain elevator, atop rusted wheels. The tower once featured a "loose leg," a long conveyor with bucketlike attachments that could be lowered into the hold of lake boats to scoop out grain and deliver it to the top of the American for distribution to its silos, or "bins" as they are technically called. This concrete landing and the second-story mezzanine connecting the two elevators behind it were ideal spots for taking in the majesty of the river. Enjoying the view of what some call "Elevator Alley" framed by elevators, both active and idle, and the Ohio Street Bridge, attendees felt a sense of exhilaration, heightened by the apparent lack of restraints that separated them from concrete and steel underfoot and around them, and the water beyond the landing. And even those lacking knowledge of architectural history, geography, or ecology were surely dazzled by the interplay of these monumental structures with the sky, river, and the accidental green growing along the banks. "Only in Buffalo," as I heard someone say on a previous visit.

Silo City Taps was just one of many cultural events and programs staged on this fourteen-acre site in the 2010s, including City of Night; Boom Day; the Buffalo Niagara Blues Festival; grounds and building tours; poetry readings; music, theater, and dance performances; photography workshops; art installations; community gardening; climbing and rappelling; weddings; and educational programs involving ecology, science, and history. In the middle of the world's greatest concentration of twentieth-century grain elevators—a monumental landscape that became a touchstone for modern architecture, what scholar Reyner Banham would later call a "Concrete Atlantis"—Silo City is an experiment in the preservation and reuse of industrial places.[4] Exploiting historic structures largely in their as-is condition and creating programming in and around them, it offers a novel approach to reusing abandoned or deteriorating industrial places in weak market areas of American cities. A place made publicly accessible through years of thrifty, do-it-yourself practices, freewheeling management and programming, and a tolerance for risk-taking, Silo City is the rare industrial heritage site that has survived the avaricious waves of demolition and clearance that have stripped the US Rust Belt of many of its most distinctive buildings and complexes and replaced them with low-density development oriented to automobiles and trucks, or nothing at all. But it is also one of the few "preserved" historic places that has yet to fully succumb to the exacting standards and market discipline that remake landmarks into high-end apartments, office space, hotels, or less

frequently, single-purpose history or architectural museums. All these adaptations have their place in American cities. Silo City will soon have some of these uses as well, but it will have arrived at this outcome following a different path. Building on its success as a privately owned cultural park, Silo City has evolved. Some of its elevators, mill and malting buildings, offices, and ancillary structures are now being adapted for revenue-generating uses through a well-orchestrated and better capitalized approach guided by preservation architects and subsidized by federal and state historic preservation tax credits and other incentives. But urban development has come after more than a decade of experimentation, tinkering, small investments, and diverse programs that have provided entrée to the public to enjoy the site in its unimproved and, in places, dangerous state. And even as these practices have now built a market for professional urban development, some preceding activities will continue after interior spaces have been adapted and brought up to code for residential, commercial, community, and arts uses.

Accident has also played a role. Rick Smith, Silo City's cowboyesque owner who nurtured the site's offbeat cultural offerings in the 2010s, was gathering permits during the mid-2000s to build an ethanol refinery in the very courtyard where I stood on that cool September 2014 morning. If not for the Great Recession and the steep fall in the value of grain commodities, these historic industrial structures might have been revived to receive grain again and feed it to refining facilities and storage tanks to be built in their midst. The Lake and Rail had, after substantial investment, already been brought back into service, and its bins held grain that very morning. And if city leaders and some property owners had had their way, the idled elevators (Marine A was last used in the mid-1960s) would have surely been demolished decades ago.

Two miles northeast of Silo City, do-it-yourself protagonists were attempting to resurrect another architectural icon, the Central Terminal, Buffalo's great train station, which closed in 1979. With its Art Deco office tower, magnificent passenger concourse, and history of public use, it is a different kind of landmark than the grain elevators. While the terminal was listed on the National Register of Historic Places in 1984, by 2014 its preservation was still very much a work in progress. Its prominent presence on Buffalo's East Side was due to decades of grassroots activism and a bit of luck. After nearly two decades of mostly disastrous private ownership that left the terminal a near-unsal-

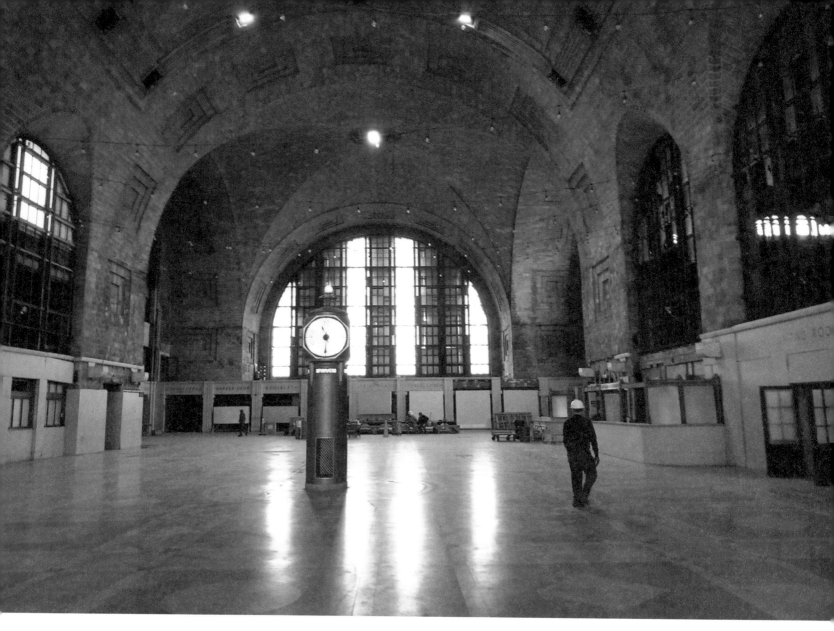

The Passenger Concourse of Buffalo's Central Terminal.
(Author, 2020.)

vageable ruin, preservation activists and one courageous city councilman forced the city to take title to the complex and convey it to a newly created, citizen-run nonprofit, the Central Terminal Restoration Corporation (CTRC).

The CTRC has long sought private-sector development partners to undertake a full restoration and fill the terminal and ancillary buildings with new uses and tenants—and make it a railroad station again, albeit far smaller. But it has been a supreme challenge given the station's enormity and structural pathologies, the weakness of the East Side property market, and the difficulties inherent in reconfiguring train stations for revenue-generating uses, even with substantial government support. And in the terminal's case, public sector support until recently had been quite begrudging. Yet at the same time that the corporation courted developers and government funding, it exploited the emotional attachment that many Buffalonians feel toward their former station, even those born after 1979 or too young to remember active train service. Almost from the beginning, the CTRC employed a veritable army of weekend volunteers to clean, dispose of the mountains of accumulated debris, and tackle modest repairs and restoration projects. It also raised funds for and oversaw critical renovations undertaken by professionals, like keeping the concourse's vaulted ceiling from falling in. Volunteers also helped prepare the concourse for regional events, tours, and media shoots. Without heat and plumbing and only a limited electrical supply, the terminal became the primary celebration space of Dyngus Day, a Polish-themed Easter Monday bacchanalia, pioneered by local cultural entrepreneurs. Thousands flocked to the terminal for Dyngus Day in the spring, while similarly large crowds came in the fall for Oktoberfest.

Like Silo City, the Central Terminal is an evolving recovery project, one that engenders passionate patrons, creative or entrepreneurial activities, and a broader sense of regional pride. But even as it strove for a market-driven, adaptive reuse outcome and legitimacy as a community revitalization project with broad benefit, it was not universally embraced across the city and even in its own neighborhood. And in 2014, when Silo City was beginning its third full season of cultural programming, the corresponding events at the terminal were being paused because of ongoing repairs to its roof, liability concerns, and conflicts among the station's board of directors. The carpenters, train and history geeks, and dyed-in-the-wool Buffalonians who show up each Saturday for volunteer

hours can make repairs but cannot by themselves address major structural issues, install new building systems, or replace thousands of window panes. Similarly, nonprofessional management and citizen directorship have their limits.

Silo City and the Central Terminal share a vitality generated from architectural heritage catalyzed by DIY practices. Under private ownership, Silo City's grain elevators provide a compelling as-is backdrop for landscape-based activities with only modest interior use of the elevators themselves (for tours, performances, art installations, and ceremonies), though this is now changing. At the terminal, nonprofit ownership has from the outset worked toward interior reclamation—of the passenger concourse in particular—and DIY is accordingly centered on restoration practices. And while Silo City in its first decade basked in immediacy and its off-the-grid aura, the CTRC too has had to embrace something less than conventional. Local circumstance and funding challenges forced it to be thrifty and resourceful and adjust its goals to enable enjoyable use of the concourse in something close to its as-is state.

Both Silo City and the Central Terminal are among the more publicly satisfying projects of an emerging movement in historic preservation, postindustrial urbanism, placemaking, and urban landscape ecology—if it could even conform to these labels: *a postindustrial DIY*. The movement aims to recover, preserve, interpret, reuse, and celebrate significant industrial-era places through locally directed and mostly hands-on building and landscape practices, cultural programming, and a range of smaller and itinerant activities. Across the US Rust Belt and elsewhere, participants have appropriated, reengaged, acted as advocates for, or taken ownership of dozens of idled industrial-era sites, even as they lack capital, expertise, political clout, and to varying degrees, permission. Protagonists, instigators, owners, and participants include a mix of traditional and nontraditional urban development actors: architecture enthusiasts, amateur historians, local activists, naturalists,

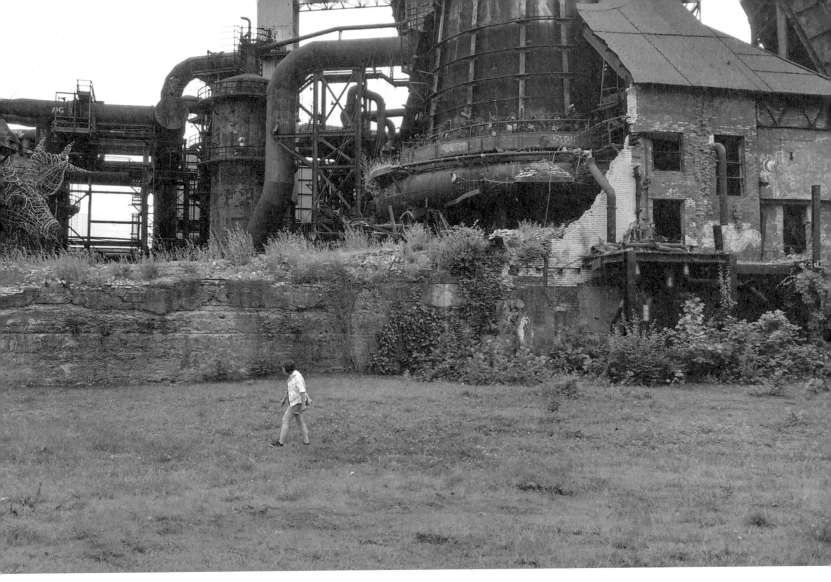

The ruins of the #7 Carrie Blast Furnace complex, Monongahela River Valley, Pennsylvania. The Carrie Deer stands amid the infrastructure on left. (Author, 2017.)

artists, and nearby residents, as well as professional architects, planners and preservationists, business owners, property developers, and building tradespersons. These groups coalesce around a shared desire to conserve, appreciate, and engage local landmarks and participate in the physical rebuilding of their cities. Their engagement with degraded or vacated postindustrial sites offers a looser and more playful alternative to conventional practices that typically result in luxe residential or office conversions, institutional space, upscale markets and restaurants, and hotels, along with a smattering of industrial heritage museums. But even more vitally, for the many historic industrial sites deemed unsuitable for market-based architectural adaption and the hefty financial and political support such projects require, these practices can provide a compelling alternative to demolition and clearance.

The movement is still in a formative stage, and many participants are not fully aware of similar project sites or that they are the vanguard of experimental practices. My investigation, which is likely the first to link these places together, attempts to assess the movement's potential (and limitations) to impact urban development practices, and considers DIY's role in providing form, meaning, and vitality at iconic but difficult-to-reclaim sites and landscapes characterized by postindustrial decline. As cities across the Rust Belt attempt to sort out their identity and purpose and engage in urban development in pursuit of revival, it is essential that we understand DIY development activities at these sites. Is the Central Terminal the new Buffalo or the old? Do seminal but decaying factory complexes like Detroit's Packard Automotive Plant have a future? And if so, to serve what functions, and who decides? And what about novel postindustrial projects like Silo City and the Carrie Blast Furnaces on the edge of Pittsburgh, ones that have beaten the redevelopment odds and are now enjoying success with cultural programs that draw ever-larger crowds and catalyze development interest at and around them? As these homegrown projects evolve and attract investment, will they continue to retain their informal essence and aura—those qualities that make them something other than profitable real estate? And how might their growth benefit those who live nearby? Despite their organic nature and legitimate claim to being local, some of these architectural recovery projects have had difficulty engaging those who live within three hundred yards instead of three or thirteen miles away. Can the urban development community, city leaders,

and citizens learn to accept and gently nurture these places, rather than destroying them? These questions drive the narrative of this book.

Postindustrial DIY and Its Place in the Rust Belt

Less a set of defined practices, postindustrial DIY could be characterized as an approach that emphasizes on-the-ground actions, making the most of limited resources and expertise with or without authorization at degraded but architecturally or culturally consequential sites. Like the growing DIY urbanism movement (and variants—tactical, everyday, and guerrilla urbanisms; creative place-making) and its brand of "lighter, faster, cheaper," these hands-on activities stretch the possibility of the present.[5] Protagonists—often unsatisfied with those vested *to do something* about idled industrial sites (owners, politicians, or their appointees) to make them productive, vital, public, or urbane again—have taken matters into their own hands, even if their ambitions are modest or their actions lack ambition entirely. At locations where economic value cannot be immediately or easily realized, they ask: *What can we do at this site today? What about tomorrow or next week? Let's get started now and ask for permission later.* Of course, some actions that I document are not concerned with recovery but rather exploitation—making use of abandoned sites for whatever purpose, even if that purpose has a destructive element (to be discussed shortly).

Unlike many landmarks saved from demolition and repurposed for public cultural use, these sites are not architectural or industrial history museums. They are not reconstructions of the past. And even for casual visitors, they engage in multiple and often surprising ways. Sites like Silo City and Carrie Blast Furnaces reveal themselves both immediately and incrementally over many visits; they are places you might visit several times a year rather than once in a decade or a lifetime. And they are not simply spaces of consumption. They function as a kind of cultural commons that invites participation from diverse parties—venues to share ideas and perspectives and, most importantly, shape an urban landscape otherwise dominated by political elites, global capital, and specialized

professionals constrained by the rigid demands of political economy and the limited number of acceptable land uses or architectural outcomes. Because these sites are incomplete, unfinished, yet to be revived—awaiting execution of the big plan or grand restoration, or in the worst case, the wrecking ball—they are places of possibility. They offer opportunities for people lacking the skills, resources, or authority to participate in the recovery of a regional icon, and to create programs of public enjoyment, culture, dialogue, and education at or around them. Postindustrial DIY is driven primarily by passion and often a sense of civic obligation rather than economic return, though for a few, there may eventually be profit as well. These practices also reorder priorities so that the accumulation of resources toward some agreed-upon end state or goal is not the foundational act that makes all other things possible. You don't need millions of dollars to practice postindustrial DIY, and in some cases, access to such resources may be counterproductive. Conversely, the presence of such activities on an otherwise idled site today does not preclude professional, well-funded development tomorrow.

Given the aspiration of some projects, participants might bristle at the notion that their actions are indeed do-it-yourself, with all the implications of "amateur" and, for some, suggestions of illegitimacy or going around the rules. And certainly, at established project sites with access to resources like Silo City and the Central Terminal, practices include building and administrative activities carried out with proper permits and insurance and within the conventions of the trade—often occurring side by side with more purely amateur endeavors. These practices include those that define preservation: stabilizing, conserving, restoring, adapting, and maintaining buildings, as well as archival research and advocacy. Yet postindustrial DIY is not simply a subset of preservation activities, and in and of itself will not keep buildings standing. And if these projects are successful and bring more people to them, they will with time become more professional. This transition can be fraught with contradiction, conflict, and compromise, while even notable or successful project sites may succumb to demolition.

Even where deterioration is pervasive, historic but ruinous structures can often be used as a setting or backdrop for outdoor programs without immediate or fully corrective actions. Where resources permit, these sites can be stabilized rather than conserved or restored to facilitate such

uses. Sometimes, outdoor programs dovetail with longer-term preservation or reclamation efforts, and contribute to fundraising, education, or advocacy campaigns, even if it is not immediately explicit to participants. Like Silo City, sites that have extensive, if often accidental grounds (the places where buildings or machinery once stood, former storage areas or rights of way) can be exploited for both large-scale programs and DIY landscape practices including gardening, low-tech habitat restoration, and engagement with successional nature and wildlife. Found objects and junked equipment can accent these landscapes and provide additional opportunities for participants to create environmental art and sculpture gardens, paths, play spaces, and places of repose or contemplation. While the grounds of Carrie Bast Furnaces are regularly used to celebrate region-defining industrial arts through iron pour events and metal craft workshops (as are the more diminutive grounds of the Steel Yard in Providence), they are also habitat to deer, foxes, coyotes, gophers, snakes, voles, songbirds, birds of prey, butterflies, bees, and other insects, which have taken to the woods and grasses that now cover substantial portions of what once was the United States' largest iron mill. These sites are now places where you can see, hear, smell, and feel the rhythms of nature, and perhaps speak to evolving ideals about urban ecology as much as industrial heritage.

This book's principal sites demonstrate the great variation in what could plausibly be called postindustrial DIY, including who owns and administers these sites, the scale and scope of building interventions, and the degree to which these projects could be considered legitimate or aspire to collective goals. Sites also differ in size, historic purpose and building types, neighborhood or area characteristics, and political context. And while *industrial* often implies production—factories, refineries, mills, and processing or storage facilities for raw materials—preservationists often use the term as a catchall for activities that aren't strictly residential, commercial, or institutional.[6] In *"postindustrial,"* I use the term in this liberal spirit, and often include former office buildings, department stores, civic complexes, railroad stations and train yards, docks and wharfs, public utility sites, and sometimes institutional buildings or campuses. These are sites of the industrial era, a time when American cities came of age and regularly produced remarkable works of architecture and urbanism—ones that today we often call "historic." And they are not limited to what geographers and demographers routinely call the "Rust Belt," which entered the lexicon sometime

in the early 1980s as a descriptor of places experiencing economic decline or crisis brought on by deindustrialization.[7] Nor are they limited to cities that planners often call "legacy cities," a more geographically flexible, if not vague label that evolved as an alternative to "shrinking cities," characterized by postindustrial shrinkage of economy, population, and physical footprint.[8] Without natural or governmental boundaries, "Rust Belt" signifies a cultural or political condition (see the US presidential elections of 2016 and 2020) as much as one based in strict geography or economy.[9] Likewise, my use of "postindustrial" connotes a condition of an urban landscape or site, and may lack the implication of economic decline. In addition to historically intense industrial regions like Germany's Ruhr Valley, Wallonia in Belgium, and the English Midlands, on a metropolitan scale, Rust Belts could, until recently, be found hugging the waterfronts or railroad lines of more prosperous cities like New York, Los Angeles, San Francisco, Boston, London, Paris, Barcelona, Berlin, and Tokyo.[10] And these cities and others still possess properties that stubbornly resist the waves of development that have transformed industrial districts and working-class neighborhoods, though far fewer than at the beginning of the century.

In the United States, most urban residents are already familiar with postindustrial DIY as a building practice: the sweat equity adaptations that have remade industrial and commercial buildings into artist lofts, including live-work, display, performance, and event spaces—often below full compliance with building, fire, zoning, and public safety codes. While the districts where loft living and arts production were pioneered, New York's Soho and Tribeca with their many cast-iron buildings, and the corresponding areas of Chicago, Montreal, Philadelphia, and San Francisco are converted into upscale living and commercial districts, newer postindustrial arts zones have evolved farther from the core and in cities previously lacking concentrated arts populations. In the Rust Belt, these practices have taken on greater urgency because demolition practices have been so effective at clearing building stock and can be generators of urban activity, even if it is seasonal or episodic, in sprawling zones of decline. In transitional or gentrifying areas, where industrial sites have been transformed into spaces of consumption consistent with the rediscovery of American cities as places to "live, work, and play," these postindustrial development practices are distinctive outliers that don't conform to the conventions of real estate, even if their nonconformity is only temporary.

Their incongruence is not just with municipal codes, but also with rigidly cast preservation incentives and development policies at all levels of government that encourage clearance or let sites languish while they await the big plan or the investors who may never come.

The tension between legitimate building practices and DIY was tragically illustrated by the 2016 Ghost Ship Warehouse fire in Oakland, California, in which thirty-six people died. Master lease holders had carved the interior of the 1930 building into an illegal warren of living, studio, and gathering spaces using highly combustible materials, and frequently hosted unlicensed parties, which included the concert the night of the deadly fire, attended by approximately one hundred people (escape was impeded by blocked fire exits and an improvised staircase made of combustible wood freight pallets). The fire at the building, which had received at least 10 previous code violations and was the subject of a city investigation opened less than a month earlier, led to stepped-up enforcement at DIY arts spaces across the United States, with cities from coast to coast shutting down buildings and evicting their tenants. Of course, many artist conversions operate in or much closer to compliance than Ghost Ship, and cities like New York have limited legal mechanisms for "interim multiple dwellings," which allows building owners and residents time to bring their buildings up to code.[11]

Beyond the ambition of sweat-equity building and occupancy practices, the range of postindustrial DIY is wide, and even more purposeful project sites must start somewhere. This frequently begins with itinerant actions, often without permission of ownership or local government: transgressions, appropriations, temporary adaptations, and wandering through the ruins and postindustrial wilds—in locations often beyond the monitoring, control, and protection of law enforcement and municipal safety codes. These practices—which I previously called the undesigned and unplanned, guerrilla urbanism, autonomous spaces, "make your own environment," and vernacular—have been observed at or near all the sites of this book and in their respective cities at large, as well as others both within and far from the US Rust Belt.[12] They include recreational, social, creative, and ritual activities and those that speak to everyday needs and have been a part of urban life since the beginning of cities; I have yet to visit a city with idled industrial sites that doesn't have some tradition of appropriation. Yet unauthorized activity at urban ruins is arguably a defining Rust Belt char-

Exploring the Concrete Central Grain Elevator, Buffalo. (Author, 2012.)

acteristic. One southwestern Pennsylvania resident claimed that wandering through industrial ruins was a "birthright" of Rust Belt youth, even as redevelopment practices continue to reduce these opportunities.

While controversial, these itinerant practices are one end of the postindustrial DIY spectrum and can be generators of more universally accepted cultural and development practices. Where they do not lead to legitimacy, many activities have intrinsic value and have helped define the cultural landscape of the American Rust Belt city in the late twentieth and early twenty-first centuries. At Detroit's Packard Automotive Plant and Michigan Central Station, countercultural activities—provocative, exhilarating, shameful, desperate, or unremarkable—have included urban exploration, ruins photography, graffiti, art installations, social gatherings, sports, guerrilla gardening, and residential encampment, along with scrapping, illegal dumping, prostitution, and predatory acts. They have provided symbolic capital for a city in flux, places to be both celebrated and despised.[13] Politicians in particular don't see—or are unwilling to acknowledge—the playfulness, irony, beauty, or utility of such activities, which they argue make a mockery of legitimate improvement efforts and bring unwanted and often sensational attention to these "eyesores" and the ruination of their cities. Noting the dangerous, destructive, or nuisance aspects of these practices—including exploration, graffiti, and widely shared "ruins porn" photography—some have also argued that such activities trivialize the lives of nearby residents and their hardships. Journalists, academics, and cultural commentators have noted the exploitative or voyeuristic aspects of these activities or mocked those who pursue them, even as they themselves have found the subject irresistible. Some have expressed ambivalence rather than

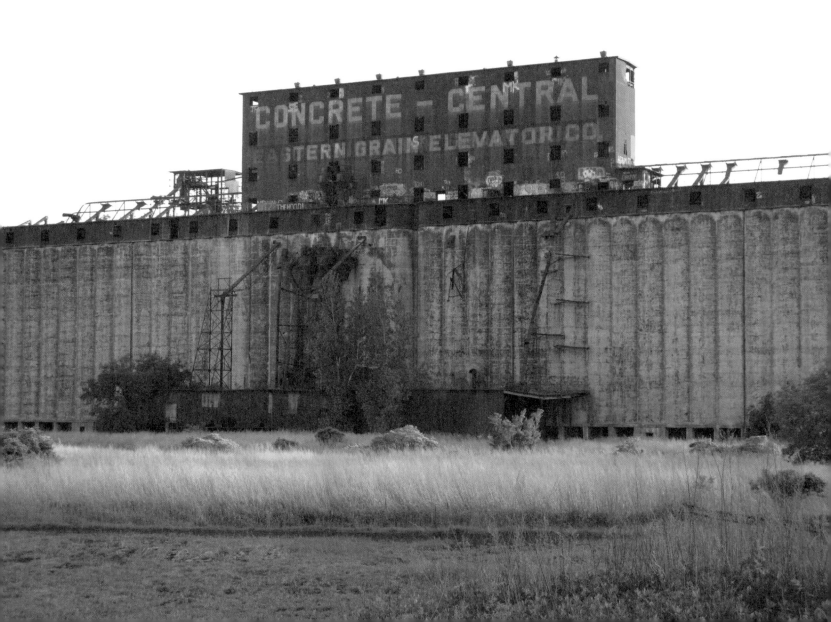

The Concrete Central Grain Elevator amid the postindustrial wilds of the Buffalo River. (Author, 2009).

condemnation in their assessments.[14] Having studied such places for over two decades, I also feel ambivalence. This book is in part an attempt to make sense of these places and practices and understand how they might evolve into projects of broader, more democratic, or lasting utility, while still retaining some of their rawer, postindustrial qualities.

Exploring Rust Belt Icons and Postabandonment Histories

This book is an intensive and at times loose exploration of five iconic postindustrial sites, each the subject of its own chapter, and the protagonists who have made these places more than just another abandoned complex awaiting its ultimate demise. Each are sites of architectural distinction and cultural consequence. In addition to Buffalo's Silo City and Central Terminal (chapters 2 and 3), I examine another magnificent but abandoned train station, the Michigan Central Station (chapter 6), now being restored and adapted for new uses by the Ford Motor Company; the aforementioned

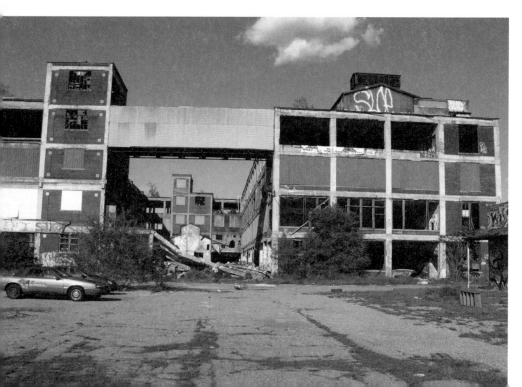

Packard Plant in Detroit (chapter 5), the world's largest automobile factory when it was constructed and the first built predominantly of reinforced concrete; and the Carrie Blast Furnaces (chapter 4) on the edge of Pittsburgh, the partially demolished iron mill of the flagship plant of Andrew Carnegie's U.S. Steel company. Beacons of modernity, culture, and prestige, they are all exemplars of architecture and engineering around which cities and regions would grow—and places that

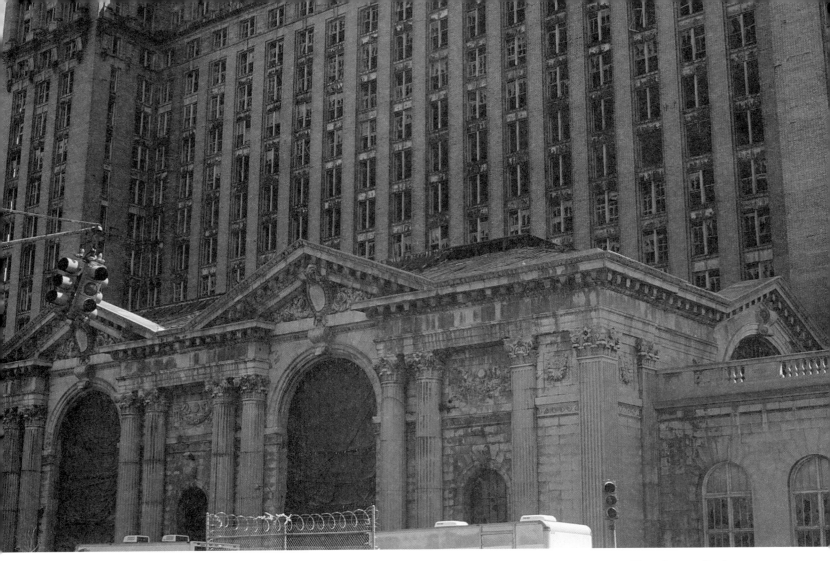

OPPOSITE The Packard Automotive Plant, Detroit. (Author, 2012.)

ABOVE The Michigan Central Station, Detroit. (Author, 2005.)

helped produce and define modern life in America and the world. Yet all five sites would decline and fall, as waves of deindustrialization, suburbanization, globalization, business failure, property abandonment, demographic change, and social conflict swept through the Rust Belt in the second half of the twentieth century. All entered the twenty-first century idled, battered shells of their former selves, threatened with erasure or continued decay—icons of decline rather than those of architecture, urbanism, or industry. Each could be characterized by a scarcity of resources, political and ownership conflicts, bankruptcies, environmental degradation, criminal activities, and challenging urban contexts. And for many politicians, regional economic leaders, and some residents, the enduring presence of these sites provides a stark reminder of failure: the jobs, businesses, and livelihoods lost; families that suffered and communities that were torn apart; on-the-job injuries and deaths; and pollution and pervasive public health impacts. Some also see the failure of both the public and private sectors to cleanse these sites of toxic remains, bring the jobs back, or make good on commitments of new development.[15] Yet the big revival plan has mostly proved elusive.

To understand these places and plan for them—and in preservation terms, tell their stories—we tend to focus on the celebrated history before the fall. These are narratives of progress, prosperity, and the rise of cities and regions, or the struggles and triumphs of labor, even as we now acknowledge that generated wealth was neither universal nor uniformly distributed. But the seeming permanence and lasting impact of these sites were, over the course of decades, fragile and short-lived. We generally don't memorialize postabandonment history—what happened after the station closed, the steel mill shuttered, or the automobiles stopped rolling off the assembly line. That history is less heroic and, at many turns, sad, corrupt, or bankrupt. And while few urban leaders want to admit failure or validate narratives of decline, these sites have endured, surviving decades of deterioration, destruction, and orchestrated attempts to bring them down. Diminished in extent and purpose, they are accidental survivors, the places where the public demolition money ran out or a property dispute or recession kept them from the wrecking ball. These accidents of fate left them standing for later discovery by new appreciators, interpreters, builders, dreamers, and appropriators, as well as many rank-and-file citizens compelled by the history, architecture, and cultural traditions of their regions. And four of the five sites have been nursed back to some form of use, though

in recovery their form, purpose, and meaning are not only a great departure from their original uses, but also from typical notions of preservation and urban development.

I use "recovery" (or "recover") rather than "revival" to emphasize the uncertain or experimental nature of these practices, their limited or incremental ambition, and the fragile and sometimes disputed nature of success at these sites. Additionally, urban revival, with its implication of broad and more permanent benefit—the province of politicians, property developers, and the heads of local redevelopment agencies—is often a commitment unfulfilled and contested terrain. Large Rust Belt cities have all had revivals, renaissances, and comebacks, yet their populations have mostly continued to decline through it all.[16] Even where the postindustrial recoveries that I chronicle have led to more lasting and better-capitalized improvements, revival has grown from a nonconventional place where typical development actors and resources were not initially present. While these projects and others like them can figure prominently into narratives that define Rust Belt cities as places of opportunity rather than distress, elected leaders often hold less enlightened views. As these projects grew and found larger audiences or numbers of participants, local and state governments often refused to call them legitimate. At some sites, they did everything they could to destroy them—even if it meant destroying their own cultural history in the process.

While these five iconic places are products of their own idiosyncratic circumstance, my investigations suggest that they might offer inspiration or guidance for other potential projects, and change the trajectory of the destructive practices that have replaced many of America's great industrial-era works with automobile-oriented office parks, shopping centers, warehouses, casinos, parking garages and lots, and in some places, condominium towers. More experimental practices, even those with disagreeable components, can create otherwise lacking vitality, collective meaning, and as the Detroit cases demonstrate, countercultural cool. While many urban professionals and leaders bristle at the notion that anything positive can come from dangerous or illegal transgressions at vacant industrial-era sites, the Ford Motor Company felt otherwise and is now capitalizing on the cachet of America's (formerly) most famous urban ruin, making a billion-dollar investment in the Michigan Central Station and its surrounding area. This book's other project sites are unlikely to benefit from similarly deep-pocketed saviors, but they continue to evolve toward

not-fully-known outcomes while being appreciated and used in the present. Are there other benefits to these practices, and what is their appropriate place in our cities? The climate crisis demands that we do something more with obsolete places than clearing them and disposing of their remains (even if disposal means materials recycling). Stories of recovery at these sites of economic failure may also tell us something about ourselves and help us understand and recover what we truly value about cities and urban life.

The Landscape of Shrinking Cities

Despite indications of recovery and rising property values in downtowns and higher-status neighborhoods, even large Rust Belt cities remain challenging places for urban development (let alone preservation), with vast zones of market failure and shrinkage. As has been exhaustively documented, Detroit's staggering postwar loss of 1.2 million residents—its 2020 population was 639,111, less than 40 percent of its 1950 peak of nearly 1.9 million—is easily experienced on the ground. It is an urban landscape paradoxically defined by emptiness: missing, burned-out, or wrecked buildings; overgrown lots used as dumping grounds; blocks with four houses that used to have forty; formerly dense neighborhoods that have reverted to meadows and woodlands; commercial corridors reduced to skeletal remains; nonfunctioning traffic lights swinging with the wind above broken pavement; and at times, an eerie sense of quiet.[17] Detroit is both extreme and paradigmatic. Buffalo and Pittsburgh have also lost over 50 percent of their peak populations, and while there are differences in geography and urbanism, on the ground they too possess expansive zones of disinvestment. Ditto Baltimore, Chicago, Cincinnati, Cleveland, Dayton, Erie, Flint, Gary, Rochester, St. Louis, Syracuse, Youngstown, and others. Diminished in population and economy, Rust Belt cities are unlikely to generate the kind of transformative activity that served as an engine for urbanization and drove so many people to them in their ascendancy. And they are unlikely to regain the cultural prestige they enjoyed as places that made the world and created the future, as is often said about Detroit and Pittsburgh.

As some have argued, Rust Belt cities' industrial-era architecture and urbanism is a competitive advantage and something you won't find much of in rapidly growing Sun Belt regions. For decades, the National Trust for Historic Preservation and (more recently) the Urban Land Institute and other influential urban development advocacy organizations have been promoting preservation as a generator of economic renewal.[18] Over many years, leaders in the three cities explored in this book have, to varying degrees, come to accept this argument (of course, Rust Belt leaders have yet to embrace architecture as something that might be intrinsically important). Buffalo, which could be considered a preservation leader among legacy cities, has facilitated strategic investments at seminal architectural sites, including those designed by Frank Lloyd Wright, H. H. Richardson, and Louis Sullivan, and partially re-created its Erie Canal Harbor as part of a leisure and culture development. And since hosting the National Trust for Historic Preservation Conference in 2011—the watershed moment that the *Buffalo News* has called, with some bombast, "the Super Bowl of cultural tourism"—the region has attracted some $767 million in state and federal preservation tax credits for dozens of projects that represent billions in investments in old buildings, with another $429 million in credits in the pipeline as of November 2021.[19] These projects include some handsome industrial conversions.[20]

An amiable docent I encountered in 2012 on the public observation deck atop Buffalo's colossal Art Deco City Hall described this growing regional sentiment while we gazed across the landscape and identified the city's architectural icons. "The best times are long behind us, but we do have this legacy in architecture," he said, adding with a laugh, "What's not to like about that?" But the city has also demolished or enabled the demolition of many landmark or landmark-quality structures— often those that do not fit market-driven reuse schemes or whose land is needed to satisfy other political objectives—and many significant buildings remain at risk.[21] Looking to the east, we could make out the Central Terminal—the city's other great Art Deco icon, whose long-term survival was far from assured at that moment. The challenges of preserving civic landmarks like the terminal are immense, and perhaps call for flexible approaches that aren't so market dependent. Such sites need to be thought of as dynamic places that support and enhance human activity rather than static works, preserved for the ages just as they were in 1920 or 1950, which is largely how US preservation policies and financial incentives treat them.

US Industrial Heritage Preservation: Successes and Failures

Since the Historic Preservation Act of 1966, preservation practice in the United States has often represented a binary choice: either buildings were preserved and adapted to the demands of the real estate market and to high preservation standards, or they were torn down or left to decay. For industrial and many commercial and institutional buildings, choices were particularly stark. Even the seemingly generous combination of federal- and state-level incentives—the legacy of the 1966 act and the US Tax Acts of 1976, 1981, and 1986, which established and amended the federal historic preservation tax credit system—has often failed to impact the fate of many significant industrial sites. Eligibility standards do not acknowledge the uniqueness of many sites and their lack of suitability for market-ready adaptations while tax credit programs simultaneously demand profit-seeking ventures. For eligible properties, federal rehabilitation tax credits provide developers who undertake a substantial rehabilitation of certified historic structures with a 20 percent income tax credit against project costs, while the preservation programs in many states often provide another 20 percent credit.[22] From the current program's inception in 1976 through fiscal year 2020, the federal Rehabilitation Tax Credits program alone has contributed to over forty-six thousand preservation projects and represented a total investment of $109 billion.[23]

These tax credits, which are often combined with other government incentives in larger projects, have resulted in the successful reuse of many historic industrial sites. Those that are thoughtfully executed and integrated into their urban surroundings often feel natural, as if the historic structures were built for their adapted uses: Soho cast-iron buildings in Manhattan; Gair daylight factory buildings of Brooklyn's Dumbo neighborhood; the adapted textile mills of Lowell, Massachusetts; Baltimore's American Can Company complex; and more recently, the Ponce Market in Atlanta and Industry City in Brooklyn.[24] These successes and others notwithstanding, the challenges of industrial preservation remain great, particularly for large twentieth-century sites like those described in this book. Incen-

tives only work when there is underlying market demand and a developer willing to shepherd these complicated and uncertain endeavors through public review and permitting, funding, design, construction, and marketing. Projects are also dependent on their immediate physical context. While a few dozen restored Frank Lloyd Wright houses may draw visitors from around the world, most preservation projects need local tenants and patrons and coordinated public investments.

At the same time, the spatial configuration, specialized architecture, and poor condition of many sites—including factories, metal mills, refineries, breweries, railroad stations, power generating facilities, water infrastructure, and some office buildings and department stores—make them difficult to profitably adapt as residential apartments, Class A office space, retail markets, hotels, or entertainment venues. For industrial places, critics have faulted US preservation practices for their lack of flexibility, political corruptibility, and failure to impact events on the ground when opportunities arise or in times of crisis (as with owners who refuse to secure, maintain, or repair deteriorating properties or file

The site of the former Homestead Steel Plant, Monongahela River Valley, Pennsylvania. (Author, 2017.)

for an emergency demolition order). And for larger multibuilding industrial sites, navigating eligibility for incentives often can become a Catch-22 where federal standards for material integrity and financial feasibility are seemingly contradictory, dooming challenging projects—many before they even begin.[25]

Public officials, who mostly view idle industrial properties neither as landmarks nor potential generators of urban activity and infrequently consider their value as holders of collective memory, are far more concerned about safety and health, adherence to law, and avoiding lawsuits and property disputes. The environmental hazards at many sites create uncertainty and potential legal liability while generating substantial expenses for assessment, abatement, or removal of hazardous materials, such as heavy metals, PCBs, leftover or leaked petroleum products, and carcinogenic building materials like asbestos and lead paint. Many larger sites are also poorly connected to infrastructure, including roads, water and sewer lines, and utilities. Where these projects move forward, the cost of the new infrastructure must often be borne by local or state government.

It is no wonder that most politicians in legacy cities see only the potential for new job- and revenue-producing building projects at old and even legendary sites, like Andrew Carnegie's Homestead Steel Works (across the Monongahela River from the Carrie Blast Furnaces explored in chapter 4), where in the 1990s, several hundred acres of the mill and nearly all its structures were cleared to build a suburban-scaled shopping center with acres of parking and some adjacent light industrial and warehouse development. Around the same time, a consortium of investors led by General Motors—armed with tens of millions of dollars in Michigan state subsidies—cleared the sixty-acre Detroit Cadillac Plant (also known as the Clark Street Assembly Plant) and replaced it with the Clark Street Technology Park, containing low-density distribution and light manufacturing facilities.[26] The former factory complex contained over two dozen buildings, including many multistory, orthogonally oriented pavilions, and once housed GM's Cadillac Division headquarters.

Few, if any, of the Cadillac buildings were architectural jewels, but many were the building types that figure into office and residential conversions in stronger markets or at those rare Rust Belt sites where local officials have the imagination and fortitude to buck the brownfields redevelopment paradigm that for decades has guided state and regional economic development agencies and corresponding public incentives.[27] Adjacent to Detroit's Michigan Avenue corridor and near

the Michigan Central Station now being restored by Ford, the Cadillac complex could have been adapted for higher-density uses that would have complemented the West Side's revival that began to gather momentum in the early twenty-first century, rather than being cleared for uses better suited to the urban fringe. A variety of adaptation schemes could have also exploited the site's heritage and the cachet of the world's onetime best-known luxury car maker, where, from 1921 to 1987, hundreds of thousands of Cadillacs (and in its last decades, Oldsmobiles and Chevrolets) rolled off the assembly line.[28] Treating historic industrial complexes as brownfields to be cleared, remediated, and redeveloped for new uses—any new uses, as long as they produce a few jobs—has long ruled the Rust Belt. There are exceptions, including the Larkin Soap Factory complex in Buffalo (aka Larkinville) and Tech Town in Detroit (Wayne State University partnership centered on former Burroughs Adding Machine buildings and others nearby), whose reinforced-concrete daylight factory and commercial buildings have been reconfigured for offices and institutional use. Yet economic development and brownfields remediation incentives are rarely geared for urban sites. They are conceived for expedient reclamation and clearance, the resolution of liability issues and title claims, and conveying property to private developers as quickly as possible, rather than for architectural, urban design, or cultural concerns.[29] A historic industrial building or complex is rarely a match for a state agency spearheading recovery.

Architecture, Urbanism, and a New Rust Belt Culture

Ironically, the demolition of historic industrial and commercial buildings in American cities in and beyond the Rust Belt comes at a time when interest in these structures is growing, particularly among entrepreneurs (real estate and otherwise), academics, artists, advocates, and young professionals of many fields. For many younger residents, buildings that define the Rust Belt and epitomize economic failure, including shuttered factories, industrial ruins, and other former work sites, have come to reflect collective aspiration and are part of a continuous landscape of historic

neighborhoods, business districts, and places of regional distinction. On my Buffalo trips, I toured the city with preservation activist Christina Lincoln, visiting at-risk historic sites, including the Wildroot Hair Tonic Factory, the Willert Park Public Housing complex, and a church and parochial school complex at the foot of the Peace Bridge (later mostly demolished to expand border security operations). While frequently chiding her city for enabling or undertaking demolitions, she also enthusiastically described a Buffalo counternarrative and emerging identity derived from the same industrial works that previously defined failure. "It takes a generation," she and others often say. And in an essay about Rust Belt heritage, she noted, "We don't remember the world before regulations, clean air, and closed steel mills; we only know that without those gritty remnants, we wouldn't know what questions to ask or what we're all about."[30]

In my travels in and around Buffalo, Detroit, and Pittsburgh—as well as Cleveland, Flint, Youngstown, Rochester, Providence, and my sometimes/onetime home bases of Baltimore and Philadelphia—and at conferences and preservation gatherings, I have met many people like Lincoln: planners, preservationists, architects, and urbanists who are committed to life in their cities and the preservation of industrial heritage. They are often people who grew up in these regions but in the past would have moved to pursue work and life elsewhere. My conversations with them have often led to mutual excursions to sites of local intrigue, including the Heidelberg Project and Design 99 in Detroit and nearby Hamtramck Disneyland; Iron Eden and Gooski's Bar in Pittsburgh; and, in Buffalo, Hallwalls Contemporary Arts Center, Jefferson Avenue Shul (demolished 2014), and the monumental Concrete Central Grain Elevator.

From these experiences I can attest to the resolve of these actors. They exhibit spunk and wear the Rust Belt label as a badge of honor. Many have formed young preservationist groups to celebrate, share, and invest in their city's historic building stock: Buffalo Young Preservationists, Young Preservation Association in Pittsburgh, City Beautiful in Cleveland, and others in Philadelphia, Columbus, Cincinnati, and Minneapolis. Their road trips and "takeovers" of other cities like Rochester, Milwaukee, and Wheeling, West Virginia, have extended the spirit of recovery. At the same time, as these communities grow and their members mature, they become more effective advocates for local preservation and urbanism or more thoughtful urban professionals.

Jane Jacobs argued in *The Death and Life of Great American Cities* that old buildings are valuable to residents not so much because they are historic or architecturally significant, but because their oldness made them inexpensive and invited dynamic urban activities and business formation. In many respects, Jacobs was startingly unsentimental about the buildings themselves and more interested in the conditions they created when in dense ensembles amid a mix of uses.[31] Jacobs is revered among the Rust Belt's preservationists and urbanists, and many reference her when talking about their own restoration projects, both personal and collective. They see their endeavors as contributions to the evolving urbanism of their cities and making their cities more livable, exciting, prosperous, or just. Engaging with larger industrial-era complexes also offers opportunities to bond with like-minded residents and enjoy regional authenticity. They are sites of possibility and in some cases, like Silo City's grain elevators and the remaining structures of the Carrie Furnaces, places where culturally compelling projects grow and build on their own success (or sometimes collapse in response to failure).

Old buildings and complexes like those explored in this book have other qualities that are not well understood by the fields of architecture, preservation, city planning, and urban policy. The Carrie Furnaces and Buffalo's Central Terminal are places of lost civic prestige: sites that are attractive precisely because they are incomplete, degraded, and in need of healing activities—or, as noted by cultural landscape scholar J. B. Jackson, they generate enjoyment and excitement from "redeeming what has been neglected" rather than building anew.[32] They appeal to our sense of betterment and common purpose and satisfy the human desire to fix, mend, build, enjoy, and share with others. Not unlike a community garden or neighborhood cleanup or improvement event, but at greater scales and complexity, these projects enable residents to come together and get their hands dirty recovering or sometimes just occupying regionally consequential sites.

Can these projects foster an even greater "shared sense of belonging"—an infrequently achieved aspiration of the 1966 Historic Preservation Act and clarion call of historians and advocates?[33] As preservation practices and fully authorized public engagement with old buildings have become subservient to economic development and the real estate industry, the challenges remain great. In this respect, each of this book's project sites are ongoing experiments to realize this ideal or those of

Leftover infrastructure of the Thyssen Steel Plant serves as twenty-first-century play spaces at Duisburg Nord Landscape Park in Germany's Ruhr Valley. (Author, 2013.)

empowerment, inclusiveness, and broadly experienced joy. Few would consider the practices that I document at Detroit's Packard Plant as democratically empowering or healing, let alone define them as recovery or preservation. Yet even at an extreme site like Packard, where local impulses toward collective recovery have not substantially coalesced to the point of effective action, historic but ruinous structures have remained open to itinerant interventions and experiments and for region-defining cultural practices, even if they may not exist for much longer.

In addition to Jane Jacobs, Rust Belt protagonists frequently invoke the postindustrial landscape parks of Europe, and in particular, Emscher Park, which sprawls across dozens of sites in several cities in Germany's Ruhr Valley. In fact, principal participants at all five case study sites cited Emscher or its constituent parks as an inspiration for their own postindustrial actions or visions. *Why can't we do this? Why can't we have our own Emscher or be more like the Germans?* they ask.

Emscher represents billions in public investment and decades of postindustrial planning, and

Postindustrial ecologies flourish at Duisburg Nord. (Author, 2013.)

demonstrates a distinctly German, if not European laissez-faire culture about the rules governing public use of these sites. Flagship Emscher sites, including the Peter Latz–master-planned Duisburg Nord Landschaftspark (former Thyssen Steel) and former Zeche Zolverein coal conversion complex (now a cultural complex and park), have become significant tourist destinations. They serve as regional heritage and recreation hubs and evolving experiments in postindustrial nature, and set a high standard for the preservation and reuse of former industrial properties.[34] While less prominent, there are similarly spirited reuse projects across the European Union and Great Britain: former factories, warehouses, port complexes, gasometers, mines, railroad terminals, storage and repair facilities, and military installations.[35] While the United States lacks the commensurate public commitment, it also is missing the larger culture of industrial patrimony and acceptance of these sites as evolving places that invite messy human activity, rather than architectural jewels in need of time-fixing preservation. American protagonists are striving to realize Emscher-like projects and see the often spectacular, if not more socially constrained landscape urbanism in parks in the United States—including the High Line

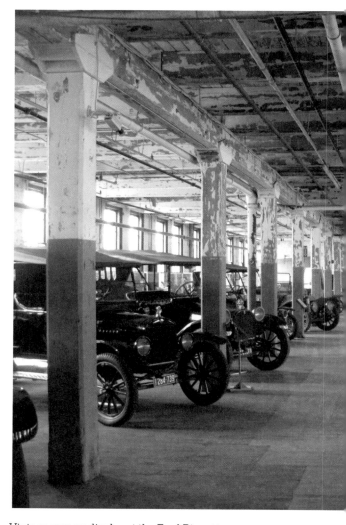

Vintage cars on display at the Ford Piquette National Heritage Site in Detroit. (Author, 2016.)

and Brooklyn Bridge Park in New York, the Presidio in San Francisco, and the earlier Gas Light Park in Seattle—as potential inspirations or models for adaption, should the necessary resources (public or private) be raised.

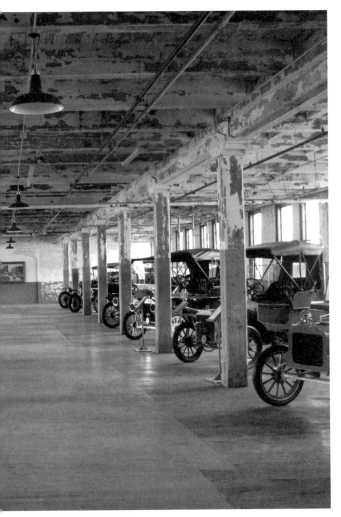

Enthusiasm for industrial heritage and the cities in which it is found is not limited to youth. For older or longtime residents, their participation in this culture may be based partly in nostalgia, as they remember their youth, livelihoods, or earlier postindustrial times when their cities possessed a grittier authenticity, greater social danger, and a wilder spirit (this is also true of many New York, Philadelphia, and Boston residents). "Nostalgia is underrated" and intertwined with other satisfying aspects of urban life, a Detroit friend frequently says. For some Rust Belt residents, the sites of this book are nodes where they can connect the dots between their own lives and regional history and culture, which are contained or evoked by their extant buildings. This is certainly the case in Buffalo with the Central Terminal (chapter 2) and in the Monongahela River Valley of southwestern Pennsylvania, the location of Carrie Furnaces (chapter 4), where the culture of steel lives on long after most of the jobs, firms, and work sites disappeared. The recoveries of these two sites and places like the Ford Piquette Automotive Plant in Detroit (noted but not chronicled in this book) offer residents a chance not just to remember but also to participate in reconstruction and share their history, memories, and knowledge with a younger generation and the world at large.

DIY building practices are not limited to the Rust Belt and have often thrived in places like Brooklyn, Oakland, and metropolitan Los Angeles, which have long shaken off the worst impacts of deindustrialization. Yet copious opportunities to "get your hands dirty" across Rust Belt cities do provide a competitive advantage over New York, Boston, Washington, and the Bay Area, where these practices were once more accessible. These opportunities also help to catalyze interest in the prospect of living, working, and building in places mostly passed over by the global market. At the same time,

the chance to buy, renovate, and inhabit a fixer-upper—a strategy that enabled many thousands of middle-class New Yorkers, Bostonians, and until recently, Philadelphians, to remain in gentrifying neighborhoods—is now beyond the reach of all but a small percentage of current residents.

This movement is less about preserving historic architecture than direct material engagement with historic structures—exploiting the unique building or spatial opportunities of Rust Belt cities. Substantial inventories of vacant, underutilized, or inexpensively priced properties provide opportunities to do things relatively unconstrained by space and time or without the urgent need for revenue or economic value, whether it is gardening, an art project, working on a car or boat, or other forms of building, tinkering, and repair. In this respect, postindustrial DIY is a logical extension of traditional do-it-yourself activities and the DIY urbanism movement, which has evolved over two decades from craft, repair, and hobbyist practices to incorporate larger, spatially based undertakings, including those focused on historic preservation.[36] Pursued by diverse and often inexperienced actors, these practices, as I have noted in previous investigations, often "circumvent professionalism, traditional notions of commodity and profit, and in many cases, city permits or time-honored conventions of building and exchange."[37] DIY projects have become ubiquitous across the landscapes of many US cities: pop-up parks constructed in on-street parking spaces (and the pandemic-induced "streeteries" occupying parking lanes), citizen-painted bike lanes, roadway space claimed for social or cultural activity, DIY signage, yarn bombing, and guerrilla art.[38] So much so, in fact, that following the lead of the NYC Department of Transportation's Complete Streets program, many American cities have found mechanisms to permit, encourage, and administer informal activities and constructions that are focused on the public realm. Rust Belt and legacy cities also have adopted Complete Streets programs, and some vernacular traditions have long been tolerated—if begrudgingly so—like unlicensed vending, the appropriation of street space for parties or vehicle repair, and reserving a shoveled parking space after a snow storm by placing a chair in it (ubiquitous in Baltimore, Philadelphia, and Pittsburgh).

In some cities, particularly those on the verge of or experiencing municipal failure, like Detroit, DIY has also long been deployed as a substitute for municipal services. Less glamorous or cool than claiming the street for an art project or dance party, it is a DIY born out of necessity, "making do"

or a form of "austerity urbanism." Such practices include resident policing and security practices, like maintaining adjacent vacant properties and public spaces to discourage would-be trespassers, vandals, or illegal activity.[39] But postindustrial DIY is mostly born from opportunity rather than necessity. And while these practices do not address the kind of critical, everyday functions that are often missing or diminished in cities experiencing deprivation or crisis, they satisfy larger collective desires that might otherwise go unfulfilled.

Can these practices reverse longer-standing trends and bring people back to the Rust Belt? Certainly not on their own. But they dovetail with a broader cultural recovery and lifestyle centered on unique places and experiences, rather than a more generic revival driven by new development. Of course, cities like Buffalo, Detroit, and Pittsburgh are not immune to broader trends, and where demand and resources exist, real estate redevelopment practices are ubiquitous. The Rust Belt's rediscovery, to which many of the protagonists in the following chapters have contributed, and the boom phases of boom-and-bust investment cycles have made it more difficult to get in on the ground floor in some cities. Affordable houses and sites in transitional neighborhoods have become increasingly scarce while property investment in other neighborhoods is often an economically unjustifiable use of personal resources, even where much of the labor will be DIY. And larger, nonresidential sites, the ones that invite collective action, are also becoming scarce as public, institutional, and private sector investments reach the outlying districts of these cities, sometimes resulting in demolition. There are certainly fewer of these sites to claim than there were at the beginning of the century.

On the Ground: Postindustrial Investigative Methods

In documenting the projects of this book I have opted for depth of story and intimacy over scientific survey. Something short of a natural experiment, the book's five principal sites were chosen less for their representative qualities than because my own narrative arc led me to them. Yet these selections were not happenstance, and I am well invested in each of these places, having for years

watched them evolve and devolve, expand and contract. Each site embodies a multifaceted and at times spectacular postabandonment history that could be the subject of its own full-length book. And their stories are still unfolding—a decade or thirty years from now, these places may be something else entirely.

Through on-the-ground immersion, time spent with site protagonists, and my broader, zoomed-out investigation (I have spent a preposterous amount of time studying these places through satellite imagery), the perspective I share attempts to be both granular and big-picture, chronicling both established metanarratives and more obscure counternarratives. At each, I examine the major events and milestones, including proposals, plans, property transfers, and interventions—a critical urban history with broad discussion of the urbanism, politics, and culture of their respective cities. But I also document more subjective perspectives, explore architecture and landscapes, and converse with the people who have shaped these places or those whom I encountered in the process of investigation. These protagonists, as I call them, are those who exploited the conditions of abandonment, made the most of flawed circumstance or have been inspired by these sites or inspired to reshape them. From these stories and perspectives, I have assembled an oral history of sorts—sometimes as it is still happening—but not everyone's story or perspective is shared. Such is the nature of this kind of research. Yet I do believe I have captured the color and texture of these places and the perspectives of those actors most responsible for recovery in whatever form it takes and have made these places a springboard of possibility for others.

As all these places are singular and idiosyncratic and their stories continue to evolve, this is an uncertain endeavor, defying straightforward proclamations or "lessons learned." This is not a how-to guide for planning, preservation, and architectural practices, or the leadership of cities, nor is it strictly a citizens' manual for "taking back." But all the DIY project sites speak to something vital but almost lost in American cities, and to the destructive building practices that have done little to engage problematic but often distinctive, meaningful, or magnificent industrial sites. In this respect, this book is a clarion call for changes in the allied building professions and the reform of urban development policies for obsolescent places. Yet through the urban lens and these sites, I also examine other critical issues, including social equity and justice, environmental degradation, and

public health and safety. Some chapters focus on these issues more than others, and some readers may be disappointed that I have not called for broader reorganization of US cities, or more radical redistribution of urban resources to address climate change, inequality, racial justice, public health and safety, and other issues of our day. As my case studies demonstrate, postindustrial DIY has a tenuous or contentious connection to these issues, and it remains to be seen where facilitating it should be placed amid so many competing priorities. And even if we can rationalize these practices as opportunities for democratic action, sustainable land stewardship practices or protection of priceless urban heritage, it will be a far greater challenge to operationalize and incorporate them into legitimate development practices, zoning and building codes, and the deployment of public resources.

Across and far from the US Rust Belt, there are dozens of similarly spirited DIY projects, and I reference several across these chapters. Only a few are fully formed, and some exist only in the minds of one or more individuals. Some will grow and flourish; others will fail or be destroyed. But we must find a means to enable these endeavors to the extent that they are possible, at least at those sites where nothing else is happening; where conventional development has failed to deliver promised transformations; where residents feel betrayed by planning and the practices to ensure that their voices and needs are not just heard, but allowed to take shape and grow on their own accord; and at those locations where something is already happening. Let's not destroy that which is growing organically and is already finding an audience or purpose, or bringing people to an otherwise left-for-dead site.

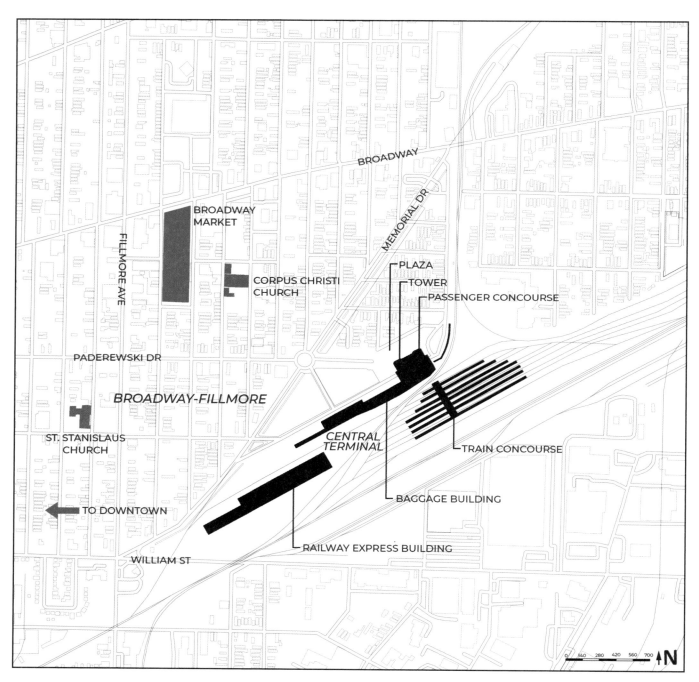

Buffalo's Central Terminal on Buffalo's Eastside.

(Cartography: Shahrouz Ghani Ghaishghourshagh, 2021.)

CHAPTER 2

Buffalo's Central Terminal

Nothing was more up to date when it was built, or is more obsolete today, than the railroad station. In its day it was a benchmark of civilization and style. These "gateways" to the cities of the United States were palaces of splendor, symbols of progress and objects of civic pride. Now they are caverns of gloom.

ADA LOUISE HUXTABLE[1]

From Broadway, the once-bustling spine of Buffalo's East Side, we passed underneath a train viaduct and made an oblique left onto Memorial Drive, and our destination came into view. Though some distance away, the Central Terminal's 271-foot tower loomed over the old frame houses and trees in the foreground. As we approached, the tower's Art Deco setbacks, crown, and embedded clocks became visible, and soon we pulled onto the raised plaza below the station's gigantic north façade. No photograph or video could fully convey the near preposterous scale of this structure and its incongruence to the houses below. Looming from a distance and dominating from up close, the terminal is both a beacon and a monument, but also, for a long time, an enigma seemingly resistant to purposeful change.

The New York Central Railroad constructed the Central Terminal in the late 1920s, when Buffalo was still an ascendant city, and the East Side possessed the city's second-largest business district. Just blocks from the district's core at Broadway and Fillmore Street but two and one-half miles

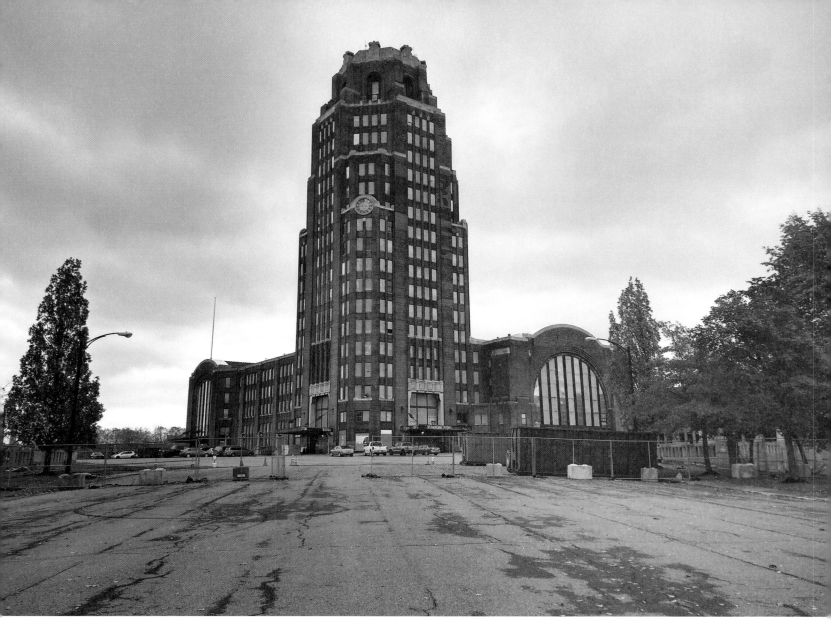

The Central Terminal. (Author, 2020.)

from downtown, the station's site gave the railroad many acres of space for its passenger and freight operations. It also placed the station near the halfway point of its flagship New York–Chicago route and relieved trains of the necessity of navigating the city's congested downtown. As elsewhere, the New York Central built the station to grand proportion and wrapped it in an architecture commensurate with its power, prestige, and wealth. Completed in 1929, just months before the onset of the Depression, the station only briefly (during World War II) operated at or near capacity, and in the postwar period, as trains gave way to planes, buses, trucks, and cars, activity at Buffalo's cathedral of transportation plummeted and never recovered. Amtrak closed the station in 1979.

By the time of my first visit in 2009, the terminal was not in great condition and was empty of human activity most of the time. Like the other large stations built beyond the peripheries of their respective downtowns—including Detroit's Michigan Central Station (MCS; 1913), the subject of chapter 6, and Cincinnati's Union Station (1933)—it had precariously survived into the twenty-first century. But its sheer size, structural complexity, and location made it nearly impossible to repurpose using the standard array of US historic preservation tools and funding sources. Politics offered another layer of complication. As in Detroit and Cincinnati, the terminal was an enduring regional icon, but for how much longer and for what purpose, no one was quite sure.

Popping out of my friend's car and into the unseasonable heat and humidity of the Friday before Memorial Day, I had a brief flashback to a similarly muggy day visiting the Michigan Central during the same holiday weekend in Detroit six years earlier. Both were giant, abandoned railroad stations and possessed a distinctive office towering over more diminutive settings. The two stations reflected the architectural fashions of their respective eras, the MCS with its Roman baths–inspired neoclassicism and the Central Terminal, a restrained form of Art Deco. But the different styles and the sixteen years between their completion dates seemed like a relatively trivial difference given their long histories of decline and deterioration. Both stations were monuments to unfulfilled ambitions and could be read in the present as icons of either architectural legacy or urban decline. But for all the similarities, there was a key difference. In Buffalo, citizens had taken back their train station and were attempting to nurse it back to health and share it with the larger public. By necessity, terminal protagonists embraced a novel preservation strategy built on ad hoc, sweat-equity-driven improve-

ments, nonprofessional administration, and public events. Engaging, thrilling, and an embodiment of Buffalo's distinctive postindustrial resolve, the project was also uncertain, slow and riddled by a breathtaking number of building pathologies, political squabbles, and accusations of insularity. This was far from a model historic preservation success story, and there were plenty of Central Terminal skeptics across the city, including multiple Buffalo mayors. Yet however disappointing the endeavor was, potential alternatives were far worse. As we arrived in Buffalo at that moment in 2009 to tour the terminal, Detroit's mayor and city council were scheming to take down the Michigan Central.

Barely out of the car, we found ourselves amid a welcome party led by then–Buffalo Common Council president Dave Franczyk and a group of mostly middle-aged men—volunteers who were

The Central Terminal's passenger concourse under construction, 1928. (Collection of the Buffalo History Museum.)

to show us the terminal. Since 1998, after years of protracted battle with the station's multiple post-Amtrak owners, the complex has been owned by a citizen-controlled not-for-profit, the Central Terminal Restoration Corporation (CTRC). Franczyk, the pivotal public figure who forced the previous owners to surrender the property and then facilitated its conveyance to the CTRC, showed us through what once was one of the main entrances, underneath a sagging canopy bearing the rusted, stylized lettering, "New York Central Railroad Co." A short corridor quickly opened into the huge passenger concourse, 225 by 66 feet, with a vaulted ceiling featuring two 64-foot domes at each end. The concourse was illuminated by giant window arches on all sides, with brass-railed balconies running underneath the windows of the east and west walls. While many of the hundreds of panes were boarded up, covered in plastic, or missing, hazy sunlight from the arches on the terminal's west wall softly streaked the concourse's terrazzo-tiled floor. And while the air had that musty

vacant-building smell, the temperature was cool—a relief from the heat outside. Along the concourse's perimeter were a series of marble ticket and service windows, chrome newsstands, and portals to the station's onetime restaurant, waiting room, drug store, barbershop, various offices, and a taxi stand on a lower level. The waiting room's large mahogany doors were long gone, and many bays and service windows were boarded up, marred by damaged or missing structural pieces or graffiti, as was, in places, the twelve-foot Botticino marble wainscoting. Yet scaffolds in a few spots suggested restoration in progress. Back near where we had entered, a young woman

A volunteer works on the restoration of the Central Terminal's signage. (Author, 2009.)

67

on a ladder was touching up the inlaid lettering on the marble panel above the portal that read, "TO ELEVATORS."

We had arrived during volunteer hours (Saturdays from mid-spring to mid-fall). In addition to the person on the ladder, others were engaged in various repairs, restorations, and cleanups, and building or breaking down temporary structures. The CTRC has frequently exploited the region's great number of skilled tradespeople, including retirees and those with an interest in trains or historic architecture. At that moment, during the Great Recession, these efforts were perhaps aided by the availability of experienced carpenters and other skilled workers with time on their hands. Under the ceiling dome at the building's northeast corner awaited a much larger repair job, one that could not be fixed by volunteers. Here, a long-standing roof leak—the corrosive effect of years of water intrusion and freeze-thaw—was one of many places where water was undermining the station's interior. A broad stain ran from ceiling to floor with many missing stone panels and bricks that exposed rusting steel behind it. Yet these pathologies did not detract from the magnificence of the Guastavino brick ceiling vault, which was mostly intact and still a marvel of structural integrity. While somewhat smaller and less sumptuous, the concourse provided the station with an architectural grandeur similar to Grand Central in New York City, and I imagined traveling decades ago between these two "palaces of splendor" as Huxtable might have said, or between Buffalo and Chicago, Toronto, Cleveland, Cincinnati, Detroit, or St. Louis. This indeed was Buffalo's gateway to the world.[2]

One of our volunteer hosts provided loose narration as we toured. For a time, he said, the Central Terminal was the country's second-busiest station (an often repeated claim among terminal advocates that I was never able to verify). Attempting to describe the magnitude and complexity of the railroad's operations, he emphasized the clockwork precision of arrivals and departures, and the speed with which luggage was loaded and unloaded onto trains bound for New York or Chicago. I found it hard to hear, and my attention began to wander. We weren't the only ones in the building, and around us were several people walking the concourse carrying gunlike detectors. These "ghost chasers," as they were later identified, were being filmed for a television show of the same name and added a kitschy, *Star Trek*–like effect to our visit. Was this type of activity the future of one of

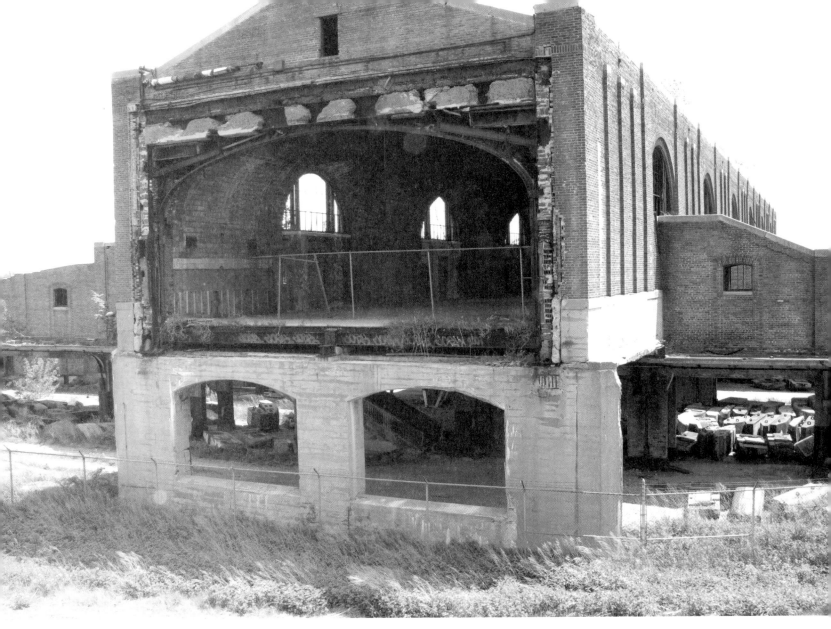

The remains of the Central Terminal's train concourse.
(Author, 2009.)

America's monumental train stations? Yes, at least for the medium term. Rentals for events and media shoots provided modest but vital revenue to support CTRC's restoration activities and pay for insurance and utilities that enabled visits like my own that afternoon. While the ghost chasers pursued the ethereal, I was more compelled by the station's real tactility and ran my hand across the chrome and marble of a restored Union News newsstand. Not every landmark provides the opportunity to touch and intimately savor its constructive craft. From the top of the newsstand's frame hung two fluorescent lights, their dangling power cords plugged into a jerry-rigged outlet installed on a wood partition. The building did not have plumbing or heat, but it did have electric power in a few places. Here and elsewhere, the building's many pathologies provided opportunities for volunteers to be direct agents of restoration, repair, and construction.

Back with my group, we toured former ancillary spaces that once offered big-city station services, including its formerly elegant, three-section Art Deco restaurant, its once-airy waiting room, the lounges, and restrooms—all of which were shells of their former selves and, except for the men's restroom, unrecognizable in their previous functions. Near the concourse's southeast corner, our guide led us through a door emblazoned with an old Amtrak sticker into a narrow office with a large bank of windows offering a view of the tracks. This was the "railbuffs room," as enthusiasts sometimes gathered here to watch passing CSX freight trains below or Amtrak trains on the station's periphery. The view also included the "train concourse" (as opposed to "passenger"), an elevated passageway running perpendicular to the tracks with ramps to the platforms below, which was no longer attached to the station. In 1981, a section of this formerly 455-foot-long corridor had been unceremoniously cut away to create vertical clearance for Conrail to run double-stack freight trains on the tracks below.[3] This severing facilitated my cross-sectional view of this narrower passage's own Guastavino-tiled vaults and arched window bays.

Across the passenger concourse floor, we headed up the stairs of the tower, stopping to explore and assess the condition of each level. The larger lower floors overlooking the concourse had been gutted and cleared of debris. On station tours later in the decade, I was told that these spaces were among the most immediately rentable and that the CTRC frequently fielded inquiries from potential tenants, though none came to fruition in the 2010s. But with each additional floor climbed, we

found spaces in poorer condition, covered in broken glass and deconstructed building materials, and holes in exterior walls. Farther up, we discovered entire floors covered in Amtrak paperwork: forms, schedules, memoranda, reports, and file folders mixed with glass and plaster bits, brick, and wood—a foot or deeper in places. I picked up a faded but readable correspondence dated September 22, 1978, from the manager of freight claims that had been stapled to a larger report. There were thousands of papers like this around me, most of them rendered unreadable by water, fire, or the sun. Upon reaching the top floor, we passed through a small antechamber with cables dangling from the ceiling and walls. These cables delivered power to outdoor lights that dramatically illuminated the tower at night. A few years earlier, volunteer electricians had restored these lights to the tower, which had long been a regional beacon and had recently been adopted by peregrine falcons who nested in the roof's arcade.

Through a doorway adorned with vertical metal accents, we proceeded onto the octagonal obser-

TOP Surviving Amtrak paperwork and debris in the tower of the Central Terminal. (Author, 2009.)

BOTTOM The terminal's Art Deco rooftop offers views of downtown and across the region. (Author, 2009.)

71

vation deck, which in its design and detailing reminded me of the similar terraces found on New York City apartment buildings and office buildings of the era. I had a touch of vertigo and gently eased my way to the edge. Looking west, the tall buildings of Buffalo's downtown defined the view. Through a midday haze, I could see Buffalo City Hall, which, like the terminal, features an octagonal Art Deco tower. Completed less than two years after the terminal, it was the United States' second-largest city hall after Philadelphia's—built for an ascendant metropolis of far greater population than the diminutive city of slightly more than a quarter million today. My eyes worked their way from downtown back to the terminal, visually tracing the area's main east-west thoroughfares, Broadway and William Street. The many vacancies of these formerly dense corridors where buildings once sat shoulder-to-shoulder were obscured by trees and greenery. In the more immediate foreground, a patchwork of frame houses, grass-covered vacant lots, and trees was punctuated by St. Stanislaus Church and its two towers—perhaps the East Side's most prominent building other than the terminal—and, to my right, the Corpus Christi Church.

From this perch, I was overcome by contradictory impulses. The Central Terminal represented a grassroots approach for recovering large, regionally consequential sites—one that offered intimate public participation and catalyzed intense regional passion and joy. "The people's train station," as one of the volunteers had called it, was being incrementally restored through sweat-equity practices like the way a homeowner might renovate an old Buffalo house, only at a much greater scale. At the same time, the terminal's board of directors was keeping it open to the public through tours and events. Yet for all of the project's authenticity and participatory spirit, the longer-term challenge of reviving the complex was also painfully clear. The terminal needed stabilization, conservation, and restoration well beyond what volunteers could provide—a $100 million or more investment in a part of the city far from downtown or areas of rising property values. And as I soon learned, aside from Franczyk's support, at that moment the station had only modest political capital. Additionally, it sat awkwardly in the Broadway-Fillmore neighborhood, which is frequently called Polonia by station volunteers but whose residents have long been predominantly African American. The station's principal stakeholders, including the CTRC's board and its regular pool of volunteers, skewed heavily toward older, white, and male, with many living in the Buffalo suburbs. While the station was

Dave Franczyk (left) and Central Terminal volunteers. (Author, 2009.)

culturally connected with Polonia's historic churches, social institutions and legacy businesses, current East Side residents, including recent immigrants from places like Bangladesh and Vietnam, and their own businesses and institutions were not well represented among terminal constituents and programming. The building stood—and gloriously so on that hot May day—and it was thrilling to take in these sweeping vistas. Yet I was enjoying a privileged view, one that I speculated that few of the residents who lived in the dilapidated houses below ever got to enjoy.

After our tour, Franczyk led us and a few volunteers to Daren's, an East Side bar in an old frame house southwest of the station, on the other side of the expansive railroad right of way. It was nice to be in air conditioning, and we saddled up to the bar and ordered beers while Franczyk chatted with some constituents. The front room was mostly empty, and looking around the place—the nicotine-stained tin ceiling, jukebox, promotional beer signs, framed photos, and other traditional bar furnishings and décor—it evoked the photographs of Milton Rogovin. Perhaps it was the site of the cover image of his 2003 retrospective volume, which depicted working-class Buffalonians in casual portraiture in authentic settings.[4] I mentioned it to the bartender, and without saying a word she whipped out several large prints from a drawer and laid them across the bar. They were poignant depictions of everyday life taken by Rogovin decades earlier inside of Daren's and across the East Side.

In its decline, Buffalo has in some respects become a warmly intimate city, and here in the shadow of the station, I could connect the dots between the narratives of Buffalo people, buildings, art, culture, economy, and politics. But such intimacy or smallness has a cost. Preservation projects like the Central Terminal would be challenging to fund, execute, and maintain in far less economically depressed locales. Additionally, not everyone in Buffalo believes the Central Terminal's revival should be a public priority. Until quite recently, the terminal has enjoyed neither the political sup-

port nor funding provided to elite architectural heritage sites in other sections of the city. And even now that it has garnered a transformative (mostly) state-funded grant of $61 million, on the heels of a $5 million state grant in 2019, the terminal remains a work in progress. If it is now on a definitive path to architectural restoration, economically productive adaptive reuse, and year-round occupancy, it is because of the preceding grassroots and DIY practices that are the subject of this chapter.

Against the odds, Buffalo's Central Terminal, a cathedral of railroad travel and among the most capacious stations ever built in the United States, has survived over four decades of vacancy, neglect, deterioration, flooding, arson, vandalism, theft, looting, and harsh weather. It is nothing short of miraculous that its vaulted ceiling has not been brought down by Buffalo's relentless winters and storms that have piled feet of snow atop its roof. This endurance is the product of the efforts of preservation activists, volunteers, and a handful of elected leaders, led by Franczyk, who collectively imagined that the station, even in its imperfection and incompleteness, could be returned to vitality.

Campaigns to save iconic train stations are nothing new—indeed, the modern preservation movement evolved in part from the protest over the demolition of New York's Penn Station in the mid-1960s and coalesced around preservation of Grand Central a decade later—yet the Central Terminal represents a vanguard of public engagement in an architectural reclamation project.[5] Exceeding traditional notions of preservation activism, from petitions and letter-writing campaigns to demonstrations and standing in front of the proverbial bulldozer (though these tactics have also been employed at the terminal), the citizens who have undertaken this project have potentially forged a new amateur-based approach to preserving, reusing, and enjoying—and yes, joy is a large part of this equation—historic complexes that stubbornly resist revival efforts or have been written off as "too far gone." While nearly all stakeholders and visitors look forward to the day when the terminal is fully restored, in the interim this project has provided opportunities for Buffalonians to rebuild, repair, manage, and enjoy a regional icon, largely unshackled from the often cruel market logic that demands substantial revenue-producing uses combined with large public subsidies in exchange for rigorous architectural restoration and painstaking conservation of existing materials. Since the Historic Preservation Act of 1966, US preservation practice has largely been dedicated

to conserving and restoring architectural authenticity—the material culture that holds collective history and memory—but often sets a standard too high to preserve places like the terminal. Ironically, the building, with its incompleteness and imperfections, jerry-rigging and temporary fixes, has enjoyed a different sort of authenticity. It is where Buffalonians have come together to recover, rebuild, and celebrate—to the extent that resources and ingenuity will allow—a fallen icon of the city, even as its own era of postindustrial DIY is now closing.

The Rise and Fall of a Big-City Train Station

In 1926, a little over a century after the completion of the Erie Canal had made Buffalo the gateway to the Great Lakes and what was then the American West, the New York Central Railroad began construction on the Central Terminal and completed the complex less than three years later. The station was designed by New York City–based architects Alfred Fellheimer and Steward Wagner, who also designed Boston's (since demolished) North Station and others in Cincinnati, Toronto, South Bend, and Winston-Salem. Fellheimer learned station design while working under Charles Reed of the firm Reed and Stem, which was one-half of the architectural team that designed Grand Central Terminal and the Michigan Central Station—projects to which Fellheimer contributed, even more so after Reed's death in 1911 while these stations were under construction. But rather than taking full inspiration from the Beaux Arts classicism of those stations, for Buffalo Fellheimer drew upon Eliel Saarinen's Helsinki Central Station (1914) and proto-deco competition entry for the Chicago Tribune Building (1922). The firm's design also paid tribute to the typical US nineteenth-century urban station, whose inspiration was often a twelfth-century Romanesque church featuring a large main structure with a clock tower at one of its corners. The terminal's core was perched on a constructed hill built to place its main level twenty-one feet above the tracks, while its northside esplanade sat above a three-hundred-car parking deck. This placement facilitated comfortable passenger movements up and down gently inclined ramps connected to the platforms below the station's south side. With over five hundred thousand square feet of interior floor space including its ancil-

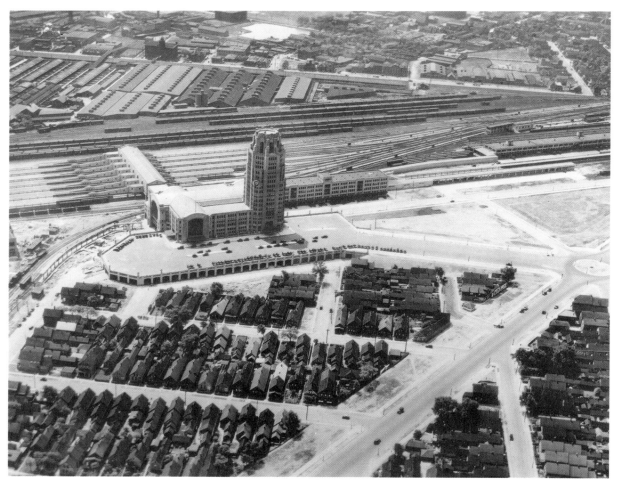

The Central Terminal was built at a time when Buffalo was economically ascendant, and the East Side possessed a substantial business district. (Collection of the Buffalo History Museum, 1929.)

lary buildings and tower, fourteen tracks (and space for ten more), and seven passenger platforms, the Central Terminal gave Buffalo a modern terminus capable of efficiently handling great volumes of trains, passengers, freight, and mail, and reduced the duration of the railroad's New York–to-Chicago service. The complex, which cost the New York Central $14 million (over $213 million in adjusted 2021 dollars), could accommodate over two hundred trains a day, thirty-two hundred passengers

an hour, and fifteen hundred railroad employees, many of whom were stationed in the complex's nineteen-story office tower. The station's freight facilities were well connected to the factories and warehouses arrayed along Buffalo's Beltline, while its concourse offered access to a full array of passenger services and a state-of-the-art baggage system, which conveyed luggage to the platforms via a system of tunnels.[6]

The firm's design made good use of its thirty-acre site, which took advantage of adjacent existing New York Central freight yards and stockyards, and the railroad's hundred-thousand-square-foot, two-story freight structure, which became the Railway Express Agency (REA, a parcel delivery service) building. In its assembly, the terminal site had required the purchase and demolition of 190 houses on 150 lots, many of which contained multiple families and were part of this working-class neighborhood predominantly Polish and other Central and Eastern European immigrants. The complex's expansive footprint would have been impossible downtown, and relieved the railroad's long-haul trains from the congestion and dangerous at-grade crossings approaching its stations on Exchange and Terrace Streets. Yet this comfortable remove would also be the source of a prominent problem: the station's disconnection from the potential passenger base at Buffalo's core. An anticipated streetcar line extension to the terminal was never built, exacerbating the problem, and many passengers relied on cabs.[7]

When the Central Terminal opened in 1929, the city was nearing its economic apotheosis, and its population was approaching 573,000 (just 7,000 shy of its historic 1950 high). Buffalo was the nation's thirteenth-largest city and punched above its weight in economic output. Its foodstuffs held by its grain elevators fed the world, while giant steel mills and numerous smaller metal manufacturing facilities made the city an industrial powerhouse. Harnessing nearby Niagara Falls, the city was also an early center of electric power generation. Electronics manufacturers clustered in the region, and automobile and aerospace industries also had substantial footprints. The terminal reflected an aspirational city poised for more growth. Yet like many big-city railroad stations of the era (including those in Detroit and Cincinnati), it was wildly overbuilt—its two-hundred-plus-trains-a-day capacity was to optimistically serve a city with a projected population of 1.5 million (and one with apparently little appetite for cars).[8]

Aside from World War II, when the station briefly reached 230 daily trains, the Central Terminal

operated well under capacity. In the postwar period, as Americans spread out across the continent, its location lost centrality, while suburbanization and deindustrialization resulted in population declines. With national passenger service losing market share to air, automobile, and bus travel after the war, the New York Central attempted to sell the station in 1955 (and again in other years) but could not find a buyer. Train service would continue over the next two decades, albeit with a steady decline in passengers. The station survived the railroad's 1968 reorganization into the Penn Central and the 1971 Amtrak assumption of intercity service. But in 1979 Amtrak discontinued service. With the westbound departure of the *Lake Shore Limited* to Chicago on October 28, 1979, a little over fifty years after the day Central Terminal opened, the train had left the station for the last time. Amtrak service in Buffalo would continue from a yet-to-be completed station in Depew, a nearby suburb, and from Exchange Street Station, a small facility constructed near the southern edge of downtown in the 1950s.[9]

Too Far Gone and in the Wrong Neighborhood

After Amtrak's abandonment in 1979 the Central Terminal's history is emblematic of Buffalo's broader fortune as a city in the throes of deindustrialization, with residents and businesses fleeing in unprecedented numbers.[10] In brief, three successive owners were unable to restore and reprogram the station with new uses as they had promised. Instead, two of the three stripped and looted valuable fixtures and ornaments or allowed others to do so. The era ended in 1997 when East Side elected leaders and preservation advocates engineered the terminal's sale to a novel, nonprofit ownership entity.

During the 1970s, while Amtrak operated passenger service, the Penn Central Railroad owned the station and operated its freight facilities until its own bankruptcy forced its sale to Conrail, the federally created consolidated freight railroad. Yet Penn Central continued to own the station through a holding company. After the station closed, the railroad cleaved the Central Terminal property into parts, with the station's main buildings sold to the first of the private owners, and the tracks, yard,

and freight facilities sold to Conrail. The freight railroad's vast acreage included the long train concourse over the tracks. With no concern for the station's integrity, in 1981 Conrail removed the connecting section of the train concourse to enable passage of double-height or extra-wide freight cars below it—the still-gaping wound that I saw during my initial visit. Anthony Fedele, a local carpenter who specialized in remodeling restaurants and bars, bought the main building—including the tower and the baggage building—along with additional acreage in 1979 for just seventy-five thousand dollars (pennies compared to its unadjusted $14 million 1929 cost).[11]

Fedele, who had been in negotiations with Penn Central long before the station closed, wanted to convert it into a shopping mall and restaurant-hotel complex and promised the city a $54 million renovation.[12] Over the years he adjusted his plan several times to appeal to potential businesses, including what would have been the world's largest polka dance center.[13] However, none of his proposals found interest among investors. While seeking tenants, Fedele and his company, Galesi Realty, programmed the station's concourse and exterior spaces with a variety of events, including trade shows, flea markets, picnics, celebrations, and Dyngus Day festivities—a bacchanalian Polish American observance of Easter Monday—and rented it out as a location for the 1984 feature film *The Natural*. He also facilitated an effort to establish a small museum on site. These events and his recruitment of volunteers and support for their activities would later inspire the fledgling CTRC to provide similar access and programs. Fedele, who upon obtaining ownership fitted out an apartment for himself overlooking the concourse, possessed a genuine desire to restore the terminal, and many credit him with keeping the complex intact and secure during his ownership. He also helped facilitate its listing on the National Historic Register in 1984 and earlier that year won a local preservation award for a $1.2 million cleanup effort and general stewardship. Yet market forces were not kind to Fedele or his railroad station. While floating various plans and seeking tenants, Fedele paid only a fraction of his tax bills. The city, eager to see his plan work, worked out a payment plan with him. Yet by the mid-1980s he owed the city nearly three hundred thousand dollars for property taxes, sewer rent, accrued interest, and penalties, which prompted a bankruptcy court–ordered foreclosure sale.[14]

The Central Terminal was in the district of Dave Franczyk, a longtime East Side common council

representative (and later council president), who was beginning his first term in 1986. Franczyk had grown up on the East Side and had fond childhood memories of the station; it was where his father, a city government employee who often had meetings in the state capital, caught the train to Albany. Quickly becoming the station's greatest champion, Franczyk fought for its survival when Buffalo's political establishment had left it for dead.

In 2015 I met with Franczyk in his office in City Hall, and he recounted the terminal's difficult postabandonment history. With Fedele in arrears, and the city having foreclosed and prepared to dispossess the station, Franczyk made an alternative case for mothballing. "The building was completely intact" at that time, he told me, with a lingering sense of sadness in his voice. But Mayor James D. Griffin, with whom Franczyk frequently sparred during these years, felt differently. With little need for and no capacity to maintain the station, the city put it up for auction in 1986.[15] The winning (and only) bid came from Thomas Telesco, a thirty-four-year-old local building contractor, who offered one hundred thousand dollars. "I'm a builder, and it's a very interesting place, a beautiful and overlooked piece of architecture," Telesco told the *Buffalo News*. "I will say this to the preservationists: We are not going to ruin what we consider to be an Art Deco masterpiece. The first job will be to clean and restore the main concourse."[16]

Franczyk noted that, much like Fedele, Telesco initially had good intentions and possessed a genuine love for the building; for a time, he lived in an apartment within it, probably the one Fedele built. Telesco floated several schemes for the station's reuse, including creating a banquet and conference center, which might also have encouraged leases to complementary uses such as caterers, florists, and tuxedo rentals. Working with the University at Buffalo's architecture school, he was developing a feasibility plan. However, he also placed an advertisement in a national preservation publication offering the terminal's sale for $3 million. Though he later denied that he had authorized the ad, all was not right with his venture. And like Fedele before him, the project's sheer enormity and a lack of investors overwhelmed him. Soon he purportedly began selling parts and artifacts from the building while doing nothing to stop vandalism or prevent weather-related decay.[17]

As Telesco's stewardship unraveled, city officials worked behind the scenes to steer the building to what they believed would be more competent and better-capitalized owners. In August 1990

the city helped engineer an agreement between Telesco and a sixty-one-year-old former Buffalonian, Samuel Tuchman, a Malibu, California–based builder, and his wife, Betty. The Tuchmans gave Telesco $350,000 for an exclusive option to purchase the terminal for $1.3 million, with the $350,000 counting toward the payment of that sum. The agreement gave them six weeks to exercise the option; if they chose not to, Telesco would be obligated to return the initial payment. The option expired in September, yet the deed was transferred to the Tuchmans anyway. Telesco challenged the validity of the transfer and in November 1991 won a state court proceeding that overturned the sale.[18] But the Tuchmans countered that Telesco had violated the agreement by allowing the theft and destruction of the station's interior fixtures and argued they were entitled to ownership without paying the near $1 million balance owed.[19]

As Telesco and the Tuchmans fought over the title, the terminal continued to deteriorate. An incensed Franczyk prodded city inspectors to issue judgments and penalties. Attempting to gain entry to the station in July 1992, Franczyk—with city inspectors, a judge, and members of the media at his side—confronted Telesco on the esplanade. "Shame on you!" Franczyk shouted several times while the news cameras rolled.[20] While denied entry, inspectors later that summer were allowed in and found the station in a thoroughly deteriorated condition. Looters had stripped the terminal of almost everything that could be taken; vandals had destroyed what was left. The terminal was strewn with rubble, broken glass, and several inches of dirt, dust, and garbage; its massive bronze doors were gone; windows had been smashed or torn out; marble tables, guardrails, and decorative sconces were all taken or destroyed. The fixtures of its Art Deco restaurant, including its distinctive double U-shaped Carrera marble lunch counter, had been reduced to rubble, and the station's famous Buffalo statue had been found smashed lying across the floor next to a trashed cigar stand. Nearly all the station's plumbing had been ripped out, while loose bricks had fallen from the ceiling. With the roof badly damaged, gutter and drainage systems removed, and the station open to the elements, rain and snow poured in during storms—feet of water had accumulated in some basement spaces. Telesco had also stopped paying his tax and water and sewer bills, and by the end of 1992 had accumulated a thirteen-thousand-dollar debt with the city. Touring the terminal in October that year, the *New York Times* called it "a dark and crumbling monument to better times."[21] Even

Franczyk admitted that the station had reached a tipping point. "If we let this building go down any farther, it will have to be demolished," he explained to the *Buffalo News*, "There won't be anything left to salvage. I won't accept that. It can't happen."[22]

Several people familiar with the terminal's postabandonment history claimed that Telesco himself had participated in the looting. Veteran Buffalo preservationist Tim Tielman told me Telesco had sold priceless fixtures to support his drug habit, storing them prior to sale in a West Side warehouse. Tielman then lived in a house adjacent to the warehouse and could see fixtures being carried in and out. Yet Telesco vehemently denied all suggestions that he participated in the terminal's pillaging. In a December 1992 deal, Telesco pled guilty to eight building code violations and acknowledged the shortcomings of his stewardship. "He's met with building inspectors and taken care of things they were most concerned with," his attorney told the *Buffalo News*, adding, "He constantly sends people over to take care of matters, but people keep dumping and vandalizing. He's going to continue to do what he can, but I imagine those who are vandalizing will also continue." The attorney also noted that Telesco was talking to a Toronto-based developer about a potential sale.[23] The court gave Telesco several options: remedy a lengthy list of repairs, pay a twelve-thousand-dollar fine, or spend 120 days in jail. Yet by January 1993 Franczyk and others were urging the city to make emergency repairs and seal the complex, which the newly formed Central Terminal Task Force estimated would cost thirty thousand dollars. Meanwhile, the Tuchmans were waiting to receive the station and had pledged an $80 million renovation and would regain title later that year.[24] Decades later, Franczyk described Telesco's brief but tragic reign: "He lost at the end of the day but by then the damage was already done."[25]

While Telesco and the Tuchmans were fighting over the station, some stakeholders were suggesting greater public action. One citizen recommended that the city should work with the Clinton administration, which was beginning its first term, to include the station in a high-speed rail plan. And the Niagara Frontier Transportation Authority (NFTA), which operates Buffalo Metrorail, the city's light rail subway line, included the terminal in a planned thirty-five-mile extension, from downtown to the airport via the East Side.[26] Another citizen, writing in the *Buffalo News*, suggested that in blaming the terminal's various owners, citizens had let the city off the hook for its own negli-

gence in maintaining railroad infrastructure. Rather than merely prosecuting negligent owners, the solution he suggested—partially foreshadowing what would occur five years later—was for the "city to seize the building and develop it as a community project," using money pledged for a new arena for the Buffalo Sabres, the region's National Hockey League franchise.[27] The Sabres did receive their publicly financed arena in 1996, but the terminal never received anything close to a comparable outlay, at least not until the 2020s.[28]

While many were relieved that Telesco was gone, the terminal continued its long slide while its new owners attempted to put together the big development deal. Working with Samuel Tuchman's nephew Bernard Tuchman, a New Orleans–based shopping center developer, the family proposed an $80 million mixed-use development that was to include offices, stores, and restaurants. The anchor would be an Internal Revenue Service center with three hundred workers occupying sixty-five thousand square feet through a $20 million lease negotiated with the US General Services Administration (GSA). But the GSA ultimately decided to place the IRS center in a business park in nearby Cheektowaga, and the larger terminal plan began to unravel without its anchor tenant. The Tuchmans later sued the GSA for breach of agreement but a US District Court dismissed the case in January 1995.[29]

Like previous owners, the Tuchmans did not pay their property taxes and did little to stem the station's deterioration. A routine police inspection found more than a dozen hazards, "including crumbling stairways, loose mortar, open elevator shafts, holes in floors and walls, and piles of garbage." Over a two-year period ending in August 1994, the Buffalo Police had responded to over two hundred calls to the station, including those for arson, abandoned or stolen cars, and break-ins by teen explorers from the suburbs. The terminal had become such a wreck that one train enthusiast who had taken to looking after it speculated that nearby residents "would be cheering to see it gone."[30] No doubt many in city government felt the same way. In November 1996 the *Buffalo News* noted that the sixty-seven-year-old complex had been "neglected by various owners and ravaged by vandals and collectors," and was the subject of 113 building code violations at the same that its owners owed forty-three thousand dollars in back taxes and penalties.[31]

By 1995 Franczyk and his constituents were desperate to wrest control of the station from its

negligent owners. Despite receiving tepid support in City Hall, Franczyk and his preservation allies pushed ahead with a multipronged strategy. Maintaining contact with the Tuchmans, he encouraged them to address maintenance issues and attempted to find them a suitable buyer. At the same time, he pushed city agencies to step up code enforcement and begin foreclosure proceedings for nonpayment of property taxes and water bills. He also sought state and federal money and found an ally in US senator Daniel Patrick Moynihan. After touring the terminal with Moynihan, an architecture enthusiast renowned for his efforts to build a new Pennsylvania Station in Manhattan, Franczyk was able to secure $1.5 million in federal preservation funding for the terminal's purchase and initial stabilization, with an implicit promise for more once the project had progressed.[32]

The funding request actually came from Buffalo mayor Anthony Masiello, who had begun his first term in January 1994. But when Masiello aide Alan DeLisle was interviewed by the *Buffalo News* about claims from a Washington-based antispending group that the allocation was wasteful and subverted federal protocols, he said that the city planned to redirect the $1.5 million to the restoration of Shea's Buffalo Center for the Performing Arts, a theater just north of downtown.[33] When Franczyk learned from the newspaper of the mayor's revised plan, he was furious. "I'm the district councilman, and this aide is unilaterally making statements in the paper without talking to me about federal money earmarked in my district, one of the poorest in the city? That is intolerable," Franczyk told the *Buffalo News*. "I'm going to fight for every penny that's been allocated for my district to do something with this building." To this end, he quickly introduced and worked with the common council to pass a bill protesting "the proposed plundering of already earmarked federal monies from the Fillmore District."[34] The legislation urged the mayor to support the terminal's restoration, which it noted "could be the key to saving a beleaguered East Side community."[35] But the administration shot back, mocking Franczyk. "If there is something out there that the councilman has got that he wants us to pursue, something concrete, something viable, let us know," DeLisle told the *Buffalo News*. "If he has an idea for how we can take this $1.5 million and make [the terminal] into the greatest thing in the world, we're all ears. But, meanwhile, we've got Shea's deteriorating, and we've got $1.5 million that would go a long way to aid a building that's being used."[36] Others agreed. The editorial board of the *Buffalo News* called the terminal "too far gone for public funds" and noted that

it had been "vandalized and neglected to the point where saving it would be a dubious enterprise. If a private developer wants to give it a try, fine, but public money has better purposes."[37]

Like Franczyk, the Preservation Coalition of Erie County was also disappointed with the revised spending request. The organization characterized the mayor's thinking about the terminal as "too far gone and in the wrong neighborhood" and noted the $1.5 million would

go a long way to securing and stabilizing a magnificent building that is part of the daily life of our citizens, a landmark of the mind, heart and spirit. Thousands of us entered Buffalo through its majestic portals, seeking a better life and a new start. We went off to war there, came back from war there. Laughed there, loved there, danced there. And we want to do it again.[38]

The Preservation Coalition, an all-volunteer citizen advocacy group formed in 1981 (and later evolving into two separate organizations, the Campaign for Greater Buffalo and Preservation Buffalo Niagara), was known for its aggressive tactics, lawsuits, "harsh rhetoric," and "loud, feisty, stubborn and self-righteous" membership. By 1995 the Coalition had grown to eight hundred dues-paying individuals and had built an impressive "track record of hard-driving success," the *Buffalo News* observed. Its advocacy had saved many prominent buildings from the wrecking ball—including the Connecticut Street Armory, the Telephone Company Building, and the "Gold Dome" Buffalo Savings Bank—and facilitated the creation of the Cobblestone and Joseph Ellicott historic districts.[39] While Franczyk worked within the government, the coalition organized a Save the Terminal march and rally. Tielman, one of the organization's unpaid leaders, explained that most politicians are indifferent to preservation causes but hypersensitive to popular opinion. "Show up with 75 people at City Hall at 2 p.m. on a Tuesday afternoon—they get that, they notice," he told me. Over seventy-five people did show up for the May 1995 rally, marching from the Broadway Market to the terminal's esplanade, where Franczyk announced that the mayor had pledged to 'return' a portion of the $1.5 million (ultimately three hundred thousand dollars) to the terminal.[40]

Yet there would be no workable reuse plan for the station if it remained in the Tuchmans' hands. When a city foreclosure auction failed to generate a buyer, Franczyk and the coalition attempt-

ed to force the terminal's sale to the nearby Polish Community Center for back taxes owed, which could allow it to be marketed to new developer partners. But the Tuchmans were unwilling to walk away unless they were absolved of all debts. At the same time, the Masiello administration, still not convinced of the terminal's potential, was considering demolition. But a city architectural study released in October 1995 estimated that demolition would cost $16.3 million, a fortune for a city perpetually operating just above solvency.[41]

Citizen Ownership for a Historic Complex

At the Fillmore District's annual Neighborhood Summit held in January 1996, the Central Terminal dominated the discourse. With Masiello in attendance, participating constituents voted by a wide margin to make the terminal's restoration the district's highest priority, beating out more typical concerns such as trash collection, public safety, schools, and snow plowing.[42] This helped convince the mayor to support the terminal's transfer to the Polish Community Center, but the Tuchmans still needed convincing. Tielman, who by the 2010s would sit on Buffalo's Preservation Board and was for a long time the Campaign for Greater Buffalo's only full-time employee, recounted his dialogue. As the city was issuing the Tuchmans a "phone book–length" quantity of code violations, he told them, "Listen, this isn't going to work for you guys. It's just going to be trouble; everyone who has owned this has just been in way over their heads." And with violations and taxes owed accumulating, and politics now working against them, the Tuchmans finally agreed to sell.[43]

The Preservation Coalition had already been working on a plan for the terminal and its new owners. From the beginning, the sale to the Polish Community Center, an organization with no expertise in owning or preserving historic buildings and no resources to dedicate to the terminal's stabilization or revival, was problematic. As Scott Field, the center's housing director and a recently minted attorney, acknowledged, "It's a big responsibility, but somebody with an obligation to the community has got to do this. . . . At the very least, the building needs to be sealed."[44] Franczyk had hoped to direct the restored federal aid toward the community center's initial costs of receiving and se-

curing the building and seeding its planning efforts, but there was no guarantee that a benevolent, nonprofit owner would fare better in preserving and repurposing the station than its three previous for-profit owners. Liability was also an issue; a lawsuit involving the terminal could easily bankrupt the community center or jeopardize its other functions.

When I interviewed Tielman at a diner near City Hall on a cold afternoon in February 2016, he recalled the coalition's strategy. In the 1990s the coalition—mainly Tielman, Fields, and activist Sue McCartney—was also attempting to save two other ruinous Buffalo landmarks: Frank Lloyd Wright's Darwin Martin House and Henry Hobson Richardson's Buffalo State Hospital, which was once the Buffalo State Asylum for the Insane and is known now to most as the Richardson. To receive the Central Terminal (and later the Martin House and the psychiatric hospital), the coalition created a nonprofit "restoration corporation" with a straightforward preservation mission and a board consisting of local leaders. As a durable ownership entity, the Central Terminal Restoration Corporation was legally separate from the community center, which would be shielded from potential CTRC liabilities or bankruptcy. Tielman described the moment when the politics aligned to enable the station's sale as "serendipity," but stressed that the coalition was able to exploit the moment. "You've got to be ready for it to happen," he explained.[45]

In August 1997 the Tuchmans agreed to sell the station complex to the CTRC for one dollar. As part of the agreement, they would pay the city half of the taxes owed, approximately $25,000. Franczyk told the *Buffalo News* that the sale was "a big deal for the neighborhood and for the city" and brought an end to the "long list of destructive private owners, who owned the property and had big dreams but no capital." Mayor Masiello told the *News* the city was "encouraged that ownership of such a significant city landmark has passed into the hands of local preservationists who have a conscience, a commitment and a sense of community."[46] To get the CTRC up and running, Franczyk helped the fledgling corporation receive $370,000 in city funding, which included $300,000 in federal aid (part of the $1.5 million earmark) plus a $70,000 Community Development Block Grant.[47]

Even with its seed funding and some political support, managing the terminal and planning for its restoration were difficult for the organization, which lacked expertise, employees, and the prominent leaders who typically serve on not-for-profit boards—the rainmakers who can jumpstart

fundraising campaigns (the type who would soon sit on the boards of the Richardson and the Martin House, and facilitated substantial state grants to these respective projects). Tielman said the CTRC attempted to recruit such leaders without success. The nonprofit's initial funding mostly went to basic repairs and security: patching the roof, repairing storm gutters, and installing fences. While necessary, these improvements were mostly invisible to city residents, many of whom still saw the terminal with all its broken windows as an eyesore or nuisance. The complex was not in good enough shape to enable interior tours and events, but its fledgling stewards understood that they had to make it public in some way to rationalize future public investments in what would be an expensive and long-term project. The terminal needed to be more visible and knitted back into the city's mental fabric.

Tielman called the station a "beautiful object," one that, like the great churches of European cities, people would enjoy viewing from the outside. The terminal's prominent but long-broken bronze and glass clocks—one on each corner of the tower, four in all, which once helped Buffalonians catch their trains or make it to their jobs on time—offered an opportunity to increase visibility. Nine feet in diameter and 160 feet above the ground, the clocks, when illuminated, could be seen and read from miles away. In summer 1998 the CTRC received a fifteen-thousand-dollar state grant facilitated by local state assemblyman Paul Tokasz to help pay for the clocks' repair and reillumination. On a series of Wednesday evenings the following year, volunteers, including members of the electrical workers' local, installed and brought power back to the repaired clock elements. By fall 1999 the clocks were functional: Buffalo's most prominent building east of downtown was again a beacon of the nighttime landscape. Two years later the CTRC and its volunteers were able to reilluminate the entire tower. Chris Hawley, a planner in the city's planning department, called the relit clocks his "symbol of arrival" when spotted from his night-arriving train from New York City, where he had been attending graduate school in the early 2000s. It was "always an emotional moment," he told me.[48]

But to enlarge public support, the CTRC needed more engagement, not in the form of meetings, but on the ground—to share the station's ownership with residents. Building on the tradition of improvement events that began during the Fedele era and would later continue with the Preservation Coalition's

grounds cleanups during the Tuchmans' ownership, the CTRC saw the revival of volunteer activities as a way to establish the corporation's legitimacy and build support for its mission. In 1998 it staged its first spring cleanup, which attracted five hundred volunteers (three-quarters of whom were apparently from the suburbs) who picked up trash and planted trees and flowers. The 1999 event, held on a rainy May day, still attracted over two hundred volunteers who loaded hundreds of illegally dumped tires and other debris into dumpsters, cut grass, whacked weeds, and spread mulch.[49] These cleanups would grow in number and breadth and later evolve into Volunteer Days. As Tielman explained,

> The whole notion was to get people on the property, to get good people on the property, to display a type of proprietorship. It was like the broken window theory except in mine, the cut grass theory. If you cut the grass, then people are going to understand that someone is watching it and then you do these events. . . . Man, the first time we did one, we had, like, hundreds of people.[50]

Terminal events were well publicized, with stories running in local media before and after they occurred. Politicians took notice and felt compelled to participate. Mayor Masiello, upon hearing about one cleanup, sent city workers with large front-end loaders to assist in the effort.[51] But overall, the Masiello administration provided tepid support—and city government officials were not the only skeptics. When the *Buffalo News* ran stories about cleanup events or potential reuse proposals, it would inevitably receive letters from residents demanding that the city tear down the building. It was an eyesore, the bygone past, a waste of taxpayer money; preservationists needed to be more selective and less prone to nostalgia and zealotry, detractors claimed.[52] The terminal often found better support in county government. In 2000 longtime Erie County executive Dennis Gorski, a Polish American who had grown up on the East Side, facilitated a $1 million grant to the terminal, initially earmarked for the sealing and repair of the tower, which CTRC leaders at the time considered its most marketable asset.[53]

While the terminal suffered from numerous pathologies, a 1996 architectural study determined it was generally in good structural condition and suitable for multiple reuse schemes. It estimated that conversion to offices or light industrial use would cost $54 million, while demolition, including

asbestos abatement, would be $53 million. Adaptation concepts proposed during the early 2000s included tech industry offices aided by a local economic empowerment zone designation and a school-library-museum complex, but momentum was building for adaptation as a casino-hotel.

The contours of casino gambling were still being debated in Albany, but locally it was widely assumed that the state would allow the Seneca Nation to build and operate three casinos in Western New York. A Central Terminal casino had many backers, including Councilman Franczyk and CTRC president Russell Pawlak, who had personally lobbied Seneca leaders. But Masiello favored downtown, and by 2003 the Seneca rejected the terminal, eventually selecting a site near downtown along the Buffalo River, opening a temporary casino there in 2007 and a permanent one in 2013. But the casino concept may have helped propel the CTRC to open the station to the public sooner rather than later. In 2003 the corporation hosted a heavily promoted afternoon of interior tours, the first such event since the 1980s, ostensibly to build support for the casino concept and demonstrate that the terminal's "inner city" location would not deter visitors. The event drew over two thousand people who were wowed by the concourse, even in its imperfect condition, some of whom enjoyed revisiting a site that lived large in their memory. In September of that year the CTRC hosted an even larger event, Picnic on the Plaza, which included free interior tours, the first of many such celebrations that would characterize the terminal's use over the next several years.[54]

By the mid-2000s the CTRC was still learning how to manage a historic property, raise money and market to development partners and investors. Allowing people inside the terminal for events had always been a prelude to permanent restoration and reuse, in whatever form it would take. Yet these events—what Tielman had viewed as a vehicle for "sharing the ownership"—took on a life of their own. Along with Picnic on the Plaza, which evolved into the annual Octoberfest, the CTRC staged or facilitated tours, celebrations, media shoots, and happenings, along with regular volunteer days. Events were frequently eclectic and often garnered attention in local and sometimes out-of-town media. In 2004 artist Spencer Tunick organized and photographed an art stunt where he filled the concourse with nearly eighteen hundred naked bodies. In June 2006 the terminal hosted an evening of horror movie screenings and punk rock performances. Promoting this event, the Toronto-based *Globe and Mail* hailed the terminal as a "weather-beaten" "art-deco masterpiece"

experiencing a renaissance as a "cultural hub." Later that summer, the station was the setting for *Terminus*, an original seventy-five-minute performance created by Dan Shanahan, artistic director of the local Torn Space theater company, working with sound and video artist Aaron Miller. Given a code to the front entrance lock, Shanahan fondly recalled many weeks of near unlimited access to develop and rehearse the production, which exploited the levels overlooking the concourse, while the audience was seated on the concourse floor.[55] In September that same year, the terminal had some twenty thousand total visitors for a train show, Brew Fest, and Octoberfest; and in 2007 Dyngus Day returned to the terminal, having been held there previously during the Fedele era. These events brought revenue and facilitated fundraising during the balance of the 2000s, as the CTRC received several small grants from government, not-for-profit, and private sources. A twenty-five-thousand-dollar donation from Buffalo-headquartered M&T Bank in 2005 enabled the repurchase of the concourse's bronze clock, which had been in the possession of a Chicago antiques dealer and offered for sale on eBay (the clock was restored and installed at M&T's office complex in downtown Buffalo before its return to the concourse in 2009).[56] The terminal was regaining some of its lost luster; perhaps a complete restoration was not far off?

The Joys and Limits of DIY and Conflicting Visions of an Architectural Icon

By my first visit in 2009, the terminal had evolved into a robust site of collective joy, a place where regional memory and traditions freely mingled with architectural heritage. It provided intimate and thrilling heritage experiences—a Buffalo joie de vivre that was not compromised by its messy or incomplete state. In fact, these qualities enhanced the experience, providing a sense of architectural intimacy that I would not receive from visits in the days that followed to other Buffalo landmarks, including Wright's Martin House, the exterior of Sullivan's Guarantee Building (which is not open to the public), and the Richardson, which was still half a decade from opening its grounds to the public. The terminal showed that architectural heritage need not be painstakingly conserved or

reconstructed to be enjoyed and appreciated. And while arguably a tourist site, visitors were mostly from the region and generated only modest economic impact—providing no direct jobs and little tax revenue. The crassness of the market had not yet arrived, and I thanked the urban gods that the station had not been turned into a casino. This was indeed a site to celebrate, and I thought that we could all learn from the citizens who fought for and now administered the terminal. But as I would learn, spunk and novelty only did so much to address structural issues that undermined the terminal's integrity, safety, and long-term viability.

When I returned in 2012 the terminal and its administrators were enjoying a moment of ascendancy. The station had been buoyed by the attention it received during the National Trust for Historic Preservation's annual conference held in Buffalo in 2011. The conference, the United States' largest recurring preservation event, included sessions and a reception at the terminal, while the trust awarded the CTRC with a ten-thousand-dollar planning grant.[57] Prone to boosterism, the trust argued that preservationists were "reinventing Buffalo" and that the city's portfolio of heritage projects completed or underway by the early 2010s, including the terminal, "speaks to purposeful, industrious people striving for excellence, a people who, even in the face of hardships, have not lost their dignity and pride." If nothing else, the conference proved to be a collective ego boost, convincing Buffalonians of their capacity for preservation.[58] The terminal was also being featured more frequently in media shoots, including an engaging segment on the Travel Channel's *Off Limits* that included an ascent through the detritus-covered floors of the tower, much like my own a few years earlier. Upon reaching the observation deck amid falling snow, the host and his guide survive an encounter with angry falcons that were nesting in the tower's crown.[59] Nature and culture were converging at the old train station—sometimes in exhilarating fashion.

In 2011 the CTRC had also completed its first master plan, produced in house by the corporation's architectural committee and published in an attractive twenty-four-page booklet. Loosely modeled on the master plan for the Richardson in North Buffalo, which helped the former psychiatric hospital to receive its $75 million grant, the plan aimed to attract investors and convince state officials, including newly elected governor Andrew Cuomo, that the CTRC was indeed up to the challenge of revival. Like the for-

mer hospital, the terminal's plan envisioned incremental development over several years with a mix of civic, educational, and market-driven uses, and additional community uses for the grounds, including an "urban habitat classroom" that started the same year. It envisioned building around the passenger concourse, which would remain open to the public and for events, while making the most of the hundreds of thousands of

Paul Lang on the passenger concourse of the Central Terminal. (Author, 2012).

square feet of ancillary spaces, including those in the tower and baggage and mail building. These spaces could be adapted as contemporary office spaces, apartments, or even hotel rooms.[60]

My March 2012 visit happened just weeks before the terminal was to host Dyngus Day festivities, the first of ten large events (held over fourteen days) planned for the year, in addition to tours and unpublicized rentals. I met the master plan's creator, CTRC board member and preservation architect Paul Lang, for lunch in downtown Buffalo, along with his fiancée, Heather (Lang had proposed to her in the terminal's tower), who was also a regular station volunteer. Lang, who grew up in the Buffalo suburb of West Seneca, had spent much of the previous decade at Penn State earning degrees in architecture and urban planning. The station had long interested him; his maternal grandparents worked in the terminal's postal division, while his father, who drove a truck, often made deliveries there. While in school, Lang interned at the Buffalo architecture firm Carmina Wood Morris and made the station the subject of his master's thesis. Upon returning to Buffalo in 2007 he volunteered at the terminal and joined its executive board in 2009. When we met, he had been working on the restoration of Buffalo's Hotel Lafayette and other preservation projects, including various downtown loft conversions that would be completed over the next several years.

Lang described the terminal's many restoration challenges, methodically reciting a laundry list of pathologies and needs: plumbing, HVAC, utilities, windows, interior reconstructions, and arresting sites of water intrusion. The terminal's roof had been patched in several places, but a complete replacement would cost $1.5 million. But most of all, he argued, the station needed commitments from future tenants. Without investment and income, nothing else was possible. Not prone to waxing nostalgic, Lang lacked the hearty sense of humor of the older volunteers whom I had met three years earlier. He also did not share their Polish heritage or possess those cultural ties to the East Side. When I asked about the upcoming Dyngus Day, he noted the challenging logistics of managing six thousand expected visitors—of whom only two thousand to three thousand would be allowed inside at any one time—and expressed concern about liability issues. Some CTRC board members, he said, were too focused on events, which was potentially distracting the corporation from vital repairs and efforts to land investor tenants or major governmental support. He reminded me that the concourse's roof could still be brought down by one big winter storm.

Lang argued that the CTRC was in a transition period toward becoming a better-funded, more professional entity. Grateful for the organization's many volunteers and their accomplishments, he characterized their efforts as "elbow grease to propel the project forward." In the previous fifteen years, volunteers played an instrumental role in securing the station from trespassers, scrappers, vandals, and, partially, from the weather—and reopening it to the public. But now the CTRC had to focus on professional restoration, attracting investment and other bottom-line concerns. Lang talked about costs and construction loans and complained that federal and state preservation incentives were not geared to large, long-in-duration projects like the terminal. The CTRC had no paid employees at that moment, but seed money from a local foundation would soon enable it to hire its first executive director.

Later in the day I met Lang at the terminal. Underneath the entry canopy, he opened a door built into a temporary wall and we entered. Inside on the vast concourse floor, it was dark, quiet, cool, and musty, not unlike the interior of a Gothic cathedral—and it evoked its own kind of religious aura. On the center of the concourse floor, I spotted the reinstalled central clock, which wasn't there on my previous visit. Set in a tall brass fixture and surrounded by a handsome interpretive

display, the elegant clock faces were operative and displaying the correct time. On a high plinth sat another new addition: a bronze buffalo sculpture, which had been salvaged from a downtown location after the completion of a temporary art show that scattered buffalos about the city. It served as a replacement for the destroyed bronze buffalo that had long graced the concourse. Behind the buffalo, a temporary stage had been erected and was covered with boxes of records and media. Lang showed me some rooms where modest restorations, fixes, and cleanups had brought them closer to reuse. Contractors had completed water and sewer lines, and temporary interior bathrooms would soon be operational. In the spaces above the concourse, he showed me side-by-side, minimally restored office spaces with generator heat. The first weatherized spaces since the CTRC gained ownership, they were being used for meetings and housed the station's archives. Outside, the grounds were tidier, and the urban habitat plantings were beginning to mature.

Lang gave me a ride to my downtown hotel, and we continued our conversation. Even volunteer days posed risk and increased the possibility of lawsuits, he argued, and needed to be factored into the terminal's general liability insurance policy. He also worried that providing entry to thousands of people would encourage some to return to explore when the building was closed, and noted the poor condition of the two-story baggage and mail building extension owned by the city of Buffalo, which was open to the elements and trespassers. Again he talked about board priorities and the challenge of finding influential people to serve on it—those who had the ability to generate funding or possessed restoration and development expertise. It was a sobering conversation.

Two days later, a Saturday, I returned to the terminal to find it buzzing with activity. Volunteers were setting up for Dyngus Day—still over two weeks away—and working on other projects, including installation of drywall to create a space for a new gift shop while someone staffed a more diminutive table of souvenirs near the entrance. A large tour group and some itinerant visitors were also on the concourse, while in one of the ancillary rooms the grounds committee met with people who wanted to initiate a composting and sustainability-oriented education program. I was to meet with CTRC board president Mark Lewandowski, but the volunteers on the floor could not find him. Instead, I was steered over to Marty Biniasz, the terminal's public information director—

Mark Lewandowski and Marty Biniasz. (Author, 2012.)

one of the few people who had keys to the terminal, I was told. Biniasz and I briefly chatted about the terminal's restoration, and he described the scrappy nature of the endeavor fueled by volunteer labor, small donations, and events. "We like to say that the station was saved by beer," he declared with a smile. "You give us a dollar and we'll get a hundred dollars of value out of it." I asked him about restoring train service, and he noted the CTRC's realistic expectations. A rebuilt railroad station would occupy only a small fraction of the complex's expansive footprint. And if the six or eight trains a day that currently pass the terminal could be doubled or tripled in volume, a laudable target, it would still represent a small fraction of the station's designed capacity of over two hundred trains a day. The building's revival must be considered in terms of a mix of uses, he argued.

Like many stakeholders, Biniasz also framed the terminal as part of the story of the Polonia neighborhood and argued it was an element of "the authenticity of the East Side" and a potential catalyst for regional tourism and neighborhood growth. As the cofounder and principal of Forgotten Buffalo Tours, Biniasz was obviously well invested in that vision, and at that moment was also guiding a group from the Albany area through the terminal. It was difficult to have a sustained conversation amid the concourse's activity, and Biniasz soon returned to attending to his tour, leaving me alone.

I wandered over to the buffalo statue, which seemed to be a hit with visitors who posed for photos with the city's namesake animal cast in bronze. The buffalo had captured the attention of a man who brought his two kids to see the station. He had recently moved back to the region from Charlotte and said that while he had never taken the train, he visited many times as a child to meet or pick up his dad, who worked as a cook at the station's restaurant. Eventually, Lewandowski appeared, and

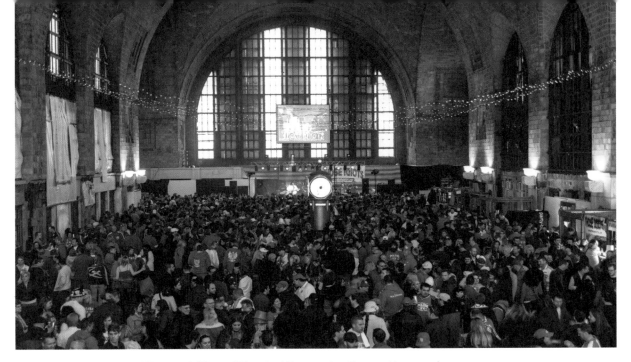

Dyngus Day at the Central Terminal. (Central Terminal Restoration Corporation, 2012.)

we briefly conversed. He repeated the CTRC's mantra, "To save, restore, and revive," but seemed distracted by the activity around us and responded to one of my questions with one of his own. "Danny, would you enjoy a Polish beer?" With that, I was handed off to Biniasz again, along with his partner, local television personality Eddy Dobosiewicz, whom I had met on my 2009 visit, and their tour group, which was preparing to leave for the next site.

Soon I found myself amid the group, who were visitors from the Albany area, at the nearby Polish Community Center, indeed drinking a Polish beer and eating perogies and golabki (stuffed cabbage). From there we proceeded to the R and L Lounge, where I met proprietor Lottie (the "L"), again for more beer and Polish food. Amid the casual conversation, Biniasz handed me a sheet with the lyrics to several polka songs, and from behind the bar with his accordion in hand, he led the group through a singing of "Beer Barrel Polka" and others. Members of the group, many or most of Polish heritage themselves, were enjoying the merriment of the Marty and Eddy show—and their narration and music amplified by microphone and speaker—and all the consuming that went with it. Just as I was about to leave to catch my plane, Dobosiewicz directed an unexpected, amplified tribute to me and profusely thanked me for being on the tour and a friend of the station. Slightly embarrassed

and feeling a bit guilty, I nonetheless said a quick goodbye and headed to the airport, just barely making my flight.

Once on the plane, I considered my terminal experiences. Like my trip three years earlier, they demonstrated that the station was the rare US architectural heritage site that provided loose, populist experiences and regional authenticity, albeit kitschy at times, rooted in both the past and exuberant present. The exacting standards of material culture and the extreme amount of funding necessary to conserve or restore it had not yet turned this place into private offices or a hotel complex. But the joy of the moment did not address longer-term issues. Threats to the building—environmental and economic—were real and could end all the fun that everyone was having at any time. This conflict of vision was playing out among the terminal's protagonists. Marty, Eddy, Mark, and others—the neighborhood heritage guys (though I suspect that some of their crew lived in Cheektowaga, a nearby suburb with a large Polish population and the destination for many ethnic white families fleeing Buffalo for the suburbs over the decades)—lived boisterously and savored the level of access they had to an architectural touchstone. But future-focused people like Paul Lang wanted the CTRC to professionalize and focus on facilitating the adaptive reuse of the terminal following the accepted practices of the field.

These perspectives were not mutually exclusive, but they did not fully acknowledge a third perspective, which understands the terminal in its present social context. While the East Side's Slavic churches still stand, the congregations have long thinned. Bars like R + L used to be plentiful, but now Forgotten Buffalo incorporates them into its tours not merely for their authenticity but also to bring in business critical to their survival. The Central Terminal still stands, as does the Broadway Market, but the Polonia neighborhood is presently a kind of construct—an idealized version of the neighborhood's past—and not entirely representative of the area's racial and ethnic diversity. As the terminal is a regional-scale tourist attraction, so too are these tours, events, and ethnic experiences, and the visitors' view is shaped by nostalgia and indulgences—and by the heroic narrative of not just the station but also the businesses, church parishes, and social institutions that have hung on. In the process, the narratives of current residents seemed to be of secondary importance, even if that was not an explicit intention, which damaged or at least complicated the terminal's potential resurrection.

Could these perspectives come together and propel the terminal forward? I wasn't sure. Three years later, it wasn't clear that the CTRC had made substantial strides in the name of diversity or embracing this other East Side. While in 2014–2015, the population of the Broadway-Fillmore neighborhood was nearly 60 percent Black and 14 percent Asian, the CTRC's board of directors was primarily white men.[61] The board was also learning the limits of volunteer leadership and labor. In 2012 the corporation received a grant from the Margaret L. Wendt Foundation to hire an executive director and pay their salary for one year. From the nearly thirty applications received, the corporation hired Marilyn Taylor, an experienced nonprofit administrator. In June 2014 she abruptly resigned after her contract was not renewed amid conflict over a fellow board member's proposal to buy the five-story baggage building for two hundred thousand dollars. Seen as a vehicle to jumpstart development and raise interest in the station's main building, the board initially approved but never consummated the sale. Allegations flew that certain board members were blocking the sale, while others claimed they were doing their due diligence and avoiding conflicts of interest. By year's end, over one-third of the board (six members) had retired or quit, including Taylor.[62]

"There are so many different things wrong with the building, it is astounding," said Paul Maurer, a board member who supported the sale and later resigned. Yet because of infighting, "Nothing substantial is getting done," he com-

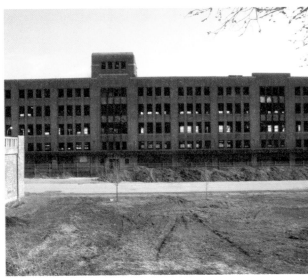

TOP A Central Terminal Restoration Corporation Board of Directors public meeting. (Author, 2015.)

BOTTOM The Terminal's baggage and mail building, a potential target of adaptive reuse development. (Author, 2012.)

plained to *Artvoice* in 2015. The "building has more structural and safety issues than most people know," said Lewandowski, the board president, adding that the corporation lacked the capacity to address the accelerating rate of decay, including the deteriorating mortar between the tower's bricks and damage caused by leaky roof drains. An exasperated Paul Lang, who was among those accused of blocking the sale, declared in an email to the board, "This entire organization, starting with its leadership, is a disgrace and an embarrassment," and noted a lack of professional respect and courtesy among members.[63]

Later, both Lang and Councilman Dave Franczyk played down the board conflict. Franczyk told me that the out-of-town reporter who wrote the article had taken things out of context. Lang said that the corporation had moved on and was excited about the responses it received to its recent request for proposals, and noted the tours he had given to developers. By the time I attended an October 2015 public board meeting held on the concourse floor, conflicts seemed to be at bay and no lightning-rod issues were raised during the uneventful proceedings (or conflict had been suppressed enough to keep it out of this public forum). At its conclusion, Lang and Jim Hycner, who became board chair in 2013, led a tour showing off some recent restoration progress and spaces for which there was developer interest: those above the concourse floor that Lang had previously shown me.

Despite disputes and the accusation that the terminal did not reflect the East Side's diversity, by 2015 the CRTC was hosting more people through events and tours. Events brought operating revenue, and grants helped pay for incremental building repairs. In 2015 the corporation was able to replace much of the concourse roof, while events such as Dyngus Day and Octoberfest brought thousands of people to the terminal or its grounds. The terminal in 2016 hosted a shoot of the movie *Marshall*, a Goo Goo Dolls' music video, and a Ken Block stunt-driving video, which made use of both the interior and grounds while providing in-kind donations. New York State Assembly majority leader Crystal Peoples-Stokes helped the CTRC secure a $250,000 state grant in 2018 that paid for a high-voltage electric transformer, solar panels, and high-efficiency LED lighting throughout the complex, in preparation for new development. With additional donations and pro bono labor from local electrical contractors, the installation was completed by the end of 2019.[64]

Can a Historic Train Station Be a Train Station Again?

During the 2010s nearly all Central Terminal stakeholders agreed that whatever restoration scheme takes hold, the concourse must remain open to the public, yet their perspectives on restoring train service were far from uniform. Advocates had long envisioned the return of Amtrak's intercity service *and* making the terminal a stop on a Buffalo light rail subway extension, while others considered these potential railroad revivals as nostalgia and an impediment to the complex's preservation and reuse. Additionally, regional, state, and federal leaders and transportation planners were not prioritizing returning service to the terminal. It might take decades to bring trains back, regional transit advocate and terminal board member Karl Skompinksi later told me.[65]

Yet for a time, the return of intercity rail looked like a realistic possibility. In 2016 a ceiling collapsed at Amtrak's Exchange Street Station downtown. Located underneath an I-190 interchange, the dingy, light-deprived, "shoebox-sized" depot built in 1952 had been pressed back into passenger service when the Central Terminal closed in 1979. Over the decades, many Buffalonians disparagingly called their station "Amshack." (The national railroad also operates a somewhat larger station relatively close to the Central Terminal, in the suburb of Depew.) Rather than wait for Amtrak to act, New York State quickly committed $25 million toward Amshack's replacement, at a to-be-determined site, which could eventually serve the Northeast Corridor high-speed rail network. Some advocates also suggested moving the city's main bus terminal to this facility to make it truly multimodal.[66]

In 2016 Governor Cuomo appointed a committee of local leaders to select a site, with Mayor Brown as chair. The committee pored over consultant reports and weighed the testimony of Amtrak, CSX (the owner of most of the area's tracks used by intercity passenger rail) and the public. Eventually, the committee narrowed the number of potential sites from eight to three—either the Central Terminal or one of two downtown sites. Supporters lined up behind each option and publicly made their cases.

Downtown supporters argued that a central business district site offered a larger potential market and supported the growth of ride-generating businesses and attractions, as well as downtown's growing residential community. It would also offer connections to the existing light rail subway and downtown's concentration of buses. Consultant-generated cost estimates also favored downtown. Yet many elected leaders, some of whom were on the committee, wanted the terminal, including Councilman Franczyk, Council president Darius Pridgen (also representing an East Side district), State Assembly representative Sean Ryan and its majority leader Peoples-Stokes, and US congressman Brian Higgins. (Mayor Brown did not support any proposal, which—though unsurprising—was interpreted by terminal backers as a form of betrayal.) These advocates argued that train service would be a catalyst for the terminal's restoration and East Side's revitalization. They also cited logistics: downtown sites would force Amtrak to back trains out into active freight tracks, something the railroad had testified it would not do. Yet CSX testified that it did not want passenger trains running amid its freight yard on tracks that were formerly part of the terminal property. The downtown sites enjoyed the support of the *Buffalo News* editorial board, local downtown business interests, and the Campaign for Greater Buffalo, led by Tielman, the longtime terminal advocate. Additionally, two competing groups of local architects lined up in support for each of the two options.[67]

In April 2017 the committee recommended a downtown location (which one of the two downtown sites was still to be determined) by an 11-4 vote, with one abstention. Panel member Howard Zemsky, a powerful Buffalo businessman who led New York's Empire State Development Corporation, noted that the selection was a "transportation decision first and foremost" based on what best serves Amtrak passengers. Yet many believed that the state had decided on downtown before it had even given the committee its charge. Terminal board member Skompinski called the selection a "pre-ordained decision," noting the state's interest in supporting its investments in Canalside, a heritage, leisure and tourism development; the city's NHL hockey arena, minor league baseball stadium, and other downtown investments. Representative Higgins, who also served on the panel, called the determination process "severely flawed" and questioned the integrity of the firm that generated construction cost estimates, which projected $68 million to $149 million for the terminal but just $34 million to $86 million for a downtown site. He noted that the train station would occupy

Buffalo's new Exchange Street Station, completed in 2020. (Author, 2022.)

only about eleven thousand square feet of the terminal, with the remaining building costs largely paid for by private development partners.[68]

Amid the COVID pandemic in November 2020 the state and Amtrak opened the new $28 million station, which was built on the site of the previous Exchange Street Station. At forty-eight hundred square feet, it is nowhere near as large as the Central Terminal's concourse floor, but is almost three times the size of the station it replaced. Designed by Sowinski Sullivan Architects, which had previously worked with the state's Department of Transportation on other stations, it incorporates some of the terminal's cherished design features, including its window arches, vaulted ceiling, a large clock, and all-caps signage. Thus far, it has received favorable reviews from travelers and media, who have praised its airy, light-filled waiting room and speckled terrazzo floor with emblazoned buffalo.[69] Yet as I observed during my own visit, the waiting room is tiny—perhaps enough space for thirty passengers—a mere fraction of the traffic boarding a typical Amtrak Northeast Corridor train

at Penn Station, New York, and well short of weekday volume on the railroad's *Empire Service* to Albany. And even now with the terminal's new masterplan barely mentioning trains, regional train advocates like Skompinski remain optimistic. High-speed rail, always a long-term project, would push Amtrak and state leaders back toward the terminal, while the NFTA could be coaxed into including the light rail extension in a future capital plan, Skompinski argued.[70]

The Big Development Partnership?

Even without train service, by early 2017 the terminal's future looked promising. The CTRC had been in negotiations with Toronto-based developer Harry Stinson, who envisioned a mixed-use plan potentially featuring office, retail, entertainment, and hospitality uses, and maybe even loft residences. In December 2015 the CTRC and Stinson had entered into a series of agreements that would allow him time to develop a detailed plan and seek financial backing as he and the board negotiated the sale and granular terms of their partnership. Over the next year and a half, Stinson's plan generated some public excitement and the cautious endorsement of the *Buffalo News* editorial board on three separate occasions. Like previously proposed plans, this one would build on the terminal's established function as an event site and exploit the sociality of the concourse by arraying restaurants, bars, entertainment, and creative spaces around it. At the same time, the plan for the larger spaces connected to the concourse, including the tower and baggage building, was flexible and open to ideas generated by potential partners. The Stinson plan at times envisioned the tower as loft apartments, and at other points as hotel rooms.[71]

Stinson added a larger residential component in 2016 in the form of a village scheme of four hundred to five hundred townhouses with the city-owned Railway Express Agency building as its focal point. In May of that year, the Buffalo Common Council named Stinson the designated developer for 59 Memorial Drive, a fifteen-acre city-owned lot containing the post office annex and REA building, which in the plan would be adapted as a food market. As the CTRC again renewed its agreement with Stinson, the emerging plan seemed to shift its emphasis to this village and away from the

station's core. Targeting workers of the Buffalo Niagara Medical Campus three miles away, Stinson said his "two-pronged" approach would enable the proceeds of townhouse sales to be reinvested into the station itself. Over the next year, Stinson worked closely with the CTRC board and a bevy of consultants, which included prominent local preservation architects Carmina Wood Harris (the firm of CTRC board member Paul Lang), structural engineers, and a Boston firm that specialized in preservation tax credit finance. Later versions of the plan also included a film and television production facility. Renderings produced for the Stinson plan demonstrated a contemporary vibe, in tune with attracting millennial-age and creative-class professionals, like postindustrial building adaptations in Dumbo and Williamsburg in New York City and Bucktown-Wicker Park in Chicago. Even the residences to be built around the REA building had an industrial aesthetic, similar to new loft-type developments of Northeast Philadelphia and the Pearl District in Portland, Oregon.[72]

Despite the apparent popularity of these plans, New York State seemed to have different ideas about the development process and who would be a party to it. In May 2017, nearing the expiration of one of Stinson's designated developer agreements, the CTRC abruptly ended its relationship with the developer. Less than a month earlier, in a communication shared with the media, the CTRC and Stinson Properties had heralded the partnership and the "nine-figure private investment" that would "restore the original grandeur" of the terminal and remake the "cherished national landmark" into a "thriving complex" and a "unified hub of activity" for the neighborhood, city and region.[73] Stinson claimed he had been "totally blindsided" and had learned of the decision from a press release even as a phone conversation with Central Terminal board representatives earlier that day had not provided "even an inkling" that their partnership was being terminated. The terminal's press release did not provide a rationale but thanked Stinson and his team.[74]

With the station site selection committee opting for downtown and terminal backers crying foul, state leaders likely felt compelled to provide a consolation prize and perhaps other sweeteners for a site that had yet to receive anything from Governor Cuomo's "Buffalo Billion" investment program. Yet the Cuomo administration had its own way of doing things and liked to be in control—and ultimately take credit when a project bore fruit. I later learned that local leaders were losing their patience with Stinson's inability to obtain financing and secure tenants. At the same time, some

terminal stakeholders were skittish about ceding control of a Buffalo icon to an out-of-towner, while others also questioned Stinson's record and ability to execute large development projects. It was simply a question of money, a source told me: Stinson had been unable to land investors. Of course, New York State was one of those investors that needed to be convinced.

With the state's new commitment and promise of additional funding, the CTRC began a fresh planning process. To support this effort, the Empire State Development Corporation and the city of Buffalo each contributed fifty thousand dollars for an Urban Land Institute (ULI) panel study, while ULI's own foundation contributed another thirty-five thousand dollars. Much like ULI's efforts at the Richardson, which ultimately helped drive the $102.5 million adaptive reuse restoration (including the $75 million state grant and the balance largely in federal and state historic preservation tax credits), the panel would match out-of-town and local experts who would tour the station, review previous reports, meet with more experts, and conduct stakeholder interviews. The panels were held in June 2017, and the organization released its recommendations the following January.[75]

The ULI panel revealed what the CTRC had been unwilling to acknowledge: the East Side real estate market was too weak to support a substantial private sector development, even with significant subsidies. Embracing a more incremental vision, the panel argued that the CTRC needed to embrace smaller investments at the complex's core while treating the larger campus as a stabilized ruin, which would remain open to phased development as proposals emerged. With an initial focus on medium-term (one- to five-year) investments, ULI recommended creating a year-round restaurant and event space that would use the concourse floor. With the extension of the calendar and full catering facilities, the terminal could host many more events, including more weddings and corporate gatherings. To make the terminal grounds more inviting and provide safer access, the panel also suggested recommended public realm improvements, streetscaping, and pedestrian-bike connections to the Broadway-Fillmore core and the rest of the city. Planned investments could also be leveraged through more placemaking activities.[76]

In April 2018, a year after the termination of the Stinson partnership, Governor Cuomo committed $5 million to help implement ULI recommendations. After twenty years of ownership, the CTRC finally received a substantial state commitment, even if it was less than commitments made to other

prominent Buffalo landmarks. The funding was to support the development of the terminal's year-round event space and catering facilities, as well as parking and other amenities. It was part of the state's Buffalo Billion Phase II, which included several strategic East Side initiatives, including $65 million aimed at reviving the area's commercial corridors (later called East Side Avenues) and the Buffalo Neighborhood Stabilization Initiative. The terminal also received a small share of the latter program, which was primarily focused on East Side housing preservation and homeownership.[77]

Following the Richardson, Reengaging the East Side

In my many conversations, Buffalo planners, preservationists, and elected leaders frequently compared the Central Terminal's trajectory with that of the city's other large, back-from-the-ruins project, the former psychiatric hospital now known as the Richardson. Designed by Henry Hobson Richardson on a two-hundred-acre Olmsted and Vaux campus that included a farm where much of the hospital's food was once grown, the complex was constructed and completed in stages between 1880 and 1895 (nine years after Richardson's death). In its later years, the Romanesque hospital and its pastoral grounds followed a pattern of decline similar to the terminal's. As psychiatric medicine evolved with the development of new drugs, a shift toward outpatient treatment, and reformed ethical standards, the hospital's once-innovative design with its salubrious setting lost its luster while deferred maintenance took its toll on the campus. Having already lost much of its grounds to the development of Buffalo State College in the 1920s, in 1969 the state demolished three of the five buildings that made up the hospital's eastern flank to create space for a new psychiatric hospital, which was completed in the early 1970s.[78] For decades, the idled complex deteriorated while its distinctive copper-roofed twin towers, bracketing the hospital's core, loomed over the upper reaches of the West Side. The leafy campus retained its pastoral feel and haunting architectural mystique, even as calls for the complex's demolition began to grow. The hospital's National Register listing (1973) and National Landmark designation (1986) did little to immediately impact the cause of its preservation.

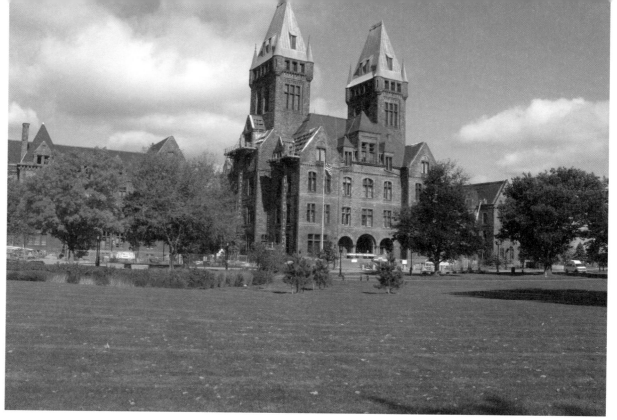

The former Buffalo State Asylum for the Insane, now known as the Richardson Olmsted Campus or the Richardson. (Author, 2015.)

As Franczyk and Tielman both described to me, the parallel deterioration and near loss of these Buffalo icons sparked connected preservation campaigns in the 1990s.[79] In some respects, the terminal had a better chance for preservation, given its very public and celebrated history, as compared to the hospital, which, even with its architectural pedigree and attractive campus, would have to overcome public perceptions associated with abandoned psychiatric facilities. In fact, the CTRC, with its advocates and boisterous constituency, had an eight-year head start on reuse since the analogous nonprofit Richardson Center Corporation wasn't created until 2006. Yet the hospital had a significant advantage: its location adjacent to a swath of relatively stable middle-class neighborhoods, and near other established Buffalo institutions, including Buffalo State, the Albright-Knox Art Gallery, Delaware Park, and Forest Lawn Cemetery.

By the mid-2000s the fate of these two complexes began to diverge. In response to a lawsuit

brought by local preservationists and elected leaders concerning the hospital's deterioration, in 2004 New York State allocated $5 million for the complex's stabilization. In 2006 Governor George Pataki provided the newly formed Richardson Corporation with another $76 million. With a staff and proper budget, the nonprofit was able to commission and guide a ULI panel and report in 2007 (similar to the terminal's a decade later) consultant-produced historic structures and cultural landscape reports in 2008, and a master plan in 2009. The first phase of the campus's mixed-use plan, the

Monica Pellegrino-Faix on the Central Terminal esplanade. (Author, 2020.)

front lawn restoration, opened to the public in 2013, while the eighty-eight-room Hotel Henry and conference center opened in 2017 and the first space of the Lipsey Architecture Center in 2018. The latter also benefited from a $5 million gift from the widow of longtime *Buffalo News* publisher Stanford Lipsey, who had been a great advocate for the Richardson and served on its board. Other campus buildings were stabilized for future development partners, potentially Buffalo State and or nonprofit, arts, and culture organizations.[80]

The person who guided the Richardson through many of these milestones was Executive Director Monica Pellegrino Faix, who stepped down in 2017 after a decade of leadership and temporarily relocated to Alaska, where she worked as a planning consultant for the city of Nome. I met Pellegrino Faix at a Rust Belt preservation conference in Buffalo in July 2018 where we were both speakers in a panel staged at the terminal. Titled "How Do You Eat an Elephant? Make the Monumental Manageable," the session enabled Pellegrino Faix; Paul Lang, the preservation architect and CTRC board member; and Paul Tronolone, an Empire State Development Corporation planner who was working on a portfolio of Buffalo Billion projects, to compare and contrast the terminal and the Richardson. Delivered to an audience of seventy-five people seated at tables situated on the concourse

floor, Pellegrino Faix and Lang drove the conversation. With the $5 million state grant and ULI recommendations, they agreed that the terminal was poised to follow the former hospital's evolution and obtain more public, private, and nonprofit investments. Chatting with board members and volunteers afterward, I sensed optimism and the spirit that I felt during my first visit in 2009.

While the hospital and train station presented unique challenges, both ULI panels emphasized immediate stabilization rather than restoration (the terminal's panel also suggested removing the word "restoration" from the corporation's name), the need for catalytic reuses at the core of each complex, outdoor spaces programmed with activities aimed to attract diverse audiences, and professional management to guide incremental development. Concerning the latter, the state grant and other allocations from the Buffalo Billion II, through the East Side Corridors initiative, would enable the CTRC to hire another executive director. And in September 2019 Pellegrino Faix returned to Buffalo to serve in that role, as she had previously at the Richardson.

I traveled to Buffalo in October 2020 to tour the terminal with Pellegrino Faix. Arriving first on a Saturday morning, I received a gruff greeting from some volunteers who were working their final volunteer day of the year. When I told them I was meeting Pellegrino Faix, it did not provide me with sufficient credibility and led to more questions and a stern warning about not taking pictures. "He's waiting for Monica," I heard one volunteer say to another incredulously, to which the second replied something contemptuous about "the boss." But soon Carl Skompinski, the board member whom I had interviewed in 2018, appeared and vouched for me, and I was allowed to wait until Pellegrino Faix arrived.

Standing some distance away, over the next several minutes I watched the hard-hatted volunteers incrementally return from their various work spots and gather near a temporary stage. As they grew in number to close to twenty—nearly all white men, and most forty or older—they engaged in the kind of jocular exchange that I have witnessed at construction sites. And I was reminded that the terminal, while on better financial and administrative footing, had yet to entirely overcome its identity crisis. Who did the terminal belong to, and what should it be? What role would volunteers play in the future? Pellegrino Faix had noted this tension over the phone a few weeks earlier. She acknowledged the contributions of the terminal's "army of volunteers" and later called their efforts "heroes' work" that

The lunch counter of the Central Terminal's restaurant
around the time of the station's opening in May 1929.
(Collection of the Buffalo History Museum.)

kept the building standing. Yet she also said the volunteers possessed "a sense of ownership about the building and what they think it should be and how they think it should happen."[81]

At that moment, Pellegrino Faix was focused on implementing ULI recommendations, which recognized but did not emphasize volunteer efforts, and conducting a new master planning process. When she arrived, we walked through the gutted space of the station's former three-section restaurant, where countless passengers and employees had eaten at its Carrera marble lunch counter. The following Monday, contractors were to begin work toward remaking the space into an all-seasons event space and catering kitchen. Like the counter, the restaurant's silver and bronze grillwork and other fixtures and furnishings were destroyed or stolen long ago. The new space would neither look nor function like its historic predecessor but had the potential to catalyze additional development within the station. The venue's operator would be selected once construction was completed. In addition to the construction of the catering space, the terminal's roof and façade needed yet more work. A persistent roof leak was sending water down through the floors above and into the restaurant and the adjacent section of the concourse. Above the restaurant, a large stain marred the bricks along a ceiling vault's long seam and around the terminal's northeast entrance—the same site of water damage I was shown in 2009. We walked across the concourse and peered into the old waiting room, which was in worse shape than the restaurant. I wondered if the badly damaged vaults above its window arches, which seemed to be covered in mold, could even be restored. Like my first visit eleven years earlier, water was still the enemy. And while the terminal's concourse remained a stunning space, listening to Pellegrino Faix describe unaddressed pathologies and needed infrastructure, I began to wonder if the $5 million grant was inadequate, even for a catalytic investment.

By comparison, over $100 million in state, federal, and foundation funds invested in the Richardson's rehabilitation, which was frequently trumpeted as a preservation success story, was not fully meeting expectations. The Hotel Henry closed in early 2021, ostensibly because of COVID, though poor performance had predated the pandemic.[82] Several people I spoke to complained about the hotel's management and level of staffing, and some questioned the interior design schemes. The hotel and development of the Richardson Olmsted campus was soon after taken over by developer Douglas Jemal, whose preservation portfolio included several prominent Buf-

falo properties, including the Statler Hotel and One Seneca, a mixed-use adaptation of the region's tallest building—the former Marine Midland Center, a 1971 office tower designed by Skidmore, Owings & Merrill.[83]

Outside on the station's esplanade, Pellegrino Faix and I looked out across the Broadway-Fillmore neighborhood. If the terminal's recovery has been an incremental project, so too was the improvement of Broadway-Fillmore, which from the esplanade didn't look substantially different than during my first visit in 2009. Similarly, the terminal's social connection to the neighborhood remained a work in progress, as did the goal of enhancing the diversity among the station's protagonists. Pellegrino Faix argued that the new master plan would have broad inputs and serve as a vital tool to engage East Side stakeholders. Similarly, preservation architect Paul Lang, then the CTRC's board chair and author of its previous master plan, hoped the planning process would provide "an opportunity to knit community hopes, values, concerns and opinions" into the terminal's reuse.[84] The CTRC had recently received four hundred thousand dollars from the East Side Collaborative Fund, a pool created by a consortium of local foundations to support planning activities around the state's East Side Avenues initiative, to pay for the plan.[85] Led by the Smith Group, the four-phase master planning process began in August 2020 with the first of three Community Advisory Council meetings and four public engagement meetings.

The terminal had always been an ad hoc restoration project and drew its gravitas from the passion of its volunteers and the lively, homespun nature of its events. The formal master planning process—administered by professionals, with its structured meetings and outreach activities, and participatory surveys with instant results—felt like the opposite of the four decades of advocacy and DIY activity that had preceded it. Pellegrino Faix certainly understood this contradiction, even as she viewed the process as necessary. She was encouraged by the large and enthusiastic (virtual) turnout for the first community engagement meeting held two weeks earlier, but expressed mild disappointment that the forum had not entirely succeeded in engaging very local stakeholders. Less than half of the participants were city residents while only 35 percent were East Siders and 3 percent identified as Broadway-Fillmore residents. The data from the second engagement meeting, held in December 2020, generated a somewhat similar participant profile.[86]

The Smith Group's attractively designed and thoughtful master plan, completed and released in August 2021, reads like a synthesis and refinement of many previous ideas with the overarching goal of remaking the terminal into a hub of the East Side, while reinforcing the area's contemporary cultural diversity. Like preceding plans, it envisions market-determined uses to be built around the passenger concourse, which would remain a lively and programmable public space. The plan rebrands the concourse and the ground-floor spaces around it including the restaurant and waiting room as the "civic commons," which would continue to be used for events and gatherings, and links them to the terminal's two outdoor "welcoming spaces"—the "great lawn," which sits below the station's west façade, and the plaza. In a City Beautiful–esque gesture, the great lawn and plaza would be connected by the construction of the "grand stairs" and activated through improved design, placemaking, and linkages to the core of the neighborhood and city. [87]

Of course, the master plan would be of little value without investors, and as ULI had recognized, there would be no investors without substantial public subsidies. The $5 million grant and other smaller outlays had been a test of the CTRC's capacity and a potential down payment toward larger public investments, but all did not go as planned. The state's investment was too small to realize the developer-ready event space and catering kitchen with its required utilities and infrastructure. In 2022 Pellegrino Faix told me that storms had again damaged the roof above the restaurant, and it had been "raining inside the building, four floors down." Contractors replaced a large section of the roof, carried out asbestos abatement, added new drains, and undertook other stabilization measures—in addition to gutting the restaurant. Pellegrino Faix said the project was "the best $5 million ever spent, because now we really understand the building, how to work in the building." Board member Skompinski concurred. "We did a ton," he said, and likened the state's investment to "kicking the tires to see how we would manage that $5 million." He added, "I think they liked what they saw."[88]

As this stabilization effort and the master plan demonstrated, the corporation was growing in capacity. And with the state's great commitment to Western New York, through its Buffalo Billion

The Smith Group's masterplan for the Central Terminal. (Graphic: Smith Group, 2021).

outlays and other programs, and its budgetary health (in part generated by federal COVID-19 aid), it surprised few stakeholders when the terminal finally received its big grant—some twenty-four years after the CTRC's formation. New York State awarded the Central Terminal $61 million from its new $300 million Regional Revitalization Partnership (targeting the cities of Buffalo, Rochester, and Niagara Falls), with $54 million from the state, $5 million from philanthropic sources, and $2 million from the city. Pellegrino Faix downplayed her own role and characterized the grant as a natural outgrowth from the planning activities associated with the state-led East Side Avenues program, which had delivered $5.4 million to the CTRC in 2019. While state officials have always maintained

that its commitment to the area was long-term, two events helped elevate the area's—and by extension, the terminal's—cause: Buffalo native Kathy Hochul assuming the governor's office in August 2021 and the Topps Friendly Market mass shooting that resulted in the deaths of ten people in May 2022. Three weeks prior to the shooting, the state had committed another $164 million to the East Side with a tacit acknowledgment that a large grant to the Central Terminal would be forthcoming. While Topps was over two miles from the terminal, the *Buffalo News* linked the two sites and argued that the shooting "served to highlight the degree of disinvestment on the East Side and the need for more community reinvestment."[89]

Even before the shooting, the terminal had been essentially reframed from a historic preservation initiative to a community reinvestment project with an emphasis on both economic development and, with its civic commons, creating a magnetic hub for the neighborhood and city and perhaps some tourists as well. And nearly all the state funding was predicated on the terminal's local economic impact. As Pellegrino Faix described to me in 2022, the terminal's revival would follow the master plan and focus on creating the civic commons first. The CTRC would prioritize stabilization for safe use over realizing a grander or more extensive restoration scheme. As for the revival of train service, she noted that the plan would preserve the possibility of later rail station development.

In addition to covering operational and predevelopment costs, funds would primarily be spent in two tranches of capital investment, with the first to address "near-term safety issues," Pellegrino Faix said. The $5 million work from its 2019 outlay had revealed previously unknown building pathologies (the structural integrity of the esplanade and its underlying parking deck was of particular concern). The CTRC board had recently made the difficult decision to close the interior and surrounding esplanade to events and tours until these deficiencies could be addressed. The completion of the first capital phase would allow reopening the terminal to a limited number of events a year (without heat, bathrooms, a kitchen, and new windows), as it had hosted in the past. The second phase would largely focus on the concourse and other spaces that constitute the civic commons, including adapting the esplanade, which had always been used for parking even as it sits atop a parking deck, into a pedestrian/gathering space. It would also be planned and executed in conjunction with the selected development scheme and developer for the bulk of the complex. The

corporation's summer 2022 Request for Expression of Interest (RFEI) had generated a significant response, with sixty people participating in the walk-through, fourteen of whom were developers and others viewing the video associated with the RFEI.[90] Douglas Jemal, the Richardson and One Seneca developer, was one of those expressing interest. He called the terminal "one of the top 10 coolest buildings in the world."[91] The 2021 master plan estimated the cost of the entire terminal project, including the tower and baggage building, to be between $277 million and $297 million, with inflation undoubtedly pushing the final cost higher.[92] But federal and state historic preservation tax credits, which were not a part of the terminal's recent award, could help additionally defray development costs. Expressions of interest were due before the end of 2022 with the selection of a developer by mid-2023. Whatever partnership is formed, the CTRC will remain an active steward of the larger project and retain underlying ownership of the terminal property.

The future of the terminal is not entirely settled at publication time, and whatever development scheme is ultimately selected, it will likely be many more years before the project is complete. Yet the "people's train station" had grown up and become a fully legitimate development project. Grassroots activism, volunteerism, and DIY practices had succeeded in keeping the terminal standing and bringing it to this moment while providing decades of enjoyable and often intimate access to an architectural icon that lived large in Buffalo's collective memory and robustly contributed to its present sense of identity. With professional planning, proper funding, prioritizing public safety, and soon, market-determined uses, the terminal had perhaps lost its forgotten jewel, its freewheeling vibe. To ensure the complex would still be standing for and enjoyed by generations of Buffalonians to come, it was time for the pros to take over.

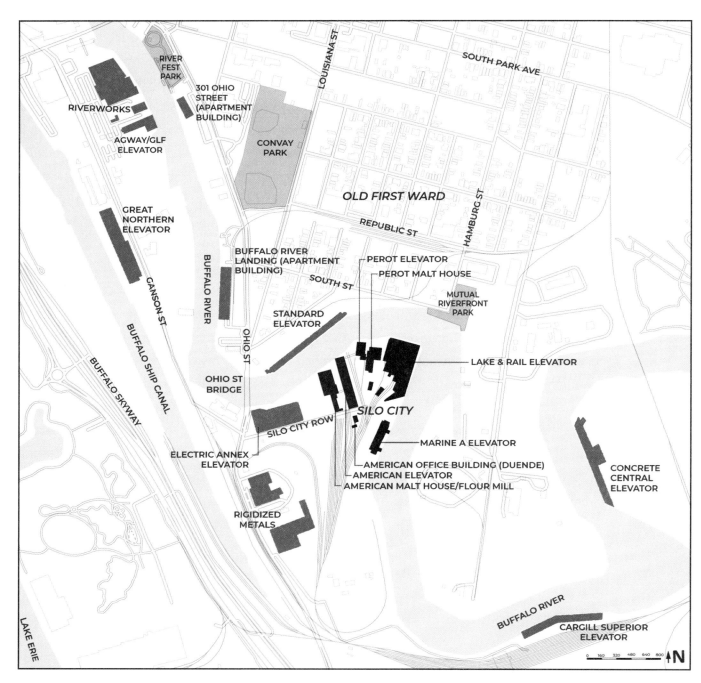

Silo City is part of the United States' greatest concentration of extant concrete grain elevators. (Cartography: Shahrouz Ghani Ghaishghourshagh, 2021.)

CHAPTER 3

Silo City

After visiting the Central Terminal and then Daren's Bar during the first hours of my 2009 Buffalo trip, my host, Common Council president Dave Franczyk, suggested we get lunch at another old bar, Swannie House on the north bank of the Buffalo River in the Old First Ward, which was also in his district. (Politics, bars, and historic preservation seem to go together in Buffalo.) I had told him I wanted to see the grain elevators, so en route, we stopped at a small riverfront landing that offered a good view. We walked across some freight tracks and onto the scruffy, grass-covered landing and looked downstream toward the Ohio Street Bridge through a stretch of the river that I later learned was called Elevator Alley. It was an apt descriptor, and I could count six elevators rising from the riverbanks with one more around the bend behind me. There were others farther down and upstream, as well as on the nearby Buffalo Ship Channel and outer harbor. These undulating concrete forms were breathtaking in ensemble and dominated the vista downriver. A breeze blowing upriver streaked the surface of the water, which otherwise lacked activity until a small, flatbottomed motorboat cruised by in the direction of Lake Erie. As the boat passed underneath the Ohio Street Bridge and then quickly disappeared while following the river's northward turn, I realized I was standing at the very spot that architectural scholar Reyner Banham had said offered "the finest urban prospect in Buffalo."[1]

Grain elevators (sometimes called grain silos) hold a special place in architectural history and in the history of Buffalo. At the beginning of the twentieth century, they were among the most ad-

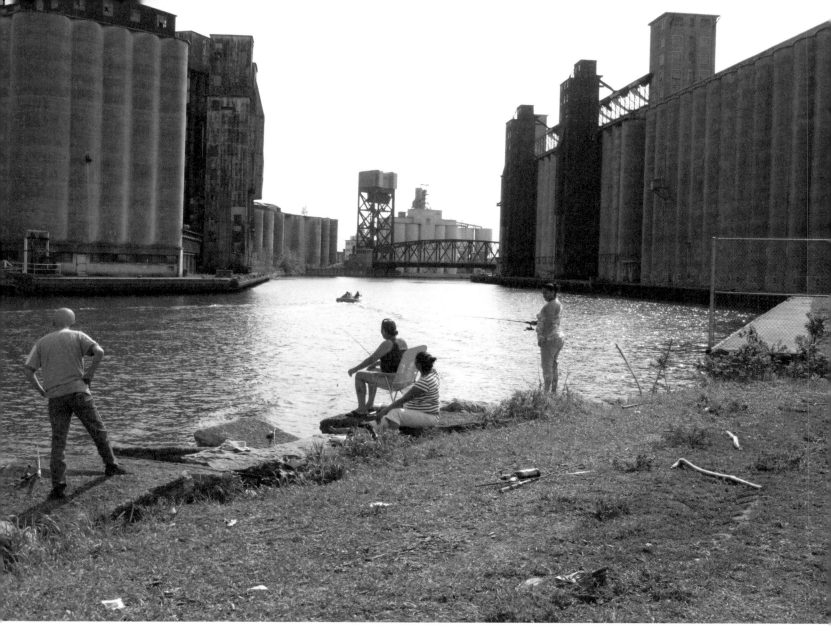

A view of Buffalo River grain elevators from the landing west of Hamburg Street. Left bank, from left: the Perot Malting, American (obscured by its loose leg), and Electric Annex. Right bank: the Standard. (Author, 2009.)

vanced and expressive uses of the new building technology of reinforced concrete. They also provided form and inspiration for cultural modernism and fueled the ideologies of European modernists, including Le Corbusier, Walter Gropius, and Erich Mendelsohn. They made Buffalo the world's largest grain storage, milling, and transshipment center for the better half of the twentieth century. To this day, several of the city's largest elevators, with capacities in the millions of bushels, still mark its landscape, and a few are still in use, including one used by a General Foods plant a mile downriver. The winding waterway's shipping channel was just wide and deep enough (with dredging) for grain boats and those of other industrial activities, like the once-giant but entirely demolished Republic Steel Plant (closed in 1982, and since 2015 the site of Elon Musk's Solar City), which was three bends farther upriver from where we stood.

It was a near religious moment for me. I had wanted to see the elevators since reading Banham's *A Concrete Atlantis* almost a decade earlier. They were so majestic and geometrically expressive and, from our vantage point, so intimate. Yet my own solemn moment was punctuated by activity in the foreground. Five or six Buffalonians were casting their lines into the placid, postindustrial river; their personal effects—including two spare fishing rods, some empty beer bottles, and a large plastic bucket to hold caught fish—were strewn about the grass behind them. They bantered and moved about an uneven river wall of broad stones and concrete blocks, seemingly oblivious to our presence. A woman, perhaps thirty years old, cast her line from a patio chair that she had dragged onto one of the larger, flatter stones. I walked over to the edge, and one of the men showed me a net with the small sunfish he had just reeled in before chucking it back into the river. A boy, maybe ten years old, sensed that I was interested and came over to show me a much larger fish that he or another member of his family or group had caught. It was a walleye, over a foot long, which he held by the gills. Perhaps caught on its way to or from spawning grounds, the fish was covered with bits of dirt and dried grass from wriggling on the ground after being detached from its hook. Walleye seemed to be running at that moment in May—minutes earlier, a man forty yards upriver who also wanted to show me his catch had pulled a chain up from the water, to which half a dozen walleye had been attached, though none as large as the boy's. These catches were testament that the Buffalo River—formerly an "industrial cesspool" so polluted that it caught on fire in 1968 and was the focus

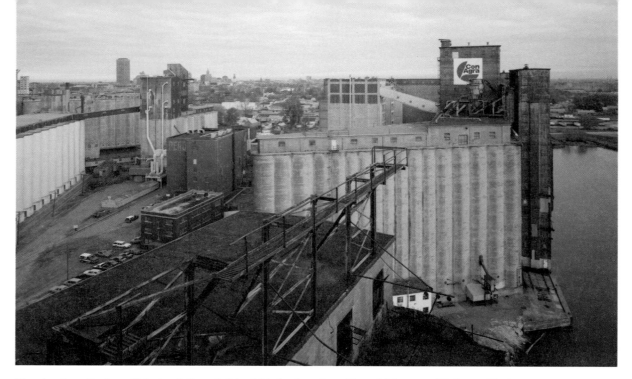

The view from the top of Marine A. From left to right: the American, Perot Malting, and Lake and Rail grain elevator complexes. (Historic American Buildings Survey / Library of Congress, 1990.)

of a decades-long EPA-supervised cleanup—was now a site where Buffalonians came to fish, relax, and commune with nature amid a landscape of globally consequential structures.[2]

This urban riverscape—equals parts sacred and profane, historic and contemporary, contaminated and biologically resurgent, productive and fallow (actually, more fallow)—was far more complex than I could imagine even at that moment, and held different meanings and purposes for different parties. A cultural landscape, its grain elevators were in some respects similar to medieval castles: their forms have been layered with new meanings as their original uses have become mostly redundant; and in viewing, they felt imposing and indestructible, yet their stories and endurance were more complicated. The elevator to my right, the Standard, was one of the few that was still in use. While a few grain hopper freight cars stood idle on the adjacent tracks, there seemed to be no discernable activity coming from inside, and its gantries and loose legs (the movable metal towers that convey grain from boats to elevator bins) looked as rusted as the others. But those on the opposite bank weren't all vacant either. The imposing Lake and Rail, distinctive in that some of its

bins were hidden by a sheer concrete wall that rose from the river's edge without undulation, and that its configuration featured a ninety-degree turn (most others were straight) betraying its 4.4-million-bushel capacity, had recently received a $1.5 million renovation. The previous September, it had begun to receive and distribute grain again. Later I learned it was part of a cluster of elevators, four in total, owned by a local entrepreneur who also owned a nearby metal fabrication facility. The owner, Rick Smith, had proposed building an ethanol refinery amid these elevators, exploiting their tremendous grain storage capacity. Smith, I learned, had an interesting perspective, viewing the refinery as a means to preserve these concrete structures and their historic functions as much as a viable business proposition.

When I returned to Buffalo three years later, the ethanol plant was no longer on the table—the Great Recession had driven the price of corn and grain commodities down to the point where the plant was no longer economically viable. But Rick Smith wasn't relinquishing control of these architectural icons; in fact, he was even more excited to move onto a different sort of venture: Silo City.

Unplanned Adventures in Grain Elevator Stewardship

In 2006 Smith, the third-generation owner of Rigidized Metals, purchased four vacant elevators tightly grouped within a Buffalo River oxbow. They are the American (1906 and 1931, closed 1984) and its adjoining warehouse and flour mill and adjacent office building; the Perot Malting Elevator (1907, addition 1933, closed 1993) and its adjoining malt house; the Lake and Rail (1927–1930, closed 2001, reopened 2008, closed in 2017) and its associated buildings; and Marine A (1925, closed ca. 1965).[3] These four elevators are among the city's fourteen extant elevators, thirteen of which are concrete.[4] When Smith repurchased the Lake and Rail in 2017 after the Buffalo Lake Port shut it down, it reduced the number of elevators in use from five to four, with two used for grain and two others for building products.[5]

Richard Smith III has long possessed varied interests and has spent much of his adult life far

Silo City principal Rick Smith (wearing hat) with University at Buffalo faculty members (from left to right) Lynda Schneekloth, Beth Tauke, and Kerry Traynor. (Author, 2012.)

Swannie Jim Watkins in front of the Swannie Shack. (Author, 2014.)

from Buffalo. He grew up first in Cleveland, where his father worked for Republic Steel, and then Buffalo, where his father took over Rigidized in the late 1960s. In my many conversations with him, he has often emphasized the accidental nature of his personal trajectory, including his purchase and plans for the grain elevators. For a time, he pursued a career in music and as a professional squash player. In 1998, at age thirty-eight, he returned to Buffalo when his mother was ill and was asked to help run the family business. Soon he became president of Rigidized, the company founded by his grandfather Richard "Stainless" Smith in 1940 to produced durable sheet metal to supply aircraft and other industrial manufacturers.[6]

I met Smith during my first tour of Silo City in March 2012, which had been arranged by Lynda Schneekloth, a professor emeritus at the University at Buffalo (UB) School of Architecture and Planning. I had contacted Schneekloth after reading her stirring essay "A Wild and Unruly River," about the Buffalo River's many fluid and sometimes contradictory meanings and ecologies. It turned out to be a fortuitous moment to make this connection. Silo City had recently been established, but it

was still more concept than place, and its free-spirited owner was happy to host visitors and engage in contemplative conversation. Accompanying Schneekloth and I that morning were two other UB faculty members, Beth Tauke, who had led a Silo City architecture studio the previous semester, and Kerry Traynor, who is also a historic preservation consultant and would be our guide. When we arrived, we also met choreographer Gerry Trentham, creative director of the Toronto-based dance and performance company pounds per square inch, and a partner, who were working out interior and exterior sequences for *The Elevator Dances*.

Trentham, who grew up in Alberta where his father was a grain buyer, has an affinity for elevators. The dance, which would exploit Marine A's unique interior spatial and acoustic dimensions, was part of the Canola Project, a suite of performances that explores agricultural production, distribution, and consumption. It would eventually be performed, filmed, and then projected onto the exterior of the elevator during a nighttime festival. Some UB graduate students scouting Silo City for a humanities program, Fluid Culture, also joined our tour. Smith wasn't there yet, but we checked in with his property manager, "Swannie Jim" Watkins, who was living in a metal shack amid the elevators—the former "Elevator Shop." A retired engineer and factory foreman, Watkins served multiple roles, including being Silo City's de facto creative director and an adviser to Smith on most matters, until he retired from the site in 2019. His "Swannie Shack" functioned as Silo City's informal headquarters, and all arrivals—including scholars, location scouts, event planners, contractors, and wandering architectural tourists—were expected to check in with Watkins before proceeding. Some visitors, as I found out, were enticed to linger and were offered a beer or invited inside to gather by his wood-burning stove when the weather was cold, if one could find a place to sit in his less-than-tidy quarters.

Watkins, who had been expecting us and knew my UB colleagues well, gave us his blessing to explore on our own. Led by Traynor, we toured the ground level of all three elevators (Silo City was only three elevators at that time) and Perot's adjoining Malt House, and then the upper levels of Perot and the American in the afternoon. I had heard much about Smith over breakfast earlier and over the phone, and when he arrived via SUV later that morning, his reputation had indeed preceded him. While the surprisingly mild weather on that mid-March morning was perhaps more appropriate for

Smith's 1973 Oldsmobile convertible, when he stepped out of the SUV he was wearing his characteristic Stetson, mustache, blue jeans, and cowboy boots. Later, over lunch at a nearby pub, we talked about how he came to own these iconic Buffalo properties and what he might do with them.

Smith said he was initially only interested in purchasing or obtaining an easement through a portion of the vacant elevator properties, which had all been owned by Conagra / Maple Leaf Milling partnership, to gain access to freight tracks and improve transportation to and from Rigidized. Making an inquiry, a representative told him the company was willing to sell and would give him a good price, but only if he purchased the entire complex, including the four grain elevators and their milling facilities and other associated parcels. Smith agreed, paying $160,000 for the properties, about eighteen acres in all. From his youth, Smith remembered the days when the docks that lined the riverbanks were still relatively active and the grain elevators had generated regular boat, rail, and truck traffic. But the purchase was not an act of nostalgia, even as he did not have a well-formed plan other than using the grounds for festivals and events. After discussing the properties with an old friend, Buffalo pub manager and beer brewer Kevin Townsell, they decided that developing an ethanol refinery would enable the elevators' material preservation and help preserve their historic functions while providing economic growth for the city.[7]

In 2006 Smith, Townsell, and two others formed RiverWright Energy to develop and operate the refinery. Neither Smith nor Townsell had any experience in biofuel production or in any aspect of the energy industry, but the duo exuded charm and were well known in the Buffalo business and civic communities. They had collaborated for several years on a riverfront festival, and between them, they believed they had the collective capacity to raise capital and obtain public approvals. Smith and Townsell contracted with an ethanol consulting firm, the KL Process Design Group of South Dakota, which was setting up similar ventures in other US locations. The consultants, who agreed to put forward their own substantial investment and guide engineering, devised a plan for an $80 million facility that would exploit the complex's staggering 10.6-million-bushel capacity and include the construction of up to eight 500,000-gallon storage tanks and an eighty-thousand-square-foot building for fermenting and distilling facilities. The complex had the potential to generate 110 million gallons of ethanol, 400,000 tons of livestock feed (a biproduct of ethanol distilling), and siz-

able quantities of sellable liquid carbon dioxide (another bioproduct) per year, and could begin operation as early as September 2007. The market for ethanol had been rising in the early 2000s, propelled by the US Energy Policy Act of 2005, which required increasing proportions of biofuels to be mixed with retail gasoline. RiverWright's potential capacity dwarfed most existing ethanol facilities, which were largely concentrated in the Midwest and lacked the ability to accept boat deliveries. The proposed refinery would also offer generous rail access and was close to large markets. The KL team members were impressed. It was a "perfect storm from an economic standpoint," one noted, and it could be built for about 30 percent less than new facilities.[8]

As RiverWright pursued permits and courted investors, the project generated support among elected leaders, including Mayor Byron Brown, and the local preservation community, which had long recognized the elevators' significance and applauded the proposal's intent to use them for grain transfer. The project received city planning board and council approval in 2007, and in 2008 secured a state Department of Environmental Conservation permit. Additionally in 2008 the Erie County Industrial Development Agency awarded the project $5.7 million in tax credits. Yet the project was not universally popular. In 2007 a group of residents from the Old First Ward, the traditionally working-class Irish neighborhood across the river where grain elevator workers and their families typically lived, filed a lawsuit to stop the project. The suit cited the environmental impacts, including noise, odors, and the potentially catastrophic risks associated with living in proximity to a facility that stored up to 2.8 million gallons of flammable liquid.[9]

While working through the permitting process and contesting the lawsuit, RiverWright was also busy rehabilitating the first of the four elevators (and the city's second-largest), the Lake and Rail, which had been closed for only a few years. After its $1.5 million upgrade, the elevator received its first shipments of grain in over six years, with 1 million bushels of feed corn delivered by rail in October 2007. But by June 2008 RiverWright had sold the elevator for $2 million to White Box Commodities, a Minneapolis-based hedge fund that would operate it for nearly a decade before eventually selling it back to Smith.[10] By September 2008, under White Box's ownership, it received its first lake freighter delivery in over a decade with 400,000 bushels of wheat from the 690-foot *American Fortitude*, reportedly the largest boat to ever travel so far up the river. Coming on the heels of a fif-

ty-railcar delivery the previous week (each car containing 3,000 bushels), the *Fortitude*'s arrival and departure was a spectacle requiring two tugboats to safely navigate the sinuous river. And even as RiverWright no longer owned the Lake and Rail, Smith was thrilled to see the waterborne delivery. "This is the first time one of these old beauties has been brought back from the dead here in Buffalo," he told the *Buffalo News*. "She's come full circle." He also noted that White Box was a potential partner or supplier to RiverWright's planned plant, rather than a competitor, and insisted that the partnership was moving forward toward an anticipated 2010 opening.[11] But market forces worked against the project. The ethanol market had peaked in mid-2006, then dropped precipitously and never really recovered, awash in new facilities amid flat demand as the national recession made it hard to find investors and estimated development costs continued to increase.[12]

In 2011, with all its permits received and the lawsuit dismissed, RiverWright abandoned the project.[13] While disappointed, Smith was ready to pivot. His vision had always been multidimensional and perhaps conflicting. Even as he pursued the refinery, he had never entirely relinquished his vision of recreation, culture, and environmental engagement on the site. The proposed refinery was rooted in economic revitalization, and Smith said that he wanted to bring wealth back to Buffalo rather than merely jobs. He often argued that after the Erie Canal's completion in 1825, locally owned grain elevators were the city's ultimate wealth generator, as opposed to other large Buffalo-area industries such as steel and automobiles, which were owned by out-of-town corporations. (For decades, many of Buffalo's grain elevators were also owned by large national conglomerates with headquarters elsewhere, including General Foods, Archer Daniels Midland, and in the case of the Silo City elevators, Conagra.) Yet RiverWright, which was only going to create sixty-five full-time jobs, was also a project of cultural and urban revitalization, one that aimed to bring historic activities back to the river and some new ones as well.

At lunch I asked Smith about the ethanol plant, which he had given up only months earlier, and he replied, "It seemed like highest and best use, but it didn't work out that way." Focused on his new, not-fully-defined endeavor, he expressed relief that Silo City was less controversial. "And it's more fun!" he said, brushing off immediate concerns about return on investment. "Passion is truly the only currency," he declared. Perhaps from his early childhood in Cleveland and many years spent elsewhere, including Philadelphia, South Africa, and Denver, Smith speaks slower and more even-

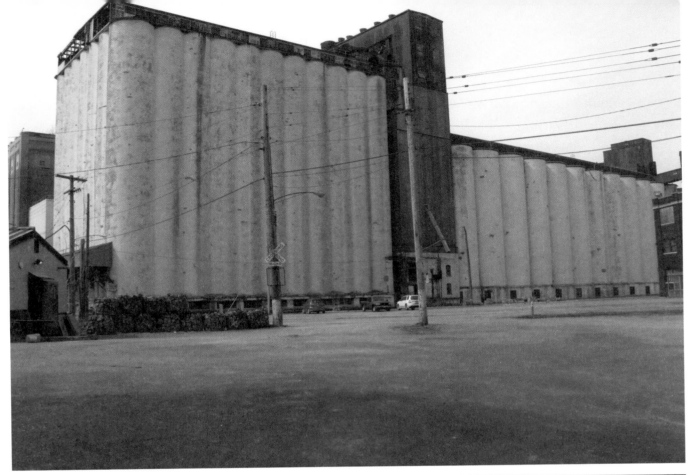

ABOVE The American Grain Elevator. The right section, completed in 1906, was the first grain elevator constructed using slip forms. The addition (left) was completed in 1931. (Author, 2012.)

RIGHT Below a bin inside of the American Grain Elevator. (Author, 2012.)

toned than many of his fellow Buffalonians who are involved in preservation projects. But he does share their enthusiasm and the sense that if people could visit these industrial-age icons, their lives would be more fulfilled. "There are some things you just *have to* see," he told me.

Without a business or master plan, Smith had set upon a very different course from the refinery development. He bought out his partners' share of the underlying properties and transferred them to two new entities—RiverSullivan LLC and SiloCity LLC—approximately twelve acres. A portion without any buildings or structures was also transferred to Rigidized Metals, corresponding to the part of the assemblage in which he was initially interested.[14] In early 2012 Smith was not sure of the project's direction—even the Silo City name was not considered firm—but he was willing to be patient and consider varied proposals. While he looks and sometimes acts the part of a cowboy, he said that he understood his role as an "interim caretaker" of monuments of international significance—ones to be preserved and passed down to future generations. It was an awesome responsibility. From the early moments of the RiverWright endeavor, he sought and built relationships with local preservationists and UB architecture faculty, including the ones who were hosting me at Silo City that day. They had been inventorying the elevators and preparing a National Historic Register (NHR) nomination for the American complex while also laying the groundwork for more comprehensive resource management, even as Smith continued to develop his refinery proposal. In return, he provided the professors and their students generous access to the site.[15]

After lunch, my UB colleagues and I returned to the elevators without Smith and explored the interior and upper floors of the American and Perot elevators. The American was constructed in two stages—in 1906 and 1931. The older structure, designed and built by the James Stewart Company of Chicago for the American Malting Company, was the world's first elevator constructed by continuously pouring concrete into "slip forms," which sat on jacks that were incrementally raised throughout the pour.[16] According to Traynor, who was then finishing the American's NHR application, the entire structure was likely completed in one very long pour that lasted several days. The American, unlike Marine A, still possessed most of its internal machinery, which made it the logical candidate for the National Register.[17] As with many of Buffalo's elevators, the simple and bold geometry of its exterior provides little hint of its functional complexity. Massive vertical and horizon-

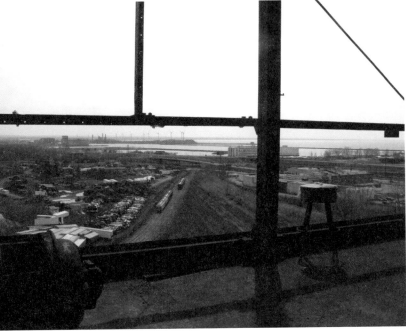

tal conveyor belts, moving arms, sifters, scales, and numerous other machines demonstrate, as Traynor often points out, that these structures were more factories than mere storage structures. Despite its catchiness, she took issue with the name "Silo City," insisting that it implies storage and obscures more active grain elevator functions. She preferred to call the individual concrete cylinders "bins," as they are referred to in technical documents.

In the interior of the river end of the American, Traynor led us up a spiral staircase, pointing out the craftsmanship of its wrought iron as it passed through corresponding circular cuts in each concrete floor. Up several flights, we passed offices that still had furniture and decades-old schedules and safety signs posted to the walls. We also passed the connecting bridge to the adjacent Perot Malting Elevator, which had no marine legs of its own and instead received its lake-delivered grain from the American via this duct. Reaching the top of the staircase, we found ourselves in the expansive "distribu-

TOP The view to the southeast from the top of the 1931 addition to the American Grain Elevator. Marine A is in the foreground right, and the Concrete Central is in the background left. (Author, 2012.)

BOTTOM A view of Lake Erie from the top of the 1931 addition to the American Grain Elevator. The Rigidized Metals complex can be seen lower right, behind the stool. (Author, 2012.)

tion floor" atop the individual bins. Climbing over machinery and ducts, we discovered long belts still covered with decades-old fermented grain and pools of powdery minerals and algae deposits where water must have collected. The belts were connected to a complicated system of installations, including chutes, pipes, conveyors, valves, and scales. Traynor reminded us to keep our eyes on the floor and never back up, as there were dozens of openings in the concrete under our feet—some to the bins below us—as well as hardware bolted to the floor. In fact, elevators were dangerous places to work. Crippling injuries and lost body parts were regular occurrences. There were also occasional on-the-job deaths, she said while showing us a rope that was used to rescue workers who fell into the bins, which, when filled, are like quicksand.

Across the headhouse of the 1906 structure to the 1931 addition, Traynor pointed out differences in their bin configurations and the corresponding ways they each received and distributed grain. At the floor's south end, we looked out over the open and unprotected view before us, over a hundred feet above the ground. Marine A stood in the foreground while farther east the Cargill Superior and Concrete Central elevators held prominent positions on the winding river. To the southwest, train tracks led to Smith's Rigidized Metals yard and, beyond, the wind turbines that now mark the former Bethlehem Steel plant in adjacent Lackawanna, and Lake Erie beyond that. It was a privileged and awe-inspiring view. But as some might reasonably argue, the unprotected vista we enjoyed would not be appropriate for more public functions and larger numbers of visitors. This was one of the many places where Silo City's raw, postindustrial conditions were in conflict with visitor safety and increasing access and programming.

Grain Elevator Preservation in a Deindustrializing City

Six months later I returned to Silo City for City of Night, a celebration staged by Buffalo's Emerging Leaders in the Arts. The days preceding the festival and that day brought large volumes of rain. While the grounds were muddy, the festival proceeded, and over three thousand Western New

Yorkers and others who had traveled from farther locales enjoyed art installations, live music, tours, discussions, historic displays, environmental programs, and performances inside and outside the elevators, including shadow dancing projected onto the exterior of Marine A.[18] During the event I mingled with several preservationists: students, young professionals and entrepreneurs. Many were members of Buffalo's Young Preservationists (BYP), a feisty offshoot of Preservation Buffalo Niagara that was contesting demolitions with tactics that included demonstrations, occupations, in-person lobbying of public officials, "heart bombings," and the posting of other physical and virtual media.[19]

I had met several BYPers the previous spring and witnessed their passion and smarts during a demonstration and public hearing aimed at saving the Trico Windshield Washer Factory. The windshield wiper is a Buffalo invention, and the orthogonal factory complex, which nearly fills out a large city block, might make a compelling residential or office conversion. But that mattered little to Trico's owner, the University at Buffalo Medical Center, which wanted to demolish the former factory to create space for parking and unspecified future development, even as it already possessed an expansive campus to the immediate east and north.[20]

The evening before the hearing, BYP held a Save Trico happy hour at Ulrich's, one of Buffalo's oldest bars, located at the north end of the factory's block. At the event, for which some twenty people showed, I received an in-the-moment invitation for a group dinner that followed at another nearby pub. En route to dinner, one of my new friends convinced me to walk with him while he placed Save Trico stickers on signs, lampposts, and parking meters. At his urging I applied a sticker onto the back of a meter. Unauthorized art and civic activism were coming together, and I felt a gentle thrill of guerrilla. (And upon returning that September, this friend and his girlfriend, a photographer, gave me a tour of the roadless and overgrown peninsula of the Concrete Central in her 1980s-vintage Toyota Land Cruiser.)

After stickering, we found our group on the pub's patio, enjoying the unusually warm weather that evening—more May than March—and joined their conversation about preservation, development, and entrepreneurial activities in the city. Listening, I began to see the grain elevators, Trico, and many smaller preservation projects as part of a multidimensional, connected landscape. For

these mostly young preservationists, historic industrial sites—both active and idle—fit seamlessly together with the old houses and neighborhoods where they lived and provided opportunities for material participation, even for those lacking in capital or skill. While few, if any, could operate at Rick Smith's scale, they shared his sense that these sites demanded personal investment—and a broader public commitment from the city.

The grain elevators are part of Buffalo's emerging narrative—one no longer defined by deindustrialization, population loss, snowstorms, and losing sports franchises—and hold a unique place in the city's collective psyche. Younger residents in particular view them as their heritage, to be cherished and shared, even as—as Smith often argues—an earlier generation saw them as symbols of failure. As Christina Lincoln, a founding member of BYP and former director of operations of Preservation Buffalo Niagara, explained to me,

> Young people don't see these industrial relics in the same way as someone who is 10 years older. We don't remember thousands of people who once worked there and lost their jobs. We don't have those feelings; it was too long ago. We don't remember the hardships; we don't equate [these sites] with plant closings like the people maybe a generation ahead of us. The guys who are fed up and say, "Let's burn this place down"—we don't think like that. Our generation sees it differently. But we can learn from those guys too. . . . It's hard to imagine what they see; we try to, but they've seen it bad for so long it's hard for them to think of it any other way.[21]

Lincoln, like Smith, was personally invested in the city's industrial fabric. She and her husband, Mark Paradowksi, had adopted the former Wildroot Hair Tonic Factory on Buffalo's East Side and regularly contributed to the maintenance of the vacant complex while fighting uncooperative owners and the city, preventing them from tearing it down.[22] Many younger and some older Buffalonians share Lincoln's concern for the city's industrial building stock, even if their level of commitment is not the same. They have expressed complicated perspectives about the grain elevators—a tripartite mix of admiration for their monumentality, beauty, and bold geometry—and their place in architectural history; an awareness of collective narratives of local industry and labor; and an ap-

preciation of the elevators' wild, dangerous, or ruinous qualities. Interpreters and admirers also appreciate the mingling of past and present narratives and personal and collective experiences incited by these structures. "There's a spirit there," said Dana Saylor, an artist and City of Night co-organizer. "There's the spirits of so many lives lived and it's incredibly textured. . . . What makes it unique is that it's this locus of activity within this history of grain transfer and transport that Buffalo *should* be famous for. It's largely an untold story."[23]

In addition to its underappreciated history, Silo City's wild qualities or otherness, and what some have called the "deindustrial sublime," have compelled many visitors, and not just those who are urban explorers.[24] In a departure from architectural tours and museum programming, during the 2010s Silo City retained a sense of being an untamed and visceral place, and its elevators were a palimpsest evocative of multiple past and present narratives. As a Silo City Vertical tour participant noted,

> At the top floor of the American building . . . I stood looking out over Lake Erie and the city of Buffalo reveling in the opportunity that each of us were getting on this tour, and wondered if any of the countless numbers of mill workers who spent countless hours collecting a paycheck in that very spot ever thought that people would be grateful for the chance to be standing there. . . . Each building's nooks and crannies had their own personality, and being able to marvel up close at each one was a really fantastic experience. I kinda felt like a kid exploring the woods behind the house I grew up in—it was all an adventure in history and discovering new spaces.[25]

Banham would have surely understood this visitor's perspective. His own visits to abandoned (and operating) Buffalo grain elevators in the late 1970s, chronicled in *A Concrete Atlantis*, titillated his senses and imagination. He admired the elevators' "almost Egyptian monumentality" and "ravaged antique grandeur," and noted that "in abandonment and death they evoke the majesties of a departed civilization." From the wharf of the Concrete Central, Buffalo's largest elevator (vacant since 1966; National Register of Historic Places, 2003), Banham reflected on the structure in front of him. Like the perspective of Rome taken in by early Christian pilgrims, he reasoned it was "a double vision of something that was in itself ancient and therefore to be revered but was also to

be respected for a new body of meanings laid over it by the beliefs of later peoples."[26] While not the palimpsestic sublime of Banham and subsequent explorers to the now-city-owned Concrete Central and Cargill Superior, what many have experienced at Silo City is the evocative power of twentieth-century industrial architecture, in a raw and immersive form.

Buffalo grain elevator history and architecture surely compels, as does the larger narrative of industrial and maritime development. But the Buffalo River corridor also possesses a preindustrial history. The Seneca once inhabited the corridor, fished the river, and hunted, trapped, and farmed along its banks. Forced to surrender their ancestral lands around the Finger Lakes in the late eighteenth century, many migrated farther west and established settlements within present-day city boundaries until they were again pushed out, forced to sell off their Buffalo Creek Reservation lands beginning around 1838. Watkins said that not long after he had started living on site, a Native American friend paid him an unsolicited visit. Upon arrival the visitor declared, "This land is sacred," and later returned with an eagle feather and other talismans to protect him.

Smith and Watkins often talk about an ancient Seneca/Iroquois Federation trail that ran along the river, part of a larger trail network that terminated where the river met Lake Erie. They speculate that the trail cut through Silo City following a path that was later paved with Delaware, Lackawanna, and Western railroad track. With their reservation now gone for almost two centuries and their history and culture largely invisible to many Americans, including those of Western New York, the Seneca today operate the Buffalo Creek Casino a mile downriver from Silo City. Smith said he hoped to reestablish the trail, which could potentially complement or connect to the Riverline, a planned 1.5-mile rails-to-trails conversion of the disused right-of-way following the river's (opposite) north bank to the historic DL & W terminal, south of downtown.[27] The Riverline corridor, which has varied renaturalized terrain, runs along the edge of Red Jacket Park, named after the Iroquois leader and orator who signed the Treaty of Canandaigua, which sadly ceded Iroquois lands west of the Genesee River to the Americans after the Revolutionary War (the Seneca had sided with the British). Red Jacket lived out his later years in Buffalo until 1830, and is buried in the city's Forest Lawn Cemetery.

Buffalo's growing appetite for grain elevator preservation also dovetails with several traditional preservation initiatives and partnerships that have directed hundreds of millions of dollars in pub-

lic money toward the restorations or adaptations of Frank Lloyd Wright's Darwin Martin House, Louis Sullivan's Guarantee Building, H. H. Richardson's former Buffalo State Hospital (aka the Richardson), and many other historic structures, as well as the partial reconstruction of the city's Erie Canal Harbor, which was filled in over a century earlier. These investments and the subsequent activity they have generated are part of Buffalo's revival narrative.[28] Yet even as restored architectural wonders have become a raison d'être, Buffalo's leaders have never fully embraced industrial heritage and structures like the grain elevators that seem to define the city. Industrial icons have often been lost to the wrecking ball because of potential public health and safety hazards, weak market demand, ineligibility for public incentives, and sometimes simply because state or federal money was available for demolition.

Public indifference, acquiescence, and complicity in the neglect or demolition of Buffalo's historic building stock indeed motivate the city's preservationists, and have for some time. Like New York City's preservation community, which grew out of the outrage over the demolition of Penn Station in the mid-1960s, Buffalo's has evolved in part from a loss of arguably similar magnitude (though not scale). In 1950 the Larkin Soap Company demolished Frank Lloyd Wright's Administration Building (completed in 1906). One of Wright's few corporate works, the building is recognized as a formative structure in the development of modern commercial architecture, one that has no peers.[29] There is a certain shame felt by some Buffalonians, even those born well after 1950, that their city was complicit in the destruction of a building of undisputed international significance, which, had it survived, would be celebrated today as an "only in Buffalo" jewel and stand among its other celebrated masterworks (some Buffalo preservationists insist that the building can be rebuilt and that the original materials could be dug out of a nearby landfill). The shame still lingers over seventy years later, and the building's site is still vacant. Yet the city's urban renewal initiatives that followed during the 1950s–1970s were in many respects worse and more extensive. They swept away hundreds of commercial, industrial, and residential buildings in and around downtown, and replaced them with vacuous office and government complexes, parking facilities, and lower-density housing, as well as the Buffalo Convention Center, constructed across Genesee Street's radial path, one block from city hall.[30] For some Buffalonians the enduring sting of these losses provides additional motivation

to fight for the preservation of historic structures like the grain elevators, even if they are not valued by the market, their owners, or city leaders.

Buffalo's substantial inventory of concrete grain elevators is an artifact of the first half of the twentieth century, when the city was the world's largest grain port and milling center. But elevator endurance has been tenuous, as much a product of decades of benign neglect and accident as preservation activism—and a testament to the strength and resiliency of their reinforced-concrete construction. With the completion of the St. Lawrence Seaway in 1959, which allowed grain-laden lake freighters from the Upper Midwest and Canada to bypass the city, as well as postwar national migration and demographic shifts, Buffalo's grain industry precipitously declined from the 1960s through the 1980s. At one time, Buffalo had as many as fifty elevators in use, and even as late as 1965, there were still twenty-seven in operation. But by 1984 the number of operating elevators had dropped to four.[31] When White Box shut down the Lake and Rail in 2017, the number of active elevators in the city fell to two. One of these elevators feeds General Mills' cereal plant three-quarters of a mile downriver, which still produces some of the corporation's most iconic brands, including Cheerios, Lucky Charms, and Cocoa Puffs, the sweet aromas of which often perfume the banks of the river and the nearby Buffalo Skyway.

Since at least Banham's residence at UB during the late 1970s and his research that established the link between grain elevators and architectural modernity, these structures have had their local champions. Yet elevator preservation has never received the political or financial support lavished on other local architectural masterworks. Sites like Wright's Martin House and Sullivan's Guarantee Building represent essential examples of quintessentially American building types: the modern, freestanding single-family home and the steel-framed office skyscraper, respectively. These buildings are rightly sources of regional pride and are promoted as tourist sites by local leaders and media.[32] While lacking the architectural pedigree of structures designed by Wright and Sullivan—which, along with Richardson, form what advocates in the region call "the Big Three"—the city's grain elevators are also significant examples of a distinctly American typology. As Banham argued, grain elevators "represent the triumph of what is American in American building art" and "one of the earliest and most powerful influences of American building art on the rest of the world."[33]

While the elevators—which Le Corbusier called "the magnificent first-fruits of the new age" and other interpreters compared to pyramids and cathedrals—remain internationally iconic, until recently the cause of their preservation garnered little political support; some Buffalonians could not understand why structures that had outlived their intended purpose should be preserved.[34] Grain elevators are difficult to repurpose, but also expensive to demolish. So many endured for decades, even as some were progressively undermined by weather, vandalism, and scrapping. The cash-strapped city, in an economic and demographic freefall during the last third of the twentieth century, had more pressing concerns than reviving vacant properties along the dirty Buffalo River. Yet a dearth of resources did not stop several elected officials and their appointees from scheming to demolish the elevators. "We're trying to find the quickest, least expensive way to take most of them down," US representative Henry J. Nowak, a Buffalo Democrat, told the *New York Times* in 1984. In the early 1980s the city had in fact found the resources to demolish two grain elevators and was looking for more. Patrick M. Marren, Buffalo's director of economic development at the time, told the *Times* that if the city could obtain more funding, he would bring down most of the others. "It's important to hold on to symbols of the past, but how many symbols do you need?" Marren asked. "The waterfront has to be put to the best, highest use," he argued, while noting that the elevators were also safety hazards.[35] In the 1990s the *Buffalo News* similarly dismissed a proposal developed by the industrial heritage advocates to create a park around the city-owned Concrete Central, which it said would dim the prospect of new riverfront development. It argued that "any public money directed toward Concrete Central should go for its demolition."[36]

As these perspectives demonstrate, the demolition of Buffalo's grain elevators has long loomed. In 2005 the H-O Oats Elevator, a steel-binned structure built in 1912, was demolished along with its adjacent 1928 daylight factory to make space for the Seneca Nation casino. And days after a 2006 fire that severely damaged the 1912 Wollenberg Grain and Seed Elevator, the city's last wood elevator (National Register of Historic Places, 2003), the city of Buffalo demolished it.[37]

By the 2020s it seemed as if Buffalo's grain elevators had reached a moment of broadly recognized appreciation, in part driven by the success and renown generated by Silo City. Local priorities and policies had evolved; demolitions were seemingly a thing of the past. Yet after a December 2021

windstorm blew a hole through a part of the Great Northern elevator, the world's largest at the time of its completion in 1897, its owner, the agriculture giant Archer Daniels Midland (ADM), applied for and was granted an emergency demolition order by the city. As outraged preservationists and the *Buffalo News* noted, the damaged section could easily be repaired and, by most accounts, did not threaten ADM operations or endanger its workers. ADM had in fact long schemed to demolish the Great Northern (National Register of Historic Places, 2003), the last brick-enclosed steel-binned elevator in North America, and, according to preservationists, had employed a strategy of purposeful neglect.[38] Frank Kowsky, SUNY Buffalo State emeritus professor of art history, compared the elevator's looming erasure to that of the Larkin Administration Building, while other preservationists I have talked to have invoked the corresponding sense of shame and the city's dereliction of public duty. Led by the Campaign for Greater Buffalo with vociferous support of local media, advocates were able to delay demolition through the court action for about nine months. Even as Mayor Byron Brown initially spoke out against clearance, ultimately the city of Buffalo opted not to contest ADM's proposed action. After a judge denied the campaign's motion in mid-September 2022, the corporation immediately resumed demolition.[39]

Grain Elevator Preservation: A Regional Strategy?

Long before ADM began taking down the Great Northern, Buffalo preservationists had recognized threats to the grain elevators and have been proactive in identifying and promoting new uses, stewards, and funding sources to ensure that they remain landmarks of the region. In 2001 the UB Urban Design Project and the Landmarks Society of the Niagara Frontier created the Grain Elevator Project. The partnership's aim was to facilitate National Register nominations and renew a public conversation about the elevators' place within the economy, culture, and landscape of Western New York. Managed and directed in part by Lynda Schneekloth, who provided me with my Silo City entrée, the project made use of grants from the National Endowment for the Arts and the New

York State Council for the Arts. It included tours and an international symposium, culminating with the publication of *Reconsidering a Concrete Atlantis* in 2006, which Schneekloth edited. The volume includes thoughtful histories, reflections, and adaptation ideas and offers an overarching proposal to create a forty-mile-long, binational landscape park that hugs both the US and Canadian sides of the Niagara River.[40] Incorporating both natural and built sites, including the elevators and Niagara Falls, the park would be a "powerful place of municipalities, heritage trails, urban and state parks, suburban and rural landscapes, a biosphere preserve, an Important Bird Area, industrial, education and medical campuses, and cultural and tourism destinations."[41]

The Grain Elevator Project took inspiration from Emscherpark in Germany's Ruhr Valley. With the 1989 designation of IBA (Internationale Bauausstellung or "International Building Exhibition"), Emscher helped change the paradigm for the administration of industrial heritage resources and, as previously noted, has become a kind of gold standard of industrial adaptation. Emscher includes several hard-to-preserve but culturally compelling complexes, including the former Thyssen Steelworks, the former Zeche Zollverein coal mine and conversion complex, and other industrial works and nature sites spread over 115 square miles and several cities. Rather than clearance, comprehensive environmental remediation, or demolition by neglect, Emscher retains the buildings, infrastructure, and internal workings of these sites and employs a variety of mostly landscape-based reuse programs with only modest architectural interventions and a conservation strategy focused on stabilization rather than adaptation.[42]

Several individual Emscher sites, including the Peter Latz–designed Duisburg Nord Landschaftspark (former Thyssen Steel) and an exhibition hall inside an idled gasometer in Oberhausen, have become significant tourist destinations and serve as regional culture and recreation hubs. Yet Emscher, a 4-billion-euro project, was created with public funding commensurate with the German commitment to heritage preservation, with government investments accounting for approximately two-thirds (2.67 billion euros) of development costs.[43] There is a weaker tradition of industrial heritage in the United States, where the bulk of federal preservation resources has long been channeled into natural wonders of the National Park Service (NPS) and the expectation that most landmark structures (of all types and uses) will be owned and administered by the private sector. The cost of a park featuring just Silo City's elevators and others of Elevator Alley would likely be prohibitive.

And unlike similarly conceived parks such as Brooklyn Bridge Park, the High Line, Freshkills Park (a former landfill), and the Hills on Governors Island in New York City, and the adaptation of the Presidio (a former military base) in San Francisco, Buffalo has neither the municipal resources nor the donor base to build and administer such endeavors.

There would be additional challenges in developing a landscape urbanism park around Buffalo's grain elevators. Sites like Silo City are part of a patchwork landscape of multiple functions, owners, and users and include active grain transfer operations.[44] Restorative practices, however they are defined and deployed, must creatively respond to this multiplicity of conditions, contexts, and conflicts in a way that defies the model of the large, inactive, postindustrial site under single ownership exemplified by the Emscher parks and American precedents such as the High Line and Freshkills.[45] Since at least 2005, Buffalo city plans have acknowledged the grain elevators' potential for heritage tourism but offered no comprehensive plan or capital for developing this complex landscape.[46] Absent a national heritage park initiative and the public funding it would require, the work has been left to entrepreneurial actors like Smith, who navigate this patchwork and cobble together resources and expertise to keep the elevators standing. In 2017 a local architect proposed and promoted a more modest version of the grain elevator national park. Modeled after the national heritage park built around the textile mills of Lowell, Massachusetts, it would incorporate those of Silo City as well as the city-owned Concrete Central and Cargill Superior.[47] Smith expressed a willingness to consider the idea but ultimately moved in another direction.

A Venue for Local Arts, Culture, and Ecological Restoration

Rather than waiting for government investment to catalyze the heritage park or for an infusion of investor funding, Smith aggressively pursued arts and cultural programming at Silo City. Providing robust public access through events and programs, during the 2010s he made only limited improvements,

mostly aimed at keeping structures standing and the grounds safe and functional. Moreover, rather than figuring it all out in advance and implementing a design according to plan, Smith understood grain elevator stewardship as an uncertain and long-term endeavor—better to share the burden and engage in trial-and-error microdevelopment by enabling creative, civic-minded, and entrepreneurial protagonists to propose and administer programs. Let arts and cultural programming create value, and leverage that value as more people discover and enjoy the site. Capitalize on resources and opportunities as they present themselves, and pursue them without too much deliberation when the stars are aligned—or move on quickly when they aren't—even as the comprehensive conservation actions that will keep the grain elevators standing for generations may lie off in the distant future.

Throughout the 2010s, events, celebrations, and performances like Silo City Taps, Boom Day, and City of Night defined Silo City's use. But Smith's vision was always broader and more flexible, with a large tolerance for risk. As Watkins noted in 2014, "It's an experiment because we really don't have any idea where this is going to go. It's controlled chaos."[48] When I interviewed Smith in 2012, before the onset of Silo City's first full festival season, he described a vision that was equal parts imagination and pragmatism, science and arts—a campus where industry and academics could test building materials in real space and time rather than in a lab or through computer simulation. He also envisioned urban farms, agricultural education programs, and recreational and cultural activities like those in the German landscape parks. Even though RiverWright was dead, he thought it might still be possible to store sand or building materials in the elevators, even as creative and cultural programming occurred around them.[49] Over several years, this vision evolved as opportunities arose or constraints receded; modest partnerships were proposed, with some succeeding or others failing or failing to materialize, until a formal development partnership emerged in 2019. But initially, cultural events evolved more quickly than uses requiring more intensive adaptations or everyday recreational uses. "We don't have any predetermined definition of what things should be," Watkins explained to me in 2014.[50] "Right now the highest and best use for the Perot mezzanine is for wedding pictures. Who knew?" added Smith. "Who could have thought of that?" About the long-term reuse of the property, Smith noted, "What should this be? We don't know yet. It's a hard task. . . . It's going to take my grandchildren to get Silo City right."[51]

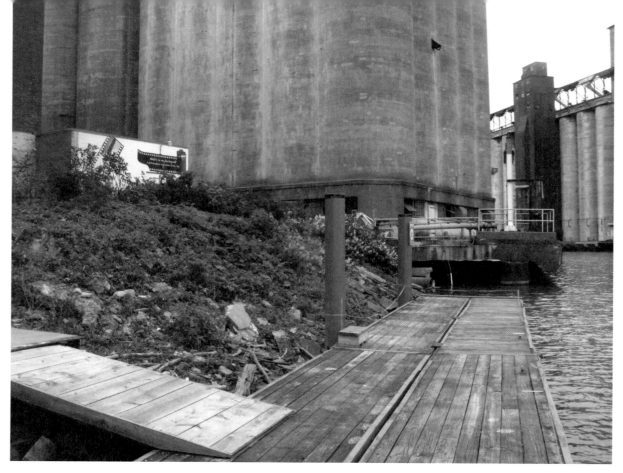

A floating boat dock, one of several inexpensive improvements realized through partnerships at Silo City. (Author, 2014.)

Most of Silo City's early programs were temporary, like the Riverscape Lighting Project in 2011, which involved the dramatic illumination of the city's "second skyline." Smith had hoped there could be a permanent version, but it didn't materialize—and since 2015 the Erie Canal Harbor Development Corporation has lit the Connecting Terminal Elevator on the city's Outer Harbor.[52] Other improvements have complemented the Buffalo River Restoration Partnership's initiatives to make the river an outdoor recreation destination, including the construction of two new docks and a small beach for launching canoes and kayaks.[53] Some of Silo City's program was driven by accident and whimsy. A beehive lodged in a boarded-up window frame of the American Office Building had become a curiosity of the UB architecture students and professors who were using the building for occasional studio space in 2011. Prior to the building's anticipated renovation, Smith decided to relocate rather than exterminate the hive. In 2012

he staged a twenty-four-hour competition to design a new home for the bees in which ten teams participated. The winning design, *Elevator B*, a twenty-foot-tall sculptural piece consisting of perforated, hexagonal rigidized metal panels, was fabricated at Rigidized Metals and installed near the building, and the colony was successfully transferred.[54] Silo City has similarly hosted several other design-build studios, competitions, and constructive events that mix art, architecture, and material technologies.[55]

Modest landscape restoration projects and insertions were pursued over the 2010s, and some can still be found across the site. Some were achieved through educational and civic partnerships involving dozens of visits from local school groups. Through an environmental justice program sponsored by the US Fish and Wildlife Service and the Great Lakes Experience in 2014, students from Buffalo's Tapestry Charter Middle School teamed up with seniors from McKinley High School to build a half-acre garden of native species and recycled artifacts and a rustic walking path to the new dock behind the Perot Elevator.[56] The following spring, Girl Scouts collaborated with fifth-graders from the Village Charter School to install a twelve-hundred-plant pollinator garden of native species designed to attract monarch butterflies. The project was administered by PUSH Buffalo, a local housing and community development nonprofit, with funding from the Erie Canal Harbor Development Corporation. Watkins also described more modest endeavors, including a math teacher who regularly brought his geometry classes to work on assignments that measure the dimensions of the elevators and calculate their bin volumes.

Burnishing Buffalo's Avant-Garde

Throughout the 2010s Smith and Watkins took a fluid approach to public programming, enabling diverse agents to propose and carry out unusual, experimental, or popular happenings. Accordingly, they considered their roles as stewards to make Silo City available for Buffalo's creative, entrepreneurial, and civic communities—what Smith often called "authentic regeneration." As Watkins explained, "There is a huge number of extremely talented people in this area, so if they come down and say we want to do this or do that, we say, 'Sure, go ahead and try it.' That's the organic part of it.

Valery Lyman's installation of projected images and sound, Breaking Ground, inside the Perot Malting Elevator. (Valery Lyman, 2018.)

Those who *get it* fall in love with the site, and that improves the value of their work too."[57]

During my visits, Watkins and I would sit outside the Swannie Shack (or inside if the weather did not permit) with his dog, Champ (in later years, Gonzo), and take in the often quiet splendor of the elevators and the river that courses around them. We would talk, and Watkins would recite the inventory of programs over the past year and note those upcoming: the Western New York Blues Festival, which drew thirty-three hundred people in 2014; Queens City Jazz Fest; the Silo Sessions, in-elevator musical performances taped and later webcast; literary readings; three-day photography workshops; instructional art and film courses; media shoots; horticultural initiatives; and a composting program. The Squeaky Wheel, a film and digital media nonprofit, projected movies against the elevators; the site-specific productions of two local theater groups included a staged reading of Ibsen's *The Master Builder*, with the play's three acts occurring at locations inside Perot and out on its dock. A call to compose an original composition for Silo City received sixty-five entries from sixteen countries. In 2015 Silo City hosted a paddle-bike-run mini-triathlon. The race, which attracted some 250 participants, launched from the Perot dock with a kayak course on the river and culmi-

Poet Hanif Abdurraqib reads inside of Marine A. (Nancy J. Parisi, courtesy of Noah Falck / Silo City Reading Series, 2018.)

nated with a 3.5-mile scramble that sent participants through elevator interiors and bushwhacking through the site's postindustrial wilds. Silo City Vertical and Silo City Grounded tours had brought twelve thousand people to the site in 2015, according to Watkins, double the number in 2014.

Watkins frequently talked about the Silo City Reading Series, which has attracted internationally recognized poets and served as an incubator for local literary talent. By 2015 Silo City had become "one of the top three venues for the spoken word in the country," he told me, reciting a rating he read somewhere.[58] When I spoke to reading series organizer Noah Falck in 2020, who is also a poet and the education director for the Just Buffalo Literary Center, he described the organic growth of the endeavor. It started without larger aspiration, inside Perot, where he had organized a friend's book release party. It was a hit, he said, and described attendee reaction as, "This is just the coolest place in Buffalo." Without fuss or great expectation, Smith and Watkins "have always allowed us to bring poets here and mess around," he explained with a laugh. Falck also valued the warm atmosphere of the Swannie Shack, where long conversations with Watkins (and sometimes Smith or others) over a beer, by the fire, and or while watching a Bills game could become the seeds of new pro-

Torn Space Theater creative directors Melissa Meola and Dan Shanahan with Rick Smith, in 2015. (Courtesy of Torn Space Theater Company.)

grams or lead to collaborations. The reading series evolved in parallel with the Silo Sessions, curated by Kevin Cain, who started the in-elevator music series, where a range of musicians have explored the unique acoustics, including the eight-second reverb of Marine A and Perot. While Falck and Cain were both expats from Dayton, Ohio, Cain knew the Buffalo scene better and had "a pulse on the underground music and arts," Falck explained. Their dialogue and sharing of resources helped propel the reading series, he said.[59]

Using Silo City's grain elevators as a venue, medium, or subject for art can be viewed as a twenty-first-century addition to a larger canon of interpretative works that began soon after the construction of Buffalo's first concrete elevators. These works include Mendelsohn's photographs published in *Amerika* (1926), the 1920s paintings of Charles Demuth, Ralston Crawford's photographs and paintings in the 1930s and 1940s, the photographs of Bernd and Hilla Becher beginning in the 1960s, Banham's 1970s–1980s criticism, and several volumes of photography and written reflection.[60] With its loose administration and availability for arts experiments, Silo City has burnished Buffalo's role as a "recurring incubator for the avant-garde."[61] "We reach out to the community so that they know that this is a place where they can come to do experiments," Watkins explained.[62] Dana Saylor, the City of Night co-organizer, credited Smith and Watkins with giving her group free reign. They told her, "Propose any idea, and we'll help you make it a reality—including all the crazy stuff you can throw at us," she recalled about the first City of Night.[63] Of course, the event's success and growth in attendance over three iterations made it more challenging to administer on site; by 2017 it was moved to the streets of the Old First Ward.

While the striking formal or spatial qualities admired by the European Modernists have provid-

The cast and crew of Torn Space's 2015 production They Kill Things, inside the Perot Malting Elevator. (Courtesy of Torn Space Theater Company.)

ed the setting for a variety of visual and performing arts, many contemporary works have explored subjects around local and sometimes nonlocal industrial legacy. In 2018 documentarian Valery Lyman staged *Breaking Ground*, a projected image and sound installation inside of Perot—the culmination of years of documentation of the oil extraction infrastructure and culture in the Bakken region of North Dakota. Juxtaposed against the remnants of a previous industrial boom and bust, it captured contemporary scenes of hard labor, raucous living, personal sacrifice, loneliness, optimism, and risk—and the implied inevitability of bust when "the caravan of dreams moves onto another time and place."[64]

Broadly defined cultural and environmental concerns and their evocative staging at Silo City have also defined the yearly productions of the Torn Space Theater Company. Dan Shanahan, Torn Space's cofounder and artistic director, initially found inspiration in the elevators' cathedral-like scale and called them an "American version of the pyramids." And as he explained to *Artvoice*, "The acoustics are fantastic, like nothing you have ever heard." Torn Space's first Silo City event—part of *American Grain*, created and produced by local historian and entrepreneur Mark Goldman in

2012—exploited these properties. Working with an architect and UB music composers, the company designed the performance component, which guided the audience through a progression of multimedia theatrical experiences inside Marine A, with each silo containing a different performance. After *American Grain*, Torn Space has staged yearly original productions on site, each exploring a different elevator or part of the campus.

Shanahan argued that their productions, which have drawn as many as six hundred people, were "public rituals" built around broad societal themes rather than theater, carried out in part by nonprofessional performers and audience members.[65] In 2012 he noted that the elevators "connect us to our utilitarian history . . . [and] are entirely functional, but they are also very beautiful, and a reminder of a time when America took on large-scale, ambitious projects."[66] Torn Space cofounder Melissa Meola, who is Shanahan's creative partner and wife, noted the elevators' contradictory mix of ubiquity and monumentality. "People have a connection to the grain elevators. They've driven by them their whole lives," she told *Chance Magazine*.[67] Torn Space's productions could be considered a metaphor not just for Silo City but all the case studies in this book: rediscover what is hidden in plain sight, make the most of imperfect conditions, and do environmentally immersive, participatory productions that exploit unique material culture.

Capital Improvements and Building a Development Vision

Silo City arts protagonists have created sets, stages, and installations mostly with what they have found or discovered. They have hauled in all the equipment and materials required for their productions—lights, speakers and sound gear, musical instruments, portable generators, food and water, porta-potties—and things like bleachers (for Torn Space's 2013 production *Motion Picture*). Rentals for film and video shoots, weddings, and other events, have required similar equipment. By 2016 Silo City was averaging about ten tours and one to two special events a week in season.[68] The increase in programs and visitors forced Smith to consider more substantial investments: plumbing

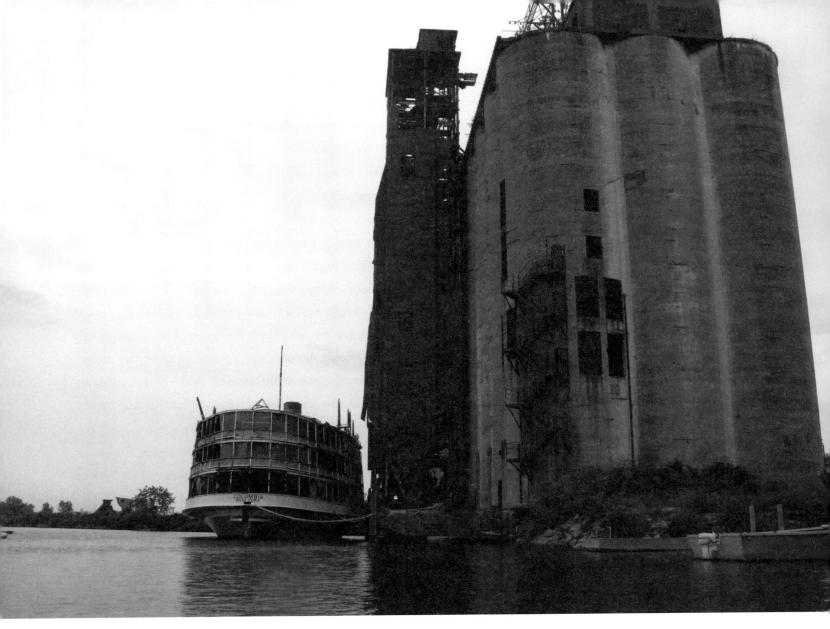

The Columbia, a 1902 excursion steamship, has become an unintended fixture on the Buffalo River. (Author, 2018.)

and bathrooms, electricity, heated interior spaces, and food and beverage concessions, all of which he realized incrementally over the next two years. These improvements also made unavoidable confronting larger questions about Silo City's future. What uses should the site contain, and how shall they be administered? How can they further historic and contemporary discourses and increase public access and enjoyment while sustaining the site?

Smith had obviously been considering these questions since purchasing the properties in 2006. Yet through the early years of Silo City, his development vision remained fluid, even as he entertained larger or more permanent improvements. "You don't have to spend millions to make things happen," he told me in 2014, noting his goal of completing a few modest projects a year.[69] While eschewing the big master plan, he claimed full commitment to long-term conservation and stewardship, even if his initial approach was more incremental and improvements did not immediately arrest structural pathologies. With Smith's development partnership that will result in the mixed-use adaptation of the American and Perot complexes, this approach has changed. Yet through 2019, most capital improvements of those realized were modest and created a foundation for later investments and structural conservation measures.

Like the stage constructed in front of Perot in 2014 (described in this book's introduction), most of these improvements were thrifty affairs making use of found materials and limited use of outside contractors, often pursued in connection with creative or educational partnerships. External partners have often agreed to build and pay for or share the costs of infrastructure that enabled their programs while creating enduring benefits. When Buffalo River Cruises wanted to bring visitors to Silo City, it helped pay for the sixty-foot floating dock that now sits behind the Perot Malt House. In 2016, partnering with the US Fish and Wildlife Service, a community group built a boat launch and beach. Not every partnership has succeeded, and one-off or temporary ventures like the Riverscape Lighting Project have often failed to blossom into permanent programs. In 2014 Smith had hoped to make the site a hub for carriage rides and horseback excursions with the Perot Malt House serving as a stable. Yet the permitting was complicated (Watkins mused it was likely the first application for a stable the city had received in a century), and the initiative was never realized. And in 2012 Smith submitted a three-hundred-thousand-dollar funding application to the Niagara River

Greenway Commission for the construction of a boat dock, electric service upgrades for Perot and Marine A, and a waterline extension that was ultimately rejected.[70] Yet he found other ways to fund and complete these improvements.

Smith's talent for creative—if not always fully successful—dealmaking has often taken Silo City in unanticipated directions. One such endeavor is the S.S. Columbia Project, a 1902 steamship restoration. Though the 207-foot, three-thousand-person-capacity *Columbia* is the largest floating vessel docked on the Buffalo River, from most of the Silo City peninsula it is cloaked by Marine A. The oldest remaining steam excursion ship in the United States (National Register of Historic Places, 1979; National Historic Landmark, 1991), the *Columbia* is indeed a surprising presence on the river. In his deal with the nonprofit Columbia Project, Smith agreed to provide docking space for repair and storage in exchange for splitting the construction cost of a new two-hundred-foot dock and opening the ship for public programs. The pile-driven dock along the Marine A wharf was completed in advance of the *Columbia*'s 2015 arrival via tow from a dry dock in Toledo, Ohio, where it had undergone its initial repairs after being found tied to a Detroit pier and deteriorating since its last cruise in 1991. The *Columbia* was to be in residence for two to three years in Buffalo, where it would undergo interior restoration before ultimately being brought to New York City for day excursions up the Hudson River. In New York waters, the project could qualify for state grants and be closer to its eventual home and potential donors. While restoration began soon after its arrival, funding has slowed the project.

Yet with the *Columbia* in place, Silo City's partners incorporated the boat into their programs and tours. Torn Space exploited the ship's ballroom and the new dock for its 2016 production *Burden*. According to Watkins, *Columbia*'s docking location behind Marine A, which required Army Corps of Engineers' approval, needed to be clear of the shipping channel and was one of the only places on the river to park a boat that large. But that location drove modest investment on land and refocused attention on Marine A, particularly the interior space where people would access the boat. It forced Smith to address persistent flooding and construct a set of stairs to bring people to dock level. Having people pass through the elevator invited further consideration: Perhaps this space could be a place where artifacts and memorabilia are displayed, either about the elevators or the boats.

Watkins and Smith both noted that the *Columbia*, which for most of its life made the run delivering Detroiters to an island amusement park, was much like Buffalo's *Canadiana* (demolished in 1990), another steamship of the era that made the corresponding journey from Buffalo to the amusement park at Crystal Beach. The *Columbia* could provide a sense of these excursions and foster appreciation for Buffalo's history as a lake port. As of 2023 the *Columbia* was still there, some eight years after landing, and has become an unintended fixture on the river.

Smith's program of larger interventions has evolved since the mid-2010s, but getting there has been far from a straight line. Long before the *Columbia* appeared, Smith had been planning a series of improvements for Marine A. In 2014 he made a compelling case for adapting this long-vacant elevator for new uses, including a climbing gym, a yoga studio, event and meeting space, and potentially a restaurant. Unlike the American, where Smith had left its interior machinery intact and facilitated its National Register listing, Marine A's internal workings were stripped long ago. Without this landmark recognition, Smith had a freer hand to reimagine the elevator and execute interventions like windows and the extension of water and utility lines. But these plans faded when respective partner-operators failed to obtain funding, and by 2015 Smith had shifted his attention to renovating the American Office Building, which sat across the street from its corresponding elevator and was a potential gateway for the campus.[71]

Smith had long wanted to have a concession that could double as a weatherized gathering spot for tours, and that might also contain space for meetings, retreats, exhibitions, performances, and most importantly, bathrooms. Constructed in 1934 as offices for an elevator complex that originally produced malted barley for beer brewing, the two-story, fifty-five-hundred-square-foot building was an ideal place for hospitality functions. "It's taken a long time to figure out where the heart of the site wants to be," Smith explained in 2015. "For a while it was Perot, and for a while it was Marine A; now it's the American Office Building."[72] Even as it took the failure of other projects before Smith gave this building his full attention, he must have been thinking about it since Silo City was incorporated in 2011. While the grain elevator parcels were transferred to RiverSullivan, the office building alone was transferred to Silo City LLC—the only property under that corporation—to facilitate a partnership and new uses without the encumbrance of the site's other properties.

During my October 2015 visit, Smith gave me a tour of the renovation in progress. Buffalo is prone to being cold and blustery, but the river corridor and its elevators seem to generate extra and unpredictable gusts. The sun was fading, and it was nice to be inside, even if it was in an unheated space. The electricity and plumbing had been installed, and on the first floor, carpenters were working on fixtures and drywall, making use of recycled materials from on-site structures as well as new lumber. On the second floor, Smith showed off the building's impressive views through the new windows, including the one installed in the opening previously inhabited by the bees. Looking at the elevators through the glass, I imagined that this was where the elevator workers waited out the Blizzard of 1977. With nearly the entire region impassable and the beleaguered city unable to get plows to Childs Street, the peninsula's only road, the marooned men apparently survived a week on pancakes (there was plenty of flour on hand) and passed the time playing cards. The nearby Electric Annex, an elevator not owned by Smith but one that everyone must pass upon entry to the Silo City campus, seemed closer and larger through the window than it did from outside. The original steel-binned Electric Elevator, which sat between the Annex and the American's flour mill, might have also been visible but was demolished in the 1980s. An abandoned red caboose, which Smith had purchased for one dollar a few years back and was parked on tracks adjacent to the office building, also seemed to benefit from this framed view. In addition to event space, Smith said he hoped the upper floor would contain a small library related to the elevators and local history and ecology. Watkins imagined participants returning from a tour of the elevators and enjoying a beer in the bar overlooking them.

Smith was developing the building with partner-friends Jerry Shelton and Andrew Minier and had named the venture "Duende"—a Spanish word taken from an essay by Federico Garcia Lorca, the early-twentieth-century Spanish poet and playwright, without direct translation to English but meaning something like "becoming" or the feeling one gets when immersed in the experience or creation of art. With most building systems in place and the exterior renovated, Smith hoped to open Duende by summer 2016, but the city denied Duende a sewage permit. This forced Smith to commission an engineering study that demonstrated the establishment would not unduly impact Buffalo's sewer system. After the study's submission and back-and-forth with the city, Duende opened two years later, in June 2018. But the delay did have a silver lining.

On a hot Sunday in July 2018 I visited Duende amid a World Cup soccer party. I made my way through the mostly young crowd that had gathered around the bar and adjacent television screen to order a beer. Like many of its fixtures, the bar was crafted from materials salvaged from the American Warehouse and Flour Mill across the street and other campus buildings. Its surface was made of well-worn wood flooring and burnished metal beams while its sides were wrapped in corrugated metal, probably from a railroad shed. Nearby tables were crafted from old flour sifters. Not everything was old: new HVAC ducts, sprinklers, and electric lines snaked across a simple, new ceiling. Exiting Duende through a side door into a new clearing that wraps around two sides of the building, young families were engaged in children's activities. I walked to the brick equipment shed, a former five-car garage that also had been renovated and equipped with sliding wood doors on two sides. The inside was packed with a lively crowd watching the match while Smith was behind the shed's little bar, trying to keep up with orders. In the grass behind the shed, kids and their parents were kicking soccer balls around. This clearing was framed in part by the lush pollinator garden planted by school groups over the previous few years and the tall grasses that have taken root on their own accord. A gravel path led some distance away to Elevator Bee, the competition-winning hive structure built for the bees that had been relocated from a Duende building window frame six years earlier.

Duende and its grounds were emblematic of a development approach that capitalizes upon unexpected circumstance both good and bad, with work often done by the principals themselves or close associates, using found or discarded materials. On a trip to Silo City that fall, Watkins argued that the sewer issue created an opportunity to consider the former garage, for which there had been no previous plan and might have been forgotten or demolished if Smith had received the permit without delay. In 2020 Smith weatherized the garage, rechristening it the Watu Cantina. He made some additional exterior improvements and added a small stage in the rear clearing, which became the site of a pandemic-era weekend concert series. The series, which showcases bands of varied musical genres from and beyond the region, has been popular with attendees and musicians and now continues inside Duende during the cold season.

Administering Heritage and Sustaining Industrial Monuments

When I huddled with Watkins in the Swannie Shack on a cold October 2015 day (and again in February 2016), we discussed administration and finances. Watkins had the wood-burning stove going and his dog, Champ, lay across his bed. Smith, returning from Rigidized business at Carnegie Mellon in Pittsburgh, walked in just as we were discussing the surprisingly favorable concert acoustics in the courtyard and a potential competition to design a permanent covered stage to replace the temporary one constructed a year earlier. I steered the conversation to ownership and financials, and Smith prompted Watkins to find the certificate issued by the US Patent and Trademark Office in 2014 that conferred RiverSullivan with the Silo City trademark. The certificate was creased and smudged but had now been placed in a sheet protector. It was Smith's self-deprecating way to show that Silo City was a homespun operation where important documents were being stored in this shack, rather than in a proper office.

Indeed, through the 2010s, Smith administered Silo City by the seat of his pants, even as its programs grew in number and complexity. Silo City had no employees, and neither Smith nor Watkins ever fully explained the arrangement between them. "Swannie donates his time," Smith said.[73] Nor was Silo City really a business entity. Administrative functions were often handled or assisted by Rigidized Metals, and individual programs were generally administered by partners. Silo City also used Rigidized as its mailing address. Rigidized personnel and resources also helped manage accounting and legal matters, but it was not a viable long-term arrangement. In its first decade, Silo City did not generate enough revenue to pay for itself, let alone maintain landmark structures. At that time, Smith estimated operating costs at one hundred thousand dollars a year, with the greatest shares being for insurance and taxes—a pittance of the capital costs of fixing the elevator roofs alone. Cash flow varied, overall hovering at around half of operating costs, but Smith was not prioritizing revenue. It was the "startup years," he explained—an apt description.

The previous year, Watkins had called Smith a "renaissance man" and said, "He wants to make a profit . . . but he really enjoys the challenge of it—and watching what people come up with and carry out" at the site.[74] Yet passion can only take a historic site so far. Even as preservationists and academics advised him to consider forming a 501(c)(3) nonprofit corporation to own and manage the elevators, Smith was resistant. Forming such an entity would have enabled governmental and foundation grants, reduced taxes, and potentially helped facilitate a National Park Service partnership, but would have also imposed constraints and reporting requirements and forced Smith to reign in his freewheeling administrative style.

In 2015 the complex was contained by three different legal entities: Silo City LLC, which held only the American Office Building/Duende property; RiverSullivan Inc., created in 2009 to hold the property assets and debt of RiverWright, the failed ethanol venture and legal owner of most of the site; and Rigidized Metals.[75] Its revenues during the 2010s came mostly from event and usage fees, ranging from a few hundred to a few thousand dollars, though larger events and film or media rentals were charged more. The cost of administering events, including everything from supplying portable toilets to security and additional insurance, was borne by event organizers. Silo City's own insurance policies covering everyday liability had also increased in cost over the past five years, and Smith noted that the city and county were contemplating a property class change for the site's underlying parcels, which would result in a tax increase. As of 2019 the Silo City properties, other than Duende, were being assessed as either "Feed Sales" or "Vacant Industrial" by the county (the city had similar classifications), generating property taxes of a few thousand dollars a year.[76] Rentals for movie shoots helped Silo City break even in 2017, and the opening of Duende generated cash flow and helped finances in 2018. But Duende, a legally independent entity, was never intended to sustain the entire site and ensure the conservation of its historic structures.

In 2015, when Smith was refocusing his development plan to the campus's ancillary buildings, he argued that the elevators were essentially ruins that resist intervention but could still be appreciated and exploited in their raw state, even if that meant leaking rainwater would occasionally fall on event participants or attendees inside of Marine A. A less intensive intervention strategy also preserved the elevators' interior spatial and acoustic qualities, Smith argued. Attendees were not

bothered by these imperfections, and in fact were excited by ruins, he said—a perspective certainly confirmed by my own research in Buffalo and elsewhere. The idled elevators were markers of failure for his father's generation, but for younger audiences, they marked shared history, culture, beauty, and possibility. Of course, persistent building pathologies and the challenges of addressing water intrusion and accompanying freeze-thaw cycles couldn't entirely be ignored. In addition to the Lake and Rail's overhaul, Smith had repaired the roofs of the other elevators, but much more work was needed. These conditions would help tip the scale in favor of the development partnership that he entered in 2019.

When I discussed elevator conservation with Watkins in fall 2018, he also noted the roofs and weather-related issues. Given that the elevators were national treasures, I asked Watkins if ad hoc, interim repairs were appropriate. Would the elevators ultimately receive stabilization and conservation interventions that were commensurate with their historic value, as the National Parks Service would expect if they were under its stewardship? He replied,

What I've come to appreciate is that we never really have a chance to see buildings get old. They normally get torn down. My preference would be that we stabilize them to the point that they can't be beat up unnecessarily by the weather. But I wouldn't want to see them completely restored. That was never a goal. That's why we use the term "regeneration." But I think to let them age gracefully, I think there's something to be said to that.[77]

At that moment, Smith and Watkins seemed to be embracing a European sensibility or counter-culture of heritage practices, which view preservation as a fluid activity rather than fixing an object in time. It was a form of "post-preservation," according to theorist Caitlin Desilvey, who, writing in a British context, notes that such practices embrace the "inherently unpredictable and uncertain" conditions brought on by entropy and favor minimalist approaches that eschew the energy and investment that keep historic structures in a steady state.[78] The movement also recognizes the multiplicity of meanings or values acquired by such structures and embraces broad possibilities: growth, rejuvenation, accident, collapse, and decay. Yet such an approach was at odds not only with

US building and safety codes and preservation practices; it was also inconsistent with Smith's professed desire to ensure that the elevators would be intact for future generations. Even as building conservation is rarely an all-or-nothing proposition, Smith seemed to be committed to opposing visions—slow dematerialization *and* stabilization for the ages.

In addition to building pathologies, human safety issues became more pressing as Silo City gained prominence and popularity. In 2018 Watkins complained about obtaining city occupancy permits. Silo City's elevators could not receive them because they lacked sprinklers and emergency means of egress. He noted Buffalo's renewed interest in building safety and fire prevention in the wake of the 2016 Ghost Ship fire in Oakland, which killed thirty-six people (see introduction). The fire at the converted warehouse, which has since been demolished, cast a harsh light over unlicensed arts and performance venues in adapted industrial buildings, with cities stepping up code enforcement across the country.[79] Even in Buffalo, the city was no longer going to look the other way. Without occupancy permits, only fifty people were allowed in each Silo City elevator at one time, and they could not stop, dwell, or gather; they had to be "going through." Thus, several well-publicized and celebrated programs were not technically allowed, including the reading series, music performances and theater productions, even as they were indeed occurring and sometimes with audiences exceeding this maximum.[80]

I imagined that during Silo City's first several years, other codes and regulations might have been overlooked or loosely interpreted. Urban building, fire, and zoning codes and environmental regulations rarely do well with unusual adaptations of property or adaptations to unusual properties. By 2018 Silo City was hardly flying under the radar, and Watkins characterized its programs as operating in a "gray area"—a kind of willful overlooking on the part of regulators. "The city loves it, the people of the city love it and love the attention that it gets, but if somebody complains," he said, the site or its activities could be shut down.[81] Participant and visitor safety could no longer be expediently administered in the moment.

Buffalo's preservation community embraced Rick Smith and his improvisational administration. In 2016 Preservation Buffalo Niagara director Jessie Fisher told me that Smith "has no fear" and expressed relief that the elevators were in good hands, enabling her small organization to fight oth-

er battles, including demolition calls and the slow but constant decay of Buffalo's older building stock. Yet some area preservationists quietly expressed reservations about Smith's operating style and professed their desire to see the elevators preserved through traditional stewardship practices and federally administered programs, such as what the Grain Elevator Project proposed. Lynda Schneekloth, the UB professor who introduced me to Silo City, framed her own concerns and conflicting feelings. She embraced the site's accessibility and free-spirited atmosphere. Possessing a keen appreciation for unguided wandering through postindustrial landscapes, she has written about her own transgressive explorations amid the elevators along the Buffalo River, which she notes "is seductive in its wildness, its looseness and the majesty of its ruins."[82] Yet, as an informal adviser to Silo City, she sometimes struggled to reconcile these impulses with administrative concerns. In 2012, when the volume of activity was still modest, she told me that the increasing number of events and visitors would overwhelm Smith's ability "to sustain a major international heritage site." Silo City could longer afford ad hoc administration, she argued, and hoped to steer Smith toward "long-term resource management."[83] Another preservation professional also faulted Smith's casualness, noting that he often treated Silo City like a "boys' club"—a gathering spot to drink beer with friends, often inside the elevators and sometimes leaving the empties behind.

Evolving Concepts of Riverfront Development

While focusing on and enjoying the immediacy of the short term, Smith never shied away from discussing permanent adaptations of Silo City structures or new construction on site. During my visits I would prompt Smith (and sometimes Watkins) about the longer term, and he would casually propose reuse programs: research labs and studios for universities, technology incubators, a hotel, residences, artist housing, permanent arts and performance venues, and mainstream recreational or commercial ventures. In fact, over the years, Smith and Watkins did have conversations with UB and other local institutions about adapting the American Warehouse as an advanced manufacturing or innovation center. While these collaborations were never realized, Smith's repurchase of the

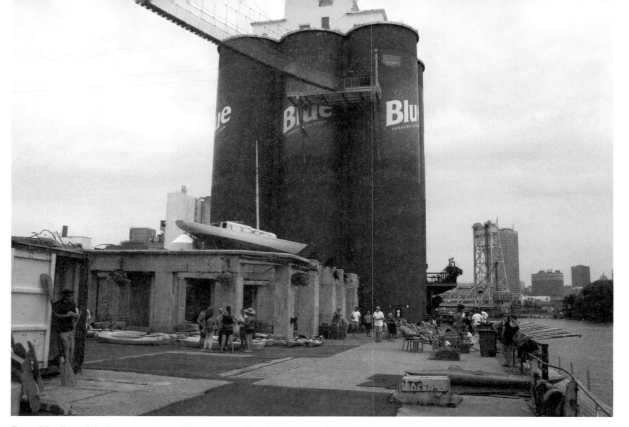

Part of the River Works recreation and leisure complex. (Author, 2018.)

Lake and Rail and its associated structures—including a three-story office building, its ten-story warehouse, and a train wash shed—provided additional targets for investment while eliminating potential land-use conflicts between grain transfer operations (the tracks that feed the Lake and Rail bisect the heart of the campus) and, potentially, residential development. Eliminating grain transfer operations also substantially reduces the magnitude of rodent and pest infestations, which are endemic to elevator use.[84]

Even as Smith brushed aside concerns about profits while indulging generous arts and cultural programming during Silo City's first years, the market for property development along the Buffalo River was evolving. Downriver, Buffalo RiverWorks adapted the G.L.F.-Agway grain elevator complex into a $34 million recreation and entertainment center featuring two ice rinks, a public boat launch, concert venues, restaurants, a beer garden and a hotel. The project's first phase opened in December

A new apartment building at 301 Ohio Street, as seen from River Works. (Author, 2018.)

2014.[85] Across the river, the $17 million Buffalo River Landing, a seventy-eight-unit, five-story residential apartment building with two office spaces, completed in 2016, represented the first residential development along the river in many decades, and a second residential building farther downstream soon followed.[86] Public infrastructure has also been upgraded with the city's reconstruction of Ohio Street and the improvement of nearby waterfront public spaces. Ohio Street provides the only (land) access to Silo City via Childs Street, which the city renamed Silo City Row in 2014.

RiverWorks' partial demolition of its elevator and mill complex generated controversy among local preservationists in 2011; its later wrapping of six of its remaining silos in a Labatt Beer promotion (the "Labatt Blue Grain Silo Sixpack") drew further ire. Yet the complex is succeeding and has brought large crowds to the riverfront for ice skating and hockey, rock climbing, ziplining, and other sports, and to enjoy its riverside restaurant, bar, and event spaces—something I have witnessed in

RiverWorks visits during three different seasons. In July 2018 I launched a kayak from the public boat ramp as part of a group paddle with compatriots from a Rust Belt preservation conference. That fall, along with hundreds of my colleagues, I attended a reception at RiverWorks, part of an urban planning conference.

After RiverWorks opened Phase I in 2014 I asked Smith for his perspective. When I compared it to Silo City, he laughed and said, "I wish them luck," and noted differences in programming, clientele, and long-term goals. He also highlighted Silo City's development challenges, including its location in the floodplain and a weak market for residences or hotel rooms in this area.[87] "Conventional development could occur, but it's not the way it's been happening. Something is going to evolve," Smith explained.[88] A year later I asked him again, and he replied, "In my mind, any development on the Buffalo River is good. That means as a catalyst that we were successful, because there was nothing down here until we bought [the Silo City properties] in 2006. And part of my own personal mission has always been to get things back on the water—redirect and reorient Buffalo back towards the waterways."[89]

Back to the river indeed. On the day of my Elevator Alley paddle, we shared the waterway with pleasure craft of various forms and sizes, including small excursion ships and the now-ubiquitous party boats. Among the latter were tiki boats—the kitschy, octagonal-shaped small craft with a bar at its core—which also launch from RiverWorks. The music blared from the decks of these floating huts as they passed, and their inebriated passengers sang, danced, and loudly conversed. Other boats had moored along the riverbank for the afternoon. It was a party scene, perhaps too much so, if you were trying to enjoy the solitude of one of America's most unique urban rivers. Around the Silo City peninsula I paddled; the passing tikis and party boats, as loud as they were, could not drown out the sound coming from the Western New York Blues Festival staged in the elevator courtyard. I looked at the opposite bank, adjacent to the Standard Elevator, and remembered my first view of these elevators from that spot during Memorial Day weekend 2009. Leisure activities along Elevator Alley had increased from a few to a few thousand in less than a decade.

RiverWorks' success and the thousands of people it brings to the grain elevator district each week, along with recent public riverfront improvements, surely primed the pump for more bricks-and-mortar development. Twelve years after Smith had bought the properties for RiverWright and seven

years after he had creat-
ed Silo City, the Buffalo
River was reviving, and
the market was ripe for
more development. The
local preservation com-
munity, ever hungry for
precedents, had noted
adaptations as part of
the Grain Elevator Proj-
ect in 2006, including a
hotel in a metal-binned
elevator in Akron, Ohio,
and Silo Point, a resi-
dential conversion of
the former Locust Point

Swannie Jim Watkins and his dog Gonzo at Silo City during his last year in residence.
(Author, 2018.)

Grain Elevator on the Baltimore waterfront, built by the Turner Development Group in 2009.[90] Con-
structed by the Baltimore and Ohio Railroad in 1923, the 2.4-million-bushel-capacity concrete elevator
is now a luxury condominium sheathed in glass, metal, and masonry (with some of its bins removed or
altered).[91] A more publicly costly analogue is the Washburn Crosby Elevator on the Mississippi River
in Minneapolis, a stabilized ruin that is part of the Mill City Museum complex and the adjacent Mill
Ruins Park. In 2012 the concrete elevator underwent a multimillion-dollar restoration, including roof
replacement and other exterior repairs.[92] And in Montreal, Grain Elevator #5, one of the world's larg-
est, sits as a partially stabilized ruin along the park-lined Lachine Canal. It's owned by the Canadian
federal government and managed by the nonprofit Canada Lands, which in June 2022 agreed to sell
the site to a developer with a plan to convert the silo into a vertical urban farm powered by a tidal tur-
bine in the river behind it.[93] Smith and Watkins were familiar with these projects, none of which they
felt provided the appropriate prototype for Silo City.

In October 2018 I sat with Watkins outside of his shack with our chairs facing the river in the gap between the Lake and Rail and Marine A. It was cloudy and cool, and an occasional breeze gently rippled the surface of the river. The growth on both riverbanks that had been so lushly green over the summer was by no means extinguished, though now paler and thinner—greens giving way to yellows, browns, and bits of crimson. As we talked, we could hear the birds chirping and cicadas buzzing. It was a pleasure observing the seasons at Silo City. Having visited in the dead of winter 2016, I could understand the downright harshness of Watkins's living quarters, but also the privilege of seeing the ebb and flow of the natural world in this unique riverine environment framed by the elevators around us. I asked Watkins about the Lake and Rail, which Smith had repurchased a year earlier. He characterized it as a defensive move. White Box had built a new, more strategically located grain facility in Ontario and closed shop in Buffalo. Smith purchased the property to preserve the elevator's integrity, keep the Silo City campus intact, and avoid potential conflict with a new owner. But the purchase has also created additional development possibilities. The Lake and Rail's locker and bathroom, situated some thirty yards from where we were seated, which Watkins used, could now become the public restrooms for the entire site. Other substructures, including its three-story office building, flour mill, and ten-story warehouse, could also be adapted for new uses.[94]

Around 3 p.m., the sun broke through the clouds and bathed the elevators around us in soft fall sunlight. It was a glorious time to be at Silo City and savor these concrete monuments. Earlier that week, a camera crew from *Monday Night Football* had visited Silo City to get some B-roll footage. Like the city itself, the Buffalo Bills were seemingly emerging from their own two-decade stupor and were to host their first *Monday Night Football* game in several years. Silo City footage would air in the first commercial break during halftime and include a shot of Watkins's new canine companion, Gonzo, dressed in Bills regalia. The shots during these breaks of NFL football games are always of regional icons: the Manhattan skyline or Statue of Liberty; city hall, the Art Museum, or Boat House Row in Philadelphia; Baltimore's Inner Harbor or its Washington Monument atop Mount Vernon; or the Hollywood sign in the hills above Los Angeles. Silo City has always been one of Buffalo's icons, but now it would be shared with the world at large.

The End of Postindustrial Ad Hoc

While Smith endorsed a revived version of the heritage park plan involving NPS in 2017, he wasn't going to wait for those stars to align. In June 2019 he announced a partnership with the Miami-based Generation Development Group to create a residential and creative village at Silo City. True to Smith's evolved vision of building around rather than inside the elevators, the mixed-use plan would mostly exploit supporting structures of the American, Perot, and Lake and Rail complexes, adapting them into four hundred residential apartments as well as arts spaces, offices, and retail, while only stabilizing the elevators themselves. Generation's plan was also to include performance spaces for creative partners, including the Torn Space Theater Company, the Silo Sessions, and the Silo City Reading Series, plus live-work spaces and affordable workforce housing units.[95] The project quickly earned an endorsement from the *Buffalo News*, which noted Smith's track record of creative stewardship and the potential to "further enhance Buffalo's reawakened waterfront and put another latent asset back into use," while providing "another blast of 'New Buffalo' energy to the Old First Ward." While residences are by far the plan's largest use, the *News* oddly emphasized the project's regional touristic potential, noting that Buffalo "needs to play up its strengths, giving more suburban residents a reason to leave strip malls and big-box retail behind to partake in the pleasures of the city's cultural scene."[96] By June 2019 the partnership had applied for an adaptive reuse permit allowing for mixed-use development on land zoned for industrial use, which quickly won preliminary approval from the Buffalo Planning Board.[97] By that December, the board had approved Generation's $65 million Phase 1 plan targeting the American complex.

Supported by state and federal historic preservation tax credits, brownfield development tax credits, and state affordable housing incentives and financing, the final state-approved plan includes 168 rental apartments and resident amenities. All units will be affordable, under a complex formula involving four different pricing levels, with the highest strata set aside for households making only 80 percent or less of the median income for the Buffalo–Niagara Falls metropolitan area. The development will also contain forty thousand square feet of ground floor commercial and

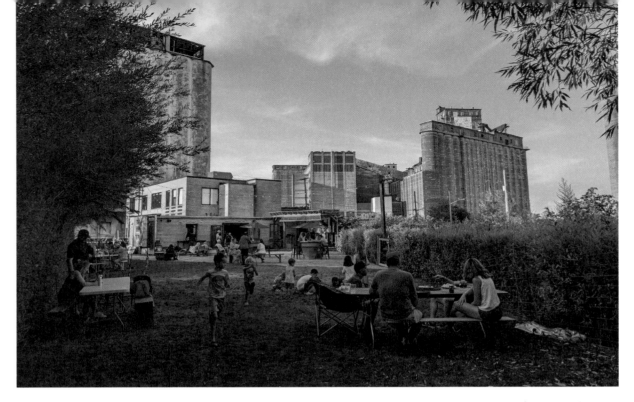

The backyard of the Watu Cantina and Duende with the American Elevator (background left) and Lake and Rail (background center right). (Author, 2020.)

community space—including a large office for rent, a business incubator and co-working space; a gallery, event, and performance space; and a small hydroponic container farm.[98] By April 2021 Generation Development's $50 million Phase 2 plan targeting the Perot Malt House had also received planning board approval and will include ninety-two apartments and twenty thousand square feet of commercial and amenity space.[99] As of early 2023 Smith and Generation's Phase 3 plan for the Lake and Rail was still to be determined.

When I returned to Silo City in October 2020, dramatic changes were underway, even if the site's architectural contours were not so different from those of the mid-2010s. The greatest social change was that Watkins was no longer in residence. During my late 2018 visit, he talked about his upcoming winter sabbatical, but now that break was permanent, and he was residing on the city's East Side and tending his garden. Without Swannie, the site's collective generosity, curiosity, and spirit had been diminished. Yet Silo City had evolved beyond its formative period and Watkins could now ap-

ply his unique talents and temperament to other Buffalo projects. Additionally, living in that shack was surely a drain on Watkins's health, if not a downright hazard. There were additional changes and new limitations due to COVID-19 protocols and liability concerns. The elevators themselves were no longer being used for tours and public arts programs.

It turned out that I had arrived on a momentous Friday afternoon. An hour earlier, Smith had closed with Generation Development on the American complex, and construction was to begin on Monday. Smith had received $2.8 million for the property. He was in a celebratory mood, and we grabbed a beer at Watu. Generation's principals, Anthony Ceroy and Marvin Wilmoth, were around somewhere, and Smith wanted to introduce me. The pair had recently completed the conversion of the Atlantic and Pacific Warehouse on Buffalo's West Side into residential lofts. "Their vision for the site aligned with mine," Smith explained, noting their emphasis on arts and culture and commitments to historic integrity and social justice. We walked around Duende's grounds, discussing Silo City's imminent transition and broader ideals about its future. The Watu Cantina, he said, was named for the Swahili word for "people" and part of a phrase that meant "land for people," which he repeated several times that afternoon.[100] Silo City would honor and advance the narratives of multiple pasts, including those of the elevator workers, the Iroquois, and others who once lived or worked along the Buffalo River, while bringing together Buffalo's diverse present populations, including refugees from Africa and elsewhere.

There was no doubt in my mind about Smith's sincerity and the laudable goals of the partnership he had entered, but I had mixed feelings about Silo City's rapidly approaching transformation. I thought about the potential tension between residences and public access to the elevators and the river, and the availability of the elevators themselves for arts programs. The plan's commitments to the site's constituent performance groups seemed vague. And where would the parking go for the more than four hundred cars of new residents, commercial tenants, and staff—and what would be lost in the process? It wasn't the time to press Smith on the plan's details or potential trade-offs, but as we talked he sensed my broader hesitation and disappointment that Swannie Jim was no longer around. "It was getting to be about time," he rationalized, noting that he and Watkins had "done all that we could pretty much do" with the festivals and programs, and the "next chapter" had

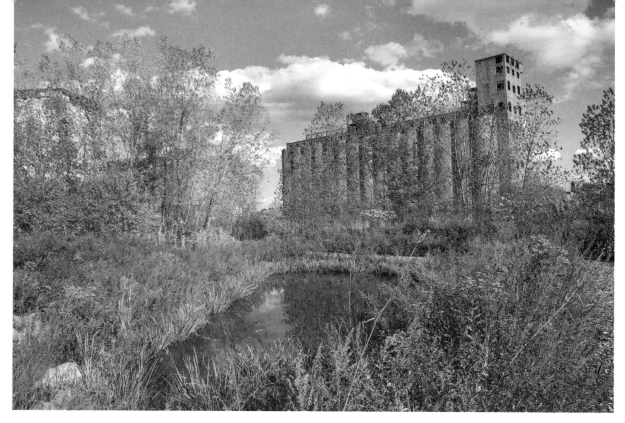

A habitat created by Josh Smith on the grounds of Silo City. (Author, 2020.)

now commenced. Almost on cue, someone called for Smith, and he excused himself to rejoin the attorneys back in the American Warehouse, where a document related to closing still needed his signature.

Upon his return twenty minutes later, Smith and I climbed into a golf cart and drove two hundred yards up Silo City Row to the edge of Ohio Street, where he showed me an almost complete youth soccer field. Cloaked by weeds and construction debris, it was a perfect rectangle thirty-five yards in length, gently graded from its crown and plied with a carpet of grass that looked as pristine as what the pros play on. An avid supporter of youth soccer leagues, like the ones his own sons have played in, Smith said he was compelled to build this for Buffalo youth who lacked access to such facilities, again noting the city's immigrant and refugee communities. From there, he handed me off to Josh Smith (unrelated to Rick Smith), Rigidized Metal's director of ecology, who was responsible for the design and construction of many of the improvements I was now seeing. Years earlier, I

Došyowëh Atainö'geh or "pathway between the basswoods" along a former railroad bed leads to a gateway to Silo City's meadow where Torn Space's Ages would be performed. (Author, 2022.)

had asked if Josh Smith was a landscape architect, to which Watkins quickly replied, "No, he's got his hands in the dirt!" and noted his contributions to community gardens across Buffalo, which he helped nurture—often using compost from Rigidized's food waste drop-off. Josh showed me an impressive pond and water course he designed and constructed amid a stunning variety of native plants. While the pond had been stocked with fish, birds of prey had depleted their numbers. Like many of Silo City's improvements made in the decade prior, this verdant habitat was created by mostly low-impact and low-cost construction. Josh was a master of restorative ecology and shared Smith's and Watkins's larger trial-and-error approach. The adjacent land to the north would soon be graded to create a paved parking lot. But there still seemed to be space for yet other landscape protagonists, including an adjacent gathering and play space created by University at Buffalo architecture students and faculty, some of whom I would converse with later in the evening.

Torn Space's Ages performed around the cottonwood tree in Silo City's meadow. (Author, 2022.)

Back at Duende, a crowd had gathered to enjoy a folk jazz band and children's activities set up inside and around the cantina. Ceroy and Wilmoth had already left, so instead I met Gabriel Shalamba, a recent refugee from Congo whose son plays soccer with Smith's. Shalamba had been helping in the construction of the soccer field and tends bar at Duende. I also ran into various Buffalo arts and culture people, including Noah Falck, the Silo City Reading Series founder, who was there with his wife and daughter. Everyone around me seemed to be having a ball, and Smith was basking in the glow of being a facilitator of these postindustrial experiences. I was glad that creative protagonists were around on this momentous day and hoped that they would continue to stage programs at Silo City, even as Smith was relinquishing control of some of the most significant portions of the site.

I sat outside at one of the picnic tables underneath the south-facing façades of the American Elevator and Warehouse, with preservation architect and Central Terminal board member Paul Lang, who was supervising the adaptation of these structures. Buffalo was indeed a small world, and there weren't many firms in the region that were experienced in preservation architecture, and certainly not with the reputation of Lang's firm, Carmina Wood Morris, where he was now managing principal. We chatted about Buffalo preservation projects, and soon others joined us. At 5:30 on a warm, late October evening—in a moment just before COVID would surge again—it felt great to be socializing outside. Partaking in the ritual observance of the workweek's end, the experience felt both regular and exceptional; it was a privilege to enjoy the monumental structures around us with such unhurried intimacy. Silo City was rapidly evolving into something different than what it had been during the 2010s, but some of its separation from the world around it—its otherness—was still intact. Two days later I returned to take part in that most quotidian of American fall traditions: watching the Buffalo Bills–New York Jets game inside the cantina.

Having seen Silo City mature for over a decade, change was at once thrilling and a melancholic affair. The site's salad days were over, and some of its informality had been lost to partnership development guided by professionals and shaped by investment capital and public incentives. Successful informal places either grow and evolve toward the conventional or they die. Silo City was following this arc of formality, moving toward something better preserved.[101] My 2020 visit, well colored by the pandemic, helped crystalize many thoughts I had about not just Silo City but all

postindustrial DIY sites: compelling places in a raw or formative state are fleeting. Enjoy them in the moment, savor them, and take pleasure in watching them grow, even if it is into something else entirely.

Yet when I returned in 2022 to see Torn Space's latest site-specific production, Silo City's evolution toward formality was progressing at a somewhat slower pace. Two days before the event, I met Smith at Duende. We sat outside at one of the tables fashioned from salvaged, conically shaped metal components set in the crushed gravel patio behind the Watu Cantina. Across the street, the conversion of the American complex was not so far along. Earlier in the year, storms had damaged and flooded the structures, halting construction inside the Warehouse and Flour Mill. The completion of the project would be delayed for at least a year, and Generation Development was still attempting to assess and repair the damage, Smith said. The developer had fired its general contractor, Arc Building Partners, and shortly after my visit, Generation sued Arc and the two insurance companies that had guaranteed the contractor's work for $20.25 million, citing "numerous material breaches of contract and construction defects."[102] Even as Silo City was growing up and becoming a professional development project, the site was still being shaped through unforeseen circumstances and the inherent unpredictability of its location. Listening to Smith talk, I was reminded of a conversation with him years earlier when he noted the hazards of building in the floodplain.

Even as Smith retained a minor stake in the development of the American, he didn't seem overly concerned about the project's delay. He was more eager to talk about Silo City's potential to go entirely off the grid and produce and store all its own electricity, the history of Buffalo's grain industry, and cultural happenings on site, including Torn Space's production. The interior of Marine A was again being used for arts and culture, including the reading series, he said. Other renewed or new creative collaborations and community partnerships were in the works. I asked about Generation's plan for the American and Perot elevators and their availability for public programming. He said the developers shared his vision but noted the diminishment of his own discretion in the firm's plan. "I still have a say, but not a big one," he said. It was happy hour. The cantina's bar was beginning to fill, and a band was setting up outside. We went inside, and I talked Premier League soccer with Gabriel Shalamba and other members of Buffalo's African diaspora, before checking out the community art

show on Duende's second floor. Silo City seemed to be retaining a diverse mix of people and activities and some of its off-the-grid aura, even if the infrastructure required to generate and store the electricity to make it literally so might be some years off.

I returned with my wife, Anne, two evenings later for Torn Space's *Ages*, which was being staged in one of the site's most surprising and serene spots, the Meadow. The focal point of the Meadow is a thick-trunked cottonwood tree equipped with a swing, whose girth indeed suggested that it had been there for ages, even as it was only decades. Historic American Buildings Survey photographs from around 1990 show this area as being mostly train tracks and demonstrate that the larger area that is now Silo City, including adjacent Rigidized property, was almost 100 percent hardscape and tracks with only a few tiny specks of green popping out from the cracks. We entered the Meadow from a passage along a former railroad bed flanked by high grasses and then through a tubular gateway fashioned from a rusted metal culvert, which pierced a wall of assembled concrete slabs and landfill topped with grasses and an undulating boundary sculpture. This artfully assembled landscape was designed and constructed by Josh Smith, with the slabs harvested from a Rigidized building expansion and the sculpture designed by local artist Dylan Burns. Later, Rick Smith called this landscape "Došyowëh Atainö'geh," meaning pathway between the basswoods in Haudenosaunee, the language of the Seneca. It was a symbolic reconstruction of the longer Iroquois Federation trail that he and Watkins had always talked about.

We found a spot of the grass facing the cottonwood amid the two hundred other attendees and performers. *Ages* was a loose celebration of multigenerational families since the beginning of human life on earth and featured readings from Pulitzer Prize–winning poet and UB Emeritus Professor Carl Dennis and modest contributions from some audience members who upon showing up had been convinced to play roles. As the sun set behind us, the monumental elevators beyond the meadow—including Marine A and, farther to the southeast, the Cargill Superior—gently reflected the last light of a late August evening. It was surely another only-in-Buffalo moment, and I was glad I had been there to take part in it.

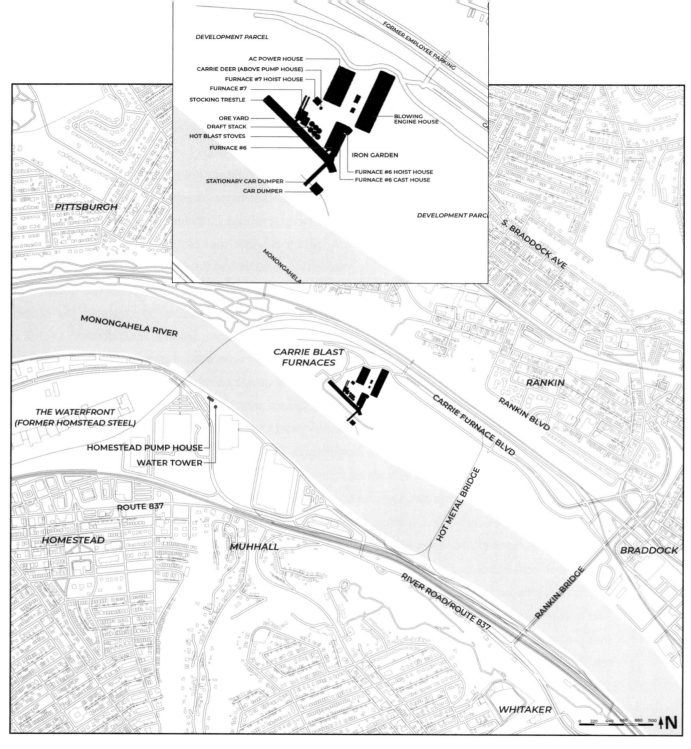

The Carrie Blast Furnaces in the Monongahela River Valley, Pennsylvania.
(Cartography: Shahrouz Ghani Ghaishghourshagh, 2021.)

CHAPTER 4

The Carrie Blast Furnaces

L ike Silo City, the Carrie Blast Furnaces, just outside of Pittsburgh, Pennsylvania, is a Rust Belt icon. The mostly green thirty-five-acre place contains the remains of a legendary iron mill and was nearly lost to the wrecking ball, but today it endures as a national heritage place and an experiment in the preservation and adaptation of former industrial complexes. While over half of Carrie's structures are gone, two of its four blast furnaces that survived into the 1980s (out of seven built over the years) now provide the focal point to a place where history, ecology, and art intermingle and juxtapose, and where the industrial culture of southwestern Pennsylvania is remembered and celebrated.

The Carrie Blast Furnaces was founded in 1884 during a formative era of the American steel industry. Named after Carrie Clark, daughter of first company president William (furnaces were often named for female relatives), it was purchased by Andrew Carnegie in 1898 to supply iron ore for Carnegie's Homestead Steel Works across the Monongahela River. In 1901 Carnegie incorporated the combined plant into the U.S. Steel Corporation, which within a decade would grow into the one of the world's largest and most consequential corporations. That same year, Carnegie upgraded Carrie's two existing 1880s-era furnaces and built two more, adding a fifth in 1903. The only remaining furnaces, #6 and #7, were constructed in 1906–1907 and were rebuilt twice before World War II.[1] This mostly peaceful site today, rich with mature flora and a variety of fauna, is punctuated by these monumental furnaces and their stoves, an intricate network of machinery, and a large guerril-

177

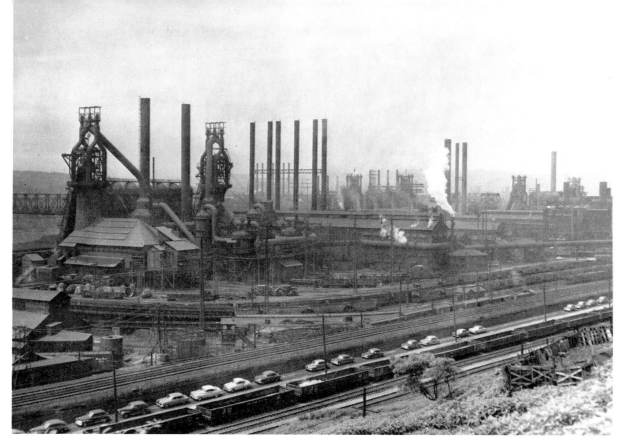

The Carrie Blast Furnaces, 1951. (Rivers of Steel—Sayko Collection.)

la sculpture. But it's hard to fully appreciate the intensity of the iron mill that operated for nearly a century. Gone are the noise, heat, smoke, ever-present danger, and seeming chaos of an operation that in the immediate postwar years employed twenty-four hundred people as part of an integrated steel plant whose total employment was close to fifteen thousand (including workers at the Homestead Works across the river).[2] An industrial behemoth, Carrie's blast furnaces—each working continuously 24 hours a day, 365 days a year for periods of two or more years—churned out up to two million tons of hot iron each year. When converted to steel at Homestead, that output eventually became American railroads, highways, bridges, skyscrapers, ships, land and air vehicles, machinery, and consumer products. It supplied the iron for the Chrysler Building in New York, the great US Navy expansion under Theodore Roosevelt and armaments for both world wars and the Korean and Vietnam Wars, as well as the plate steel for US space travel.[3]

If modern American life is unthinkable without steel, then the history of steelmaking in the Monongahela Valley is the history of building modern America. Along the banks of the Mon, the world's most productive concentration of steel plants evolved, and steelmaking innovations spread to the rest of the world. Owned and operated by U.S. Steel, the world's largest producer during most of the twentieth century, the combined Homestead-Carrie complex was the corporation's and region's most capacious plant through the first half of the century. While continuously upgraded through the 1940s, in the shifting postwar global landscape of steel production, the corporation opted to invest in other existing and new plants and began shutting down Carrie's furnaces in 1978, closing the site entirely in 1983. Across the river in Homestead, U.S. Steel shuttered major portions of the plant in 1983 before closing

The surviving infrastructure of the Carrie Furnaces includes (from left to right) the A/C Powerhouse, Stocking Trestle, Furnace #7, the hot stoves, Furnace #6, and ore bridge. Goats can be seen trimming the grasses of the ore yard (center right) while the hot metal bridge is visible underneath the ore bridge. (Author, 2016.)

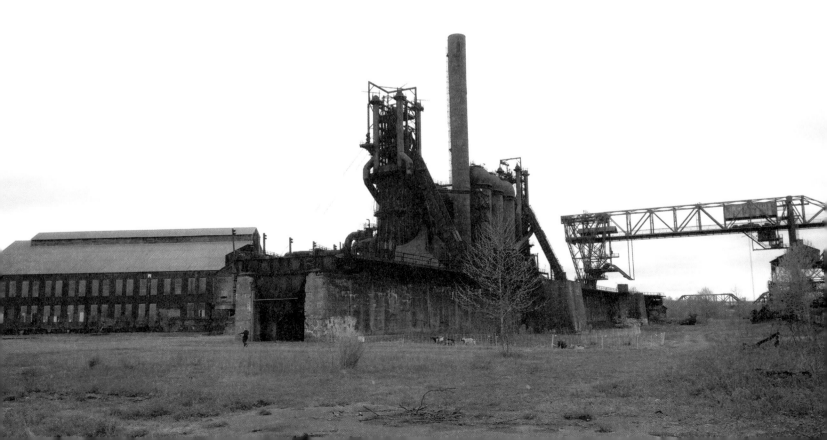

it in 1986.[4] The corporation sold the entirety of the Homestead-Carrie complex to the Park Corporation in 1988, and in the ensuing years Homestead was cleared and developed into a suburban-scaled retail, entertainment, and light industrial complex with many acres of parking.

Now several decades after its abandonment and partial demolition, Carrie has been resurrected as a Rivers of Steel (ROS) National Heritage Area cultural park. The two extant blast furnaces, last used in 1978, and other remaining structures and grounds are now a venue for historic tours and education programs, art events and installations, craft workshops, gardening and landscape restoration, nature appreciation, music, theater, regional celebrations, and other events. The ruinous but majestic complex forms a striking tableau with the resurgent landscape in which it is set, part green and part rusting machine. And like Silo City, the sublime setting is only part of the Carrie story. Recent and present-day protagonists have remade this landscape (and it is more landscape than building) and found innovative ways to welcome the public to a prominent but paradoxically inaccessible place. Yet if Silo City's relaxed vibe was in large part derived from its freewheeling owner, Carrie, which is constrained by its underlying public ownership, derives its vitality from a different narrative arc and administrative approach.

Much like dozens of abandoned industrial sites across southwestern Pennsylvania and hundreds across the United States, the idled Carrie Furnaces drew visitors intrigued by its ruins and their evocative or monumental qualities. These trespassers, who came with various agendas but none with long-term constructive aspirations, were there to admire, explore, engage, and document. Indulging a variety of constructive and destructive impulses in a place seemingly without rules or constraints destined to be entirely cleared, these guerrilla actors played at Carrie the way that youth and young adults have long played at abandoned sites in the Rust Belt and elsewhere. And like many former industrial sites, artists were among the interlopers. Pioneers of transgression, their activities and installations evolved into beacons that attracted others. While creative engagement in abandoned industrial spaces (with or without authorization) has evolved into a common practice, Carrie's artists created a sculpture that became a regional icon even though it was built in secret and never intended for full public display, which helped change the fate of a site destined for full demolition and clearance.

The view from the Furnace #6 Cast House toward the hills above of the mill. In the years before Rivers of Steel assumed administration, Carrie's ruinous verdancy frequently attracted unauthorized visitors. (Courtesy of Rivers of Steel—Randy Harris Collection, 2006.)

This chapter chronicles the Carrie Blast Furnace's history since its 1983 closing and its evolving postabandonment landscape. It shares the perspectives of the guerrilla insurgents who created the Carrie Deer and unknowingly altered the site's history and impacted its design, programs, and administration—and helped Carrie remain an icon of both the industrial and postindustrial eras of the Mon Valley. It also examines the novel strategies of Rivers of Steel Corporation, which administers Carrie, largely through the perspectives of its longtime leaders and from my own observations generated from several visits and attendance of onsite events. Working within the context of government constraints and limited funding, ROS has managed to provide a broad and popular array of programs while retaining and building around the Deer, incorporating it into the story of

Pittsburgh steel. Rivers of Steel has also made sure that the Furnaces retain some of the postindustrial wildness that compelled the Carrie Deer artists and other unauthorized visitors. Yet the mill's present status as a cultural landmark and a venue for cultural activities is not finalized. The Carrie of the future—say, thirty years from now—may not be entirely knowable, just as its recent history and present state could not have been foreseen by those who worked at or knew the mill before it closed in 1983.

Guerrilla Explorations in a Deindustrializing Landscape

In a relentless downsizing and modernization campaign that began in the 1970s, U.S. Steel closed Carrie in 1983 and Homestead in 1986. Yet few who lived in "the boroughs" lining the banks of the Mon or in Pittsburgh believed these closures would be permanent. Throughout its history, U.S. Steel had shuttered mills for various reasons, including reduced demand during economic downturns or labor unrest and for retooling or modernization. But this time was different. Looking toward its bottom line, the United States' second-largest corporation (by most measures) was selling off assets, including current and former flagship properties. In 1988 U.S. Steel sold Carrie along with Homestead to the Cleveland-based Park Corporation for $12.5 million. The firm, which specializes in dismantling and repurposing former production sites, in the ensuing years demolished two of Carrie's four remaining blast furnaces along with many supporting structures, selling the material for scrap. Across the river at Homestead, the firm first retooled and sold valuable machinery before it began comprehensive demolition. Park had opted to develop Homestead first, as it was larger and in a more advantageous location than Carrie, one that offered better connections to the regional road and highway network. These connections would also help Park efficiently extract scrap from the site. The Continental Real Estate Company, Park's development partner, opened the first phase of the Waterfront in 1998, an automobile-oriented shopping and entertainment complex with some light manufacturing (and, later, limited residential uses).

The sale of the Homestead and Carrie properties was a significant blow to the region's nascent industrial preservation movement. The Steel Industry Heritage Task Force had been formed the same year as the sale (two years later, the task force became the nonprofit Steel Industry Heritage Corporation [SIHC], now known as the Rivers of Steel Corporation). Yet SIHC, which had only modest political capital and limited financial backing, could only watch in frustration over the next decade, as Park dismantled and cleared most of these two storied sites. During the 1990s, while the Park Corporation was focused on redeveloping Homestead and SIHC was developing a heritage park plan, the idled Carrie site was evolving into a destination for transgressive activities. Unlike Silo City, which is a straightforward two-and-one-half-mile trip from Buffalo City Hall or the Packard Plant, which sits in squarely in the Detroit grid, Carrie straddled the peripheral towns of Swissvale and Rankin, with its western edge touching the Pittsburgh border; Carrie is hemmed in by the river, hills, and railroad tracks, and at the time lacked direct access by paved road. These impediments kept the number and frequency of unauthorized visitors down but also added to the site's allure. Infiltrators included explorers, graffiti artists, photographers, naturalists, paintballers, scrappers, and various teens and young adults, who sometimes consumed drugs or alcohol. Guerrilla activity often consisted of nothing more consequential than socializing, exploration, or destructive activity at a site destined for complete clearance. During a 2017 furnace tour, a regular guerrilla of the early 2000s who was also on the tour, described a milieu of working-class youth with time on their hands. "Being able to wander around ruins is a big part of our identity," she said.

In addition to those who came to wander, party, or scrap, by the mid-1990s, several local artists, some of whom were students, former students, or graduates of the Art Institute of Pittsburgh, were exploring the mill. They had formed the Industrial Arts Co-op and were veterans at executing installations, photo and video shoots, and creative experiments on abandoned industrial sites. Some co-op members had grown up in the region and had memories of steel production from the 1970s and 1980s. They had witnessed and were impacted by this tumultuous period of mill closures and the ensuing economic hardship. Other members had come from elsewhere, including Michigan and New Jersey, but shared a blue-collar upbringing or an interest in industrial places. Sharing a pas-

sion for the exploration of the region's dramatic postindustrial landscape, they found each other through the intimacy of Pittsburgh's art and commercial art worlds.

Tim Kaulen, one of the co-op's founders, came to Pittsburgh from Greenville, Pennsylvania, a blue-collar town seventy-seven miles north of the city, to study graphic design at the Arts Institute in 1984. In the 1970s his father was laid off from his job with the Greenville Tube Corporation, and Kaulen had personally witnessed the town's collapse in the wake of the company's mass layoffs. Inspired by Pittsburgh's topography, neighborhoods, and the large-scale industrial works along its rivers, Kaulen told me the environment encouraged him "to think in three dimensions and try to make things in some of these forgotten spaces." While he spent many hours exploring vacant mill complexes, these experiences were somewhat unfulfilling. "I always left those spaces feeling empty," he said. So he and other co-op members "started tinkering" and developing a "weird idea" that "you could create something out of leftover materials that would speak to the emptiness of what were once all these really active, dynamic, active, populated mechanical spaces, which were just sitting there quietly rotting."[5]

As Kaulen described, the artists had cut their teeth at the shuttered industrial sites on Pittsburgh's South Side, where many lived or had studios. In its pregentrified state, the gritty Southside Flats along the Mon contained many idled or partially-abandoned industrial structures. These were compelling sites for interventions, material finds, creative play and an ideal setting for photographs, film, and video. By the mid-1990s, the artists had infiltrated and created installations at several South Side sites, including the Lawrence Paint and Varnish Building, where they built and installed *The Swimmer*, and the prominent but partially abandoned Duquesne Brewing Company (closed in 1972), known today as the Brewhouse. Infiltrating the brewery's ancillary buildings as they were being demolished, the artists, using only hand tools, created two identical thirty-five-foot-high "Space Monkey" figures out of steel scrap. The team installed one of the monkeys on the façade of one of the brewery's buildings, below its massive, illuminated clock.[6] The installation lasted only a few days before being taken down by the demolition crew, members of whom, Kaulen said, told him that the monkey was a sign that "voodoo was happening." Kaulen ultimately recovered the installation after chasing the perpetrators' truck down the street. Both Space Monkeys were later installed

and displayed at other authorized and unauthorized locations, including, for a brief time, Pittsburgh's Fort Wayne Railroad Bridge.[7]

The artists' growing nimbleness in infiltrating and avoiding detection at prominent sites, working in dangerous milieus, and on works of great scale that involved hundreds of person-hours, would help propel them to other site-specific projects, including authorized public commissions. In 2015 I met Kaulen at Southside Riverfront Park, the location of *The Workers*—one of the co-op's authorized commissions. An ode to steel workers, the sculpture was made from the scrap of the former Jones and Laughlin's Pittsburgh Steel Works (the "J & L"), which closed in 1985 (and had been previously purchased by Dallas-based

Industrial Arts Co-op artist Tim Kaulen in front of The Workers on the site of the former J & L steel plant, now the Southside Riverfront Park. (Author, 2015.)

LTV Steel in 1968) and formerly occupied the site. The location of several co-op exploits, the J & L was redeveloped beginning in the mid-1990s and resulted in the mixed-use Southside Works, whose first phase opened in 2002, and the park, which sent the members farther afield to find postindustrial playgrounds.[8]

Nature and Rust: The Making of the Carrie Deer

By 1994 the group began planning their first significant installation at Carrie. While the mill had been closed for twelve years and much of it was already demolished, it retained intriguing buildings and structures that in abandonment had become enshrouded or overtaken by plant life. Enthralled

The Owl inside the A/C Powerhouse, 1994. (Courtesy Rivers of Steel.)

by the postindustrial dialectic of rust and nature, these artists began to engage Carrie with small installations and ephemeral gestures. The artist-explorers were good at accessing tight spaces and were good climbers. Making use of Carrie's extensive network of vertigo-inducing staircases, ladders, and catwalks facilitated commanding vistas of the Mon Valley from the top of the furnaces, hot stoves, and stacks. They also discovered largely undisturbed spaces that contained the everyday materials of what would have been the last operating day of the plant: workers' uniforms, boots and hardhats, furniture, maintenance and safety equipment, paperwork, and records. These spaces were still largely untrammeled by other explorers, scrappers, and vandals.

One day while exploring Carrie's former A/C Powerhouse, the artists discovered an owl in one of the building's dark recesses. Inspired by this raptor and its appropriation of the building for habitat, the artists began planning their first of two large-scale works. Over the course of five weeks, using found materials, they filled several large plastic bags with hay (a surprising find) and then attached

the bags to wire that they suspended from a gantry. The Owl, which possessed a whimsical quality, was completed at a time when Carrie was being visited by more unauthorized visitors. Responding to a tip from a binocular-wielding resident in the hills above, the police had chased two art students (not part of the Industrial Arts Co-op) and a tenth-grader through Carrie and shot the high schooler in the leg (he lived). When local media covering the story discovered the Owl, they portrayed the sculpture as being constructed by members of a "satanic cult." The police had in fact been investigating the potential presence of this cult for two weeks. The Parks Corporation had also known about the sculpture and had been cooperating with the investigation.[9] Soon after, the Parks Corporation dismantled the work, added additional security patrols and new fencing, and removed some staircases to thwart thrill seekers looking to climb to the top of mill structures.

With Carrie under greater surveillance and attention, for a time the Industrial Arts Co-op members found an alternative setting for appropriation: the abandoned Brier Hill iron mill (closed in 1979) in Youngstown, Ohio, where Kaulen had moved. At this site they created *Giant Woolly* [or *Wooly*] *Millipede*, and later, shot *The Attack of the Giant Woolly Millipede*, a short film. The installation was destroyed when the mill complex was demolished in 1997.[10] Eventually, they returned to Carrie to build the Deer. Like the Owl before it, the Deer explores the dialectic between Carrie's industrial past and extant material culture and the resurgent nature that had overtaken it. Co-op members had appreciated the site's abundant wildlife, including various mammals and birds of prey—and had debated creating a wild turkey but ultimately decided upon a deer, a stag. Deer had been a frequent presence, and the group installed a salt lick to attract them and capture in images their movement against the mill's ruins. At the same time, Kaulen noted, the material used in the Deer embodied Pittsburgh's steel industry and its workers and was "a placeholder" that calls attention to the region's "unique geography," which "allowed industry to boom and then crash."[11]

I learned much of the Deer's story from Kaulen and Liz Hammond (and from the 2015 film *The Carrie Deer Documentary* by Pittsburgh-area filmmaker Sharron Brown). Hammond, who was younger than the others and the only female of the seven-member core group, had come to Pittsburgh from suburban Michigan in 1994 to study at the Art Institute. She had not been involved in the Owl but well recalled building the Deer and the challenges it entailed. Carrie's remoteness was

both an impediment and an asset. Its lack of paved roads forced Industrial Arts Co-op members to hike in from the edge of a Swissvale neighborhood to the north where they parked their cars. Their route, approximately one-quarter of a mile from the furnaces, took them downhill through thick postindustrial growth, including what was once the workers' parking lot, underneath or across active freight tracks and through a hole in a fence. Hammond said it was "never a direct route," and they would often pause to observe something. On a few occasions they flushed out a wild turkey; she says that this where she learned of the "the turkey's impressive wingspan."[12]

The artists entered and quietly moved about the site with heightened awareness. They kept unnecessary noise to a minimum, covered their tracks, and closed the hole in the fence upon entry and exit. Hammond described the Furnaces as "eerie quiet" and noted that "the smallest noise would ricochet off the buildings." Given Carrie's overgrown state and lack of roads and the fact that they worked only on Sundays, their encounters with security patrols were infrequent. On occasion, they did run into graffiti artists, photographers, or explorers, some of whom Hammond described as "friendlies." Yet if they heard someone approaching, they quickly found a hiding place, often up a level or two above the ground. "You did not want to be discovered," Hammond said. While the artists would hide, they did not have to cover their sculpture in progress. "We built that deer head out of different piles [of materials] lying around so it just probably looked more like mangled piles of the same stuff," she explained.[13]

Co-op members began working on the Carrie Deer in 1997 and finished it nearly a year later. The sculpture was constructed of half-inch diameter steel tubing, copper ties, metal wire and conduit, and rubber hoses using simple hand tools, mainly lineman's pliers and bolt cutters. The artists also used a hacksaw and a few other tools they found on site, while others were improvised. Most of the work took place on the ground, where they bent, cut, and fastened metal tubing into the components of the deer head, including its neck, head, ears, nose, and antlers. To help them bend steel into neat circular or spiral shapes, they created jigs out of metal grates and pegs they had salvaged.

The group targeted the roof of a small one-story structure as a pedestal for the work. The building, a decaying pump house flooded with water, sat in a kind of hidden courtyard, nearly enclosed by other buildings and the mill's intricate web of ducts and machinery, close to both remaining blast

furnaces. This location would make the sculpture somewhat hard to find for security patrols and other visitors; and while its siting atop the building would not preclude destructive acts, it would make casual vandalism more difficult. At the same time, the location provided a theaterlike setting for the sculpture, and its improvised pedestal would raise the Deer to a level where it would sit more confidently amid the large-scale machinery around it while the viewer could imagine the rest of its body below. The deer head would be installed facing and in direct dialog with Blast Furnace #7, some one hundred feet across the courtyard. Yet no one was fully confident that the decaying building would actually support such a sculpture. The artists constructed the Deer's neck first and then sketched a plan to install it on the roof before returning to the assembly of the head. From salvaged materials, the group built scaffolding, and using cables and ropes at-

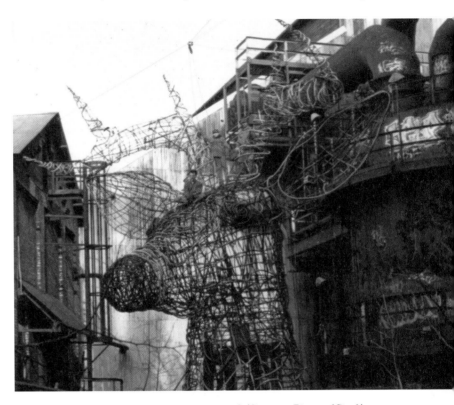

The Carrie Deer artists atop of their creation, 1998. (Courtesy Rivers of Steel.)

tached to the surrounding structures, hoisted the neck gently into place. Once the neck had been securely installed, they returned to work on the head.

As the Deer took shape, it seemed somewhat transparent and blended in against structures around it. To give it more visual definition, they wove lengths of various colored hoses that they had found in the plant. While the hoses were covered in dirt and grime, wiping them off revealed surprisingly vibrant colors: red, green, blue, and yellow. The process of dragging, cleaning, and sorting

the hoses was tedious and dirty, but worth it. After the head was complete—with all of its members joined and the hoses woven throughout—came the crucible moment of installing it on the neck many feet above the ground. Much like the neck's installation, the even larger head required significant planning and the strength of additional friends. Using a boat winch, several ropes, and cables attached to the structures around it, the artists hoisted the head into place. A nervous affair, none were sure if the great mass of bent metal would hold together or collapse from its rooftop perch. But when they cut the supporting cables, the head stayed in place.

Co-op members had no idea that the Deer would persist, let alone become a permanent installation of an industrial heritage site, and initially shared the work only through photographs. "It really didn't matter if anyone saw it," Hammond noted. "It was a lot of fun, but I didn't want to get a charge of trespassing—so, yeah, you kept it under wraps. . . . And I really relinquished ownership of the deer the moment we called it done."[14] In his assessment of the Deer, Kaulen emphasized the collective design and building process rather than its monumental qualities or unlikely permanence. He noted the "camaraderie that exists when people put themselves in a situation to solve problems and discover things together," and called the "fifty-odd Sundays working on the Deer the most rewarding and inspiring periods of time that I will ever experience."[15] Kaulen, Hammond, and the other artists assumed that the sculpture would be destroyed by vandals, the elements, or the site's owner. Yet even as the artists were wary of publicity, word of this unusual monument began to spread.

Ron Baraff was certainly aware of the Deer. He had joined the Steel Industry Heritage Corporation around the time it was being completed. Having grown up in the region, he remembered playing in the Mon Valley's woods and slag dumps and referred to Carrie and other metal mills, many still operating at that time, as "the backdrop of my childhood." However, like many of his generation, Baraff left to attend college—at Portland

Rivers of Steel's Ron Baraff (Author, 2017.)

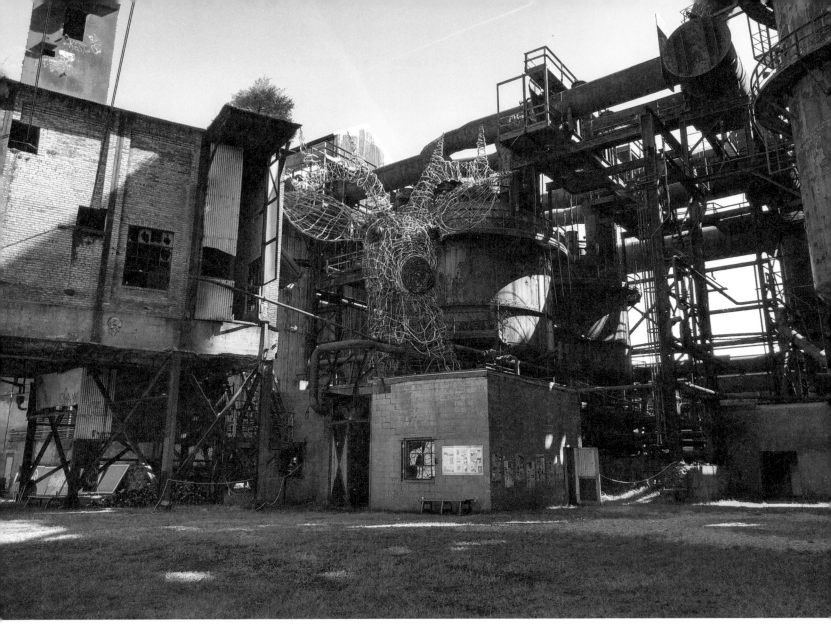

The Carrie Deer, 2019. (Author, 2019.)

State University, studying public history—and spent almost a decade and a half mostly in the Pacific Northwest, before returning with his wife who was also originally from Pittsburgh. With his background in history and his sensibility shaped by his Mon Valley childhood, Baraff was both an ideal person to become the ROS director of museums and archives—a title (or similar title) he has held since he began working there in 1998—and to be a champion of the Carrie Deer.

In 2000 Baraff was helping prepare the Carrie Furnaces National Historic Register nomination and needed photographs of the mill, which was then still owned by the Parks Corporation. While Rivers of Steel had an often contentious relationship with Parks and had fought the corporation to prevent the demolition of Carrie and Homestead, Baraff was able to obtain permission for a chaperoned visit. As corporation representatives escorted him through his photographic documentation, he fruitlessly attempted to keep them from seeing the Deer. But when the inevitable moment occurred, he was surprised to learn of their positive reaction. They thought it was cool and wanted to know more about it and its creators. Not long after, Kaulen organized a bus tour of public art projects for attendees of a sculpture conference being held in Pittsburgh, which included a stop at Carrie. Parks approved but insisted that the visit be chaperoned. As Hammond remembered the bus tour, the corporation's representatives and local media were compelled by the discourse among members of the international sculpture community and gained a larger appreciation for the cultural cachet of this guerrilla work. While there was no explicit agreement, Parks did not demolish the Deer. When the property was later sold to Allegheny County to be managed by Rivers of Steel, Baraff made sure that it was not demolished or forgotten in the larger effort to preserve the mill's historically significant structures.

Preserving Industrial Heritage While Growing a Postindustrial Economy?

During the 1990s, while the Industrial Arts Co-op was working on installations, both guerrilla and authorized, on former steel sites, the Steel Industry Heritage Corporation was fighting to save the

Carrie and Homestead mills. When I met with longtime SIHC / Rivers of Steel executive director Augie Carlino in 2017, he described the long and bumpy preservation campaign. A former lobbyist, Carlino had been the organization's leader since its inception as the Steel Industry Task Force in 1988. At its onset, SIHC's guiding vision was an industrial heritage park straddling both sides of the river and incorporating the near entirety of both sites, over five hundred acres, including property in at least five boroughs. Much like the Buffalo Grain Elevator Project, the SIHC found inspiration in Germany's Emscher Park, with its varied sites spread on a regional scale with generous support from the federal government. The Carrie and Homestead sites would form the park's core and could be adapted much like Duisburg Nord Landschaftspark, once the Thyssen Steel Plant, which closed in 1985.

Carlino and others imagined that the park's development would both preserve the history and culture of the steel industry, the most pervasive shaper of everyday life in the Mon Valley, while helping to heal the economic, social, and environmental scars the industry had left behind. Yet from inception this vision was not shared by the new owner of the Homestead and Carrie sites, the Park Corporation, which had purchased both sites from U.S. Steel, the same year as SIHC's founding. The heritage park concept did have a few champions in Washington, DC, and Harrisburg, the state capital, who were periodically able to direct resources to the initiative. Like other proposed American industrial heritage projects, the SIHC's plan never received anywhere near the equivalent public investment as the billions of euros dedicated to Emscher.[16]

By 1992, as SIHC was courting funding from federal, state, and foundation sources and promoting the heritage park's potential to attract tourists and generate jobs and tax revenue, the Park Corporation was busy scrapping machinery and demolishing buildings in preparation for some yet-to-be-determined development. Yet with the financial backing of the local Howard Heinz Endowment and other foundations, SIHC negotiated a preliminary agreement to purchase seventy-seven acres from Park (twelve at Homestead side and sixty-five at Carrie) for $1.5 million, contingent upon obtaining additional long-term funding.[17] While there was now clearly less to save, SIHC pushed ahead with a plan focused on the remaining buildings, including the Homestead Pump House, a focal point for one of the seminal events in US labor history, the 1892 Battle of Homestead. In this conflict, striking steel

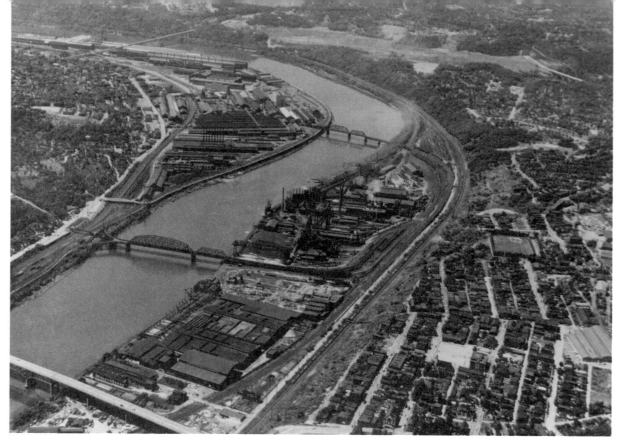

The combined Homestead Steel (background left) and Carrie Iron works (foreground, right) formed the world's largest integrated steel plant in the early twentieth century. (Library of Congress, ca. 1950s.)

workers fought the Pinkerton guards hired by Andrew Carnegie to secure the mill, which resulted in the deaths of ten people and ultimately set back by several decades the cause of organized labor at the plants, with unions not re-forming until the 1930s.[18] The park would be modeled on the National Park Service (NPS) industrial heritage park in Lowell, Massachusetts, focused on textile mills, which at that time drew approximately eight hundred thousand visitors a year.[19]

The plan needed a congressional designation and an NPS commitment to fund and administer the park. By 1994 NPS was still in the early stages of evaluating the project, and a designation was still several years away. Without NPS's firm commitment, SIHC could not obtain contingent foundation and state funding, thus jeopardizing the complex land sale. The Park Corporation had already demolished 90 percent of its buildings, as negotiations with SIHC dragged on. Concerned

that SIHC lacked the capacity to rehabilitate and maintain the properties, Park leaders feared that the heritage park project might drag down the appeal of their own development. While publicly committed to preserving the Pump House and adjacent water tower, the firm came under fire when it began demolishing "The Big Shop"—Homestead's machine repair shop that served all of U.S. Steel's Monongahela Valley steel mills, which Park's chief engineer noted was "right in the middle of our development."[20] SIHC had planned to use the building to display Homestead's two-hundred-ton, forty-eight-inch steam-powered rolling mill, apparently the last one of its kind in the United States. Previously, SIHC convinced Park to dismantle the mill and store it off-site for eventual inclusion in the park or museum, a modest victory for the campaign.[21] The Big Shop's demolition was halted when the town of Munhall, where that portion of the plant was located, realized that Park lacked a valid demolition permit and the building sat half-demolished for a time.[22] The setback was only temporary, and eventually Park cleared the Big Shop and other significant structures.

By 1996 SIHC's industrial heritage advocacy campaign was finally beginning to bear fruit. The US Congress and state officials designated the Rivers of Steel National Heritage Area, a seven-county district of southwestern Pennsylvania that included dozens of potential steel heritage sites. SIHC would administer the tourism-oriented program and be eligible for $1 million or more annually in state and federal grants to create sites within the heritage area. The following year, Continental Real Estate (Park's development partner and successor) donated the twelve acres containing the Pump House and water tower to the organization. In another victory around this time, SIHC convinced the Union Railroad (a small railroad owned by U.S. Steel whose purpose was transporting materials into and out of its southwestern Pennsylvania metal works) to donate the extant Hot Metal Bridge that once facilitated the conveyance of molten iron from Carrie to Homestead.[23] Yet the heritage campaign was progressing at a far slower rate than the competing Homestead redevelopment. In 1997 the Park Corporation and Continental broke ground on The Waterfront, a $300 million mixed-use development. And in 1998, Park sold its entire share of The Waterfront to Continental but retained ownership of Carrie. To facilitate development, Allegheny County commissioners approved a $21 million 279-acre Tax Increment Finance District to pay for new roads, water, sewer, and other infrastructure at the Homestead site. The Waterfront's first business, a McDonald's,

opened in 1999; other national retailers would soon follow.[24] Carlino, reflecting on more than a decade of negotiations for Homestead and over seventeen years for Carrie, argued that Park had bargained in bad faith and never possessed genuine interest in industrial heritage. SIHC enjoyed a better relationship with Continental, which recognized the potential value of historic attractions adjacent to its own development. Continental also decided to retain and stabilize a series of hundred-foot-tall 1900-era smokestacks, which now sit in the vast parking area of the western end of The Waterfront.

The negotiations for Carrie continued to drag, complicated in part by the uncertain level of required environmental remediation, and Park leaders continued to treat the industrial heritage park concept with disdain. President Ray Park called Carrie "unsightly" and said the corporation was holding onto it only because of the ongoing negotiations.[25] But Park would have likely demolished and scrapped Carrie if it could. The 1990s market for scrap was less than robust, and Park had no economically efficient way to remove scrap from the site. There were no real roads into Carrie, and the Hot Metal Bridge was owned by SIHC, Carlino explained. This condition provided the organization with additional leverage and the ability to effectively forestall demolition.[26]

Around the millennium, Allegheny County officials, ever hungry for opportunities for economic development, began playing a greater role in the negotiations. Then county comptroller and ROS board member Don Onorato emerged as a Carrie champion, and his election to county executive in 2003 provided fresh momentum for the heritage park project. By 2004 the county, in a series of public meetings and with the media, was touting a plan for Carrie's reuse, largely derived from a 2001 consultant's report. The plan envisioned preserving remaining mill structures as a centerpiece to a steel industry museum that would include the Pump House and other extant historic structures across the river. The iron mill would also serve as an anchor for adjacent development, including an office park or light industrial space to the east and a residential development to the west. The Hot Metal Bridge would be rehabilitated to carry automobile traffic, which would provide access to the new development and connect new residences directly to The Waterfront's retail district.[27] Downriver, the Urban Redevelopment Authority of Pittsburgh had converted a similar hot metal railroad

bridge in 2000 to connect redevelopment projects at the J & L's former respective iron and steel sites.[28] The county's plan was speculative, with uses and configurations ultimately determined by the market, and only retail was ruled out as to not compete with The Waterfront. Carlino and Baraff both told me that the bridge was the key to the county's involvement. Rivers of Steel had to essentially trade the bridge to secure the county's eventual purchase of Carrie's historic core, which would be then conveyed to the nonprofit.[29]

With Onorato now its county executive, Allegheny officials took the lead, engaging in weekly discussions with the Park Corporation. To support the emerging vision, Governor Ed Rendell awarded the county a $6 million grant earmarked for Carrie's purchase and remediation or infrastructure development.[30] In 2005, when Park filed demolition permits for Carrie's remaining structures, the discussions took on greater urgency. By the late spring, the arduous negotiations, which had lasted the better part of two decades, were finally completed, with Allegheny County purchasing 137 acres from Park for $5.75 million (some three times the value of the properties, according to county assessors). The purchase included the core thirty-five-acre historic property containing the two remaining blast furnaces as well as adjacent acreage around the mill and a small area on the river's opposite bank. While Rivers of Steel, local preservation advocates, and some former steel workers were happy that the blast furnaces would remain standing and could envision the heritage park built around them, the county was thinking more about the ancillary spaces. County executive Onorato called Carrie a "remarkable development opportunity" that could "provide the spark to stimulate job growth and revitalization of some of our more distressed neighborhoods in the Mon Valley" and "another key step in our ongoing effort to redevelop old industrial sites in order to spur private development."[31]

The Carrie Furnaces had been saved from demolition, but its new steward, SIHC, still lacked funding to develop a full-fledged industrial heritage park on both sides of the Mon. In fact, the public funding commitments and agreement with Allegheny County, now the underlying owner of the site, stipulated that the organization find additional matching funds for development. Further, SIHC's mission, now as the administrator of the six-county Rivers of Steel National Heritage Area, designated by Congress in 2006, had been significantly broadened—and it spent much of its efforts

and funding administering dozens of smaller industrial heritage projects and programs across the region during its first two decades, according to Carlino.[32]

More invested in the ancillary sites, the county's preliminary development concepts were neither integrated nor dependent upon the preservation of Carrie's thirty-five-acre historic core. In the years after the purchase, the county became consumed with preparing these sites for development, including executing plans for environmental remediation, infrastructure installation, and marketing. Yet by 2008 its more immediate development priority focused on the economically struggling city of Braddock, upriver from Carrie. While possessing U.S. Steel's last remaining active integrated steel mill in the region, Braddock was a hollowed-out city that had shrunk from over twenty thousand in population in the early twentieth century to under three thousand by the turn of the millennium. In Braddock, the county's development projects included a hospital expansion (which was closed and demolished a few years after the expansion's completion), a senior housing development, and the rehabilitation of the Rankin Bridge, which was also a key precursor for marketing the Carrie sites.[33]

By 2009 Allegheny County had spent $7.2 million on Carrie, including its acquisition and environmental engineering, site design, and remediation. But it estimated that another $35 million was necessary for new infrastructure—the site still lacked paved road access—and grading to raise portions of the property so that infrastructure would sit above the floodplain. The county was hopeful that developers would ultimately pay for some or all of these expenditures. Even as the recession slowed the pace of reinvestment, County executive Onorato was bullish on the Mon Valley. About Carrie and other brownfields in the county's portfolio, Onorato told the *Post-Gazette*, "We just have to clean them up and business will come." The Carrie site, he said, "has all the things that investors are looking for. It's only a few miles outside Downtown Pittsburgh, and it's easily accessible by water, by rail, and the East Busway," referring to three often-discussed but yet-to-be-built transportation systems. The county's emerging vision included a mix of riverfront housing, light industrial manufacturing, and office space built around a steel heritage museum on the site's historic core.[34]

In 2011 the county received what the *Post-Gazette* called the "last piece of the Carrie puzzle," when US senator Bob Casey and local US representative Mike Doyle secured $10 million from the federal Department of Transportation for a flyover ramp from the Rankin Bridge to facilitate access

to the mill.[35] Doyle—whose grandfather worked at Carrie for forty years, and his father served thirty-one years at U.S. Steel's Edgar Thomson Steel Works in Braddock—had long been a champion of the project and had sponsored the legislation to fund the National Park Service's historic resource study that ultimately led to the mill's NHR designation in 2006.[36] The flyover, completed in 2015, complemented the county's investment in new water and sewer lines and would provide "unparalleled access" to the site, according to Doyle, and represented a "holistic approach" to safety and the utilization of existing infrastructure.[37]

Not Strictly Industrial Heritage Tourism

As the county moved ahead with contracts for sewer installation and raising the easternmost parcel (the first to be redeveloped) above the floodplain to facilitate office or light industrial development, ROS was beginning its own incremental plan for Carrie's historic core.[38] Even with the mill's challenging access, the organization was not waiting around for the flyover's completion or the realization of a museum or park, whose estimated cost was $78 million at the time of the county's 2005 purchase.[39] While absent funding to make Carrie a legitimate tourist attraction, ROS did receive a five-hundred-thousand-dollar grant from the Pennsylvania Department of Conservation and Natural Resources for repairs, such as replacing roofs. But the organization was also moving forward with dozens of volunteers, including some of the mill's former workers, who cleaned, repaired, and secured the site.[40]

With only rudimentary vehicular access provided by a gravel service road—and no running water, electricity, or other utilities or comforts—in 2012 Rivers of Steel began offering Carrie tours. Often guided by former steelworkers, the tours were immediately popular. ROS soon expanded its offerings to incorporate other regional cultural practices, including special beer tasting tours and the "hard hats and babushkas" tour. But industrial history remained at the core. As Baraff, who had organized the initial "hard hats" tour program, informed the *Post-Gazette*, "The story told here is not just about the region but tells the story of our country and how we got here."[41]

Carrie Furnaces Boulevard, completed in 2015. (Author, 2019.)

I have taken some variation of Carrie's industrial history tour four times. All provided a loosely structured journey through the plant following the progression of raw iron ore, coke, and lime to the "finished" product of molten iron poured into torpedo cars ready for transport to the steel plant across the river via the Hot Metal Bridge. Along the way, we discussed many topics, including working conditions, labor relations and worker camaraderie, the history and culture of U.S. Steel, contemporary steel manufacturing technology, and the region's broader history and geography. During my first two tours, the structure and easy narrative flow were broken when we got to the Deer. The former U.S. Steel engineers who guided these tours could not provide answers to the earnest questions of participants, some of whom had eagerly anticipated this moment. On a solo tour a few years later, Carrie retiree and guide Jim Kapusta said the Deer was "just something that somebody did who thought it would look nice."[42] Baraff says some older guides would express displeasure or acknowledge it and quickly move on. One apparently said, "I don't like it, but they make me talk about it." Baraff is constantly attempting to balance the big and consequential industrial history narrative with the much smaller and nearly lost postindustrial narrative of the Deer, and meaningfully connect them. Guides are free to construct their own script, he says. "I don't tell them what to say," he explained. "I just tell them, 'You can't bash it, okay? And you can say that it is not your thing, but it is an important part of what happened here.'"[43]

River of Steel's evolving administrative approach for Carrie can be characterized by the tension between the preservation and touristic presentation of the industrial past and engagement with the postindustrial ecologies that guerrilla actors had previously found so compelling. My first two visits, a few days apart in 2015, provided a taste of these conflicting ideals. Getting to Carrie from downtown Pittsburgh, about eight miles away, is not straightforward, and I got lost on both occasions. Prior to the late 2015 completion of the flyover from the interchange of South Braddock Avenue and

the Rankin Bridge approach, a driver could only access Carrie via a hard-to-find, well-pitted gravel service road sandwiched between two sets of railroad tracks; at no moment upon approach could one see the furnaces. On the first occasion I found the access road after an unplanned tour of Braddock's former commercial district and the marginal spaces underneath the Rankin Bridge, before proceeding across what seemed to be a barely maintained railroad crossing (on the second, determined not to get lost, I employed GPS directions via my phone, but alas, I found myself even farther afield). Once on the gravel road, hemmed in by raised railroad berms on both sides, I was still unable to see my destination or anything else other than the gravel in front of me, some weeds, and the dust that my car kicked up. That's when I realized that a Fiat 500 was not the appropriate vehicle to rent when visiting a place of this nature. I was fortunate not to have damaged the car on either visit.

I thought about Carrie's relative inaccessibility upon arrival the following year. After the long descent from the hills above the valley down South Braddock Avenue into the Rankin Bridge approach, I made an easy and intuitive turn to the right on the recently completed flyover and cruised down the smooth pavement of Carrie Furnace Boulevard with the blast furnace complex squarely ahead of me. "Unparalleled access" had arrived, and the former mill had been opened to the driving masses (but for pedestrians, cyclists, and those dependent on mass transit, not so much). Carrie had been partially knitted back into the region's fabric, but part of its off-the-grid aura and the heightened sense of anticipation or uneasiness one experiences prior to arrival had been lost. The contradiction of being a culture-defining landmark that could be seen throughout much of the valley even as it remained hidden and inaccessible had been partially corrected. I also thought about the Deer artists and other unauthorized visitors who in an earlier era entered Carrie on foot and encountered it in a more pristinely ruinous state, overtaken by plant life. While part of Carrie's essential experience had been getting there, progress does create trade-offs. Yet transportation improvements have enabled Rivers of Steel to increase programming and allowed more people access.

ROS's administration has frequently attempted to strike a balance between the postindustrial wilds and more accessible touristic experiences, but also exploit opportunities created by this tension. Carrie had long been a destination for graffiti artists, and after ROS assumed control in 2005, graffiti break-ins continued, much to the dismay of administrators and their Allegheny County part-

ners. Baraff assigned to volunteers the task of removing or painting over graffiti while the organization initiated practices to thwart graffiti writers, including installing security cameras, and pursuing prosecution for those caught, and establishing a more regular presence of employees and activities on-site. These measures may have been necessary but seemed to contradict Carrie's countercultural spirit. Straddling the fine line between curator and steward, Baraff recognized that, like the Deer, graffiti had played a role in making Carrie a viable destination and understood it as a defining postindustrial characteristic. In fact, those on early industrial history tours would often ask about the graffiti, but again the former steel worker guides could not provide answers. In 2013 ROS offered its first Carrie urban art tour, which focused on graffiti and the Deer but also included a smattering of industrial history.[44] Much like the industrial history tours that were led by former workers, the urban art tours were guided by graffiti writers who had previously created (unauthorized) works at the mill. They also featured a workshop component that enabled participants to create and leave with an artwork they created.

But having tours and engaging a few prominent graffiti artists would not necessarily stop others from breaking in and tagging. Likewise, Baraff did not view graffiti as an artifact of the postindustrial period, but an ongoing activity that added to the site's vitality and could potentially make ROS's industrial history mission more viable. Taking a broad view, he often says that Carrie's history didn't end when the last batch of iron was produced in 1983. "Not everybody has to be a history geek to fall in love [with Carrie], and the guys that were coming in here even illegally years ago and were doing pieces here weren't coming in necessarily to be destructive," he argued. Other than "people climbing to the highest point and hanging off and doing their initials . . . it wasn't an act of desecration." Rather than outright prohibition, Rivers of Steel attempted to gently nudge the graffiti artists toward lawful activity. As Baraff explained in 2015,

Our rules for people that want to come paint is that they work through us. I don't tell them what to paint. . . . All I tell them is where they are allowed to paint and they have to do it with someone here. They can't break in. And what it's done is taken what was a regular occurrence here—a high level of stress for all of us—and reduced it down to virtually nothing.[45]

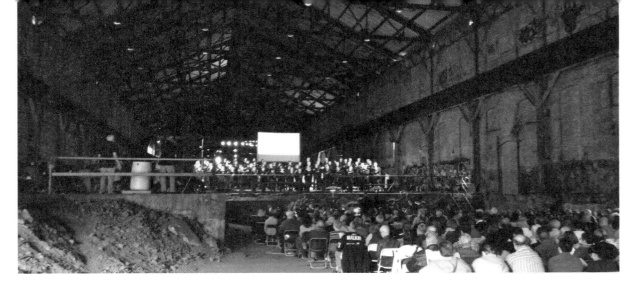

Pittsburgh's Bach Choir performs Smoke and Steam in Carrie's Blowing Engine House. (Author, 2017.)

The American Ninja Warrior competition staged at the Carrie Furnaces in 2015. (Michael Henninger for the Pittsburgh Post Gazette.)

Carlino and Baraff both admitted that some stakeholders, including some county officials and former steelworkers, are uncomfortable with graffiti and didn't understand how it was related to industrial heritage. But those perceptions have been changing as attendance continues to increase at Carrie arts programs and events.

The presence of the Carrie Deer and abundant graffiti has helped catalyze Rivers of Steel's broad programming, which includes concerts by Pittsburgh's Bach Choir, a 2019 production of *King Lear* by the Pittsburgh-based Quantum Theatre Company, and—like Silo City—Valerie Lyman's *Breaking Ground* installation, in addition to staging the *American Ninja Warrior* competition for television, classic car shows, weddings, and retreats. When the pandemic struck, Carrie hosted drive-in movies and, later, outdoor events like Taco Fest, Beers of the Burg, and a motorcycle show, the latter two events drawing thirty-five hundred visitors each. "The Carrie Deer brings people to this site," argued Baraff. Unusual arts programming, including graffiti tours and workshops, the Festival of Combustion, and other "metal pour" events—some administered by the Deer artists—has enlarged the constituency interested in industrial history and made more viable the core mission of telling the mill's story. Since the first tour in 2012, programming has expanded despite raw conditions and a dearth of amenities (in 2022 there were still no permanent restrooms). Creative offerings now include a variety of photography sessions and weeklong iron-making workshops, while popular events such as multiday music festivals in 2016 and 2017 each drew some ten thousand people over a weekend. The urban art tour has evolved into two separate programs: the Arts and Grounds Tour—which combines content about the Deer, graffiti, and recently created installation art with landscape design, horticulture, and ecology—and a separate Graffiti and Style Writing Workshop. ROS also offers a separate botanist-led Iron Garden Walk, which focuses on the site's postindustrial ecologies.

Carrie's programs, initially limited to weekends, now run throughout the week, although they're still mostly seasonal with few occurring from November through March. And while the site still lacks a weatherized indoor space, running water, and sewers, during the peak months (June through September) there is rarely an idle day. Even when nothing is scheduled, a crew may be setting up or breaking down for an event, or a location scout might be touring the site. Carrie has been in demand as a setting for film, television, and media shoots, particularly for productions seeking gritty indus-

trial (or postindustrial) locations, which are ever harder to find across the Rust Belt due to pervasive redevelopment practices. Carrie is also attractive to news or other crews seeking scenic or regionally distinctive locations or simply places to generate B-roll footage. In recent years, feature films shot at Carrie include *Out of the Furnace* (2013) and *Concussion* (2015); television shoots included the Cinemax crime drama *Banshee* (2013–2016), the late Anthony Bourdain's CNN travel and food series *Parts Unknown*, and PBS's *GlobeTrekker* (for a piece where Carrie was the subject rather than scenery), as well as BBC and History Channel programs.

Other rentals—where the programming is being generated outside the ROS umbrella, including weddings, corporate meetings, and other one-offs—have provided revenue that is reinvested in on-site improvements and the organization's own programs. They have also raised Carrie's visibility. Yet overseeing these rentals is time-consuming. For Baraff, it grew into a significant part of his responsibilities, one that he never anticipated in his early years with the organization. During my visits, our conversations were regularly interrupted by his need to provide supervision for a maintenance project or visitor group, monitor an event set-up, or deal with the myriad problems that inevitably arise administering these endeavors. His phone pinged constantly, often with the messages or calls from people less than seventy-five yards away. "Sorry, I gotta take this," he often said.

Media shoots and rentals for events such as concerts and weddings have become *de rigueur* in the twenty-first-century for adapted US industrial sites administered by nonprofits. They often provide these organizations with a significant revenue source, which enables other free, more public or unusual offerings. Such event rentals regularly occur at The Stacks at the former Bethlehem Steel plant in Bethlehem, Pennsylvania, but also at even more unlikely venues, such as the Brooklyn Grange, a farm located on the rooftop of fifteen-story industrial building in the Brooklyn Navy Yard in New York. While the Grange sells its produce to local restaurants and stores, weddings and corporate retreats really pay the bills. Like the Central Terminal and Silo City in Buffalo, ROS attempts to limit rentals and keep the emphasis on its own arts, history, and ecology programming. It also works to engage the local boroughs and often holds "community days" where residents from nearby zip codes can visit for free. Community days also apply to events such as *King Lear*, where one of the nineteen performances was set aside for free admission for residents of the six Mon Valley cities

and towns where Carrie and Homestead Steel were located.[46] Programming, Baraff explained, is initiated through different avenues but usually begins with a phone call or email—often a referral from another organization that has staged something at the site. Much like Silo City and Buffalo, Carrie benefits from the large arts community of Pittsburgh, and Rivers of Steel attempts to keep it available for programs generated by local arts organizations such as the Bach Choir and the Quantum Theater.

With so many events, safety has emerged as an ever-present concern. Potential hazards abound, with numerous objects to trip over or gaps to fall into, and the site lacks a single paved path. Carrie visitors, whatever the event or activity, are not confined, protected, or buffered by smooth walkways, guardrails, rigid fencing, and other barriers typically found in fully improved postindustrial sites, such as the Steel Stacks or the park built around the artifacts of the former Domino Sugar Refinery in Brooklyn. "Unless you know the site and you know where you are, it's a death trap. Unless you're with someone who knows this site, it's a big risk," Baraff explained to the *Post-Gazette* in 2012.[47] In a place where guerrilla activities were mostly unmonitored or undetected, now nothing happens without some form of supervision. Walking potential renters through the site, he is sure to point out the fences, chains, and limits of access. "I do a lot of saying, 'No. No, you can't be there, you can't do that,'" Baraff told me.[48]

Much like Silo City, Rivers of Steel has also become far more insistent that renters possess their own substantial insurance. In 2016 ROS generally required a $4 million aggregate insurance policy plus another $1 million alcohol liability policy if organizers plan to serve alcohol, Baraff explained. While lower-intensity events such as the Bach Choir performance and most weddings can carry less, film shoots are required to have even more coverage (usually in the $6 million to $7 million range) because of the intensity and duration of site use. For individuals who participate in tours, potential injuries are covered under the organization's general liability policies, but all must sign a liability waiver before the tour.[49]

Baraff maintains a healthy sense of humor about the tasks he must manage and problems he must solve. But these responsibilities have impacted his and the organization's ability to think beyond the current moment, day, or week. Recently, Rivers of Steel expanded and went through a profes-

sionally facilitated reorganization and in 2022 was in the middle of a strategic planning process that is leading to a capital campaign. With greater financial backing from local foundations and more revenue generated from activities and rentals, the nonprofit has been able to expand its staff and create new departments. Creative activities are now managed through a spinoff, Rivers of Steel Arts, which has its own director. The organization also hired Carrie's first full-time maintenance manager. All aspects of ROS's administration of the furnaces continue to mature into something more professional with more forethought and better funding.

Postindustrial Preservation: Two Approaches

While the Carrie Deer and graffiti have proven to be popular—and, in the case of the Deer, awe-inspiring in a way that complements the industrial heritage experience—such additions or alterations to a designated historic site are generally taboo. As I noted in earlier chapters, the narrowness with which the National Park Service interprets the term "historic" jeopardizes, disqualifies, or discourages the nominations of many potentially worthy industrial sites. The US Secretary of the Interior's Standards and Guidelines prioritizes the conservation of original material culture over other potential aspects of historic places, including preservation of activities and uses, people or populations who occupied them, and narratives or dialogues with the past that are not dependent on strict retention of historic materials.[50] Sites that are more landscape than building present additional challenges. To obtain and maintain a National Historic Landmark designation (which Carrie received in 2006) or even the lesser listing on the National Historic Registry, nominated sites must have significant "material integrity" related to its "period of significance" (for Carrie, 1906–1941). Yet according to these standards—which apply to all national historic sites regardless of their size, use, design, age, or materials—a former steel mill, with dozens of structures covering a hundred acres or more must essentially meet the same standards as a historic single-family home. The standards concerning feasibility of rehabilitation and reuse in most cases is left to the market, supported by federal, state, and sometimes local incentives. It makes sense: Without a capable, well-capitalized

steward and a plan for reuse, preservation projects will fail and historic structures will ultimately be lost.

Yet with the paucity of historic places under public ownership at all levels of government and little allowance for slowly evolving projects with indeterminate outcomes and only modest financial backing, many worthy reuse and adaptation activities never occur. The material integrity require-ment often overwhelms potential projects, given that industrial works usually possess multiple and sometimes dozens of structures, often built in different eras, and have been subject to component replacements, expansions, and upgrades. At the same time, too much material integrity jeopardizes feasibility of conservation and adaptation, given that most industrial structures don't lend them-selves to straightforward conversions to market-valued uses such as residential apartments, office or institutional space, or retail.[51] Many industrial structures, including blast furnaces, coke ovens, and draft stacks, simply have no viable reuse other than being objects of visual contemplation or scenery to punctuate new development. This is true of Homestead Steel's former smokestacks that are used in The Waterfront's retail development and the former blast furnaces at Bethlehem Steel, which form the core of Steel Stacks, a history, entertainment, and leisure destination.

For Carrie, the NPS nomination—prepared by Michael G. Bennett, a Vermont-based historian, with significant assistance from Baraff—was fraught with uncertainty. While the nomination wasn't submitted for formal review by Pennsylvania's State Historic Preservation Office (SHPO) until 2006, the application was mostly prepared in the early 2000s while the Park Corporation owned the property. So much of the site was already demolished, and the corporation provided the most meager of access for the required field evaluations. Bennett was allowed only two one-hour visits.[52] The advancement and approval of Carrie's nomination was helped by growing political backing and commitment of public investment, even as the political actors were more interested in the redevel-opment potential of ancillary spaces, rather than preserving the remaining historic mill structures.

Baraff framed the designation dilemma for me: how could Rivers of Steel structure the nomina-tion in a way that would ensure its success but also acknowledge the passage of time and the many alterations made, including those by guerrilla actors, while maintaining the looseness that would allow for the continuation of activities that might threaten material integrity and intactness? The

answer was to interpret the mill's historic significance narrowly. The nomination would delineate the site as a "pre–World War II blast furnace complex," including the furnaces, hot stoves, hoist house, powerhouse, and dumper car system, instead of defining it around a broader concept of significance and a longer period that would incorporate more buildings:

> Because what is here is a relatively intact, extremely rare and in many cases, the only example of pre–World War II blast furnace technology. Nothing on this site other than a few exceptions changes after 1936. So, these are turn-of-the-twentieth-century blast furnaces that reflect the technology of the day, . . . What it doesn't have is the automation that comes in after [1936]. That was the hook. And once we found that hook . . . the pathway became really obvious, and it became a much easier sell.[53]

Material integrity issues were avoided by dividing the site into "contributing" and "noncontributing structures." The nomination included nineteen contributing buildings and structures but also seven non-contributing buildings and structures and one noncontributing "site." This kind of division, based upon the question of whether structures support the historic significance as described in the nomination and limited to those built during the period of significance, is common to multi-building applications. Preservationists who prepare these reports often define "significance" narrowly, omitting portions of a historic site so as not to tie the hands of potential property developers or stewards, who might be able to save only the most significant building or buildings within a complex. This was done at the Domino Sugar Refinery in Brooklyn, where only three buildings (which visually read as one) from 1884, were designated landmarks, while the site's nearly twenty other structures, built over the long life of the plant (closed in 2004), were not included in the 2007 local landmark nomination and were cleared—but not without controversy—by the complex's ultimate developer, to make space for new buildings and park areas.[54] At Carrie, structures were left out not so much for their potential market value but to facilitate sensible stewardship and to allow the site to continue to evolve organically. The pump house underneath the Carrie Deer, built in 1955, was non-contributing and had "no real bearing" on telling the story of the pre–World War II complex, and

thus did not jeopardize the nomination or require interventions that would result in the Deer's removal, Baraff explained. About the building and Deer together he noted, "In our eyes, it's protected; but under the NHL [National Historic Landmark] we can do pretty much anything we want."[55] Similarly, structures such as Carrie's numerous walls that were not included in the nomination can also be altered. This approach enables Rivers of Steel to allow new graffiti works in designated areas.

Yet Carrie has not been entirely immune to preservation issues concerning designated structures. During my 2017 visit, Baraff pointed to the towering draft stack built in 1936, located adjacent to Blast Furnace #7. The 250-foot stack, the site's tallest structure, vented the waste gases produced by six hot blast stoves, which created the hot gas (eleven hundred degrees Fahrenheit or higher) that fed Furnaces #6 and #7 (the blast of "blast furnace").[56] The following week, a work crew was going to dismantle the stack's most deteriorated portion, the top seventy-five feet. Left untreated, the stack might collapse or simply continue to deteriorate, risking human safety and the integrity of other structures. For two years, Rivers of Steel considered potential interventions, but its options were constrained both by funding and the pervasiveness of deterioration; the stack had been a victim of nearly forty years of inactivity, no maintenance and punishing cycles of western Pennsylvania weather. Baraff explained that ROS's original intent was to leave the stack in place and repair it with banding or plating, but its condition was simply too degraded.

Rivers of Steel's dismantling plan was complicated by the draft stack's status as a historically contributing structure. The organization had to first seek approval from Pennsylvania's Historic Preservation Board and make a commitment to reconstructing the removed portion. As part of the application, the organization needed to submit a rebuilt design scheme. When I asked whether there would be an eventual reconstruction using the removed materials, which is what preservation boards typically expect, Baraff replied, with some resignation, "In a perfect world, sure you reuse some of the materials, but it's just impossible because . . . the steel and the brick are so far gone. . . . The brick is mostly turning to powder." As an alternative, Rivers of Steel would "interpret the process" and at some point install a panel near the stack documenting "what [it] looked like in its original form and here's what we did and why we did it, and probably [include] renderings of what it will look like when it's redone," he explained.[57]

The demolition, which required a crew working in baskets at the top of two cranes, cost Rivers of Steel over $250,000. Baraff noted that the cost of imploding the stack entirely was only about $50,000, but such an action "wasn't the responsible thing to do."[58] To pay for it, the organization had to redirect funds targeted for other purposes, primarily a general maintenance grant it received from Allegheny County from the state gaming money pool. He estimated that the organization could have realized six to twelve other projects from his "laundry list." And because the demolition was funded with public money, Rivers of Steel had to conduct a formal bid process before issuing a contract. Eventually, ROS signed a contract with Songer Services, a firm specializing in steel and iron plants (though usually functioning ones), and work was completed in the summer.[59]

Maintaining Carrie's historic structures was like walking a "tight rope," Baraff said. The extant parts of the mill were never built as monuments, and funding has never been in proportion to all the structures that need conservation. "Our goal is slow deterioration. We're never going to stop it," he said with resignation and a chuckle. "Sometimes it's like putting a Band-Aid on a gaping wound," Baraff explained. "But when your previous option was no Band-Aid at all? Well, if you put enough little Band-Aids on it, it will hold it closed."[60]

Yet Rivers of Steel organizational capacity was growing, including its ability to plan and carry out professional preservation measures to keep the mill's designated historic structures standing and accessible. After two years of fundraising that resulted in federal, state, and foundation grants, in 2023 ROS began a two-phase initiative to stabilize the #6 Cast House and rebuild the sluiceway behind it (and open the sluiceway alley to visitors), and undertake additional stabilization measures on the Hot Stove Deck. The organization has additional preservation interventions planned for the coming years that will also improve access to, and the usability and durability of, Carrie's historic core.[61]

One unanticipated preservation project—which, in contrast to the Draft Stack and #6 Cast House was outside of the historic designation—concerned the Carrie Deer itself. By 2014, some sixteen years after its completion, the structure was sagging, rusting, and in danger of eventual collapse. Its nose and snout, originally perpendicular to the ground, were now noticeably angled downward. The sculpture had been made of nonrigid steel pipes and bonded to itself only through metal ties, many of which were no longer ensuring that verticals were supporting horizontals. Perhaps even

Low-tech approaches characterize landscape maintenance practices at the Carrie Furnaces. (Author, 2016.)

more alarming was the condition of the building on which it sat, whose roof and walls had for years been carrying the weight of the Deer. The former pump house wasn't in particularly good shape before the Deer's installation, and had long been permanently flooded with a combination of river and rainwater, which continued to undermine its foundation and walls. While the cost of conserving and stabilizing the deer and the pump house below it would be significant, Rivers of Steel was unburdened by the need to involve the preservation board and could be creative and economical in devising intervention strategies. To help pay for it, ROS's Save the Carrie Deer fundraising campaign, which included a Kickstarter fund and an onsite screening of *The Carrie Deer Documentary*, raised approximately twelve thousand dollars.[62]

The Deer's 2015 conservation was a hands-on affair involving some of the Carrie Deer artists,

who oversaw the contractor's work. The conservation required adding steel I-beams, which were welded to the sculpture and anchored to the ground and other nearby structures. Additionally, a new roof was installed on the pump house and a new steel ring attached to the base of the Deer's neck, which now sits better positioned on the roof. And to correct the malleability of the steel piping, all junctions of horizontal and vertical members formerly connected by metal ties were welded together to create rigidity to maintain the sculpture's proper form and placement. The original ties were left in place, but the sculpture was also treated with a rust-resistant preservative. The interior renovation of the pump house, still partially flooded, was left as a future project.[63]

DIY Landscape Design and Waterfront Access

On my spring 2016 visit, Baraff and I took a walk around the grounds. Around the edges of the Ore Yard, the extent of growth seemed diminished, less than I remembered from the previous spring; the site's weedy perimeter seemed farther from the mill structures. Baraff said the yard had received an unanticipated enlargement thanks to volunteers who showed up one day with a bulldozer. It was only a temporary taming; the hearty grasses, including many invasives, would quickly grow back if left to their own devices. On the berm above the Ore Yard, volunteers had also moved a previously obscured locomotive some twenty yards to a prominent spot on the tracks feeding the car dumper/ ore bridge complex. Amid the light greens of April and the grassy carpet in which the tracks were set, the rusty locomotive was now a picturesque ruin—a kind of metaphor for Carrie and its vacillations between rust and nature. Yet in the minds of the volunteers, the job was not complete, Baraff said. These railroad enthusiasts were eager to fully restore the engine to its former glory.

Back along the long concrete foundation that separates most of Carrie's structures from the yard, we found a crew of goats munching away on the resurgent grasses lining the wall. Loaned to ROS by a local nonprofit, for almost a year the goats had been rotating through various sections of the site, reducing growth to a manageable volume. They would be around on and off throughout the spring and summer, alternating stays at Carrie with a job in the suburbs and stints at city parks. The goats

seemed to recognize Baraff as we approached. "They're super friendly, they're my buddies," Baraff said, noting the goats were also a hit with visitors. While the goats did need regular brushing (they regularly get covered in burrs), they were generally low maintenance and could subsist much of the year just on Carrie's growth and water.[64]

Despite poor soil and drainage, Carrie's plant life grows so fast that landscape maintenance in season is a near daily activity. Using the goats and standard equipment like mowers and hedge trimmers, the shaping of Carrie's landscape has been an ad hoc affair, driven by volunteers, trial-and-error experiences, and allowing nature to take its course. "Other than a little bit of grass seed, we have not planted a thing here. Everything that's come is from what nature's doing," Baraff explained. Along the yard's wooded edge, we paused to consider head-high honeysuckle. "We'll allow honeysuckle to grow and we'll maintain a path right through it. And you can cut 'em like hedgerows. So we allow it to work. It's going to hold this soil . . . without taking the entire site over." Yet Baraff conceded that some landscape strategies weren't "totally informed decisions," and others were more accidental in nature. "We realized we don't want to rip all this down," he said, gesturing to the grasses and trees in front of us, a mix of native and nonnative species.[65]

While far more landscape than building, Carrie has never had a big landscape plan and lacks the guiding hand of a prominent design firm or visionary landscape architect. The plans for US landscape urbanism parks like New York's High Line and Freshkills Park—created through the resourceful repurposing of former production, port, railroad, sanitary landfill, and military infrastructure—have generally required hundreds of millions of dollars to realize. These parks celebrate their own form of resurgent nature, but large investments do create compromises. Carrie benefits from its unfussiness and vigorous sense of otherness in addition to its historic focus, which are often lacking at more prominent parks, including the High Line, a project that evolved from an earlier period of successional nature, appropriation, and informal use.[66]

Even without an explicit plan, Carrie's landscape design has required many small, in-the-moment decisions. Yet each decision represents a larger struggle of competing ideals. Clearing and cutting back growth allow for more access and usable space and a greater variety of activities. The more growth is cleared or brought under control, the more the site loses its postindustrial wildness.

Baraff acknowledged the difficulty of striking a balance and sometimes feels conflicted:

> Part of me really misses the way the site used to be, not that we totally turned it into Disneyland by any means, but it used to be that you'd wander in here, there were trees growing everywhere, the grass was this high, and you felt like you were the only people in the world that knew about this and discovered it. It was something special. It still is, but that feeling doesn't exist anymore. It's far more traveled, a lot more people here, a lot of events, it's a little more user friendly now. We mow; we clean some areas up. That's the price of progress. But it's my job to stand in the middle and make sure we don't lose that old feeling, but we also make it useable for others.[67]

To find the balance between wild and cultivated, and establish effective, minimal maintenance regimens, Rivers of Steel brought on Rick Darke, a landscape consultant whose expertise includes horticulture on brownfield sites and embraces a strategy of "managed wildness." Darke helped ROS establish Carrie's Iron Garden and retain and enhance Carrie's wild aesthetic in other spots. About the riverfront, Baraff framed the dilemma similarly: "What can we save and what can go? How do we open up the riverfront without sacrificing the environment . . . [and] without impinging upon habitat?"[68]

Along the wooded edge that separates and obscures Carrie's connection to the river below—an area, as historic photographs show, bereft of a single tree or speck of green while the plant was in operation—Baraff showed me a modest clearing with seating, adjacent to a small railroad depot. The space was created by a kid going for his Eagle Scout certification in a spot formerly dense with invasive trees and fast-spreading vines, including thick-rooted bittersweet, knotweed, and lots of junk. The growth below us was not at its summertime apex, and we could see down the bank to the river below. This was as close to the river as you could get without bushwhacking. Rivers of Steel hopes to selectively open more of this vista, to visually reinforce the connection between Carrie and the Homestead Pump House across the river. Baraff pointed to the top steps of a mostly obscured, dilapidated staircase, which could be rebuilt to provide access to a planned kayak launch and larger boat dock.

In 2016, Rivers of Steel absorbed the financially troubled RiverQuest, a water-based environmental education nonprofit and its boat, the *Explorer*. The dock could be used by the *Explorer* and other boats, bringing visitors from downtown Pittsburgh. For over twenty years Pittsburgh-area schoolchildren learned about river ecology in the *Explorer's* floating classroom, but RiverQuest almost folded when its funding from both the Pittsburgh School District and the state was cut. A consortium of prominent Pittsburgh foundations engineered the acquisition and provided ROS with operating money for RiverQuest programs but not for capital improvements.[69] The potential synergies between the *Explorer's* on-river programs and those at Carrie are great. Iron and steel plants were necessarily built on water because they required vast volumes of cool water to prevent furnaces from overheating. Additionally, the river was used for transporting raw materials, finished products, and workers. Yet in postabandonment, Carrie's previously critical river connection had been severed. ROS awaits funding for the dock and necessary infrastructure to get visitors, including those with disabilities, to and from the water's edge via the steep hill below us. Fundraising for these improvements had not commenced by 2021, and Baraff estimated it would be several years before anything was built.[70]

Another project awaiting funding is a trail that would lace the river's postindustrial woods and connect Carrie to the expanding regional bicycle and pedestrian network. The planned Great Allegheny Passage, which will connect Pittsburgh to Washington, DC, will likely run from downtown Pittsburgh over the Mon, and then to the east along a south bank riverside trail, connecting with the Steel Valley Trail through Carrie via a rehabilitated Hot Metal Bridge. Like the waterfront improvements, the pandemic and competing priorities have slowed the trail's development, but in 2022 the county was examining grant and funding opportunities for the bridge's reconstruction for bicycle and pedestrian traffic and for trail approaches to the span.[71]

One undefined improvement on Baraff's wish list involves vertical rather than horizontal movement. Long before ROS assumed ownership, guerrilla actors would regularly climb the mill's furnaces, boilers, stacks, and other vertical elements. In some cases, such ascents were made easier by the presence of ladders and staircases, but these features hardly made the experience safe. Taking

a cue from these unauthorized climbers, Baraff would like to find a way to safely bring people to Carrie's high points and enjoy the commanding Mon Valley views, making the critical visual connections between the mill, river, and towns that grew around the production of steel. Given national and state concerns about liability, he concedes that this is a great challenge.

Realizing a Long-Term Development Vision?

Since its founding as the Steel Industry Heritage Corporation, Rivers of Steel leaders and board envisioned that the Carrie Furnaces would eventually anchor a national heritage park administered by the National Park Service and ensure the endurance of the iron mill and other southwestern Pennsylvania industrial heritage sites in perpetuity. The heritage park designation has thus far not come, and Allegheny County's development plan for the parcels around the Furnaces might compromise such a designation. Yet Carrie has been incrementally evolving without such a designation and the accompanying federal funding that would remake it into a better-conserved, more fully accessible and year-round industrial heritage monument or park. In 2017 ROS's long-serving president, Augie Carlino, argued that Carrie was "growing organically" and not following conventional NPS practices for industrial sites. While Carlino and other advocates hatched the national heritage park plan in the late 1980s and worked for years toward it, he now viewed the site differently. "I don't know where it's going," he admitted. "We want to maintain flexibility outside of typical preservation programs. If NPS owned the site, all of the stuff at Carrie would not be happening."[72] Baraff felt similarly: "We've realized that the standard historic preservation route doesn't always work," he said. "We've enlarged our thinking and developed it into a new aesthetic and organic approach."[73]

In many respects, Rivers of Steel, both at Carrie and its other sites, is fulfilling the mission of the US National Heritage Area (NHA) program. As historian Constance Boderow notes, the NHA program, established in 1984, was "conceived of as being a partnership between NPS and the local community to extend the NPS mission of resource preservation and interpretation without direct

ownership and management."[74] Critics have bemoaned NHA's limitations, including the paucity of direct federal investment in historic sites, the relatively limited number of industrial or labor history sites, and the program's inability to prevent the demolition of significant industrial structures, including those within the Rivers of Steel NHA catchment.[75] Yet at Carrie, ROS has maintained the administrative flexibility to offer an array of popular and eclectic programs, some of which evolved from guerrilla practices. Further, the current federal political climate does not necessarily favor the creation of new national parks, so at a minimum, ROS administration can be seen as effective resource management in the face of scarcity.

Preserving historic steel plants in the United States has been a difficult endeavor. Most of the material culture of steel making is in structures that have no obvious market-oriented reuse, even before the cost of environmental remediation and strength of the local property market are considered. Historic resources, like those found at Carrie, are mostly structures rather than buildings—closer to equipment than spaces to house human activities. This dilemma makes steel sites better candidates for landscape preservation and adaptation strategies than those built around building interiors, a strategy pursued with great success (and expense) at the former Thyssen Steel Works in Duisburg, Germany. But in the United States, the value of former steel plants has been calculated as its scrap value and its potential to support new development once all structures are cleared and the site remediated. The salvage of working machinery and scrap value has enabled downsizing companies such as U.S. Steel to recoup or cushion losses, or in the case of Bethlehem Steel, which declared bankruptcy in 2001, to pay off creditors. Yet Rust Belt leaders are most excited by redevelopment opportunities, which often drive the push to clear these sites.

The demolition of steelmaking facilities was always controversial, at least initially. Carlino and others have noted that former workers and their families and other residents and business owners who are economically dependent on the plant reflexively cling to the idea that a closed mill, if preserved intact, will be reopened. And history until the 1970s shows that steel mills often go through periodic closures or slack periods during economic downturns, for retooling or expansion or because of labor unrest.[76] But as years pass, plants remain idle, and dismantling begins, local

sentiment changes. Once the possibility of resuming steelmaking had been eliminated, many Mon Valley residents, including some former steelworkers, saw no point in preserving all or parts of the Homestead and Carrie complexes. As economic devastation and despair swept through the mill towns and cities in their postclosure years—and with them, waves of depression, suicide, bankruptcies, business failures, property devaluations, loss of family savings, and other public or individual impacts—many residents came around to the idea that the economy generated by a shopping center, office park, or warehouse complex was far better than nothing. Likewise, over time some view idled plants, and the slag heaps they produced, as massive scars in the landscape representing abandonment, broken commitments, and betrayal of the steel companies, politicians, and others who contributed to the destruction of their livelihoods and community prosperity.[77]

Thinking about Homestead and Carrie, I am often reminded of that common refrain among industrial heritage preservationists that critical reappraisal and public appreciation often take a generation. Yet most steel plants do not survive long enough to enjoy reconsideration. Like Homestead, other Mon Valley plants—including the J & L on the South Side and across the river in Hazelwood, and U.S. Steel's Duquesne and McKeesport works—have all been scrapped and redeveloped. Likewise, robust grassroots campaigns in other steel cities, including Chicago and Youngstown, Ohio, to save steel sites or structures within them have failed.[78] The unlikely survival of the Jeannette Blast Furnace at Youngstown's Brier Hill Works (site of the Industrial Arts Co-op installation the *Giant Woolly Millipede*) sparked a grassroots preservation effort some twenty years after it was abandoned. Yet it too succumbed to the pressure applied by elected leaders and their agents, businesses, and residents who viewed the furnace as a "rusting reminder of a past best forgotten," and a symbol of a region unable to create a new identity and rebuild its economy.[79] Jennette was demolished in 1997, and today there are no standing blast furnaces in the Youngstown District, once the United States' third-largest steel center. Similarly, the 2015 demolition of the thirty-two-story L Furnace at Bethlehem Steel's Sparrows Point plant in Dundalk, Maryland, outside of Baltimore was noncontroversial. Local residents, including some former steel workers, observed the demolition with sadness and resignation.[80] The thirty-one-hundred-acre plant, which when it closed in 2010 was one of the United States' five largest

and the only one of the five on tidewater, has been cleared and is being redeveloped into Tradepoint Atlantic, a multimodal freight transportation center and industrial park.[81]

The few successful steel mill preservation projects in the United States have typically focused on blast furnaces, which are the plants' most prominent and distinctive structures. One such effort has targeted the furnaces of Bethlehem Steel's flagship plant in Bethlehem, Pennsylvania, one of the few facilities as storied as Homestead. The huge mill, which had nearly twenty-four thousand workers during its World War II peak, closed in 1995 and has become an equivalently huge brownfield reclamation project.[82] Much of the eighteen-hundred-acre plant has been demolished and redeveloped into office parks, light industrial space, and warehouses (it includes a voluminous Walmart Ecommerce Fulfillment Center opened in 2015), along with a casino-hotel and shopping complex, originally developed and operated by the Sands Corporation. Yet at the mill's ironmaking core, a public-private consortium has developed a $78 million ten-acre arts and cultural campus with Bethlehem's five blast furnaces, now known as Steel Stacks, as its backdrop. The campus, which opened in 2011, was developed with the assistance of tax-increment-financing and is managed and programmed by a specialized nonprofit, ArtsQuest.[83]

ArtsQuest has done a masterful job of programming. For much of the year, Steel Stacks is the setting for concerts, festivals, and arts, education, and children's programs. Many outdoor events are staged in the Levitt Pavilion, a modest-scaled concert shed set against the furnaces, providing the audience with a sublime postindustrial backdrop that is dramatically illuminated at night. Across the street, the ArtsQuest Center, a sleek new building of concrete, steel, and glass punctuated by art installations, contains airy spaces for performances, meetings, and events and includes the Musikfest Café, Capital Blue Cross Creativity Commons, and a movie theater / ale house. Immediately east of ArtsQuest is its companion, PPL Media Center, which houses the local PBS television affiliate. Around these new buildings and the furnaces are several large mill structures that await repurposing, a few of which still contain significant internal machinery. Finally, the blast furnaces themselves are accessible via the public walkway atop the Hoover Mason Trestle, a two-thousand-foot-long elevated railroad viaduct that facilitated the conveyance of raw materials to the furnaces. Today the trestle connects the cultural campus with the casino at its western end, though visitors

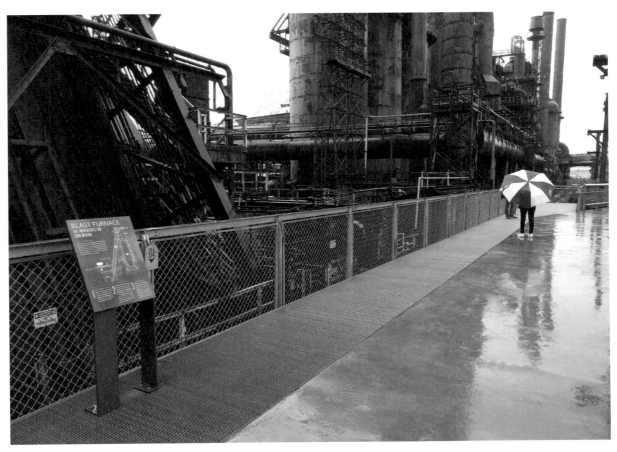

Mason Hoover Trestle at the Steel Stacks, Bethlehem, Pennsylvania. (Author, 2019.)

exiting the trestle must still walk through part of the casino's parking lot. At its eastern end, the trestle terminates at the Civil War–era stock house, which predates nearly everything else on site and has been adapted as a regional visitors' center and contains displays of Bethlehem Steel machinery, media, and ephemera.

The walkway, designed by the firm Wallace, Roberts and Todd and modeled in part on New York City's High Line, is open seven days a week and is handicapped accessible. It is made of simple industrial-grade materials, deftly bends in one section to provide eye-level views of the furnaces'

intricate machinery, and is accompanied by handsomely designed interpretive signage. This is as close as most of us will ever get to an intact blast furnace. Yet the intimacy of Steel Stacks is mostly visual, and the walkway gets you close but not close enough to touch the structures. Carrie's furnaces, while not open continuously for itinerant visitors, provide visitors with the opportunity to touch the machinery and move loosely around the historic structures as they tour them.

Like Carrie, Steel Stacks draws inspiration from the postindustrial *landschaftsparks* of the Ruhr Valley.[84] Yet unlike Duisburg Nord, the adapted Thyssen Steel plant, Steel Stacks doesn't include much park space. ArtsQuest and the media center were built close to the trestle and furnaces, and large parking lots flank the furnaces on either end, with the larger east lot used mainly by the patrons and many buses of the casino complex. The furnace's back side is close to but separated from the Lehigh River by active freight tracks. The concert pavilion is mostly grass, and modest green grows from atop the trestle, but there are no other sizable landscaped or tree-covered zones. While Steel Stacks is more complete and feels more purposefully preserved, it lacks Carrie's wildness and the tension between resurgent accidental landscape and rusting monument. The ArtsQuest economic development model is attractive to many, and it is not hard to imagine Carrie following a similar arc—with partnership development of new companion buildings, elevated walkways, and a permanent concert venue with paved parking. In fact, Allegheny County and Rivers of Steel previously had discussions with LiveNation, the concert production company, about developing a permanent concert venue on site. LiveNation staged the music component of the Thrival Festival at Carrie in 2016 and 2017, but the event moved to another location in 2018 and further discussion with the concert producer was not pursued.

Cultural programming at Carrie in something close to its "as-is" form has been a difficult sell among some county leaders and development officials, who viewed the mill as "just another brownfields site" awaiting private sector–led redevelopment, Baraff explained in 2015. These officials and some residents could not "see the broader scope and appeal" of Carrie's programs and landscape.[85] With the great increase in visitors and programs over the past several years and the critical buzz that Carrie continues to generate, many skeptics have been converted, yet escaping conventional paradigms is difficult. The county's 2005 purchase was made with the stipulation that the site's

Allegheny County's development parcels constitute the bulk of the former Carrie Blast Furnaces site. (Redevelopment Authority of Allegheny County, Pennsylvania, n.d.)

historic core be supported with economic development on the nonhistoric portions of the 137-acre property. Pursuing market-determined development of these adjacent areas county officials have expressed a strong preference for schemes that offer robust job creation, with the often-repeated target of "one thousand good-paying jobs." In 2018 the Carrie development parcels were floated as part of the region's ill-fated bid for Amazon's second headquarters.[86] Progress on marketing and developing these parcels was slowed by the pandemic, but the county still hoped to break ground on a built-to-spec structure on the first parcel adjacent to the Rankin Bridge in 2022.

While Rivers of Steel leaders and stakeholders have always preferred to have the entire Carrie site be parkland under their control, they have come to accept the county's development plan. With

capital funding scarce, they see it as a way to obtain critical infrastructure, including water and sewer lines, full electricity, restrooms, weatherized spaces, and parking. Carrie Furnaces Boulevard opened in 2015 and a few years later was extended westward to run the length of the site to provide access to the westernmost parcel. When this parcel is developed, it will bring shared infrastructure to the Furnaces via the boulevard. Baraff and Carlino have long argued that Carrie and its programs have added significant value to these other parcels, even as county leaders often viewed the mill as an impediment to development. Now the county's planned development can return some of that value to the mill's historic core.

In early 2023 the Regional Industrial Development Corporation and Allegheny County broke ground on the thirteen-acre first phase of its plan, which targets the parcels east of the furnaces. The development will include an access road and utilities; a twenty-million-dollar soundstage facility for television, film, and media productions; and a fifteen-million-dollar flex-tech, multipurpose building. Anticipated future phases will include similar flex, light manufacturing, and workforce training spaces.[87] The Carrie Furnaces will be getting its shared infrastructure to make it a more accessible, year-round heritage site, but it remains to be seen how much of its untamed spirit will be lost in the process.

Iron Postscript

In 2019 I returned to Carrie to attend the Festival of Combustion. The day before, I toured the mill with retired Carrie worker Jim Kapusta, who wasn't leading ROS tours at that moment but agreed to walk me around. Kapusta began at the mill straight out of high school in 1964. Though he had plans to attend aviation college in Minnesota and become a pilot, his uncle worked at Carrie and directed him to take a job there too (Kapusta did obtain his pilot's license later in life). He stayed on until the mass layoffs of 1982, and, like many of the mill's workers, survived a few lean years. In 1985 he found another permanent job working for the Parks Department of Peters Township and enjoyed a second career that lasted twenty-six years. Since 2011 he has kept himself busy operating a tractor on a produce farm, giving Carrie tours, and playing his saxophone.

Over two leisurely hours, Kapusta walked me through the production process and offered vivid descriptions of the worker experience, something I hadn't fully received on previous tours. Warm with the humor that often accompanies dangerous work, his plain-spoken lesson on twentieth-century ironmaking well described the mill's corresponding division of labor, which during a daytime shift involved eight hundred people (nearly all were men). What seemed like "chaos" and was "overwhelming" for new workers was actually a well-rationalized system of production with dozens of different jobs, many of which Kapusta had held over the years.[88]

Former Carrie worker Jim Kapusta guides the author through the mill. (Author, 2019.).

The stock house, or what Kapusta called "the dungeon," was typical of our stops. Here "larrymen" opened and closed the discharge doors that allowed coke to drop, tons at a time, from the covered hoppers above into "larry cars" that were sent to the furnaces. "It was dirty, it was filthy and, in the winter, you froze to death," while breathing in coke dust the entire time, he said. At the stock house's other end, cars were received by men who opened the cars' bottoms, dropping the material into the skip pit where it landed on vibrating coke screens, which shook off the high quantity of dust produced by the easily fracturing coke. From there the material was transferred to skip cars that were sent up the skip hoist and dropped into the top of the ninety-six-foot furnace. While the coke dust, also known as "coke breeze," was collected below and could later be used to fire boilers or for other purposes (with the exception of slag, iron plants redirect most waste products back into the production stream), clouds of dust went airborne, which might eventually lead to black lung disease or other potentially fatal ailments. "The men who worked here lived in dirt," Kapusta said flatly.[89]

Each furnace required three and one-half to four tons of material for every ton of iron produced. At their postwar capacity of over one thousand tons of iron produced a day per furnace, #6 and #7 required continuous feeding of fifteen hundred pounds of raw material a minute, which went on relentlessly twenty-four hours a day, every day of the year, for two or more years before the furnaces were shut down and relined. Kapusta was good at recalling these numbers and making the corresponding capacity calculations.[90] Yet the human costs were harder to calculate. At every stop of the tour, Kapusta offered similar stories of dangerous, dirty, and physically taxing jobs, some worse than others. Workers at the hot stoves could suffer severe burns and even death from the accidental venting of furnace gases. The maintenance crews who worked everywhere cleaning, repairing, and replacing components endured some of the most difficult and dirty tasks. Throughout the plant, burns were a common occurrence and fingers were occasionally lost (particularly on the trestle crew), while most jobs even on good days required the continuous application of brute force, and workers were often exposed to extremes of noise and temperature.

Kapusta had been relatively fortunate and coolly described his worst injury. Working at Furnace #6 he was sent to buy coffee at the canteen. Returning along a designated walkway, he suddenly was on the ground with the coffee spilled all over him and blood was running down his leg. A metal shard had pierced his leg. "It was like being hit with a bullet," he said. It had come from a worker who was hammering a railroad spike into new tracks. When the worker missed and hit the track instead, it cleaved a shard from the hammer, turning it into a projectile. Kapusta was sent to an infirmary where he was cleaned up, given a tetanus shot and stiches, and sent back to work. The pea-sized shard has been in his leg ever since.[91]

In the cast house, we paused at the base of Furnace #6, where "the charge" (coke, iron ore, and lime), upon reaching a consistent liquid state at twenty-eight hundred degrees, was "tapped" by a worker with a pickaxe who pounded through a temporary clay barrier, allowing the molten iron to bubble up and run down an open channel in the sloping floor toward the torpedo cars below. From where we stood, the furnace obscured the higher tap off to the side where the corresponding slag, having risen to the top of the material, was run off into its own channel and eventually into specialized cars, which were dumped at two different Mon Valley slag dumps in a still mostly molten state.

Returning to this spot for the fourth time did nothing to dampen my astonishment of the elementality of metal manufacturing, and I imagined a heroic worker with his body bent over the channel, whacking or poking away at the clay until the iron freely flowed. Since the dawn of the Iron Age to the most modern plants today, the smelting process is largely the same, though innovation has allowed great leaps in scale, efficiency, material quality, and safety.

Working in the cast house was among the mill's more hazardous jobs, and Kapusta described a gruesome incident in which someone fell into the channel during a cleanout, while boiling water was running through it. The worker suffered severe burns but was back to work at the mill a few months later. After the passage of the Occupational Safety and Health Act (OSHA) in 1970, worker safety substantially improved here in the cast house and across the plant, Kapusta argued. Before OSHA, workers often lacked necessary protective equipment, including face shields and vests, and protocols were spotty; after OSHA, accidents became less frequent and severe, and those that maimed or killed became increasingly rare. Of course, steelworking has often caused or contributed to debilitating disease and early death, and lesser impacts like hearing loss are pervasive among retirees.[92] And steelmaking, including that at the active U.S. Steel plant in Braddock, has also contributed to some of the highest regional rates of lung diseases among all large US metropolitan areas.[93]

I was forced to confront these impacts the next day when my wife, Anne, and I returned to Carrie for the Festival of Combustion, which featured metal arts making, nonmetal arts, heritage tours, music, and regional indulgences. Some of the Carrie Deer artists, including Tim Kaulen and Liz Hammond, were on hand fashioning thick steel wire into a scaled version of the Carrie Deer, one topping out around twelve feet. But the event's core was the creation and tending of a minifurnace and the iron pours it enabled, including those into art molds and, after nightfall, the grand spectacle, into blocks of ice. Installed in the former train yard below Furnace #6's cast house, which decades ago would have been filled with torpedo cars awaiting their iron loads, the furnace was operated by about twenty artisans, who rotated in and out, staffing specific stations, like tending the hearth or monitoring the ladle bucket above it where the iron was cooked. Suspended from a wheeled gantry set on two widely spaced tracks, the bucket could be repositioned over various ceramic molds set on the adjacent ground. Around the periphery a crowd gathered in anticipation

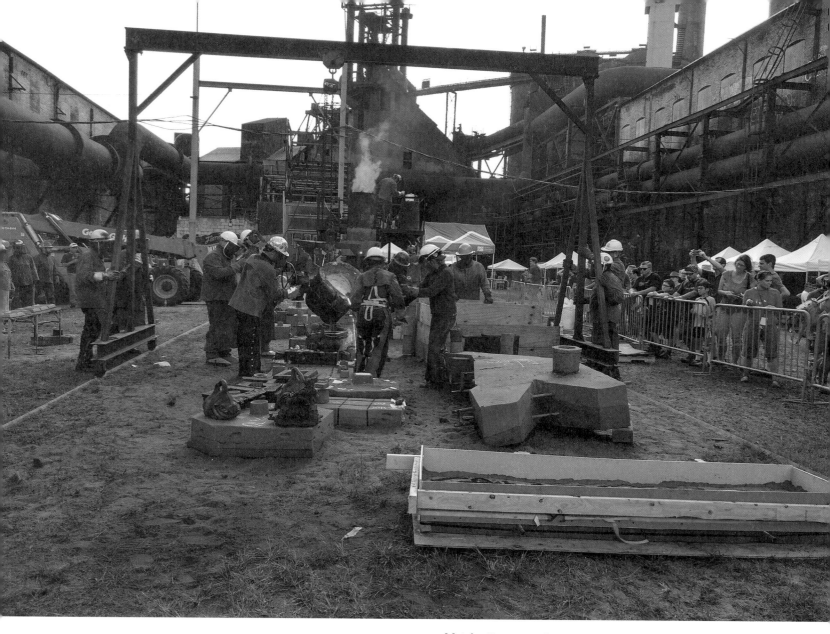

Metal artisans pour iron into ceramic art molds in the train yard below the Furnace #6 Cast House during the Festival of Combustion. (Author, 2019.)

of that moment, when the crew, using their hands, gently tipped the bucket so that the molten iron poured into the molds. When that satisfying moment occurred, Carrie's industrial past was viscerally revived right down to thick and caustic-smelling smoke that blew across the line of spectators.

It was a hot and humid late September day, and even before the first metal pour, a haze of particulates was already hanging in the air around us. By the end of the day, we were covered in furnace dust. Back at the hotel, we threw our smelly clothes in a plastic bag and took hot showers, but the burned-coke odor continued to linger in the

The Festival of Combustion's after-nightfall iron pour into ice blocks. (Author, 2019.)

room, and I could still feel irritation of the dust in my nasal passages. A healthy person like myself, even as I have mild asthma, can take a day at the furnaces, but it was hard not to think about the workers exposed for decades or those who lived in the boroughs nearby—or across the region, who would breathe a lifetime of this dirty air in a more diffuse but potentially still toxic form. And now that much of the steel used in the United States is imported, there are the impacts to steelworkers and local populations in countries lacking OSHA-like regulations. These iron pour events, as Kapusta said, "bring the past back to life." They are thrilling in their exuberant present and speak to what Pittsburgh is today as much as what it used to be. At the same time, they provide vivid reminders that the good old days of industrial production were never as good as we remember them.

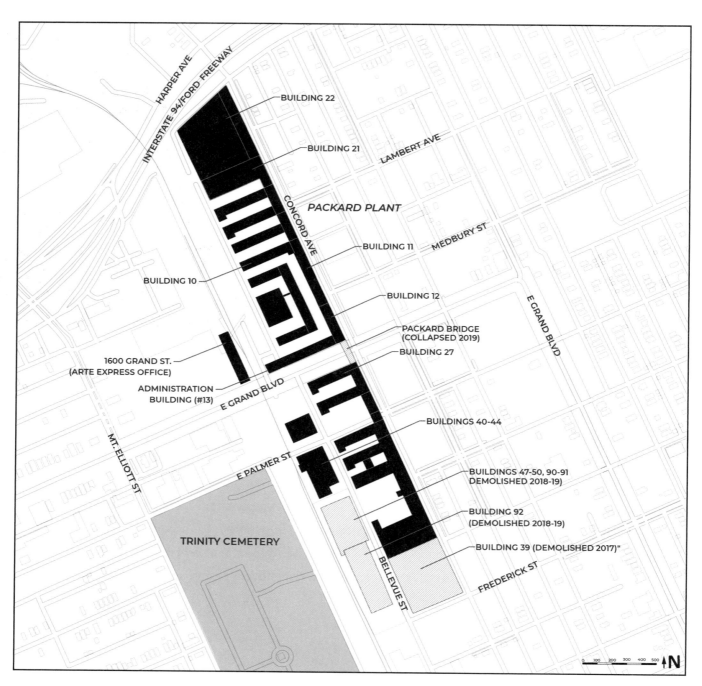

The Packard Automobile Plant as it existed in the 2010s (Cartography: Shahrouz Ghani Ghaishghourshagh, 2021.)

CHAPTER 5

The Packard Automotive Plant

I f the Carrie Blast Furnaces demonstrate how guerrilla activities on a site destined for demolition can contribute to regional cultural cachet and change the trajectory of redevelopment, then Detroit's Packard Automotive Plant demonstrates the limits of such activities in the face of steep decline and broken governance. Like Carrie, the ruinous Packard Plant, sprawling across some forty acres, compelled engagement from a variety of participants, even as government officials were actively promoting its demolition. Yet the furnaces' resurrection, in part facilitated by guerrilla artists and now evolving through Rivers of Steel's cultural programming, has no Detroit equivalent. Until the mid-2010s, local and state officials could see nothing in Packard other than a derelict complex of buildings that invited illegal activities and embarrassed the city. In fact, since nearly the moment the plant stopped producing cars in 1956, the city has desperately sought to clear the complex—better to have anything, even vacant land, than that troublesome factory on Detroit's equally troubled Lower East Side. But Packard's "after automobiles" story, which is this chapter's subject, is thrilling at the same time it is awful. Postindustrial countercultures flourished at Packard and were internationally celebrated, at the same time the plant had become *the* symbol of everything that was wrong with the Motor City.

The Albert Kahn–designed plant—the world's largest automobile factory of the formative first decade of the twentieth century—has been celebrated for its pioneering use of reinforced concrete and urbane design, with its multistory light-filled pavilions on an orthogonally clustered site. But today,

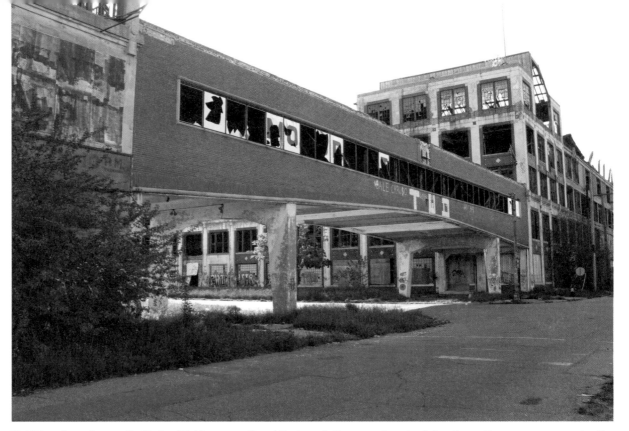

Until its collapse in 2019, the Packard Bridge across Grand Boulevard often served as a backdrop for media coverage concerning the plant or city. (Author, 2010.)

Packard is known more for its ruination than its place in automotive history and remains a symbol of Detroit's spectacular decline from a prosperous metropolis of nearly two million people in the 1950s and a world-renowned center for invention, engineering, and production to a largely impoverished city of fewer than seven hundred thousand today. Once a paragon of modernity, the prototype for American automobile factories through the 1920s, Packard was outdated by the 1950s, and the Big Three manufacturers (Ford, General Motors, and Chrysler) were producing cars more efficiently at larger plants across southeast Michigan and elsewhere. Likewise, in the 1950s, Packard was surpassed in sales in the increasingly competitive American luxury car market first by Cadillac and then by Lincoln. In 1954 Packard merged with Studebaker, and the new Studebaker-Packard Corporation closed the plant in 1956, moving most of its production to a South Bend, Indiana, plant, before it too was closed in 1963, and the company faded out of existence over the next few years.[1]

In the decades since, Packard's flagship plant and headquarters has been progressively abandoned by the smaller firms that replaced the auto manufacturer, which by 1983 was organized as the Motor City Industrial Park. For a time, the park contained smaller manufacturers, wholesalers, and automobile service and storage businesses, and as late as the 1990s it had nearly ninety firms employing approximately five hundred people and occupied approximately 35 percent of the complex's 3.5 million square feet of building space.[2] Only a few firms persisted into the twenty-first century, and none exist today. While Packards are long gone from US roads, the plant that built most of them has had surprising staying power. In a city and region that created the automobile industry—where the moving assembly line, five-dollar-a-day wage, and vertically organized global corporation were all pioneered; where in just a few months in the early 1940s, the great automotive production lines, including Packard's, were retooled to produce armaments for the arsenal of democracy that facilitated Allied victory in World War II; where the means to an American way of life were created—Detroit has made surprisingly little effort to preserve the structures of its storied manufacturing past. Ironically, Packard is the plant that survived, even as those that were built after and remained in production long after Packard's closure have been demolished.[3] Though durable, the plant's survival has been accidental and tenuous, with its deterioration hastened by decades of arson, scrapping, vandalism, punishing cycles of weather, and partial demolitions.

By the early twenty-first century, Packard's progressive ruination made it an icon of Detroit's concurrent decline. National news media flocked to the plant for photo ops during the national financial crisis and auto manufacturer bailout (2007–2009) and Detroit's bankruptcy (2013–2014). *Time Magazine*'s yearlong *Assignment Detroit* kicked off with the 2009 story "The Tragedy of Detroit," with Packard on its cover.[4] Also that year the plant's Grand Boulevard bridge made the cover of the *Times Magazine* for the story "G.M., Detroit and the Fall of the Black Middle Class," even as Packard, out of business for over half a century, had little to do with the twenty-first-century fate of General Motors.[5] In fact, a photograph or television or internet video shot framed by this bridge, where hundreds of thousands of auto bodies were once transported toward final assembly, became *de rigueur* for media covering these events. As Detroit reached bankruptcy in 2013 and the plant's ownership was still being sorted out after a tax foreclosure auction, the *Times* called Packard "the ultimate abandoned

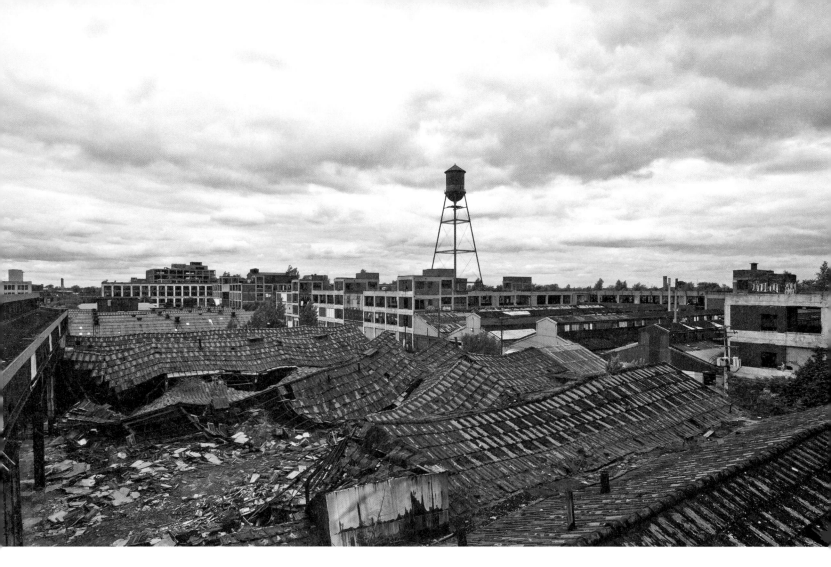

The expansive buildings and grounds of the Packard Plant were undermined by arson, scrapping, weather, and public demolition initiatives, and long served as a regional dumping ground. (Scott Hocking, 2009.)

building in the city that has become America's unofficial capital of blight."[6] With its symbolic value amplified by the spread of ruins photography and video in both print and electronic media, Packard had become a stand-in for the troubled city itself, one that still resonates today, even as Detroit's narrative has evolved to include resurrection with billions of dollars of investments within its core.

While Packard has supplied evocative images to accompany just about any story about Detroit's decline, the plant itself has often been the news: arson, illegal dumping, scrapping, automobile theft rings, drug dealing, prostitution, ownership disputes, unlawful evictions, failed economic development initiatives, and more. Vandalistic activities and "prankster mischief" became frequently reported spectacles, which possibly reached its nadir in 2009 when the *Wall Street Journal* documented in video a successful effort to push a truck off the fourth floor of a Packard building to the street below.[7] While this sort of pointless destruction garnered attention, Packard's many buildings were far more undermined by nearly two decades of scrapping. The city of Detroit did little to prevent these agents from dismantling buildings and harvesting materials, even in those years that it claimed to own the complex. Unwilling or unable to maintain public safety, city officials instead schemed to demolish Packard. Yet as the plant devolved into a wasteland and target or setting for illegal and destructive acts, the city could neither gain full legal title nor find the money to pay for clearing it. The steep cost of demolition, out of reach of the cash-strapped and then bankrupt city, was due in part to Julius Kahn's (Albert's brother) then-experimental reinforced-concrete structural engineering, which resulted in Packard's multistory buildings being far stronger than necessary.[8]

As Packard's owners stopped paying its property taxes, performing routine maintenance, or providing security, the plant became a dumping ground for the stuff that Detroiters or Detroit businesses no longer wanted or could not afford to keep, including old cars and boats, hundreds of thousands of car tires (often dumped by unscrupulous repair and tire shops that pocketed the recycling fee charged to their customers rather than paying for authorized disposal), and at one time, thousands of pairs of shoes. For a time when the plant's ownership was in dispute and the court-recognized owner was in a California federal prison for dealing drugs from a former school across the street from the plant, arson had become so frequent that the overstretched Detroit Fire Department let fires burn out rather than risk lives and equipment in the dangerous and, in places, unstable plant. Many suspected that arson

and scrapping were done in coordination; fires would expose or bring down metal that could later be harvested and sold.[9] Against the will of Packard's apparent owner, the city did make some demolition progress, clearing buildings with almost half a million square feet of floor area in the late 1990s. In the two decades after, the city made additional progress and in 2019 took down buildings that it legally owned. But its larger goal of complete clearance in preparation for some to-be-determined development has remained elusive but perhaps for not much longer.

While Packard's ruination is infamous, its underground or countercultural history has yet to be fully considered. Amid the piles of garbage, broken glass, metal, and concrete; abandoned cars and junked boats; weeds, mosquitos, and rodents, the plant had another life, one more transgressive than destructive, often more illicit than illegal. A venue and subject for postindustrial counterculture, it became a destination for graffiti artists, photographers, filmmakers, musicians, DJs, partiers, paintballers, and those looking for escape, adventure, or urban nature, as well as the homeless, drug users, prostitutes and their patrons, and countless minor vandals. And just as the plant allured those wanting to break windows or push a truck through them, there were also constructive acts. In 2014, just before Packard's new owner instituted new security measures, snowboarders appropriated the plant. Packing snow onto deconstructed terrain and found materials, they created jumps and obstacles spanning both interior and exterior spaces. *The Telegraph* (UK) celebrated their resulting runs in video—one of many global news media outlets seemingly obsessed with guerrilla activity at Packard.[10] Improbably, the plant was also for nearly two decades the home of a man who claimed to have found his purpose and salvation living on a two-acre machine shop floor. In exploring Packard's ruinous recent history, *USA Today* called the plant "a monument to industry and an elegy to the declining fortunes of the city that forged America's middle class," but also "a muse to thinkers around the world who find anger, grief, astonishment and beauty in its decaying space."[11] Yet demolition-obsessed city and state officials failed to appreciate or acknowledge this perspective, even as it was shared by untold thousands of visitors to the plant, including those who had traveled from far beyond the United States.

While their counterparts in Buffalo and metropolitan Pittsburgh have been cajoled into accepting incremental adaptations of obsolete but iconic structures as generators of economic

growth, Detroit officials have stubbornly clung to the hope that cleared sites—Packard and many others—paired with public subsidies will bring developers eager to build whatever without old buildings getting in the way. Their relentless efforts "to erase the visual residue of Detroit's ongoing demise," in the words of landscape architect Charles Waldheim, have thus far not been entirely successful.[12] But demolition's perverse logic is part of a uniquely American faith in progress and growth that drives agendas in city halls across the country. As inner-city documenter Camilo José Vergara noted about ruins in Detroit and elsewhere, "For public officials, these derelict structures are a source of shame, something that gives journalists material for critical articles that keep investors away from the city. Merely empty land, on the other hand, means opportunity for development."[13]

Detroit's long campaign to demolish Packard has been thwarted for numerous reasons, including scarcity of public capital, lack of market interest, corruption, incompetence, legal setbacks, and the distractions that have evolved from being a city in perpetual crisis. Yet Packard's complexity has also played a significant role. For decades, different buildings have had different owners, and today the plant is legally an assemblage of over fifty parcels owned by four different parties, including the city. In 2013 the plant received a reprieve. After years of legal wrangling with the plant's primary owner, Wayne County foreclosed on forty-three Packard parcels, because of tax delinquency. Later that year, the plant was sold at auction for a mere $405,000 to Fernando Palazuelo, a Spanish-born property developer whose building restorations have been credited with spearheading downtown revitalization in Lima, Peru. Palazuelo won Packard only after higher bidders failed to make required payments to secure the property. His company, Arte Express Detroit, hoped to develop a creative economy–themed mixed-use development that would retain and restore most of Packard's buildings.[14]

Arte Express's assumption of ownership was viewed in Detroit with both optimism and skepticism. The city had been burned before by saviors with big plans and has a long history of slumlord owners controlling prominent properties or assemblages. Often little more than speculators, these owners promise a lot but deliver little, while sometimes milking public subsidies. Packard's previous owners had never delivered on their promises, but residents, city officials, and the me-

dia were willing to give Palazuelo the benefit of the doubt. They praised Arte Express's immediate efforts to clean and secure the complex, and actively patrol the area (if not a bit overzealously so). The company removed trash and debris; stopped the fires, scrapping, and vandalism; and replaced the broken letter-emblazoned panels of the Grand Boulevard bridge to declare "Packard" again in place of the more generic "Motor City Industrial Park." Local media coverage of Palazuelo's plans for Packard was deferential if not enthusiastic. Additional buzz came in 2016, when the plant was a featured subject for the American Pavilion at the Venice Biennale.[15] But not all was well. After gutting Packard's Administration Building and apparently securing rent commitments from what would be the complex's first new tenants in decades, followed by a 2017 ribbon cutting, the project sputtered. When the Grand Boulevard bridge collapsed in January 2019, due to the elements and previous undermining by scrappers, the project's lack of progress came into full relief, and local media revealed that Arte Express was in property tax arrears. While the company quickly vowed to pay taxes owed and rebuild the bridge, Packard's future was again in doubt.[16]

If Detroit is to recover some measure of prosperity, urbanity, or cultural cachet at sites like Packard, it must embrace a different set of expectations of what these ideals look like on the ground and the means to achieve it. It must follow a different course, one that accepts imperfect, incomplete, or degraded places as a starting point for creative appropriation, reoccupancy, and an incremental reknitting back into the urban fabric, as guerrilla actors once did.

Packard Parties:
The Postindustrial Soundtrack of Detroit

Vacant industrial spaces across North American cities have long attracted youth who gather to party or engage in transgressive acts. At the same time, warehouse parties (both in licensed and underground venues) were for decades prominent events in the music scenes in dozens of cities. Packard was both a site of itinerant gathering and warehouse parties. For a few years, it was Detroit's iconic rave site, a venue that helped define a 1990s counterculture and brought the plant worldwide

renown. With music supplied by prominent Detroit area DJs and out-of-town guests powered by high-octane sound systems, the parties attracted hundreds of attendees and helped place the city on a new cultural map. They also played a significant role in the rise of techno, a Detroit-born music genre, now popular across the world.

By my first trip to Detroit in 2003 (in part to attend an electronic music festival), Packard raves were already the stuff of legend. The last party had occurred only a few years earlier, but memories were fuzzy and have only grown more so in the decades since; rigorous documentation of these events remains elusive. Years later I learned about Packard parties from Adriel Thornton, a long-time Detroit promoter who is now the executive director of Detroit's bikeshare program and a few veteran 1990s Detroit rave attendees, and perusal of secondary sources and social media.

Thornton and his Tribe 9 promoter group along with the Pod group organized what was likely Packard's first dance party, a May 1994 affair attended by a few hundred people. A friend had developed a relationship with a Packard tenant, who leased the space to Thornton and his crew, who hired DJs, distributed fliers, and brought in sound equipment and lights. Charging just a few bucks at the door, the event was a success and would inspire future Packard parties, thrown by Tribe 9, Pod, and other groups. Thornton remembers that his parties were mostly inexpensive and staffed by co-promoters and friends, but others remember admission for some parties being twenty to thirty dollars, depending on the prominence of the DJs, and staffed by security.[17]

Throughout the 1990s, portions of the plant were still relatively intact and occupied by tenants including light manufacturers, repair and storage businesses, and "lofters" (artist live-work occupants). "It was still a functional place," Thornton explained, with electricity, water, heat, and spaces without broken windows. His parties were on the ground floor of Building #12 (built in 1907), where Packard chassis were once fitted with bodies, part of a complex of connected four- and five-story buildings north of Grand Boulevard and west of Concord Street. The space was part of an active business, where large reams of paper were stored. Thornton remembers attempting to move these paper coils, which standing upright were perhaps four or more feet high, but they were too heavy and decided to leave them in place.[18]

Access to the party was from the complex's interior. Attendees arriving by car proceeded to a driveway through Building #12, which was staffed by a security guard, and parked in the series of courtyards between buildings, where tenants typically parked. For later parties, the driveway was through the adjacent Administration Building (#13) along Grand Boulevard, which provided access to the same courtyards. The gate and security guard added legitimacy to these events—attendees "had to get checked in," he said, while the party space's garage-front entrance oriented to Packard's interior made detection from the street unlikely. About Packard's owner and management and the company that leased the space, Thornton said he wasn't sure if they were aware of the parties or ultimately cared, but he emphasized legitimacy—they were not "breaking in." Cleaning up the day after the first event, someone from the company that leased the space showed up and asked about all the water bottles scattered about. Thornton told him that they had staged a party scene for a music video rather than a party itself and paid this person the agreed-upon rental fee. Several other parties were staged in this space, by Tribe 9 and others, so the tenant company must have known, even if not right away.[19]

The risk of being shut down was ever present. Thornton and others had to negotiate the fine line between promotion and keeping the parties underground, particularly as their popularity grew. In addition to Packard, regular rotation sites included several other unlicensed spaces. For unlicensed venues, often warehouses or former factories, promoters typically took pains to keep locations secret. Partygoers learned of upcoming raves by word of mouth, record store signs, or postcard mailing—or, when attending a party, being handed a flyer for the next event. These flyers or "pre-flyers" were also distributed to "lock down the date," so other promoters would not stage a competing event. Promotional materials often used logos and minimal text. "Constructive," "Pod," or "Systʒm" conveyed identification of promoters and sometimes expected DJs. But underground venues were only sometimes mentioned, and text would often include the date and a phone number to call hours before the party to learn of its location. Attendees were sometimes directed to a nearby "checkpoint" to receive entry instructions. Veteran 1990s Detroit partygoer Carolyn Geck recalled receiving "cryptic" driving directions, but noted that "part of the allure was not really knowing if we

were going to the right place." Once inside, her exhilarating sense of disorientation continued. "I never quite knew where I was," she said.[20]

Booming sound systems were a common denominator at Packard raves, with equipment rented or borrowed from others in Detroit's underground music and party communities. Inside, attendees could feel the thunderous pulse of the bass through their bodies. At the same time, comforts and décor were minimal as was lighting. Sometimes, a fog machine and strobe lights were rented but it was "not an extreme sort of light show that you would see at a party today," Thornton explained. While the parties were alcohol free, they often featured a "smart bar" with water and smoothies, sometimes with supplements like B vitamins to provide energy for a long night of dancing. "At this time in the city, no rave promoters would have ever served alcohol. . . . This was a whole different lifestyle, a whole different culture," Thornton said. "We just didn't want to take the risk either, it just wasn't worth it."[21] He conceded that some attendees may have brought their own alcohol, while other accounts suggest, at some parties, the presence of a bar serving alcohol or a refrigerator of beers for the taking.[22]

To create smaller spaces within the large open floor, Thornton and his crew hung tarps, including those that delineated the "chill out room" where ambient or softer music was played over its own sound system, even as the main music of the party well penetrated this plastic-walled sanctum. At the first party, he recalled the filthy process of attaching them to pipes running along the ceiling. "You're up there tying them to these pipes, and as you reach up and tie the string over, this huge amount of black stuff that you have no idea what it was—it's been there for years and years and years—it just got all over us and in our faces." He laughed and acknowledged that this building was "not good for human occupation" and speculated about the toxins in the thick dust he had surely inhaled, including asbestos and lead paint.[23]

As a promoter, Thornton had been exposed to these hazards more than others, but contact with toxin-laced dusts became a point of pride among partygoers. And a night spent at the plant was a status-conferring event that made you a "badass," and the infamous "black snot," "black boogers," or "Packard boogers" that one might have for days afterward were a considered a badge of honor,

particularly among suburban attendees.[24] Geck also recalled spending time sitting on a filthy floor and coming home very sweaty and dirty. Corroborating social media accounts, she praised the vibe of Packard raves, which encouraged interactions among strangers and physical contact (perhaps fueled by widespread use of MDMA, aka ecstasy or the hug drug). While dancing and the music's visceral impacts were arguably the parties' core experience, she enjoyed the opportunities to socialize with interesting people from across metropolitan Detroit and sometimes much farther. "I felt so cool being at Packard," she said.[25]

A Packard Party circa 1994. (Courtesy of Adriel Thornton.)

While Thornton and others have described attendees being racially mixed and from both the suburbs and city, many Packard ravers were young white suburbanites. For these teens and young adults, these parties provided an entrée to Detroit and often left indelible but often contradictory set of impressions about the city. Trips to Packard provided an intimate view of deindustrialization and urban decay but also stimulated one's imagination, a complex experience that exceeds simple characterizations of voyeurism or slumming. One suburbanite recalled attending his first Packard rave as a college freshman home on break from an East Coast university. Having never previously visited and possessing no previous knowledge about the plant, he described Packard and its location as the "blankest blank spot on the whole map of Michigan, enchanting in the way that only a no man's land can be."[26] The fact that many partygoers had heard years of warnings about the dangers of Detroit from parents, teachers, and the media probably intensified this feeling and added to Packard's off-the-grid aura. For some, drugs may have also heightened the awareness and thrill of having such warm, intimate, and intensely social experiences in a deteriorating factory complex in an area characterized

by depopulation, property abandonment, and poverty.

Thornton noted that Tribe 9 was one of a few promoter groups that threw parties on Building #12's ground floor, while the promoters of the Syst3m parties used a different Packard building, which he could only remember as being "closer to I-94." He estimated that among all promoter groups, there were perhaps only ten to fifteen rave or ravelike parties total at the plant, which typically drew three hundred to five hundred people.[27] Other accounts suggest higher attendance at some events, with a particular late 1990s rave drawing over 1,500 people.[28] Despite their limited number and modest size, today these events hold a unique place in Detroit lore. One such party was the legendary summer 1994 "Spastik" show, featuring internationally renowned DJ Richie Hawtin, aka "Plastikman," who grew up across the river in Windsor. In 2010 Hatwin recalled the event for the *Detroit News*: "It was a moment in time when people in a dark warehouse dancing to music that they perhaps never heard again, and they, even at that moment, felt it was something special."[29]

The music of Detroit raves was mostly techno, an electronic dance music pioneered in the late 1980s by Juan Atkins, Derrick May, and Kevin Saunderson, musician-DJs from Belleville (aka the Belleville Three), a middle-class enclave west of Detroit Wayne County Airport. While the music's defining characteristics are debatable, to untrained ears (like mine) techno has similarities to other dance genres including house, acid house, trance, and "drum and bass." It is electronically produced music often featuring spare, repetitive, industrial or futuristic sounds and a heavy bass line. Popular culture scholar Richard Pope notes that techno is marked by its use of "modulated industrial noises such as alarm bells or sirens, all of which combine to produce a post-human, though funky, musical form appropriate to a dystopian environment."[30] While this appraisal sounds like the essence of post-Fordist Detroit as embodied by the modernist ruins like Packard and the Michigan Central Station, techno's evolution is multifaceted and at times contradictory.

In its formative years during the early 1990s, techno was more popular and commercially viable in the United Kingdom and Europe, and gritty industrial cities like Sheffield, England, developed their own artists and scene. Many pioneering Detroit DJs and producers were doing gigs and producing records in Europe during these years, while Detroit's scene remained relatively small. In its earliest days, techno did not have strong associations with postindustrial locales and was

mainly played in intimate Detroit-area clubs (Thornton helped promote a regular Monday night series of ambient and experimental music at Zoot's Coffee Shop). Its connection to gritty postindustrial or abandoned sites may have also come initially via import from hardscrabble English cities like Sheffield and Birmingham and Ghent in Belgium.[31] Nor did techno have a strong association with drugs and their culture (its founders shied away from partying and party scenes). And techno was not an "urban" music like hip-hop, Motown, or jazz—and its pioneers, while black, lacked the kind of Afrocentric perspective that often imbues these other genres.[32] Even in the late 1980s and early 1990s when techno DJs regularly played downtown clubs, the scene was more metropolitan than inner city, and its founders had viewed their music as being inspired in part by European new wave pop and electronica. As techno gained popularity in Detroit—and across the United States—it was to a large degree a stylistically expanded import married to raves and rave culture.

Pioneered in the United Kingdom in the late 1980s, raves arrived in the United States around 1990 and likely came to Detroit via New York, Los Angeles, and San Francisco, among other cities. In the United Kingdom, raves were large, all-night dance parties often thrown on the outskirts of major cities, featuring internationally renowned DJs and sometimes live bands, accompanied by light shows. With their welcoming democratic vibe drenched in a kind of psychedelic revival often fueled by ecstasy use, they appealed to largely middle-class youth who flocked to these events, many of which were staged on farmland, not unlike an earlier generation had flocked to outdoor music festivals and hippie gatherings of the late 1960s and early 1970s.[33] When raves reached Detroit, there was already a tradition of warehouse parties, and it was easier to throw these events in the city rather than on the periphery of a sprawling metropolitan area of nearly five million people. Sites were plentiful and typically available for a modest rental fee. While raves at many regular rotation venues were unlicensed and staged in violation of building and safety codes, most had some form of consent and were secured by payment to the property owner or tenant.

Detroit's raves had their own particular flavor. Thornton often traveled the "the circuit," attending parties in Chicago, Milwaukee, Toronto, Pittsburgh, Philadelphia, and elsewhere and was part of a national network of promoters and DJs. While some cities like Chicago had bigger scenes and

events that drew thousands, Detroit was "the mecca," he said, and attracted electronic music enthusiasts from across the nation and from overseas. He recalled the reactions of out-of-town promoters and DJs at Packard and other Detroit parties. "You may only be getting three hundred people," he recalled one visitor telling him, "but that's three hundred people all on the dance floor vibing to the music." If you attended a Detroit party, Thornton said, "you were really into it." Recalling his role in the producing parties at Packard and elsewhere—and he always called them parties or gigs, with "raves" often being the province of sensationalist media—Thornton emphasized innovation and experiment:

> Part of the beauty of it was that we were just "on go"—none of us knew what to do but we figured it out. . . . It's more formulaic today—I could do a party in my sleep. [Back then] we were always trying to do things a little different at each party. Sometimes I forget about the radicalness of what we were doing. It was much more DIY.

The size and notoriety of Detroit raves and their seeming ubiquity across the city—even as they occurred infrequently at any one venue and were invisible to passersby in the daytime—eventually would doom them. Thornton said that the Detroit Police, aka "party patrol," practiced "inconsistent" enforcement, tightening in periods after sensational news stories. But as the 1990s progressed, these media accounts became more frequent. Unwanted publicity may have reached its nadir when "Crave the Rave," a 1998 undercover exposé was broadcast on local television news, which prompted the police to employ more aggressive tactics to locate and break up parties and sometimes make arrests.[34] A Detroit Police Vice Section inspector noted the dangers of these events: they are staged in "abandoned and structurally unsafe" buildings; attendees, many of whom are underage, leave "drunk or high" and they're "wandering around in the middle of the night in a neighborhood they are not familiar with—and they are liable to get robbed—or worse." While some of Packard's apparent hazards may have been the product of hype, there were certainly legitimate public safety concerns, including the lack of fire prevention and suppression systems, appropriate means of egress at parties that may have also exceeded occupancy limits,

and exposure to toxins. There were also risks associated with the on-site consumption of drugs, including ecstasy, nitrous oxide, and cocaine.

Yet it is impossible to know just how many significant injuries, illnesses, or incidents happened at or were associated with a Packard rave, whether it be an accident at the plant, an overdose, a car accident, or a late-night robbery of a lost suburbanite looking for the entrance to I-94. While my informants emphasized that Detroit party kids were taught not to mix alcohol with ecstasy, one wonders if everyone indeed got home okay after a long night at Packard. They also noted that they never witnessed or were the subject of a serious accident or crime. About transgressing the boundary of legality, Geck noted that the sheer "number of people there made it seem okay, like we were buffeted from any real problems because we were just part of a huge crowd." She remembered a Packard party shut down by police, who provided attendees the opportunity to leave without being detained or given a ticket. Thornton, who had been given a ticket or brought in by police many times, but never at Packard, said individual officers had little enthusiasm for writing tickets and simply let most attendees leave. And tickets were nearly always dismissed by a judge in exchange for admission that the police had "just cause."

Media coverage of Packard and other Detroit rave sites suggests that not everyone was so fortunate, particularly those who possessed drugs or were younger than twenty-one. And more persistent police attention contributed to the demise of these parties. In 1999 Dominic Cristini, the Packard's notorious manager and disputed owner, told the *Detroit News* that he had "banned" raves, even as he recognized that attendees "never caused any trouble." About his own fifteen-year-old son, he said, "I wouldn't want him hanging around in this neighborhood at four in the morning."[35] Yet the likely presence of a twenty-four-hour police detail at Packard for most of 1999, stationed there in response to the ownership dispute between Cristini and the city, while Cristini was mostly holed up in the Administration Building, may have provided party organizers with a larger disincentive.[36] By the early twenty-first century, Packard raves had ceased and the scene had mostly moved into legitimate clubs and sanctioned outdoor festivals. Transgressive practices in appropriated spaces have short life spans.

A Culture of Demolition
and the Battle for Packard

Packard's brief but memorable rave era existed in an almost entirely different reality than the local politics that threatened to destroy the plant and remove its legitimate businesses and tenants. The 1990s and 2000s were heady times for the demolition of industrial complexes, and diverse American cities including Baltimore, Buffalo, Chicago, Detroit, New York, Philadelphia, and Pittsburgh were eager to clear idled industrial sites for new development, even if such actions were speculative and costly. While the federal initiatives that often paid for local demolition or "blight removal" programs primarily targeted declining residential neighborhoods, some municipalities and state development agencies devised ways to direct this funding toward larger industrial, commercial, or institutional sites.[37] Part of what geographer Jason Hackworth called the "demolition paradigm," such initiatives have driven development policy in the Rust Belt and shrinking cities for over forty years. Demolition programs are supported by a near unshakeable faith that removing blighted properties and the illegal or undesirable activities that occur at them will spur investment while improving lives of those nearby.[38] While Packard has demonstrated remarkable staying power, the city has been more successful in clearing the building stock of the surrounding neighborhoods, which are among the 269 in forty-nine declining U.S. cities found to have lost over half their residential buildings since 1970, and to no economically positive effect.[39] By the early twenty-first century, vacant lots well exceeded 50 percent of the area of most blocks in the plant's vicinity.

In Detroit, city leaders and planners were eyeing federal and state funding for Packard's demolition. The city possesses a particularly dubious record of demolishing locally iconic structures, including Detroit Edison's Conner Creek Power Station (aka "The Seven Sisters," 1996), Hudson's Department Store (1998), the Madison-Lenox Hotel (2005), the Detroit Statler Hotel (2005), and Tiger Stadium (2009). And while Detroit still clings to its Motor City moniker, its record at preserving its historic automotive manufacturing architecture has been poor. Working with the state, the Big

Three automakers, and property interests, the city has demolished or facilitated the clearance of many storied plants, including Dodge Main (partly in Hamtramck, 1981), Chrysler-Chalmers Jefferson Avenue (1990), Clark Street Cadillac (1998), Lincoln Motor Car Company Plant (2003), and the McGraw Avenue Glass Plant (2011). While Dodge Main and Chrysler-Chalmers were subsumed by newer, larger automobile plants, most others have been replaced by low-density development or storage—or sit vacant today.[40]

City leaders long desired to demolish Packard, since at least as early as its closing in 1956. Before the plant closed, a mayoral committee was already studying the alarming "flight of industry" from Detroit and was particularly concerned with the rapidly deindustrializing East Side. The area had recently lost the nearby Hudson plant and American Car and Foundry, the former to a merger with Kelvinator-Nash to become American Motors, whose operations were largely consolidated in Nash's northwest Detroit plant (today, another ruinous, partially demolished complex). Building a rationale for economic development policies for decades to come, the committee found several causes for manufacturing flight, ones that are still heard today throughout the Rust Belt: high labor costs, noncompetitive state and local tax structures, and "outdated plants, which make manufacturing operations costly," high construction costs for new plants, and "a lack of room for plant expansion in the city."[41] The committee recommended redeveloping large portions of Milwaukee Junction. Fed by its generous number of train lines, the junction served as the cradle of the early automobile industry, and in the 1950s it still possessed several plants, many still in use, including Packard but also Studebaker, Dodge, multiple Fisher Auto Body plants, the sprawling Murray Body complex, and several smaller supplier factories.[42]

Less than a year after Packard's closure, the city moved to condemn 19 acres of the plant, the first phase of a largely unrealized initiative to clear 245 acres of the junction for new industrial redevelopment, including new or expanded automobile plants and those displaced by freeway building projects.[43] The Detroit Planning Commission optimistically estimated the cost of Packard's acquisition, clearance, and preparation for new development at $909,000, most of which the city could recoup when the property was sold. The plant, while in reasonable condition, was by the 1940s outdated by the standards of the industry but kept afloat, like many other US industrial

plants, by wartime and defense orders.[44] The *Detroit Free Press* praised the "imagination and fore-sight" of the condemnation plan but also ominously noted that "rehabilitating industrial slums may conceivably prove the best and most economical safeguard against the deterioration of adjacent residential areas."[45] The loss of Packard and its estimated four thousand workers (down from a wartime high of about thirty-six thousand) had been a blow to the East Side, already reeling from Hudson's closure earlier in 1956. Some workers transferred to the Studebaker plant in South Bend, Indiana, where Packard-Studebaker's operations were consolidated, even as the company would only last a few more years. But most were forced to find jobs elsewhere and many struggled with unemployment for years.[46]

Perhaps given the difficulty of obtaining federal funding, the city's redevelopment plan was never executed. By the end of 1957 Beckwith-Evans, a firm that made and sold carpets, bought an option to purchase the plant from Studebaker-Packard. Yet by February 1958, real estate investors from Miami, San Francisco, New York City, and upstate New York bought the option and completed the purchase for the bulk of the complex, encompassing thirty buildings, for slightly more than $1 million, $243,000 of which was to settle city taxes owed. Calling their venture "Packard Properties Inc.," the investors said the plant would be "a pilot experiment . . . in returning specialized industrial real estate to a productive state." The firm, which hoped to have ten thousand jobs on-site within a few years, already had commitments from a machine tool rebuilder and from electrical equipment, rubber, and trucking companies for warehouse space. The Wayne County Road Commission also committed to leasing space for equipment storage. Another portion of Packard along the Ford Freeway, where Rolls Royce airplane engines were once manufactured, was sold to a Detroit-based wire company and would also be occupied by a Chicago-based box manufacturer. Other real estate investors bought another ten acres and eventually developed a strip mall supermarket south of Grand Boulevard.[47] Even as many new occupants would be downcycling space, using it for storage or repair rather than manufacturing, many East Siders, including former Packard workers, were desperate for employment. In June 1958, amid a national recession, hundreds if not thousands of unemployed Detroit workers lined up outside of the Administration Building, hoping to apply for one of fifteen hundred jobs announced by firms set to move into the plant.[48]

In addition to industrial and warehousing concerns, by the 1960s Packard housed Arlan's, a discount department store that later became Kingsway, spanning the four-story Building 27 immediately south of Grand Boulevard. And while the 1970s brought decline to the neighborhoods straddling the Boulevard, Packard survived in part to the tenancy of sales offices and government agencies.[49] By the early 1980s the Kingsway store shared the plant with some thirty other firms, including a GM subfacility, a job training center (occupying part of the Administration Building), a printing company, and a food distributor. Over the decades, firms came and went, but the overall trend in jobs was downward. Only a third of the complex's floor area was occupied when the city included Packard as part of a fifty-eight-acre assemblage offered to General Motors for its new assembly plant.[50] But GM opted to build its facility, the Detroit-Hamtramck Assembly Plant (aka Poletown, now GM Factory ZERO), at the old Dodge Main Plant north of I-94, and additional contiguous blocks, which required public condemnation via eminent domain. By 1983, New York City–based investors purchased Packard Properties for $7 million. Having previously converted former automobile plants in Philadelphia and St. Louis into mixed commercial-industrial complexes, the investors were "bullish on Detroit" and viewed Packard as undercapitalized, citing its own market study. A representative told the *Detroit Free Press* that "the complex could be profitable for owners willing to put money into it. All previous owners have simply taken money out of it." Rebranding the plant as the Motor City Industrial Park, the firm announced plans for a multimillion-dollar renovation to create a retail-office-industrial-warehousing complex that would take advantage of its strategic location and proximity to GM's Poletown plant, then under construction to the northwest.[51] Yet the plant's new owners struggled to attract the anticipated GM subcontractors after Poletown opened in 1985, and their renovation plans remained unrealized.

In 1987 Packard Properties sold the complex to Bioresource, a company formed a by prominent Detroit property owner, Aziz Khondker, backed by some two dozen investors. Khondker had learned of Packard's availability at a fundraiser for Mayor Coleman Young. In the early 1990s the plant had some one hundred tenants paying approximately $1 million in total yearly rent, but Bioresource wasn't paying its property taxes, prompting the city and state to initiate foreclosure proceedings in 1993. The following year, Bioresource shareholders ousted Khondker and installed

Edward Portwood, an electrician and Packard tenant, as president and manager of the property. After filing for Chapter 11 bankruptcy in 1997 the reorganized company now with Portwood as its sole owner reached an agreement with the city to manage the complex and collect and convey rent from tenants, approximately forty-six thousand dollars monthly. Portwood was a colorful but dedicated manager, who put in long hours and decorated his office in the Administration Building with mounted game heads, parts of his extensive gun collection, and a pet python. An overweight, four- to five-pack-a-day smoker who subsisted largely on junk food and coffee, he suffered a heart attack and died in his office at age thirty-six in September 1998.[52]

Portwood had apparently frequented a Detroit topless cabaret where he may have met and developed a relationship with Dominic Cristini, the club's manager or his girlfriend, Robin Cristini, a dancer, who used Dominic's last name even though they were not married. Cristini bought Packard Motor Properties/Bioresource from Portwood's estate and installed himself as manager and collected rents as Portwood did previously, but little if any money was conveyed to the city.[53] City leaders viewed their agreement with Portwood and then Cristini as a short-term measure until they could obtain undisputed title and federal money for the plant's demolition. In their minds, demolition would accomplish multiple objectives: Detroit would rid itself of one of its great eyesores and sources of shame, clear buildings that incited illegal and dangerous activities, and make a large site available for new development. The city claimed that the cleared plant would be occupied by BUDCO, a warehouse business, which desired to move from Highland Park—another struggling city nearly surrounded by Detroit, where remnants of Ford's Highland Park Plant still stand. BUDCO's interest was tied to Packard's inclusion in Detroit's federally designated Renaissance Zone, which would nearly eliminate its state and local taxes.[54] If the city had succeeded and the business relocated, it would have shifted a small number of jobs a few miles to the southeast at great public expense—the kind of economic development deals that represent little tangible gain for the region and are frequently criticized by economists and public policy scholars.[55] At that moment, the city and state were working on a similar scheme on the West Side, which resulted in the demolition of the Cadillac Plant and its replacement by the Clark Street Technology Park, a suburban-density light manufacturing and distribution center.[56]

In late 1998 the Detroit City Council voted 5-1 to replace Packard Motor Properties (PMP) with Central Maintenance Services as the plant's manager. And while ownership was still subject to court dispute, the city also began aggressively evicting Packard tenants, which still numbered in the high eighties. At the same time, the state tapped into Michigan Department of Environmental Quality Funds for a $4 million contract awarded to Diamond Dismantling for the first phase of the plant's demolition and hired another contractor to remove up to a half million illegally dumped tires. Before the year's end, Detroit Police attempted to forcibly seize the plant, citing multiple illicit activities, including a car theft and insurance fraud ring, as well as seventy thousand dollars in rent owed to the city. Detroit officials also argued that they were at liberty to replace PMP, as the firm had no actual contract with the city.[57]

By this time, Packard had few remaining large tenants. Chemical Processing was still present, as was SplattBall City, the paintball—war games venue, whose operations sprawled across multiple floors of different buildings and advertised that it was the world's largest indoor paintball course.[58] And a few auto repair shops, including those that did vintage car restoration. Several other tenants were businesses or individuals renting storage space. Cristini, who later claimed that before the city started removing tenants, the plant earned a two-hundred-thousand-dollar monthly rent role, sued the city for breach of contract. A Wayne County judge put the management switch on hold while the case was being adjudicated and ordered the city to stop continuous surveillance of the plant.[59] Yet the city did not comply and by 1999 was forcibly removing tenants in preparation for demolition, with Wayne County bailiffs or their designees cutting through locks and throwing possessions out on the street. Tenants complained to the media about the city's heavy-handed tactics and being forced out without due process or reasonable advance notice.[60] Don Summer, the president of the American Arrow Corporation, which stored a collection of classic cars at Packard, accused the city of employing tactics more appropriate for the Bosnian War, occurring at that time. Some local leaders were also perplexed. "I don't know what the city's big rush is," local councilwoman Brenda Scott told the *Detroit News*. "I think both sides of the story need to be heard before the city comes in and starts tearing the plant down."[61]

Progress on demolition was slowed by owner and tenant resistance—but also because of the discovery of asbestos and other environmental hazards. At the same time, the city's intimidation tactics failed to dislodge Packard's embattled manager and disputed owner. Refusing to relinquish control, Cristini holed himself up in his office (sometimes with Robin) to prevent his own expulsion and the plant's demolition. During an ugly eight-month standoff, the Detroit Police gang squad officers remained at the plant on twenty-four-hour assignment. The *Detroit News* recalled the bizarre scene of police officers sitting around the lobby of the Administration Building in folding chairs watching a television while Cristini refused to leave his office unless in the presence of his lawyer or media members. The city also constructed a twelve-foot-high wall around the Administration Building. Like the gang squad detail, the wall was supposedly to protect tenants and the building itself from Cristini.[62]

While holed up in the Administration Building in February 1999, in the same garishly decorated office that Portwood had once used, Cristini formed OPPMAC Inc. (Old Packard Plant Mortgage Acquisition Corporation) to raise money to settle a mortgage claim from Land and Norry, a Rochester, New York–based firm, which claimed it was never legally notified of the foreclosure (Edward Land and Irving Norry were two of the principal investors who bought Packard in 1958).[63] With the mortgage paid, Cristini/OPPMAC won another court order in March that stopped the city's evictions and demolitions. But before the not-so-proverbial dust had settled, Detroit had managed to push out or forcibly remove most tenants and had demolished four Packard buildings, totaling an estimated five hundred thousand square feet of building space.[64]

While the city had used state funds to initiate demolition, it was eyeing federal empowerment zone funding to complete it, and for incentives to attract new development. Planning Department officials claimed their feasibility studies had determined the plant could not be salvaged, even as Cristini/OPPMAC expressed interest in renovation and a nascent preservation movement had formed around it.[65] Tenant Don Summer, American Arrow president, argued that the city's studies were wrong. "I've had three architects say that the building is sound," he told the *Detroit News*. The city is just "coming in and knocking it down and never looked at the alternatives of what could

be done."[66] Summer and Cristini were among the trustees of a new nonprofit, the Motor City Automotive Exposition Inc., formed by Russ Murphy, a former Packard Motor Car Company employee. Cristini had committed to donating the Administration Building, Building 27, and the bridge over Grand Boulevard connecting them to the museum, which would house Murphy's 150-car collection and other automotive artifacts.[67] While Cristini's portrayal in the local media was often unflattering or worse, tenants and automotive history enthusiasts viewed him and his girlfriend as underdog heroes who fought the city and saved the plant from destruction despite the "mental, physical and financial strain" they suffered in the process—a strain that would contribute to Cristini's drug habit and eventual prison term, and perhaps Robin's gunshot suicide in Florida in 2003.[68] Writing to the Society of Automotive Historians, Murphy noted that Packard's apparent saving was

> a great victory for all automobile historians. Now, because of the valiant efforts of Robin and Dominic Cristini, at least a portion of one of the world's most historically significant automobile factories can be preserved and developed into a facility for the benefit of present and future generations.[69]

In October 2000 Cristini settled with the city for about seven hundred thousand dollars in back taxes with a promise to pay more later.[70] Yet disputes over taxes, maintenance, and violations of building and environmental codes continued until Packard was taken from OPPMAC via bankruptcy and awarded to Arte Express in late 2013. And unknown to the public in 2000, prominent Detroit-area land speculator Romel Casab and other potentially unsavory characters were OPPMAC backers and put forward the money to pay the taxes owed. Later Casab would be (temporarily) revealed as Bioresource's president. In 2004 Cristini was accused of dealing the drug ecstasy from a former school adjacent to the plant and pled guilty in 2006. (Later, Casab would also be convicted of a drug-related felony.) Cristini was sentenced to five years in federal prison and was released to a Detroit halfway house in 2010. In 2007 the Michigan Supreme Court declined to hear the case for ownership of the disputed plant, and the city formally gave up its claim, though it would soon revive its demolition efforts.[71]

Motor City Crisis and Urbex

While the city and Cristini fought over Packard's ownership and during Cristini's prison term, insurgents were exploiting the plant, unhindered by barriers, alarms, security guards, or fear of arrest or penalty. If the heyday of Packard raves was the mid-1990s, a decade later, urban exploration (aka urbex) was the plant's ascendant transgressive practice. With the development of digital photography, the internet, and social media, by the early 2000s urbex was becoming a sport, and Detroit sites like Packard were attracting a larger audience, including many out-of-towners. The emerging international urbex community—featuring explorers in dozens of cities, including those across the American Rust Belt but also New York, Toronto, London, and many others—had discovered "the D," as had many "strolling explorers" (in the words of a Buffalo explorer), including architects, city planners, academics, and others whose day jobs involved urban development. Some of Detroit's most energetic citizens, many of whom were building careers facilitating the city's revival, were occasional explorers at Packard and elsewhere.

While Detroit pushed ahead in its decades-long effort to demolish Packard and create another large potential development site in a city that already had many, these interlopers found the plant to be a spectacular place for exploration, play, environmental engagement, and creative expression. Visits to Packard provided opportunities to contemplate the city's rapid rise and steep decline, from a global powerhouse of industry and culture to obsolescence and collapse. Detroit was like medieval Rome after a millennia of decline or like Berlin in the aftermath of World War II, as critics and journalists have often argued, and Packard was ground zero for these experiences.[72] History at Packard had been made and now was being unmade. Likewise, the plant's ruinous and increasingly green landscape was a front line in a rapidly unfolding shift in ecology. Never as lush as the Carrie Furnaces, Packard had less open landscape and no nearby hills or rivers, and its footprint within the city's grid worked against a more expansive sense of the natural. Yet insurgent grasses could be found growing from just about anywhere exposed to the sky, slender trees took root on broken rooftops, and a variety of animals made habitat in the complex where the world's first luxury cars were

An explorer navigates a damaged section of a Packard roof.
(Emily Flores, 2012.)

once built. Many Packard guerrillas—and there were many more than at Carrie, given the plant's centrality and ease of access—intensely appreciated nature's resurgence and some imagined returning after ten or more years and finding it completely overgrown, perhaps not unlike how those medieval pilgrims received the Rome of antiquity. Packard was rewilding, and nature's juxtaposition, disjunction, or dialectic with the plant's architecture stimulated, provoked, and soothed.

A place for both quiet contemplation and intensely visceral experiences, exploring Packard nourished the mind and body, providing what some scholars have called the "deindustrial sublime."[73] Some of these experiences delivered the adrenalin rush of adventure sports like skiing, rock climbing, mountaineering, or in an urban setting, skateboarding or BMX. One blogger called Packard the "Swiss Alps of Michigan, the Urbex Matterhorn of the Motor City" and noted, "The feeling I have walking up crumbling stairs in Packard is the same sensation I experience descending down the ridge of the Zinalrothorn in Zermatt."[74] And trips to the plant's many rooftops provided expansive views and opportunities to savor the sunset or to gather with friends while drinking beer or tending a bonfire of discarded freight pallets.[75] Part of Detroit's vast network of "gray space," Packard existed "somewhere between the social categories of legal and criminal, fixed and temporary and safety and death," according to urban planning professor Kimberly Kinder.[76] It possessed what I have often called "otherness"—a contradictory separation from city fabric and the rules and conventions that normally govern urban space.[77] There is a joy in transgression, breaking rules, or being in an environment that is unpredictable or dangerous. Like the ravers before them, Packard's urban explorers enjoyed these *other* qualities and the "looseness" it allowed.[78] A browse through the thousands of Packard urbex images on Flickr confirms an exuberant *other* documented by explorers.[79]

Packard also provided opportunities to discover and probe historic architecture and sometimes pilfer leftover or abandoned material culture, including machinery, furniture, records, and ephemera—and items formerly secured in storage. This was quintessentially American detritus representing a century of production and consumption, of changing lifestyles and material wealth, even if objects were often abandoned self-storage possessions or the product of illegal dumping. A twenty-year-old aspiring photographer called his four years of Packard wanderings, "walking on history."[80] The trips of a retired Detroit-area technical-writer-turned-explorer, and her husband, a photogra-

pher, revisited personal history and satisfied an "insatiable curiosity about how these buildings had come to be ruins."[81] This couple's 295-page ebook, *Detroit's Spectacular Ruin: The Packard Plant*, a companion to their broader guide to Detroit urbex, documents and contextualizes their colorful and at times nostalgia-soaked explorations of "a site where America's industrial might once flexed its muscles, where beautiful automobiles once rolled off the world's longest assembly line."[82] Some photographers also brought a missionary-like zeal to their visits. They rationalized their exploits as documentation for posterity, recording the details of abandoned buildings before they were reduced to rubble.[83]

Detroit urbex perversely benefited from the devastating hit the city took during the Great Recession of 2008–2010. The auto industry's substantial contraction, the city's concentration of failed mortgages, the broader climb in unemployment, and reduced local purchasing power crippled the city's already weak economy and culminated in its bankruptcy filing a few years later. In spring 2009 first Chrysler and then GM declared bankruptcy, beginning reorganizations backed by $80 billion in federal money that resulted in thousands of southeast Michigan jobs lost as well as cuts in salary and benefits. This created a ripple effect throughout the regional economy and deflated property values, which in many parts of Detroit had been inflated by the availability of cheap credit.[84] When the bubble burst, many owners (residential, commercial, and industrial) simply walked away. At the recession's depths, enterprising parties like Dan Gilbert's Bedrock Properties swooped in and bought up properties on the cheap. Gilbert, whose firm Quicken Loans wrote many subprime loans that arguably helped inflate and then sink Detroit, acquired a roster of formerly blue-chip downtown properties, including several prestigious office towers and vacant land.[85] These properties would later become part of Detroit's much-heralded downtown revival. Yet most property owners were not as fortunate. As many walked away or ceased maintenance activities, they left behind a veritable cornucopia of unsecured buildings ready for exploration.

By the late 2000s, Packard anchored a constellation of Detroit urbex sites, including Fisher Body #21 (another of the formerly numerous Kahn-designed automotive manufacturing buildings in the city), the Michigan Central Station, the Woodward Presbyterian Church, several downtown office buildings, the Belle Isle Nature Zoo, and the former Cass Technical High School. In 2004 the Detroit

School District inexplicably left Cass Tech (demolished in 2011) stocked with furniture, lab equipment, art supplies, books, cabinets stuffed with records, audiovisual and computer equipment, and pianos when it relocated the school to a new building north of the original. There were also many less prominent sites to explore, including automotive supplier factories, warehouses, theaters, churches, schools, and apartment complexes.

The vastness of the city's gray zones and availability of prominent sites like Packard for all forms of transgression enabled urbex to become a regular part of the Detroit experience, dovetailing with traditional touristic activities. With stories appearing in the travel or arts sections of newspapers and electronic media, ruins were no longer just an icon of Detroit's fall, they were almost-legitimate attractions. Stories often accompanied by alluring photographs appearing in the *Washington Post*, *New York Times*, *Wall Street Journal*, *USA Today*, *the Guardian*, *National Geographic*, and others celebrated the spectacle of the plant. "Nothing prevents you from wandering the vast remains of the Packard Automobile Plant," the *Washington Post* noted in a 2011 travel story, accompanied by provocative photographs taken from the plant's interior.[86] Three years later, the *Post* returned to Packard and published yet more in-plant shots in its photo essay, "Detroit's Faded Beauty."[87] While tours of Detroit techno sites, which included Packard, occurred at least as early as 1999 and attracted a small but enthusiastic number of national and international tourists, visitors by 2011 were regularly coming as part of organized ruins tours. (After 2014, the tours would continue with the consent of the plant's new owner.)[88]

Detroit urbex destinations were varied and plentiful and access easy, but danger was ever present. If explorers had access, so too did the scrappers, and the removal of structural support or building systems made these places unstable. Past fires and abundant water intrusion and flooding with subsequent freeze-thaw cycles further undermined many abandoned buildings. Packard was an exceptional case; it had been broadly accessible long before the recession, and the complex contained nearly every kind of known safety hazard. Suspicious fires were a regular occurrence and increased in frequency as the recession began and the city's underfunded fire department's capacity declined. Typical of this era, in June 2009, a little over a week after GM declared bankruptcy, firefighters struggled to contain a fourth floor fire in a six-story Packard building, which apparently started and spread

from stored plastic. Firefighters were unable or unwilling to go into the dangerous building at night, and allowed it to burn through the night and eventually it burned itself out.[89] Weeks later, two ladder companies battled another upper-floor blaze at the plant. "We're out here just about every week," a firefighter told the *Detroit News*.[90] Some fires were set in concert with scrapping, with scrappers and scavengers torching sections of the plant and then returning after the fire had been extinguished to harvest the exposed spoils, including structural steel. "It's like we work for the fucking scrappers," one firefighter complained to journalist Charlie LeDuff.[91] Other fires may have been arson or started accidentally by the dozen or more homeless people encamped at the plant. Their fires started for warmth sometimes burned out of control. According to the *Free Press*, during the first nine months of 2012, firefighters responded to fifty-nine different fires at the plant.[92]

The recession years and those that followed as the city slid into bankruptcy were good times for Packard scrappers, including those who harvested crafted materials like wood flooring or interiors, wrought iron, and ceramics. They worked with impunity, Packard informants told me, a perspective well corroborated through print and electronic media. Touring the area in 2010, Dave Biskner, organizer of the Friends of Milwaukee Junction (an industrial heritage group), told me he would not wander inside Packard because it had been structurally compromised by scrappers and that damage done by these agents had made the plant's salvation unlikely.

Packard's great size, relative isolation, uncertain structural integrity, and the fact that members of the police and fire departments had trepidation about entering did give some explorers pause: *What if something happens and I am alone? Will anyone come to my rescue? Will they even be able to find me?* Explorers also had to confront the fear of carrying expensive camera equipment: Would they encounter someone who would attempt to take it from them or do them harm? Would their cars parked on-site or nearby be broken into? Alone at Packard in 2012 I entered the plant through one of several open bays along the continuous stretch of buildings along Concord Street, south of the Boulevard. It was dark and eerily quiet, and piles of debris were all around me; broken pipes and metal members dangled from the ceiling. Gently walking around the debris and large cracks in the concrete floor toward the sunlight streaming through the other side of building, my gut instructed me to go no farther, and I opted not to proceed deeper into the plant or to its upper floors. The many

An abandoned bus amid the emerging green of one of Packard's many courtyards. (Author, 2003.)

explorers who did enter during these years, often traveling with a friend or in groups, stuck to day-time and treaded lightly. But the very qualities that made Packard risky also generated excitement, and as the word spread, more people were willing to take the risk. And the more people explored and publicized their exploits through web-based and traditional media, the more it seemed like exploring a vacant factory complex full of hazards was a normal, not-so-risky thing to do.

The work of professional and amateur explorer photographers made Packard an international urbex destination as well as a flash point in the national debate about the dissemination of urban ruins imagery. Websites such as The Fabulous Ruins of Detroit, which began in 1998, and internet message boards and chat rooms helped propel urbex from an itinerant practice spread mostly by word-of-mouth. Likewise, acclaimed documenter Camilo José Vergara's many trips to Packard from 1987 forward, which were published in *American Ruins* (1999) and elsewhere, added legitimacy and poignancy to Packard urbex, and implicitly encouraged visitation by more thoughtful interpreters who often viewed the plant as an elegy to a rapidly vanishing America and made comparisons to Rome's fall.[93]

Taking inspiration from Vergara, photographer Andrew Moore published *Detroit Disassembled* (2010), a volume that accompanied an exhibit at the Akron (Ohio) Art Museum, and Yves Marchand and Romain Meffre published *The Ruins of Detroit* (2010).[94] Moore's elegiac, long-exposure photographs are arguably part of a romantic or picturesque tradition of ruins interpretation that "emphasize the fragility and impermanence of human achievement in the face of nature's power" that began in eighteenth-century Europe. In their depiction of "re-ruralization" and the "recycling of human construction by nature," Moore suggests that these photographs represent "signs of hope" and "radical solutions" for Detroit's future.[95] His vision could be written off as romantic or worse, unconcerned about the fate of the hundreds of thousands of residents living amid this re-ruralizing landscape, yet such perspectives were not inconsistent with emerging proposals from architects and planners, who envisioned a form of orderly shrinkage or "rightsizing," and a potential withdrawal of urban infrastructure from vast outlying sections of the city. While some proposals were clearly provocations, Detroit Future City's *2012 Strategic Framework Plan* envisioned depopulated neighborhoods becoming "Alternative Use Areas," where urban systems would be repurposed or decommissioned as residents vacated and land was returned to "an ecologically and environmentally sustainable state" characterized by agriculture, forestry, storm water control, park spaces, and visual landscape amenities, as well as art and event spaces.[96] Rightsizing and a return to nature have proved a difficult sell to residents and operationally challenging to implement. Yet some aspects of these practices have been adopted by the city and the Detroit Land Bank.[97] At the same time, Moore's Detroit pastoral can be seen in the thousands of Packard photographs and videos taken by amateurs at Packard and across the city and posted to social media websites.[98]

Art historian Doris Apel observed that early-twenty-first-century Detroit had become "the global metaphor for the current state of neoliberal capitalist culture and the epicenter of the photographic genre of deindustrial ruin imagery."[99] Similarly, many explorers have argued that urbex and ruins photography form a critique of global capitalist practices.[100] At Packard, explorers often made such rationalizations about their exploits or reveled in the experience of strolling through what they considered the ruins of capitalism, corporatism, Fordism, or modernity. Several years after her last Packard rave, my informant Liz Beale rediscovered the plant as she became interested in photogra-

phy, and today she makes a living photographing cars for the advertising and promotional materials of Detroit-area dealerships. Like many, she argued that the Packard ruins were those of a plant that helped build Detroit but also ensured its demise, as the automobiles it produced enabled people to leave the city in droves—and they did, as the neighborhoods around Packard demonstrate. Or as LeDuff noted, "The car made Detroit and the car unmade Detroit."[101]

The rationalization of urbex and ruins photography as critique or documentation of capitalism's failure is so pervasive that it has become a cliché. In Detroit, ruins photographs and essays have sometimes risen to the level of art and literature, but they have also generated significant criticism (particularly among elected leaders) and, at times, downright mockery.[102] LeDuff called Detroit explorers "grown men who get their thrills traipsing around ghost buildings, snapping photographs and collecting bits of this and that for odd pieces of art."[103] Others have noted that urbex and "ruins porn" trivializes the experience of local residents and the city's history, and exacerbates racist attitudes and practices.[104] But explorers often claim that few others love these sites as much as they do—and that their behavior is far less reprehensible than that of the building owners. Likewise, some have noted that Detroit's demolition programs are a far greater spectacle than urbex and ruins photography, and have had a greater destabilizing impact on the city.[105]

Some explorers viewed their exploits as part of a larger continuum—part of the "resurrection and reinvention of the city of Detroit"—and are involved in traditional preservation advocacy activities.[106] Yet Detroit explorer-preservationists trail those of Buffalo and Pittsburgh, where participants are more likely to speak of their city's industrial-era monuments with reverence, as sites that must be preserved for posterity. Like Detroit as a whole, Packard has rarely generated that kind of architectural passion. In many conversations with local urban development professionals, the mere mention of Packard and preservation often generated laughter or a rolling of the eyes, and it was difficult to suggest a connection between transgressive activities with legitimate preservation pursuits.

Urbex and ruins photography are also part of a counternarrative to the story of the city's demise. As Apel observed, Detroit is a mecca not just for explorers and photographers but also for artists, musicians, writers, architects, planners, and "the curious who are drawn to a city that seems

to embody not only disaster but also open-ended possibility."[107] Engagement with abandoned places resonated with the city's emerging DIY scene that included makers, tinkerers, urban farmers, entrepreneurs, designers, and artists. Part of Detroit's lore is Henry Ford inventing things in a small workshop—and the many other inventor-entrepreneurs that built the country's automobile industry, including Ransom Olds, Henry Leland (one of the founders of Cadillac and later Lincoln), and the Dodge brothers.

While the myth of the lone genius inventor has largely been debunked, my informants, including planners, architects, artists, and business owners, have all invoked Detroit's legacy of innovation, technology, and entrepreneurialism.[108] Likewise, creative transplants saw opportunities to live, make, and play in Detroit at costs far below New York and California. In 2010 the *New York Times* observed that Detroit's "long-dwindling population and landscape of abandoned buildings have made it a singular—or perhaps prophetic—case study in Rust Belt decline. But its particular brand of civic and economic decay has also drawn . . . a small but well-publicized movement of artists and other creative types trying to wring something out of the rubble." The paper also noted, "The city that birthed the assembly-line age is now cultivating a slew of handmade salvagers, and it has not gone unnoticed."[109] In 2012–2013, "creative class" guru Richard Florida decamped to Detroit, where he penned several articles and made videos, promoting Detroit's heritage of innovation and creativity, low cost of living, and emerging quality of life.[110] City government was, in a limited fashion, also getting aboard and had hired a film, cultural, and special events director. However, city leaders could not see the connection between this movement and places like Packard, a site of Detroit authenticity steeped in the histories of automotive manufacturing, modern architecture, and postindustrial counterculture.

On the contrary, Packard remained the bane of city government. Yet frustrated city officials had few resources to patrol the plant, let alone demolish it. By 2010, as Detroit was scaling back public functions like police and fire patrols, road and traffic control maintenance, its administrative capacity was also breaking down. With a "sexting" and corruption scandal with Mayor Kwame Kilpatrick at its center gripping Detroit, at Packard the city could not determine who was the rightful owner. [111] Was it Cristini and his company Bioresources, which was listed on city deeds, or was it

Oakland County land speculator/investor Roman Casab, who had previously provided money to settle Packard's mortgage claims and some back taxes? With Cristini recently released from jail, he again claimed ownership. At the same time, Casab had claimed ownership when he sued a Detroit-area art gallery for unauthorized removal of a guerrilla artwork at the plant (to be discussed shortly).[112] Then in November, the *Detroit Free Press* revealed that the city had not billed Packard owners (whomever that might be) for property taxes since 2007. After the city lost its ultimate claim to the properties in Michigan Supreme Court, it never properly recorded changes in its billing files, and had inexplicably changed the records to show it was the complex's owner, even as Bioresource/OPPMAC had been the owner of record since at least as early as 2003, when the city lost an earlier version of its court case. Yet within hours after discovering the error, the city amended its records to show Bioresource as the owner of over forty individual Packard parcels. It also updated each parcel's corresponding assessed value from "zero/not-taxable" to various amounts, with the total assessed value for the entire assemblage being $1.6 million, reflective of 50 percent of market value as determined by city officials, according to the *Free Press*, in preparation for billing its owner—or leveraging debt in yet another attempt to take title to the properties.[113] But Cristini, now living in a Detroit halfway house, blamed the city for the error and the property's decayed state. "The city kept claiming they owned the plant, they evicted my tenants, and then knocked down a half-million square feet," he told the *Detroit News*. "Then everyone and their brother went in and scavenged it while I was in prison. Did they expect me to take care of it while I was locked up?" But Cristini also indicated he was "open to ideas" and willing to work with the city on a new plan.[114]

Yet the city had no intention of preserving Packard. In 2011 the Detroit City Council ordered the complex torn down and demanded that Cristini foot the estimated $10 million demolition bill, a small part of which could be recouped through the sale of scrap. By 2012 Packard's lone legal tenant, Chemical Processing, which had been at the plant since the late 1950s, moved to the suburbs, with its nine employees. Soon Cristini was working out an agreement with the city to fund demolition—between a city lien and back taxes, he owed Detroit approximately $1.21 million. Despite his desire to preserve the plant, he now seemed resigned to clearance. "The preservation people want it saved, but we did a cost analysis for rehabbing and it just wouldn't work," he told the *New York*

Times. "Plus, there's a danger element, all the graffiti artists in and out of there and the illegal scrapping. So I've got to knock it down. . . . I know it's history, but the place just isn't safe for anyone," and estimated that demolition could begin in thirty days.[115] In the end, the city and Cristini never could agree on who would pay for demolition or control the property once it was cleared, and probably other points of contention. Packard would again avoid the wrecking ball.

Ironically, the many rumors, declarations, and near agreements concerning demolition only served to drive more people to the plant during the early 2010s. And in the months during Detroit's bankruptcy proceedings until the plant was sold via auction, Packard perhaps enjoyed unprecedented numbers of visitors. As Spaniard Fernando Palazuelo and his company Arte Express was taking title to the property in early 2014, the city's alternative weekly, *Detroit Metro Times*, published "Your Guide to Detroit's Ruins." In it, a veteran Detroit explorer complained about crowds and claimed to have counted two hundred cars at the plant on a recent Saturday.[116] But Packard's new owner would soon put an end to exploration and other unauthorized activities.

Packard Art: Exploiting the Intersections of Public and Guerrilla

Billy Voo was likely one of the explorers at Packard that Saturday. Since 2003 he had been a regular visitor and had previously played paintball at the plant. Voo, who shot some of the video for the *Wall Street Journal* of the infamous 2009 truck drop, called Packard a "playground" for his crew. "We hung out there at night, we hung out there during the day, weekends, twelve hours at a time, through winter, year round," he explained. Yet he was also interested in history and noted with admiration Packard's speedy conversion to armament and military vehicle production in the 1940s as part of southeast Michigan's arsenal of democracy and the thousands of women employed there, often in demanding production-line roles during those years.[117]

Like many Michiganders who have spent time wandering ruins, Voo, whose given name is Riddle, tends to view transgressive activities in old factories as an extension of working-class culture and

through the lens of the city's manufacturing heritage. Additionally, he argues that almost everyone in greater Detroit has a connection to the automotive industry through family or friends. In a phone conversation and email exchange during 2018 and 2019, Voo, who now lives in Oregon, described growing up in Lincoln Park, a southwest suburb, part of a swath of towns known as the Shores Community or, more colloquially, "Down River"—near Ford's mammoth River Rouge complex and the region's steel mills that served the Rouge and other factories. When I asked Voo about Packard raves, he said he hadn't attended any and steered the conversation toward Down River's contributions to Detroit's music history. Lincoln Park is where the iconic rock band the MC5 hailed from, and nearby were the childhood homes of other famed area rockers including Bob Seger, Alice Cooper, and Iggy Pop. But aside from these rock stars, most Down River kids would have a difficult time escaping their blue-collar upbringing. "You were either going to work on the [automobile factory] line or you were going to work in a steel mill," he explained. The growth of graffiti, urbex, and ruins photography was, in his estimation, an outgrowth of this culture, before it was co-opted by visitors from beyond the region.

Graffiti artists were among the plant's original transgressors and for decades had used Packard's walls as a postindustrial canvas. And as the new century progressed, there was more graffiti to see, with the greatest density and most ambitious of works in the plant's interior. By the late 2000s Packard had become an international destination for graffiti and street art, and as Voo explained, explorers routinely "followed" graffiti-writing crews into the plant, looking for new tags to photograph and post on the internet. Having tried his hand at graffiti earlier in life but finding the camera more to his liking, Voo was a champion of Detroit's scene and spent many hours photographing works at Packard. He was also among the first to discover the plant's most notable graffito, created by British street artist Banksy, and helped facilitate its removal.

In 2010, guerrilla artworks began to appear in several North American cities, coinciding with the premiers of the Banksy documentary film, *Exit through the Giftshop*. Its May 2010 premier in Royal Oak, a Detroit suburb, generated excitement and, according to Voo, spawned local copycats, who attempted to mimic the artist's style and wry humor. Looking at the official Banksy website one evening, he noticed the posting of a new work in what seemed to be a familiar setting. Voo, who said he

I remember when all this was trees

A Banksy graffito at Packard. (Elizabeth Beale, 2010.)

knew every inch of Packard, went to the plant and quickly found the work—apparently before anyone else, though the *Detroit Metro Times* located it the next day. On a mostly demolished cinderblock wall in a debris-littered building exposed to the sky, the work displayed a Black youth holding a paintbrush and can with the message, "I remember when all this was trees." While the work was one of two attributed to Banksy at Packard and one of at least four executed in the Detroit area in 2010, it was the only one immediately authenticated by the Banksy website, according to the *Free Press*.[118]

Voo worried about the safety of the many visitors he thought the Banksy would generate, including his fourteen-year-old sister, and noted collapsing roofs, caustic materials, and "people [who] shoot blindly into these buildings with guns." He also rationalized that the work would soon be destroyed by scrappers or excavated and sold on the internet, which is what many think happened to the other Packard Banksy. Attempting to locate a permanent home for the work, Voo quickly found willing partners at the 555 Gallery in Southwest Detroit. Within days, the 555 artists moved to salvage the graffito, cutting a fifteen-hundred-pound section out of the cinderblock upon which it was executed and transported it to the gallery, where it remained on display for a few years. The removal prompted a lawsuit against the gallery from Bioresource (led by Casab). The case was settled out of court with 555 paying Casab twenty-five hundred dollars but retaining ownership. Contrary to its stated commitment to keep the Banksy on local display, in 2015 the gallery put it up for auction, which was won by the CEO of a Los Angeles toy company paying $137,500. The gallery was ridiculed for first removing the work from Packard and then from profiting from its sale, though it claimed that the proceeds would be reinvested in a cooperative arts space on Detroit's East Side.[119]

While Banksy brought international attention and set in motion a contentious debate over the ownership of guerrilla art in the public or not-quite-public realm, Packard has a longer history of appropriation by visual artists looking for space for more than just a graffiti tag. One such artist, Scott Hocking, began exploring Packard in 1997. Hocking called the late 1990s and early 2000s a "golden era" for Detroit's abandoned factory complexes, many of which were still intact and contained voluminous material culture, yet to be pilfered or disturbed by scrappers, vandals, and explorers. In much of Packard, the last "active" use was storage. At some point, stored items were abandoned like the plant itself: furniture, clothing, shoes, personal effects, appliances, tools, vehicles, automobile

parts, and boats. Hocking described the conditions in some Packard spaces and those of other idled factories as a "hoarder situation," unbelievably packed with materials and possessions.[120]

Defying easy categorization, Hocking's projects are often deep explorations of Detroit's abandoned spaces and discarded materials with significant connection to history, geography, ecology, and consumerism. And like the Carrie Deer artists, Hocking was enthralled by Packard's postindustrial ecologies. He enjoyed watching the progression of the seasons and monitoring the entropic forces, natural and human, that were transforming the plant. His experiences at Packard and other abandoned industrial sites were his "nature retreat," he told me. They represented an "escape from the city" and from his "gritty, low-income, blue-collar upbringing" in the adjacent working-class suburb of Redford Township to a place "where nature had taken over" and "animals had started to return." Many hours spent on Packard rooftops and walking through seemingly miles of once-productive factory floors was a "meditative experience . . . like a walk in the woods," he said, referencing Thoreau and other naturalists. Visiting Packard mostly during the day and usually on weekdays, Hocking enjoyed the "quietude" and on many occasions did not see another person even though he was there for hours. While frequently following the paths created by scrappers, he generally avoided contact with these people and others.[121]

It was in fact a decade of quiet engagement before Hocking executed his first and only installation at Packard. He had already created works at other postindustrial sites using found materials, including Fisher Body #21, where he assembled found bricks into a large pyramid. While at an abandoned trailer park south of the city airport on the East Side, he made a sculpture out of thousands of illegally discarded automobile tires and would later create an installation at the Michigan Central Station (chapter 6). For Packard he made use of old console television sets he found in the plant and

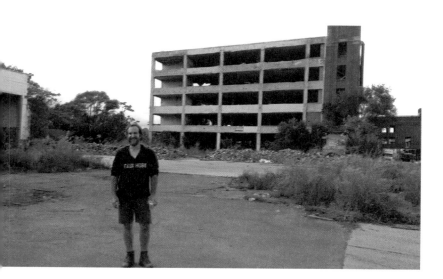

Scott Hocking at the southern end of the former Packard Plant. (Author, 2017.)

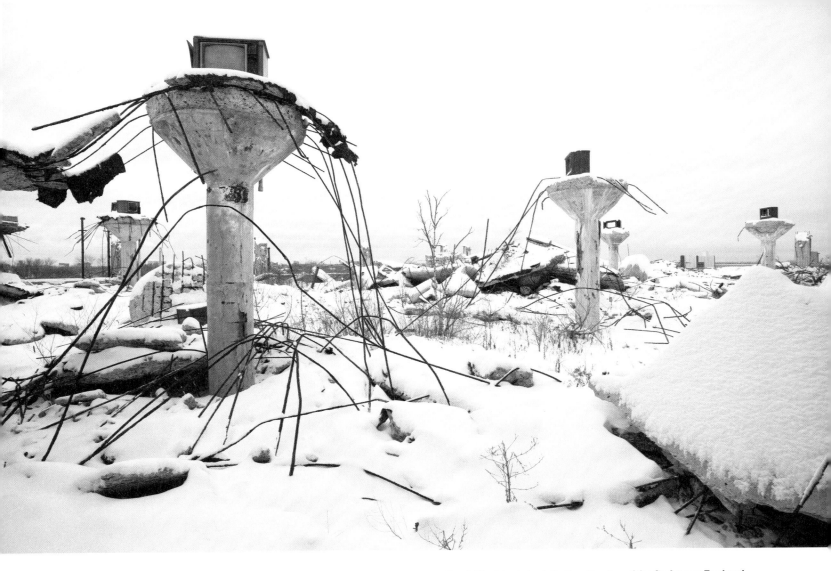

Scott Hocking's installation *Garden of the Gods* atop Packard Building #92. (Scott Hocking, 2010.)

many hours of his own physical labor. Over the course of several visits beginning in summer 2009, he carried these heavy televisions, one at a time, from a space in Building #39 dubbed the "TV Room" by explorers, up several flights of stairs to the now-exposed top floor of Building #92.[122] Making use of a found ladder, on a series of cold and blustery December days, he hoisted each of the televisions, up onto individual mushroom columns, twelve feet high, that once held the building's roof.

Hocking has a great interest in mythology and often contemplates the myths of past and present societies in his work. His installation at Packard, *Garden of the Gods*, references the classical Greek Pantheon, with each television-crowned column representing one of its twelve gods. The garden, towering over the flat expanse of the once-productive city below with its abundant vacant lots and buildings, represented a godlike vantage point. Knowing that entropic conditions, both social and environmental, would swiftly destroy the installation, Hocking was quick to document it but had little desire to bring others to see it. Rather, he wanted people to happen upon it and be provoked in a way that would induce critical reflection about American myths and how they played out in Detroit.

While *Garden of the Gods* was Hocking's only work at Packard, he has continued his dialogue with the plant. In 2019, with permission of the ownership, he salvaged three abandoned boats at the plant for *Bone Black*, his installation staged in an empty East Side foundry near the Detroit River. Little known to the world, Detroiters love their boats, and boating on Michigan's lakes is a major leisure pursuit of city residents. Yet with ownership comes the eventual problem of disposal—and boat disposal costs are high given that most recreational craft are made of fiberglass, which is difficult to recycle. Thus, many Detroiters, particularly those experiencing economic hardship, simply dump their boat somewhere rather than pay for proper disposal. Decades of abandoned boats can be found on vacant lots across the city—and for years, Hocking documented them on his Instagram account.

For a while, Packard served as a place to store boats during the off-season. As the plant deteriorated, the most distressed boats were simply left behind, never reclaimed by their owners, while others were illegally dumped on-site. The boats Hocking removed were, at that moment, the last three in the buildings owned by Arte Express. When I visited the installation, Hocking asked me to guess which three of the thirty-three boats, most of which were precariously dangling from the

foundry's ceiling, were from Packard. It was impossible to tell; there was a certain ubiquity to these objects of lost prosperity—all smeared with bone black, the pigment made from animal bones, a product produced in Detroit since at least the early nineteenth century. He pointed them out and noted that they, like all the boats, would soon be dismantled by hand (like *Garden of the Gods*, Hocking's own labor figured prominently in this work) and properly disposed in a landfill.

Hocking had initially wanted to do something like *Bone Black* in Packard and had proposed an even more ambitious installation with the salvaged columns of Building #92, which was being demolished by a city-hired contractor in early 2019. He called the Kahn brothers–designed columns of Packard and of countless other buildings across Detroit the durable "bones of the city," and envisioned vertically stacking these massive concrete members on top of each other like a pyramid of champagne flutes. Representatives of the demolition contractor did entertain his request but determined that because the columns came from a building contaminated by asbestos, they too were contaminated and must go directly to the landfill.

In the decade between *Garden of the Gods* and *Bone Black*, Hocking's career has taken off and he has received several prestigious commissions, fellowships, and awards. Like the city itself, Hocking's work was evolving toward something more sanctioned. Sponsored by the Cranbrook Art Museum, *Bone Black* was executed with full permission, insurance, and proper power and safety equipment. Yet when I asked about Packard and whether it too might go legitimate, Hocking expressed skepticism, just as he had previously. He noted that in five years of ownership, Arte Express had made no progress in fulfilling any part of their plan other than cleaning the site—a perspective further validated by the collapse of Packard's Grand Boulevard bridge, which he was one of the first to photograph.

A Postguerrilla Packard?

With the city entering the uncharted depths of municipal bankruptcy, in 2013 Wayne County offered the foreclosed Packard properties at auction. The auction generated considerable public and some

investor interest, but the winner was not determined until several months after the event. Much to the surprise of local leaders and the media, the winner was Fernando Palazuelo, a Spanish-born, Lima, Peru–based property developer who had never previously visited Detroit. The Madrid-native, who took title to Packard in December 2013 at age fifty-eight, has been credited with the restoration of dozens of historic buildings in Barcelona during the 1980s, and then in Palma, Mallorca. At the beginning of the global recession in 2008 he hit bottom, almost lost everything, and decamped to Lima, Peru where he possessed options on several downtown buildings, his last significant assets. Over the next decade, he resurrected himself as he restored over twenty-five late-nineteenth and early-twentieth-century buildings in Lima's Centro Historico, a UNESCO-designated site.[123]

Palazuelo is passionate about historic architecture and urbanism, and his property-based preservation work is aimed at restoring an elegance and urbanity of formerly high-value, dense, centrally located districts—qualities that Packard and the area surrounding it never possessed, even during the plant's busiest years. Had he misread Packard and Detroit when he placed his bid? Having never done a project in the United States before, he learned of the plant from reading about Detroit's bankruptcy in the *New York Times*.[124] Intrigued, he flew to the city in August 2013 and visited the Wayne County Tax Assessor's office to see about purchasing Packard and other available properties.[125] Weeks later at public auction, Palazuelo's bid of $405,000 was only third highest. The $6 million top bid came from Jill Van Horn, a Texas doctor who planned to manufacture modular homes at the plant. When she failed to make the 10 percent down payment, Packard fell to Bill Hults, a Chicago-area developer who bid $2 million and envisioned a $250 million to $300 million mixed-use complex. It was his second attempt at buying the plant that year, but after putting down two hundred thousand dollars, he failed to pay the balance owed. It then fell to Palazuelo who put down 10 percent in November 2013 and paid the balance of the sales cost the following month.[126]

Packard Plant owner Fernando Palazuelo. (Max Ortiz, Detroit News, 2016.)

Unfamiliar with Detroit prior to winning the auction, Palazuelo hired Kari Smith to be the project's director of development. Smith has a master's degree in historic preservation and for a time worked as a historic review technician for the city of Detroit. In March 2016 I met Smith in the small suite of offices leased (not owned) by Arte Express in one of the only functional former Packard Buildings (#82), just west of the Administration Building. At that moment, Smith was busy coordinating with University of Michigan Taubman School of Architecture faculty and staff who were organizing the Detroit exhibition for the US Pavilion of the Venice Biennale, which was opening in May. In the exhibition titled *The Architectural Imagination*, Packard was one of four sites fantastically reimagined by twelve teams of architects, which aimed to resurrect the idea of Detroit being a modern metropolis with advanced architecture, culture, and lifestyle—and, according to the curators, the "center of American imagination."[127]

While the Biennale exhibition generated a buzz in architectural circles and drew a record number of visitors during its six-month Venice run and strong attendance at Museum of Contemporary Art Detroit where it was shown after, the proposals for Packard could be characterized as eco-futurism, broad provocations rather than grounded concepts that might directly impact the site in the near term. Yet the Packard Project was making progress, and Smith was eager to tell me about it. I sat down across from her at her desk and listened. Arte Express had secured the plant and gutted several buildings in preparation for development—and much to the relief of area residents and the city, twenty-four-hour security patrols had kept scrappers and arsonists as well as more benign guerrillas off the property (and sometimes hassled the idled motorist or rare pedestrian who dared to pause to view the plant). Palazuelo also purchased additional properties on the plant's periphery and was in discussion with the city about parcels that it owned, including Building #92 (site of *Garden of the Gods*) and Building #27 (the onetime Arlan's department store) south of Grand Boulevard, connected by bridge to the Administration Building, as well as financing and incentive programs, zoning, and building codes.

I asked Smith about Packard's unlikely savior and why he had undertaken such a challenging project. She replied that in addition to Palazuelo's zeal for architecture and history, he was a developer who makes investments in undervalued buildings on a "cost-per-square-foot basis." As of that moment, his total investment in Packard and peripheral properties, Smith said, was over $3 million, and included over

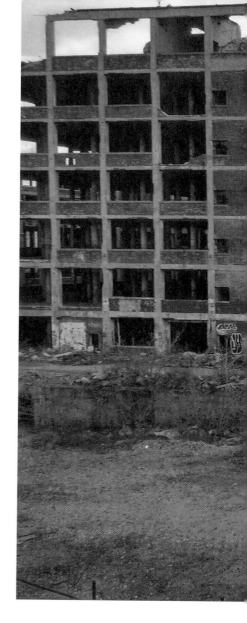

fifty parcels, and the settlement of back taxes and security. At Packard, Arte Express was developing a flexible arts and culture plan that would also contain substantial office space and perhaps residences. Smith described a fifteen-or-more-year buildout executed in four phases. The $16 million Phase 1 restoration of the four-story, 121,000-square-foot Administration Building would be inhabited by office tenants with an art gallery and potentially a restaurant. As Smith described other potential uses, I looked out the window, across a courtyard enlarged by city demolitions in the late 1990s, to the spread of not-quite-fully gutted Packard buildings that might house these new uses, including the "creative village" combining music, art, cultural, and hospitality uses; a Packard museum (there was already one in Warren, Ohio, the car maker's birthplace); as well as studios, apartments, a magnet school, retail, and light manufacturing. These buildings were still a mess and entirely open to the elements except for some window bays of the Administration Building, which were draped in plastic. The intense March grayness perhaps magnified building pathologies, including missing brick panels, glass, and window frames, and damaged concrete. Yet upon longer examination I could visualize performance, culture, and hospitality uses spilling out into the courtyards between the pavilions. Albert Kahn's buildings, even well-abused, century-old ones, have a kind of urbanity that exceed the functions for which they were built. These uses were in the realm of the possible, but it would take deep-pocketed investors willing to make a bet on Detroit and the city's tattered Lower East Side backed by large public subsidies.

Smith possessed a strong sense of Packard's history from its pioneering turn-of-the-century plant design and decades of production to its latter days as an industrial park and site of counterculture. She also had a personal connection: her grandfather had been a Packard employee

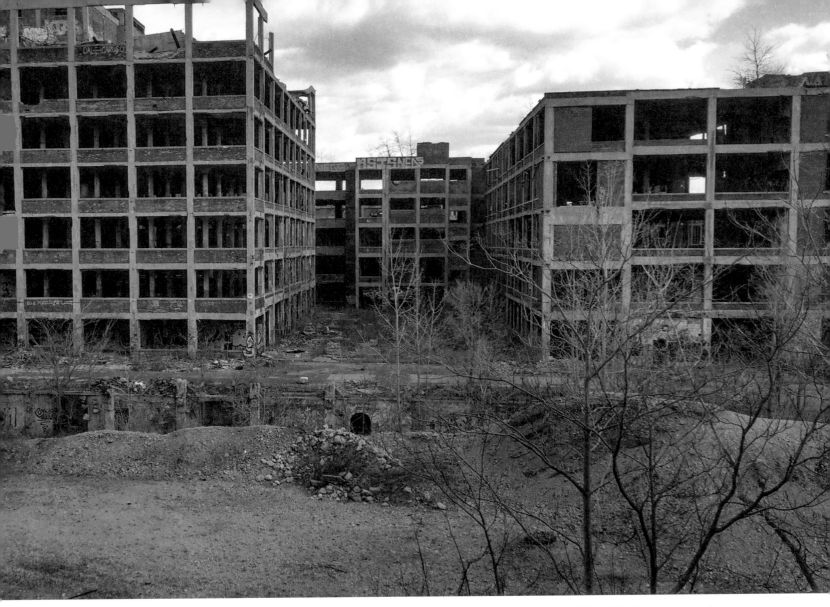

Packard buildings north of Grand Boulevard as seen from the Arte Express office. (Author, 2016.)

for twenty-five years. And while working for the city she had urbexed at the plant. She spoke with reverence about architect Kahn and noted Arte Express's commitment to preserve and restore as many buildings as feasible. Like others, she reasoned that Kahn's reinforced concrete buildings, including the first such building constructed for the auto industry in 1905—featuring the Kahn-bar system developed by his brother Julius—had much greater steel content than many later concrete factories, thus pushing demolition costs beyond the means of the revenue-starved city.[128]

In addition to the plan for the Administration Building, Arte Express was in discussion with international techno impresario Dmitri Hegemann about developing an electronic music venue—a potential homage to Packard's postabandonment past. Hegemann, who opened and operated famed music clubs in Berlin (another city with a long association with techno), had been talking to city representatives about creating a venue at the Detroit-owned Fisher Body #21. He had apparently been wooed over not just by Packard's prominent association with techno but also the opportunity to work in the context of a larger project and with Arte Express rather than with the city, according to Smith. The music club could serve as a focal point in the creative village that might also include a techno-themed hostel on the floors above. In addition to these postindustrial uses, I imagined recreation components that have transgressive histories both at Packard and elsewhere in Detroit, including skateboarding, Parkour, urban climbing, and indoor skiing, and envisioned coworking and maker spaces, the kind of private or institutionally supported infrastructure that is becoming de rigueur for any American city interested in attracting educated residents. On a wall I examined the color-coded maps and satellite photographs displaying conditions and ownership. When I asked about the techno venue's potential location, Smith said matching uses with buildings was still in a fluid stage.[129]

Having missed its original project start date by six months, in May 2017 Arte Express "broke ground" on the now $21 million restoration of the Administration Building. While its creative economy plan was still evolving, the initial phase would contain offices, space for a Detroit catering company, a ground-floor gallery, an events venue, and a coffee shop. At the time of groundbreaking, the firm had commitments for 80 percent of the building's floor space, even as most tenants were less "creative village" and more ordinary southeast Michigan office endeavors, including engineering, security, and marketing firms. The Detroit Training Center, which offers adult vocational instruc-

tion, was to lease an entire floor.[130] In December 2017 Arte Express announced plans for a Packard brewery/restaurant in a standalone building on Grand Boulevard just west of the plant assemblage, anticipating a 2018 groundbreaking and a 2019 opening.

After my 2016 visit to Arte Express's office, I monitored the media for progress. For years, the Packard Project's website was barely updated. And while provocative photos of gutted interiors were frequently posted to the project's Instagram site, none showed construction. Tours of the plant's perimeter in 2017 and 2019 validated my sense that little progress had been made. And Arte Express representatives rebuffed or ignored my attempts to visit again or discuss the project. In 2020 a representative referred me to a real estate attorney, who also declined a response to my inquiries.

For a few years, Palazuelo and his company enjoyed amicable relations with the media and public. He proved to be an affable owner, and many who dealt with or met him referred to him as "Fernando." For those residents who had remembered the plant just a few years earlier, with the fires and scrappers, illegal dumping, and the previous owner, who went to prison for dealing drugs across the street, Palazuelo must have indeed seemed like a savior. Charismatic, well-dressed and mannered, he showed up and essentially ended the unsavory and illegal activities. If he could deliver on his development promises, which potentially included jobs and training programs for nearby residents, and perhaps affordable housing down the road, all the better. Yet it was unclear how deep Palazuelo's pockets were and whether he had been charming enough to convince investors to make the project a go.

Also contrary to media portrayals, Palazuelo did not own the entirety of Packard. Some buildings were owned by the city or other private owners (a vestige of the complex's original 1958 sale to multiple buyers and the city's earlier, partially successful foreclosure efforts). In fact, during my 2017 visit, a demolition crew with a backhoe was busy clearing the remains of the city-owned Building #37 on the southernmost parcel of the assemblage. Another owner controlled a large one-story structure (Buildings #40–45) covering several acres south of Grand Boulevard, which once housed a metal fabrication and auto body shop and served as the home of Packard's unofficial ambassador, Allan Hill, for nearly twenty years. At the north end of the assemblage, adjacent to the Ford Freeway, Building #22, a 225,000-square-foot moderne structure constructed in 1939, was purchased from yet another owner in 2015 by the Display Group, which stores movie and media sets and props.[131]

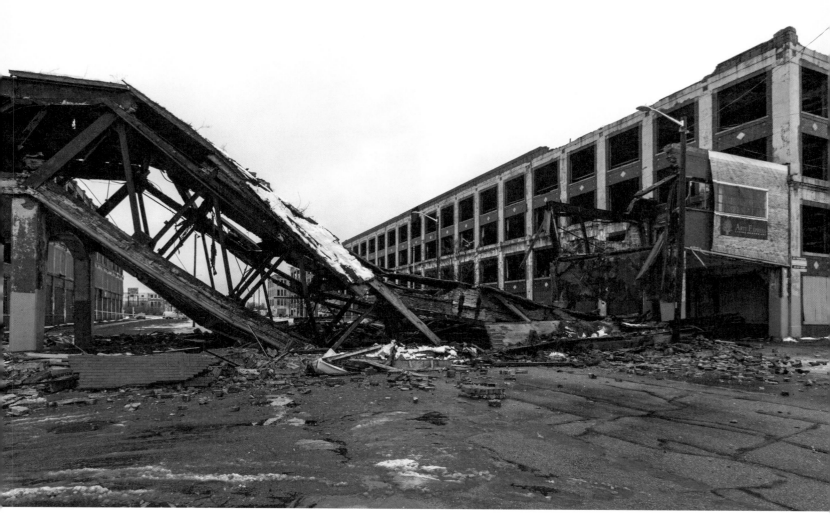

Packard's Grand Boulevard bridge after its collapse in January 2019. (Scott Hocking.)

This building, where aircraft equipment was once manufactured, has been in near continuous use for some time and was in better condition than those owned by Palazuelo or the city. While the media widely reported that Palazuelo's ownership of Packard buildings contained 3.5 million square feet, what Arte Express possessed was substantial but less than that. In fact, the media had long used this number—even before city demolitions in 1998–1999 and then again in the late 2010s.

After Palazuelo bought Packard, Detroit development leaders were cautiously optimistic. Over conversations going back to 2003, nearly everyone I talked to, including planners, architects, preservation advocates, and automotive history enthusiasts, had accepted the fact that Packard would eventually be demolished. For decades, it was also the official city position that the plant was unsafe and needed to be cleared for new development. Yet by 2016, much like the city itself, Packard was being cleaned up and there was a sense that the infamous plant could be a vital part of the postbankruptcy, resurgent city attractive to knowledge-based professionals and businesses. Steven Lewis, then the city's urban designer for the district that includes the plant, noted that the Packard Project was consistent with Mayor Mike Duggan's goals to grow population and jobs. "Detroit is ripe right now for corporate life," he reasoned and hoped the development would create employment for residents of the surrounding neighborhoods.[132] Francis Grunow, a planning consultant and onetime executive director of Preservation Detroit, was more skeptical but noted that the public conversation around the reuse of Packard rather than its impending demolition was progress for a region where the demolition of historic structures has been the rule rather than the exception.[133]

During the first few years of Arte Express ownership, there was also an implicit public expectation that something would happen at the plant, and soon—as a measure of good faith as much as anything else. Early on, Arte Express partnered with Pure Detroit to administer tours (the company had been giving ruins tours of the city since at least 2011). At approximately forty-five dollars per person, the Packard tours were popular until they ceased after the 2019 bridge collapse. And like the owners of other iconic postindustrial sites, Arte Express rented parts of the complex for media shoots and at least one wedding, which provided modest cash flow. Movies and media shoots, most prominently *Transformers III* (shot in 2010) and *A Most Violent Year* (released in 2014)—and some smaller productions and rentals for intimate urban exploration experiences—have also contribut-

ed to Packard's lore. During a 2015 fashion shoot booked by a British photographer, a tiger was loose on the plant. The big cat decided to camp out in a staircase before eventually being coaxed back into his cage unharmed by his handlers. Two wolves and a bobcat, which were to play supporting roles, never had the opportunity to leave their cages, as Arte Express, apparently unaware that the photographer intended to bring animals, let alone a tiger, quickly terminated the shoot.[134] Yet the firm failed, or never had the intention, to stage the kind of robustly public events, open free of charge or at nominal cost, that defined the early programming at Silo City and the Carrie Furnaces. Aside from their intrinsic value, these programs have shaped emerging preservation plans and helped build a constituency for more permanent investments. In Detroit, arts groups, including the Detroit Symphony Orchestra and rave organizers, had apparently expressed interest in performing or exhibiting at Packard and had discussions with Arte Express. None of these events came to fruition.

When the bridge over Grand Boulevard collapsed in 2019, the project's lack of progress came into stark relief. With the bridge's remains now spread in an elongated rectangle across the boulevard, the plant had again become a spectacle. It was clear to the local and national media as well as the residents who came to snap photographs of the fallen icon of Detroit's iconic ruins site. As I noted in the chapter's introduction, Detroiters retain a hearty sense of skepticism even in the face of a compelling counternarrative of progress, and thus the revelation was not shocking. Packard's postautomobile history has been so surprising, and at times preposterous, that nothing would really surprise those who have seen it unfold. Perhaps the collapse was only a setback and Arte Express's plan would eventually attract investors and subsidies. Or maybe the city would resume and eventually succeed in its seven-decade campaign to demolish the plant.

A Packard Life

At the plant in October 2019 with urban explorer/photographer and onetime raver Elizabeth Beale, we encountered Allan Hill. For most of the twenty-first century, the good-natured Hill had been living

Packard Plant resident Allan Hill. (Author, 2019.)

in a complex of one-story, gabled-roofed Packard buildings (#40–45) with a corrugated steel facade, where he took on small auto repair jobs to supplement his Social Security income and ran what was essentially an ever-growing salvage yard. The complex looked beat up from the outside and lacked heat, but had other utilities and was mostly weather tight. Known for giving impromptu Packard tours to international tourists, helping people (and animals) in need, and for tinkering (including his cargo bicycle prototype), his presence at the plant had evolved into an unofficial but celebrated caretaker and ambassador who regularly received visitors. But at that moment, he wasn't doing well. In August he was served with an eviction notice and had recently been released from a hospital, where he was treated for heart problems.

We found Hill on Bellevue Street outside of his former residence and workshop, with his friend Connie, who regularly visited and was the one who called for an ambulance on the stressful day when Hill complained of chest pain and an erratic heartbeat. He had been living with a friend but had been returning regularly, attempting to reclaim and find new places for his extensive possessions, including tools, equipment, and vehicles in various states of disrepair. They had come with a small trailer that had been hitched to an old convertible, and Hill was dressed for work with thick nonmatching gloves, grease-stained pants, an old leather jacket, and a blue cap with "Chaplain" stitched above a cross.

Connie described her seventy-four-year-old friend as "frantic," "frazzled," and a victim of his own generosity in allowing friends to store their junk at the property but never returning to reclaim it. She too became a bit frantic in describing Hill's predicament. Detroit's Buildings, Safety Engineering, and Environmental Department had recently issued citations to Hill's landlord, Greg Meyer, for maintenance violations concerning health and safety, noting "an extreme amount of material and waste located around the building" and apparently "closed" Hill's unlicensed auto repair busi-

ness.[135] This prompted the emergency eviction notice, in which Hill was initially only given twenty-four hours to vacate with his possessions, Connie said. In the moment, Hill was able to bring some of his stuff across the street to Arte Express's property; until recently, he had enjoyed good relations with Palazuelo and the firm. But while he was in the hospital, Arte Express changed course and began compressing his stuff and pushing the piles back across the street. When Hill learned of these events, he checked himself out of the hospital, rushing back to find "thousands of dollars' worth of his tools crushed into pulverization," Connie said. Our conversation was interrupted when an Arte Express security or maintenance agent came over and a short yelling match ensued concerning the removal of Hill's remaining items. The agent also sternly told us that we were trespassing and "had to go," even though we were standing on a public street. Tension was high, but eventually the guard departed, and we resumed our conversation.[136]

While distracted by the sight of a forklift moving things around inside the Arte Express building across the street, Hill described his Packard life. As he had told local and national newspapers over the years, he called his long and unexpectedly fruitful tenure a "real blessing," emphasizing his own arc of maturity—from his selfish "suburban attitude" and recovery from alcoholism, job and business losses, and two failed marriages—which he accredited to life at the plant. Packard had provided "a little tranquility," Hill said, and enabled him "to see life for what it really is, not what people think it is." Perhaps it wasn't the best time to ask him for his assessment of Arte Express's ownership of the larger complex. Since the bridge collapse, the firm had become more aggressive in policing the plant and its surroundings. As he described,

It's become a nightmare. They have the security come over here and they chase everyone away who has any interest in sightseeing or taking pictures. They've alienated the public. If you don't have the public rooting for you, you don't have anything. . . . They've threatened people . . . and they've been harassing me like crazy, as you can see.[137]

Beale noted that Arte Express had also tightened security in response to the death of a twenty-one-year-old, earlier that year, who had fallen nine stories down an elevator shaft at the Grand

Trunk Warehouse, two miles away. The warehouse, a frequent destination of explorers, had recently purchased by the firm.[138] Yet Hill no longer seemed interested in talking about Packard and steered our conversation onto the subject of God. He asked if I was a religious man. When I replied no, he seemed unsatisfied and gave me a puzzled stare, before calmly resuming sermonlike invocations. It was a good moment to leave, and we made our way to Beale's car with Hill trailing behind us. As we pulled away, he was still staring at us through the windshield. While Hill's eviction was probably not driven by concern for his well-being, his health would probably be better served in a more conventional residence. But I did feel sympathy for this man who had made a useful and, at times, joyous life amid Packard's ruins and shared it with many others. With his expulsion, an era was closing, and when he passed away in March 2021, the era felt entirely closed.

Packard's Preservation or Demise?

A short time after leaving Hill, I stood on the broken roadbed of Concord Street and considered the continuous expanse of Packard structures in front of me (encompassing Buildings #12, #11, #16, and #18). The façade had been mostly reduced to a concrete skeleton framing once elegant square sections while the roof had collapsed in many places, threatening to reduce five stories to four and four to three. Behind me on what was once a Packard parking lot, the trees, bushes, and grasses had thinned and turned autumnal colors: pale yellow, brown, and gray—and one tree, bright crimson. From this accidental meadow I could hear the continuous chirp of cicadas. But even with this soothing auditory enhancement, the plant could hardly be considered a splendid ruin benignly reclaimed by nature or an object of pleasant contemplation in the romantic tradition—a "sign of hope," as photographer Andrew Moore claimed—perhaps in another hundred years. Despite the moment's stillness, the scene felt rather grim and was further undercut by the drug treatment clinic, a warehouselike structure with few windows and a parking lot surrounded by a high wooden fence that was 150 feet from me.

Packard was a wreck, one that even a late-to-the-game observer like me had watched deteriorate

over nearly two decades. Yet it was still a landmark; there was no complex of this extent, density, and elegance (albeit well faded), built with such a clear sense of purpose, left on the East Side. Staring at what was once the plant's core and earliest complex of concrete buildings, a small part of which had been appropriated by ravers in the 1990s, I thought about what this view might have been like seventy-five or one hundred years earlier, with all the concurrent noises, vibrations, and odors. I also considered Albert Kahn's pioneering plan and building designs. After raising capital for a substantial investment in what was then the Ohio Automobile Company of Warren, Ohio, in 1902, new board chair and future president Henry B. Joy enlisted Kahn's to design a factory on what was then a tract of farmland beyond the built-up part of Detroit, intending to move the company (renamed for its founders, the Packard Brothers) to Joy's hometown.[139] According to the most authoritative account, written by W. Ferry Hawkins in his 1968 history of Detroit architecture, Kahn's first nine buildings, erected between 1903 and 1905, were standard New England mill construction, not unlike countless nineteenth-century brick industrial buildings found in American cities. But Joy's company quickly outgrew its buildings and the limitations of wood post-and-beam construction. For Packard's sequentially numbered #10, Kahn collaborated with his brother Julius, the president of the Trussed Concrete Steel Company of Detroit, to create the city's first reinforced-concrete factory building, a two-story L-shaped structure consisting of two 60-foot wide pavilions of 457 and 240 feet in length, respectively. Built in 1905 in just two and a half months, the building's light-filled pavilions offered generous floor space between interior columns set 32 feet apart; it was also fireproof, and with concrete, the floors could withstand exceedingly heavy loads and was more rigid against vibration. With #10 as the new standard, the company quickly rebuilt its earlier buildings and built many more, nearly all designed by Kahn.[140] In fact, #10 itself was expanded to four stories.

Preservation strategies often target the earliest or most historically significant buildings, like #10, and leave others until later or demolish them. But such targeted actions would be difficult here. As is common in large manufacturing plants, individual buildings were expanded, modified, or demolished as needed, and in a way that challenges easy identification of one building from the next. For over a century, #10 has been obscured from the street by the five-story Building #11 and is accessible only through other buildings, interior courtyards, or from the railroad tracks that bisect

Packard is a stop on a fall tour of Detroit automotive heritage sites in a restored Ford Model A. (Author, 2019.)

the complex. And even in its deteriorated condition, #10 fits seamlessly together with the other buildings.

At the onset of the twentieth century, reinforced concrete was still an experimental practice whose origin likely began with Auguste Perret's practice in Paris. Number 10 was neither Detroit's nor Kahn's first reinforced-concrete building. With architect George Mason, Kahn had designed the Palms Apartment Building (1903) on Jefferson Avenue and then, working with Julius Kahn, the Engineering Building at the University of Michigan in Ann Arbor (1903).[141] But the concrete pavilions he designed for Packard would be the basis for his later designs for Detroit automakers and other industries through the 1920s, and the prototype for the factory buildings of other architects. The Packard Forge, a one-story seventy-two-foot-wide, column-free building with sawtooth windows, constructed in 1911, would also serve as a prototype for his buildings at other factories, including Ford's Highland Park and River Rouge plants, and become a standard for the industry.[142] One of the buildings clustered at the plant's north end, the Forge was demolished for the construction of the Ford Freeway in the 1950s.

Even before the construction of #10, the expanding Packard factory had caught the eye of its competition. Undoubtedly aware of his competitor's developing plant, in 1904 Henry Ford commissioned the local firm Field, Hinchman & Smith to design a capacious new factory on Piquette Avenue two miles west of Packard, to replace its cramped quarters on nearby Mack Avenue and exploit the same concentration of Milwaukee Junction train lines as Packard had. It would only be a few years before Ford outgrew Piquette, where the company manufactured thousands of its "letter cars" and Henry Ford conceptualized the moving assembly line, later realized at the company's expansive, Kahn-designed Highland Park Plant, which opened in 1910.[143] Piquette was sold in 1911 to Studebaker, which operated an adjacent factory that still partly stands. Today it is known as the Ford Piquette Avenue Plant (also sometimes called the T-Plex), a historic site that functions as a museum and event space. Owned by a nonprofit and staffed by volunteers, many of whom are automobile or Detroit history enthusiasts, it features one of the great collections of early Ford automobiles, mostly on loan from their owners who pay to "store" their vehicles and from the Ford Company itself. The plant's three-story main building is a 56-by-402-foot brick structure with a timbered post and beam frame, similar to the original nine buildings designed by Kahn at Packard.

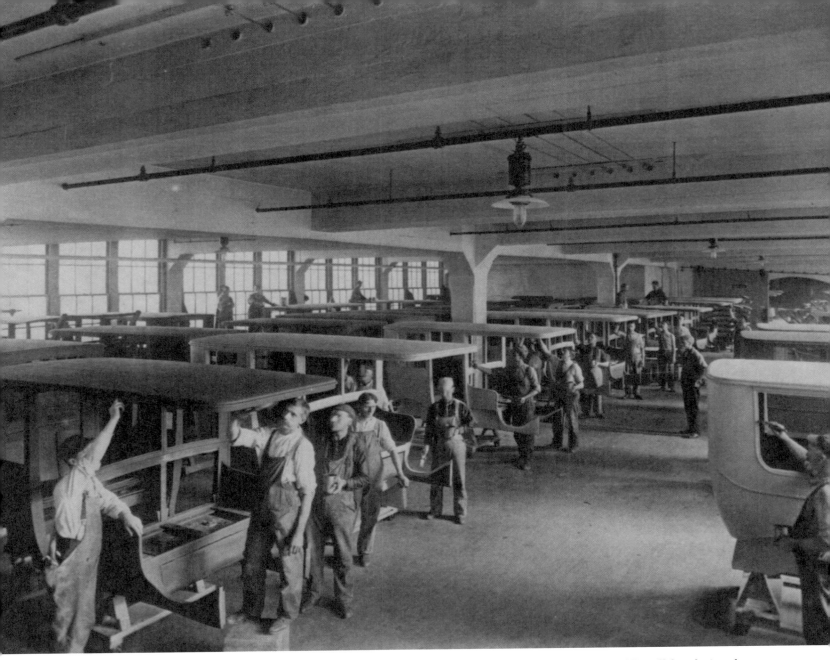

Auto body assembly inside an Albert Kahn–designed Packard building in 1910. The building's concrete structural system was engineered by the architect's brother Julius Kahn. (Courtesy of the Detroit Public Library.)

Volunteer Dick Rubens provides the author with a tour of the Ford Piquette Avenue Plant. (Author, 2012.)

The organization formed and took title to Piquette in 2000, around the same time some Packard tenants and enthusiasts had formed their own nonprofit dedicated to creating an automotive museum at the Grand Boulevard plant. Demand for another Detroit-area car museum has long been debatable, given Piquette and Ford's own Henry Ford Museum and Greenfield Village in Dearborn and their River Rouge factory tours, and regional GM, Chrysler, and independent heritage facilities. An effort to create an automotive heritage museum at Ford's Highland Park plant was scrapped in 2016.[144] A Packard museum, whether the one proposed by car enthusiasts in 2000 or the one casually proposed by Arte Express fifteen years later, would have only occupied a small amount of floor area and would have been dependent on other rent-generating uses. Piquette was and continues to be largely supported by the businesses who lease the building's ground floor and basement, and events and visitor donations. And there is only one building remaining (of the handful constructed by Ford), containing a fraction of Packard's floor area, making it a discreet and manageable structure, one that had been in continuous use in one form or another until 1989. The T-Plex has also benefited from Ford's largesse, even as it arguably competes for attendees and charitable support with the company's own museums—and its dedicated constituency of volunteers, board members, and now a small staff, as well as its location closer to Midtown and Detroit's core. Yet it has been an uncertain, twenty-year undertaking—a low-capitalization project with the need for regular repairs and incremental improvements, including a new heating system and roof, and restored windows.[145] It is not entirely fair to compare Packard to Piquette, but thinking about these two historic factories, it becomes clear that Arte Express's investment-driven, adaptive reuse scheme was never realistic given its location and Detroit's political climate.

Detroit's most successful recent industrial adaptation project is arguably Wayne State University's TechTown—a mixed commercial, educational, and institutional development spread across

former Burroughs Adding Machine buildings and nearby properties.[146] (In 2012, TechTown also generated the ire of preservationists when it demolished the Kahn–designed American Beauty Iron Works Building to create parking for the adaptive reuse of the city's onetime flagship Cadillac dealership, also designed by Kahn.[147]) Located in Midtown, one of Detroit's legitimate areas of market desirability, the project was underwritten by significant nonprofit funding and public incentives. While Packard is not so far from Midtown, on the ground it feels many miles away and it lacks adjacent institutions like Wayne State and the Henry Ford Hospital, willing to make major investments in its restoration. Likewise, large public subsidies have underwritten Detroit sports and tourism facilities, corporate retention and relocation programs, and assorted real estate ventures, but city and state leaders, through successive administrations, have never wanted to invest in Packard, which in their minds has always been a brownfield rather than candidate for adaptation.

With tax arrears ballooning to $774,000, in October 2020, Arte Express scrapped its mixed-use plan and retained the commercial real estate brokerage, Newmark, to explore leasing to an industrial-only tenant for whom it would potentially clear the plant and build new facilities to suit. While the firm expressed a desire to retain and restore the Administration Building and salvage the Packard water tower, the strong market for warehouse and e-commerce distribution centers might require the entirety of the north of Grand assemblage. Newmark's prospectus featured a satellite image with the footprints of two giant rectangular structures and adjacent parking areas where Packard buildings now stand or once stood.[148] Yet Palazuelo, who estimated his firm's total investment in Packard was over $7 million, could not find buyers at his apparent $5 million asking price.[149]

By 2021 the city was again poised to demolish the plant. City and county officials crafted a strategy to expediently take title with full legality and due process, unlike attempts during the Cristini/Bioresource years. Likewise, they were determined to exploit federal funding that was unavailable during 2012–2013, which led to Packard's auction rather than demolition. Citing unpaid taxes and public safety, it sued Arte Express and moved to have the plant be declared a "public nuisance," which would enable emergency demolition. A Wayne County Circuit judge ruled in the city's favor and ordered Palazuelo to apply for demolition permits, but he did not comply, enabling the city action. In July 2022 the Detroit City Council, using money from the American Rescue Plan Act of

Detroit mayor Mike Duggan and other local leaders celebrate the beginning of the demolition of the Packard Plant. (David Guralnick, Detroit News, 2022.)

2021, issued a $1.7 million contract for the plant's demolition. At the same time, Wayne County foreclosed on over thirty Packard parcels, citing $784,000 in unpaid taxes and water bills.[150]

In September 2022, the city staged a kickoff event with contractors on hand to begin demolishing the first Packard target: 6199 Concord Street, Building #21, which posed "imminent danger" to the adjacent Building #22 and its tenant, the Display Group, and other nearby businesses and residents. It was the beginning of a planned two-year, $25 million Packard demolition initiative, which will be mostly paid for by the American Rescue Plan. Standing at a lectern in the parking lot west of buildings #21 and #22, with a dozen community leaders behind him and demolition trucks at the ready, Mayor Duggan made his pronouncement. Even years earlier when the Packard project received tacit approval (but no funding) from the city, Duggan had never been entirely comfortable. He called the plant "a source of national embarrassment" and a "source of personal pain" for nearby residents. "We had an owner that gave us nothing but basically a decade of false and broken promises," he told gathered members of the press. Duggan also noted his local roots, having been born at nearby at St. Joseph Mercy Hospital (demolished in 1980s, site of the present GM Poletown plant) in 1958, just when the first post-Packard owners were making ultimately unfulfilled commitments toward the plant's revival. His own mother, he said, frequently chided him about not being able to demolish the plant.[151]

On the day of the demolition kickoff, I happened to be talking to Adriel Thornton about Packard parties some twenty-five years earlier. He lamented the plant's fate, which was a missed opportunity to create a "fantastic, creative, mixed-use" complex where Detroiters could have gone to hear

music at all hours (not dissimilar to what Arte Express had once proposed) and contribute to a "24-hour culture," which Detroit was lacking. He continued,

> I think that on one hand [Packard] symbolizes the decline of this city and absolutely of that particular industry, but it also shows, in my opinion, the complete lack of imagination and political will that's not just problematic in Detroit, but that a lot of places have. . . . They designed [Packard] to last a long, long time. And our politicians and our business community, to be honest with you, let it decay. . . . And now the city's like, "Let's just tear this shit down." It's not like there is some pressing thing that we have in the pipeline that we need space for.[152]

The narratives documented in this chapter could be interpreted as a gross glorification of transgression. Detroit's Lower East Side has suffered through untold disinvestment and abandonment, and its residents have experienced significant hardship. To this day, it remains among the poorest and most segregated places in urban America. Yet it is clear something was happening amid Packard's buildings that created excitement and helped Detroit maintain and build upon its Motor City cool. Many understood Packard in this way even as city and state governments could not. Packard's demolition, whether some, most, or all of the buildings come down, demonstrates the city's long-standing development approach—one that has long been standard practice across the Rust Belt. It may still be possible to reuse part of the Packard complex, but time has almost run out—and by the time you are reading this, the plant may be gone entirely.

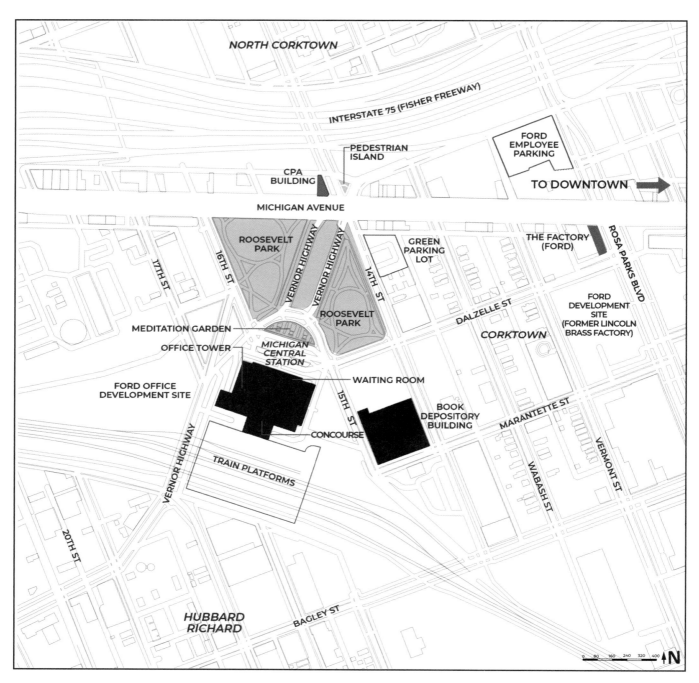

The Michigan Central Station on Detroit's West Side. (Cartography: Shahrouz Ghani Ghaishghourshagh, 2021.)

CHAPTER 6

Michigan Central Station

The main entrance leads to a vaulted waiting room filled with light streaming through enormous windows. If you are down and out or mentally ill, this is a place to buy tickets to nowhere, to draw angels or write graffiti, to pace, to stay out of the rain and wind. More than any other derelict space I've seen, this fine neoclassical structure says, "We were once a great city."

CAMILO JOSÉ VERGARA[1]

As an icon of decline and a site for transgression, Packard had few if any equals, in Detroit or anywhere. Yet the peripherally located, horizontally spread factory would be easy to miss (or dismiss) entirely. To the many thousands of drivers who pass the plant each day on the Ford Freeway, it's hard to even know it is there. While Packard is cloaked in Detroit's vast expanse, the Michigan Central Station (MCS) reaches to the sky. At 230 feet in height, it towers over its diminutive surroundings and can be seen throughout much of Detroit's West Side and from across the river in Windsor, Ontario. Less than two miles from downtown, it was for decades a monument to decline, whose prominence was enhanced by the sizable footprint of its office building rising thirteen to eighteen stories (depending how you count them) above its triple-vaulted waiting room, inspired by the Baths of Caracalla in Rome.

While the MCS and Packard mark the landscape in different ways, they share a narrative of eco-

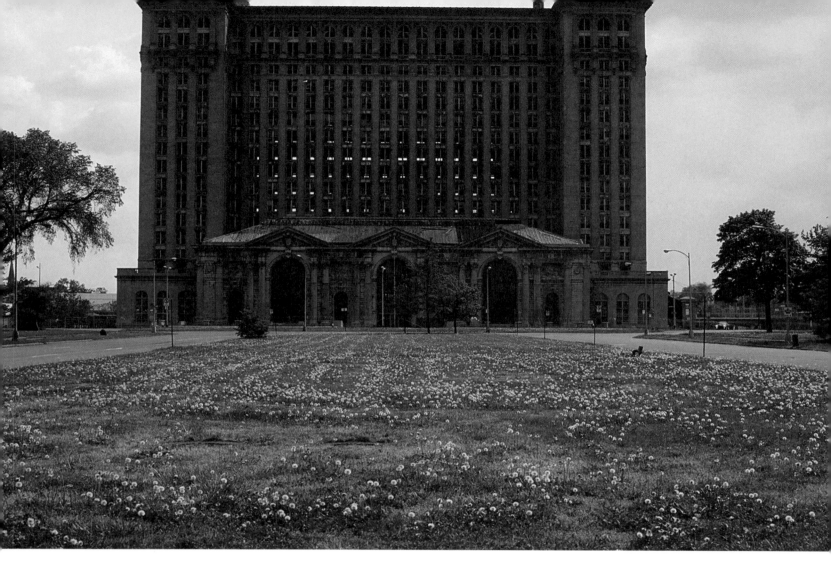

The triple-gabled main entrance to the Michigan Central Station from the Vernor Parkway median through Roosevelt Park, Detroit. (Author, 2003.)

nomic obsolescence, deterioration, abandonment, and failed redevelopment schemes. And much like Packard, the station became the bane of city government and its leaders, who were determined to rid Detroit of its most prominent ruin. But unlike the old automobile plant, the MCS has found its savior. In 2018 the Ford Motor Company purchased the station and ancillary properties for $90 million and is adapting it as the core of a billion-dollar mixed-use tech campus integrated into the surrounding neighborhood. The ultimate car company of the ultimate company town is coming home to save a train station.

Yet long before Ford recognized the train station's potential and strategic location in Corktown, Detroit's oldest surviving residential neighborhood, others too were drawn to this structure. After its abandonment in 1988, the depot attracted a vast spectrum of people and activities, some exhilarating and others desperate: vandals, squatters, thrill seekers, explorers, graffiti writers, artists, photographers, musicians, partiers and many admirers—but also squatters, scrappers, IV drug users, prostitutes and their clients, paintballers who defaced if not destroyed many interiors, and wild dogs. Others were content to enjoy the sight of the MCS from adjacent Roosevelt Park, the 7.5-acre public expanse that the city constructed in the early 1920s to provide the neoclassical station with a formal foreground and connection to Michigan Avenue. Like the station, for decades the city-owned park was poorly maintained, but now too is poised to make a comeback with a major capital investment.

By my visit in 2003 the Michigan Central was already a wreck but one that possessed a kind of surreal power. Designed by architecture firms, Warren and Wetmore and Reed and Stem, and opened in 1913, ninety years later the station retained its neoclassical essence. At least from the outside—and my visits would always be from the outside until 2019—its majesty was compromised (or enhanced) less by its own deterioration than its perseverance as a marker of failed aspiration and a vision of urbanity that never fully materialized in Detroit. Standing on a field of May dandelions in the Vernor Highway median running through Roosevelt Park, not a soul around except for my friend and I and an occasional passing car, we admired the city's fallen icon. On this hot and humid day, the weirdly bright but overcast conditions magnified the station's pathologies: the main entrance's missing doors, the chipped and grime-covered limestone façade, unmoored copper members of the

lower roof, and hundreds of broken windowpanes in well-rusted frames. Eerie daylight emanating from the far side of the office tower filtered through the grid of broken windows—in one side of the building, out the other. Behind the lower façade with its three gable-topped giant window arches was the station's magnificent but wrecked waiting room, likely the most celebrated abandoned interior space in all the United States. I could not help but think of Vergara's descriptions in *New American Ghetto* and *American Ruins*, which had been an inspiration for the visit and responsible for much of what I then knew about the station.[2] The chain-link fence topped with concertina wire surrounding the station helped provide it with "a menacing presence," as Vergara once described. Moving closer and pausing underneath the façade, we felt the palpable urge to transgress, yet there was no obvious entry point. Even without getting inside, we felt the exhilaration of having Detroit's "temple of transportation" seemingly to ourselves to contemplate amid the unsettling quiet of the West Side.[3] It was like being alone outside the Colosseum in Rome.

By 2003 the comparisons of Detroit and its many ruined monuments to the fall of Rome had already become a cliché, one that betrayed the complexity of a living city that still possessed nearly one million inhabitants in a metropolitan area of almost five million. And while the station's design did in part come from Roman antecedents, one could say that about hundreds of buildings in US cities built during the same period, including several other train stations. And New York's Pennsylvania Station (1910, demolished 1963–1966), designed by Warren and Wetmore rivals McKim, Mead and White—larger and more imposing than the Michigan Central—was also inspired by the Baths of Caracalla.[4] Yet Detroit's great early-twentieth-century station in its erect but damaged state also evoked its own mythic golden age—before the railroads succumbed to automobiles and planes and the explosive suburbanization that was already underway when the station opened in 1913. This too was part of the city's undoing—a simultaneous rise and fall driven by automotive production and the great wealth it generated—as Detroiters and Americans spread out across the vast landscape made possible by automobiles produced in a city and metropolitan area largely built around their production. By the time the station opened, Packard was already producing tens of thousands of cars a year in its Grand Boulevard factory; Ford produced nearly two hundred thousand Model Ts in Highland Park, and regional production—or that other

"Detroit," meaning the auto industry—would soon surpass one million cars a year. The ideals of progress, aspiration, and mobility and a uniquely American lack of faith in the collective urban endeavor had doomed the station from the beginning. Looking at the depot on that afternoon in 2003, it was a wonder it was even standing.

Yet the station's near-fatal demise cannot be simply attributed to the macro forces that reshaped American life in the twentieth century. It is also a story that is particular to Detroit, a city that for decades was not sufficiently invested to care for one its greatest civic structures. But somehow the station, its longtime slumlord owner, and city and state governments, which did nothing to arrest the station's fall, have been bailed out. Ford's preservation plan is indeed surprising, and the station's unlikely resurrection makes this postindustrial narrative different from those of the preceding chapters. The company's plan is everything that DIY isn't: expensive, deliberate, permanent, painstakingly detailed, and breathlessly grand. Yet it would be a mischaracterization that Ford alone has brought the station back from the dead and that DIY played no role in bringing Ford to the station.

Building Detroit's Temple of Transportation

In 1913, over a decade before construction began on Buffalo's Central Terminal, the Michigan Central Railroad (a New York Central Railroad subsidiary) completed the Michigan Central Station on a fourteen-acre site on Detroit's West Side. Its architects, Warren and Wetmore and Reed and Stem, had previously designed Grand Central Station, which opened earlier that year. Much like Grand Central, the Michigan Central Depot, as it was also known (it had no formal name, and many to this day simply call it "the train station," or the MCS), was an architectural icon from the moment it was completed. On the first weekend it was open, during the week between Christmas and New Year's Day, and unexpectedly so because a fire at the old Michigan Central Depot downtown necessitated opening two weeks early, an estimated one hundred thousand people came to see the new station, most of whom had no plans to take a train.[5]

While generously ornamented in neoclassical motifs, the station was a thoroughly modern structure, with its steel frame and massive concrete foundation and floors, sheathed inside and out with stone (pink granite and Indiana limestone), brick, terra cotta, plaster, and glass.[6] Its soaring waiting room featured Guastavino ceiling vaults with their characteristic herringbone pattern of buff brick, reaching a seventy-six-foot apex, and giant arched windows and lunettes on all sides and three great chandeliers. This room—along with the more restrained passenger concourse and the many columns, pilasters, marble wainscotting, and ornament throughout—did indeed provide the station with a grandeur worthy of Rome or the Second Empire. And in decay, these elements gave it a corresponding sense of fallen grandeur, of elegy. Architect Robert Benson, writing in the *Detroit Free Press Sunday Magazine* in 1982, noted the station, "like the monuments of Rome, bestows prestige upon the users of the building and the surrounding community."[7] Of course, at that time, just six years before its closure, the MCS was a shell of its former self, and one could hardly feel the prestige passing through its decrepit interior mostly bereft of passengers, with the waiting room itself walled off from the public.

But when it was built, the station was the embodiment of City Beautiful optimism and the era's boundless enthusiasm for public works and monuments. Unprecedented population gains, invention, entrepreneurialism, commercial trade and finance, industrial production, and soaring wealth helped push the American city outward and skyward. With its blossoming automobile industry, Detroit was poised to join an A-list of American cities (principally New York and Chicago) as an economic power. Decennial censuses bracketing the station's completion document Detroit's explosive growth, with its population nearly doubling from 465,766 in 1910 to 993,678 in 1920. By 1930 the city had grown to 1.569 million, becoming fourth-largest in the United States.

As Detroit rose, its civic leaders, business titans, builders, and architects pushed for commensurate functional and aesthetic improvements to compete with more established cities. With its emerging wealth, its baroque street plan devised with broad diagonal avenues emanating from Judge Augustus Woodward's original 1805 hexagonal block plan, Detroit was indeed ascendant, and some would call it "the Paris of the Midwest." It was a place that people and businesses wanted to be. The Vanderbilts, scions of the New York Central, clearly understood this. Wanting to main-

tain their primacy over the Detroit market through their Michigan Central subsidiary, they hired architects with the commensurate skill and reputation to design the station. In addition to Grand Central, Reed and Stem had recently completed train stations in Seattle and Tacoma, while Warren and Wetmore had designed many high-profile buildings, including the Commodore and Biltmore Hotels and the Vanderbilt Residence in New York and the Ambassador Hotel in Atlantic City. New York City native Whitney Warren, who had spent seven years in Paris and graduated from the Ecole des Arts, is generally acknowledged as most responsible for the station's classically inspired elements. He returned to New York in 1894 and in 1898 formed a partnership with Charles D. Wetmore, a lawyer by training, five years after the White City at the World's Columbian Exposition in Chicago had popularized neoclassical architecture and urbanism. With its society connections, the firm was well positioned to capture prestigious commissions like Grand Central and the MCS and were the Vanderbilts' favored architects (Warren was married to the daughter of a Vanderbilt cousin). In addition to Grand Central, the firm designed buildings for the railroad's Terminal City project around the station, including the New York Central Building (later known as the Helmsley Building).[8]

If Grand Central had Terminal City, the adjacent high-rise commercial district realized by the railroad when it buried its tracks underneath Park Avenue, the Michigan Central had its office tower rising above the four-level station, making it the world's tallest train station at its completion and one that contained over six hundred thousand square feet of floor space.[9] Underneath the office building and the copper-clad roof of the waiting room, the capacious station offered a commensurate array of passenger services and amenities: restaurants and shops, gender-specific lounges, smoking and reading rooms, mail and baggage services, banking, a pharmacy, a barbershop, a beauty salon, and full bathing facilities for those who desired to get cleaned up after arriving on an overnight train or to freshen up before a business meeting or social event. Operationally, the station's elegant steel-roofed train shed provided access to eleven tracks, and another seven served freight and mail. While the station's passenger areas define a sumptuous version of American neoclassicism, the office building's more restrained design reflected the office and hotel architecture of the day. In fact, some have reasoned that the architects designed the office building, which was never fully occupied and its uppermost floors never built out, so that it could be converted to a hotel. The

larger top floors and the commanding views they offer could have also been a grand ballroom or executive suites, something that the station's owners, including the Michigan Central, New York Central, Penn Central, Conrail, and Amtrak, never exploited. Yet Ford, the station's new owner, will not let the same opportunity pass.

Of course, the depot was not simply a building, but an ensemble of infrastructure intricately overlaid and connected to the urban fabric. This ensemble included the Detroit River Tunnel—a marvel of engineering in its own right—passenger and freight yards, switching facilities, a customs house, and a new elevated trackway. The station's location responded to the needs of a rapidly growing city on an international border that by the early twentieth century was already constrained by existing development. Like other big-city stations of the era, it was to replace an older facility, the Michigan Central Railroad Depot (at West Jefferson and Third avenues, adjacent to the river). The 1883 brick-clad Romanesque Revival structure survived a fire in 1913 (though its signature clocktower was destroyed and never rebuilt), and despite its replacement farther west, it was used as a freight depot for over a half century more, albeit in ever more decrepit condition, until its 1966 demolition. Yet the railroad had outgrown this earlier depot likely within a decade after its completion. The eastern terminus of a spur laden with dangerous, at-grade street crossings, the station slowed and challenged the logistics of through trains—the great volume of east-west traffic that connected Detroit to New York and Chicago. New York trains were particularly challenged as the prevailing route through Southwestern Ontario required ferrying people or train cars across the Detroit River.[10]

Construction on the tunnel, which would connect Detroit with Windsor, began in 1906 and was completed in 1909, four years before the station. The 2,620-foot underwater portion of the two-tube tunnel was built in a trench-and-tube system with ten prefabricated steel segments that were sunk to the river bottom and joined underwater.[11] Logistics dictated that the station be set back from the U.S. tunnel entrance (entering Detroit at the present-day location of Ralph Wilson Park) to allow trains to gently rise to meet the level of the new elevated tracks. The tracks also had to enter the city obliquely to the northwest to facilitate connections to the railroad's existing right-of-way along the river and its West Detroit Yard. This placed the station approximately two miles west of downtown and one mile north of the river.[12] The station, tunnel, trackage, and ancillary facilities required the

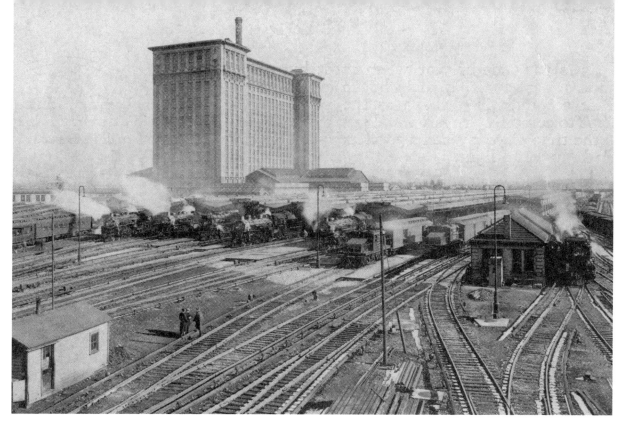

The Michigan Central Station possessed extensive passenger and freight facilities and offered seamless connections to the transcontinental rail network. (1925 photo courtesy of the Detroit Public Library.)

purchase of fifty acres of West Side land, which at that time was an area of wood homes dotted with small industrial works along with substantial existing railroad property. Some three hundred of these homes were condemned and demolished while those that survived form the core of the Corktown Historic District.[13]

With the station's completion, the railroad's east-west alignment issue was solved, and it now possessed the capacity for thousands of trains and millions of passengers a year in Detroit. In its first years, the station handled some seventy-five trains and five thousand passengers a day (nine thousand on special days). On weekdays, there were eighteen trains to or from Chicago and fourteen to or from New York. World War I would bring extra traffic, and the station bustled through the 1920s. In 1929 a typical day at the station featured forty-three daily departures and forty-seven arrivals. The station was busiest during World War II, when the military ran a regular schedule of

trains for personnel heading to or returning from the war.[14] But its demise was seeded long before 1940s. Annual automobile production grew in metropolitan Detroit during the 1910s and topped one million cars just four years after the station opened, with some seven hundred thousand of those cars produced in Ford's new Highland Park Plant.[15] The golden age of railroading was already in its twilight—all the more so in Detroit, where vast portions of the city and region were just being developed. Through annexation, the city grew from just 23 square miles in 1900 to its current footprint of 139 square miles by 1927. This emerging metropolis—most of Detroit beyond Grand Boulevard—would be dependent on the automobile.[16] As suburbanization and car travel took hold and the city entered the Great Depression, ridership declined before its short-lived World War II boom. But like Buffalo's terminal, ridership declined steadily after the war. In 1956 the ailing New York Central put the station up for sale—one of 406 stations offered in its fire sale—but could not find a buyer at its $5 million asking price. The railroad made another ultimately unsuccessful attempt to sell in 1963. By 1967, with no money for maintenance and declining ridership, New York Central closed large portions of the station, including the waiting room, restaurant, and arcade shops.[17]

The 1968 merger of the railroad industry's failing giants—the Pennsylvania and New York Central to form PennCentral—did little to improve the station, nor did it reverse the long decline in passenger volume.[18] Amtrak assumed national intercity passenger service in 1971, and in the mid-1970s it undertook a modest $1.25 million renovation, which included reopening the station's main entrance on Roosevelt Park and sprucing up the waiting room, which had been used for storage and was closed to passengers; it also added a bus depot (from underutilized track and platform space) to feed its trains transferring passengers.[19] Amtrak also expanded train service. PennCentral service had offered just two departures daily, both to Chicago. By 1975 Amtrak had added three additional round trips, restoring one of New York Central's flagship routes, Detroit to New York City via southern Ontario, as well as a third Detroit-Chicago train. The railroad also introduced new French-built Turboliner (gas turbine–powered) trainsets on its Chicago route, which could reach speeds of 125 miles per hour, even as poor tracks would limit speeds to a 65-mile-per-hour maximum, and often much slower than that. The state of Michigan, which had substantially subsidized capital improvements to railroad infrastructure, was working with Amtrak on expansion plans—a statewide net-

work incorporating five different routes, each with no less than four daily round trips. State officials envisioned trains that would run 110 miles per hour by the late 1970s or early 1980s. They were also helping the railroad plan its high-speed network, which would connect the MCS to major midwestern and northeastern cities and might include ten daily round trips between Detroit and Chicago.[20]

Decades in retrospect, these plans seemed wildly optimistic, and few if any of these improvements ever got off the ground. Since its inception, Amtrak has never had the necessary support from the federal government to effectively operate robust service across the national network in the manner that European nations do, let alone maintain cavernous station complexes like those in Detroit and Buffalo. Half a century later, the United States and Amtrak are still attempting to figure out how to fund, build, and operate a high-speed rail network, and Americans are still largely wedded to their cars and planes for intercity travel. Yet by 1975, as Amtrak had ceremoniously reopened parts of the station in preparation for the US bicentennial, it had experienced a substantial ridership gain on its Detroit-Chicago route, with MCS passengers increasing from about 90,000 in 1972 to 236,744 in 1974, a 163 percent increase, exceeding the railroad's own expectations.[21] The improvements in both service and the station's condition also won plaudits from the Detroit press, transportation advocates, and the passenger public.[22] And when the Detroit Historical Society's 1975 application placed the station on the National Register of Historic Places, it afforded preservation advocates and others the hope that renovation was not far off.[23]

Despite these developments, the station was a tremendous liability for Amtrak and Conrail (which inherited PennCentral's freight operations in 1976), whose mandates were about rail service, not preserving landmarks. Neither Amtrak nor Conrail had the expertise, resources, and full interest in the station's restoration or addressing its persistent maintenance issues. And the MCS continued to deteriorate as business closure, property abandonment, and population loss accelerated in Detroit, draining Amtrak of potential passengers. Architect Garnet Cousins, who wrote his 1972 master's thesis on the station and for decades advocated for its preservation, lamented Amtrak's narrow vision and poor maintenance practices. And Conrail, he said, would have likely demolished it if not for the cost. About the station's history and the voluminous records and paperwork it contained, Cousins said Conrail threw most of it away. In fact, many of the source materials for his pair

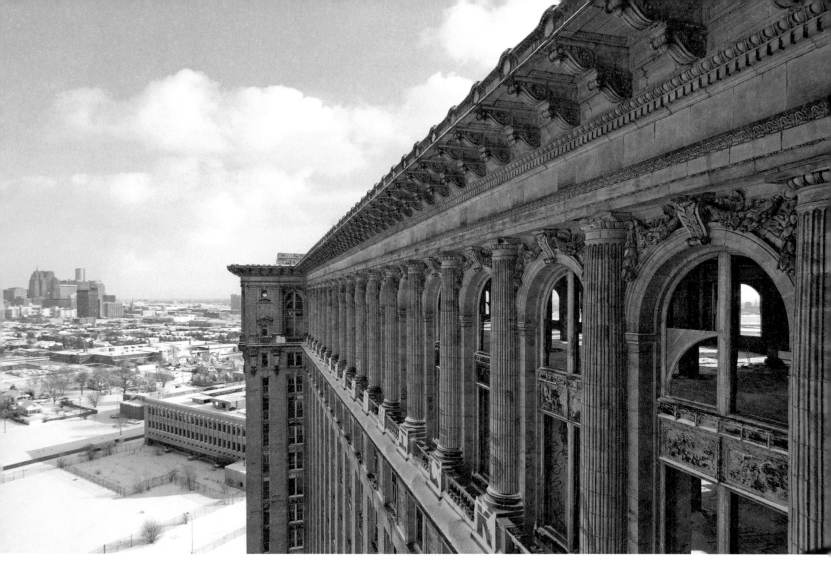

The upper floors of the office building of the Michigan Central Station. (Scott Hocking, 2009.)

of 1978 articles documenting the station's history were obtained by his coauthor, Paul Maximuke, who salvaged them in dumpster dives and through access to files enabled by Conrail employees before they were dumped.[24]

As in Buffalo, the station was substantially overbuilt at a time when trains were still the means for most intercity travel. In addition to occupying office space with their own passenger and freight operations, New York and Michigan Central officials envisioned that other railroads and transportation interests would occupy portions of the tower. (Ford is now following a similar strategy, with plans to lease space to other transportation or tech firms.) This calculation was based on the ultimately erroneous assumption that Detroit's two other major stations would eventually close and the railroads using them would consolidate operations at the MCS, making it a "union" station. However, the Fort Street and Brush Street stations hung on until 1973 and 1974, respectively, and there was little demand for the MCS's office space amid a softening rail travel market. By most accounts, the railroad's own substantial office operations, even in peak service years, were mostly limited to the tower's first five floors.[25] Cousins told me that in the station's inception, the New York Central had an expansive vision that was never fully embraced in Detroit. Rather than build out the upper floors for executive offices, he reasoned that Michigan Central executives were focused on the bottom line and wanted to keep a close eye on their hundreds of employees in the complex, expansive views be damned.[26]

Like in Buffalo, railroad executives also thought that the new station would be an anchor for growth and draw commercial development around it. The city did too, hiring Burnham and Bennett, the world-famous City Beautiful architect-planners, who created a plan for new diagonal boulevards and public plazas to expand the city's commercial and civic core (Burnham died before the plan was completed). An unrealized diagonal would have connected the station to the planned beaux arts cultural campus straddling Woodward Avenue north of downtown and its new cultural institutions, the Detroit Public Library's flagship branch (1921) and the Detroit Institute for the Arts (1927).[27] Even Henry Ford would buy up several blocks of properties north of Michigan Avenue in the 1920s, speculating that the West Side would be an ideal location for a commercial center.[28] With neither the boulevard nor Ford's office complex (which the corporation is now realizing), and

undercut by the region's rapid suburbanization and metropolitanization of commercial activities, the West Side never blossomed into a central business district extension or satellite. Without a direct major street connection, the station also remained awkwardly linked to downtown, offset from Michigan Avenue by nearly one thousand feet. A few businesses did cluster around it, including the modest-sized Hotel Roosevelt—a far cry from the hotels build around New York's Grand Central—and the area's one legitimate office building, the six-story CPA Building (Conductors Protective Association—an organization supporting train conductors), constructed at Roosevelt Park's north end in 1924.[29] The depot did help anchor the Michigan Avenue corridor lined with small retail establishments and modest-sized factories and warehouses and nearby Briggs (later Tiger) Stadium (demolished 2009), completed the year before the Depot. Yet the corridor never grew as anticipated, and a larger secondary business district formed along Woodward and Cass Avenues in Midtown, which was cemented by the construction of GM and the Fisher Brothers' cathedral-like New Center complex (1928) designed by Albert Kahn.

The Last Days of the Station

As Amtrak entered its second decade as the station's principal tenant and steward, even as it was owned by Conrail, it was unable to arrest deterioration. By 1982 the waiting room, which had been briefly reopened for the bicentennial, was walled off from the public again. Its ceiling vaults were continually undermined by water intrusion while the unique wall paneling in areas like the men's smoking room had rotted away. For most of the Amtrak era, just the passenger concourse, ticketing area, and a few platforms were open to the public. The four hundred employees of Amtrak and Conrail, which maintained its western regional headquarters at the MCS—down from over three thousand at its peak—were mostly stationed on the ground floor, while a substantial portion of the former track and passenger platform space was used for employee parking and bus service.[30] Conrail did little to quell competing rumors of imminent demolition and of adaptive reuse as a casino-hotel complex. Preparing for a potential stock sale to private owners or its own employees amid the na-

tional recession of 1982, a spokesperson could only confirm that the corporation had neither plans to renovate nor demolish the station. Even as Conrail was negotiating the sale of the corresponding Detroit Rail Tunnel to the Canadian National Railroad, it was only interested in selling the station if a new owner could guarantee continued office space for its employees.[31]

By the mid-1980s Amtrak and Conrail both were looking to move out. Amtrak had discussions with Michigan Department of Transportation (MDOT) officials and SEMTA (the regional rail authority) about moving to a planned but never realized downtown regional transit center, adjacent to Joe Louis Arena (completed 1979; demolished 2020), which would also anchor commuter rail service to Ann Arbor. At the time, Conrail was apparently considering moving operations elsewhere and its two hundred employees to a new regional headquarters in Toledo, Ohio. An Amtrak spokesperson complained to the *Detroit Free Press* about the station's enormous maintenance and utility costs and noted it was "substantially larger than our present and projected requirements." While an MDOT planner noted the station's poor condition and the need for a "cost effective and attractive" facility.[32] Amtrak was already hedging its bets by building a new station in nearby Dearborn, where Ford had its headquarters and near substantial Chrysler and General Motors facilities—and closer to many thousands of potential suburban riders. Within two years of its operation, Dearborn passenger volume was exceeding the depot's.[33]

By the end of 1985 Conrail had sold the MCS to a subsidiary of the New York–based Kaybee Corporation created by retired Citicorp president William Spencer. Amtrak and Conrail remained tenants for the next few years while Kaybee planned to make the station the core of the Great Lakes World Trade Center, an office and shopping complex. Yet the MCS continued to deteriorate as restoration plans foundered. Ridership also continued to decline. In 1985 the station served only 82,408 passengers and 64,097 in 1986—about 176 people a day on two to three daily round trips to Chicago and one round trip to Toledo. In 1987 Kaybee forfeited a $3.25 million federal grant earmarked for the station's renovation due to lack of progress.[34] On January 5, 1988, the very last Amtrak train left the station, the 11:40 a.m. #353 bound for Chicago.[35] After nearly seventy-five years of continuous operation, the Michigan Central Depot, Detroit's temple of transportation, had closed. Amtrak relocated passenger operations to a temporary facility built next to its platforms, where it

remained until 1994 when it moved to a new station on Woodward Avenue, where it still operates today.

With Spencer unable to move forward with the World Trade Center, in 1989 Kaybee sold the station to thirty-nine-year-old Mark Longton Jr., a real estate broker in Detroit's Downriver suburbs, for an undisclosed sum. Like others before and after, Longton envisioned transforming the station into a casino, hotel, and entertainment complex complete with a nightclub called the Midnight Express—after a long-defunct New York Central train. But his proposal was a few years early, as casino gambling in Detroit was not approved until 1996 (three casinos opened in 1999 and 2000), and the project proved to be too challenging as utility and maintenance bills accumulated. Longton was a colorful character and was known to patrol the station himself, carrying a pistol and accompanied by his German shepherd. But the station was often left open and unattended, and the Longton years were marked by substantial looting.[36]

In 1991 Longton's company, Southwestern Associates Limited Partnership of Windsor, Ontario, filed for bankruptcy, and the station was claimed by Windsor-based BSI Security Services (which Longton owed thirty-one thousand dollars), with a mere eighty-thousand-dollar bid, even as Oak Park, Michigan, architect William Wizinsky was attempting to purchase it with plans to adapt it as a hotel, health spa, and condominium complex.[37] By 1992, with the MCS still in bankruptcy, the University of Michigan School of Architecture and Planning put forth a speculative proposal to adapt the station into a mixed-use complex with senior housing, retail stores, and an exhibition space. But the proposal found no developers willing to invest in the estimated $30 million project in a weak economy. By October, a limited partnership led by Manuel "Matty" Moroun, the trucking mogul who owned the nearby Ambassador Bridge, proposed a $52 million renovation that would include a mix of warehouse, office space, and retail. Three years later, Moroun would wrest control of the station out of bankruptcy.[38]

With its ownership still in limbo during the early 1990s, the idled station with its numerous leaks and breaches was defenseless to the weather, vandals, and thieves, while Amtrak operated from what was essentially a box on its platform. A Michigan Association of Rail Passengers study suggested that Amtrak consider two new station sites within the city. In February 1993 the railroad began

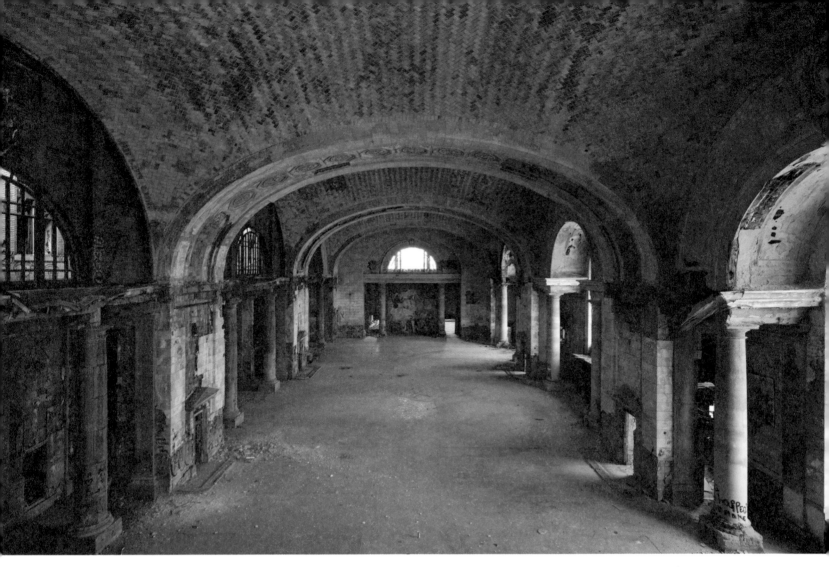

The station's waiting room. (Scott Hocking, 2011.)

construction at one of those sites, in Midtown near the New Center. The state agreed to contribute a paltry $1.35 million to the new station, while Amtrak agreed to some modest service expansions to Detroit's northwest suburbs.[39] Opening the station in 1994, Amtrak ended service from the temporary structure behind the MCS. Its new station was closer to the relative concentration of Midtown businesses as well as Wayne State University, the Henry Ford Hospital, and Detroit cultural institutions, but the building itself couldn't have been more utilitarian if not mean-spirited. It was and remains a one-story, stucco-over-cinderblock structure set back from the street to allow for parking, surrounded by an iron fence. From the outside, it could be mistaken for a fast-food restaurant if the corresponding signage were added. The station's arched window frames that wrap around two of its sides perhaps recall the MCS's windows, yet the new station's waiting room with its drop ceiling and fixed-in-place plastic chairs is a charmless space that evokes the Department of Motor Vehicles or the bus station of a third-tier city.

Transgression Binary:
Destructo-Disneyland and Collective Soul

While Amtrak settled into Midtown, the MCS continued to deteriorate. In the years after the railroad's departure, the station became a prime target for transgression, much of it unsavory and destructive. Like the Packard Plant, the station served as a haven for vandals, scrappers, thieves, explorers, partiers, squatters, wild dogs, and those escaping the weather or seeking space for illegal acts. While slowly decaying for decades under the deferred maintenance of the railroads, after 1988, what had not been previously undermined by the elements was stolen, sold off, or callously destroyed. By the mid-1990s the waiting room had been stripped of its marble walls, its chandeliers, and mahogany doors; its mahogany benches had apparently been sold for twenty-five dollars apiece during an earlier period when Amtrak used the room for storage, while the prominent bronze clock above the ticket windows was also pilfered along with many decorative and functional fittings.[40] The waiting room's elegant light sconces were also stolen; some were later discovered to

have been installed in the Gandy Dancer restaurant in the former Ann Arbor train station.[41] Copper plumbing and wire were removed and sold for scrap, as were most metals that could be pulled from the building. The removal of metal from the HVAC system installed by Amtrak in the 1970s left conduit and plaster chunks dangling from various ceilings, while the asbestos-laden insulation ripped out in the process was strewn about the floor. Frequent fires, often set by squatters to keep warm, also damaged the station.

While scrappers and the elements took the greatest toll, vandals were responsible for some of the most dramatic and disturbing damage. From the outside, hundreds of broken windowpanes provided only a hint at the destruction within. By the late 1990s the station had become what the *Detroit News* termed a "destructo-Disneyland" and an "ongoing demolition party," attracting suburban youth who acted with an "aggressiveness that makes one gasp" and "smashed all the sandstone and and marble detailing they could crowbar loose." The sheet marble that lined most of the station's interior walls did indeed prove enticing to suburban "marauders" who engaged in activities like "dropping 25-pound chunks of marble through the hole in the waiting room's domed ceiling that once held a gold-plated chandelier." At the same time, the *News* noted the room's Doric columns were "riddled with water damage and tarred with angry graffiti, giving the enormous, domed space . . . the feel of a desecrated Egyptian tomb." While many visitors were neither vandals nor engaged in antisocial activities, a small subset seemed to be more destructive and engaged in confrontational behavior with the building's small community of squatters. The complex's unofficial "station master," Catfish—a resourceful Vietnam veteran and resident since 1995—who was one of the few, if only, men to live there year-round, noted the contempt and wanton nature of some visitors. "Some of these kids would just as soon push you off the roof," he complained. "Shoot, they figure you're just a bum. 'We did him a favor.'"[42]

Traditional media reportage about transgressive activities in abandoned buildings tends to be sensational and based on accounts that cannot be verified. It's impossible to know just how many visitors were hellions partaking in the great demolition party and how many were adhering to an ethic closer to "take nothing but photographs; leave nothing but footprints." On nearly the same 1999 day that the *Detroit News* published its Destructo Disneyland story, a Detroit Police Third Pre-

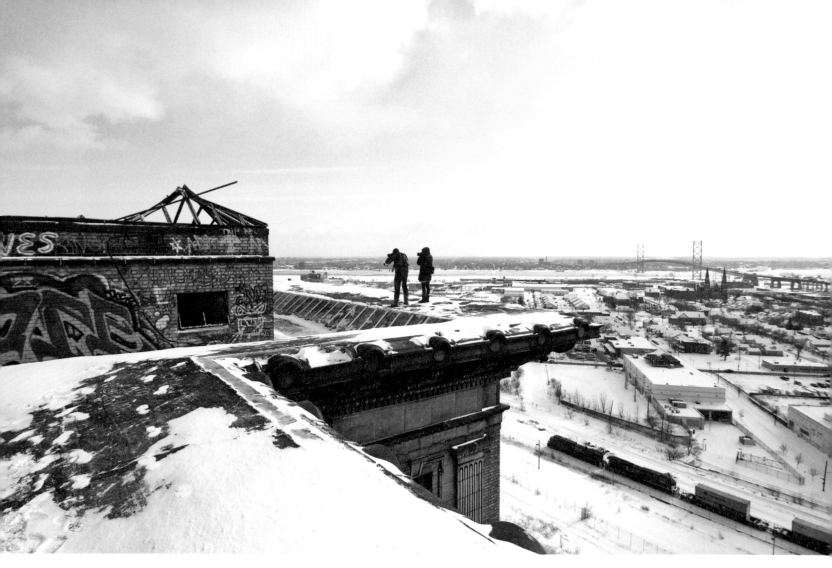

Itinerant visitors to the roof of the station's office building.
(Scott Hocking, 2009.)

cinct representative told *Crain's Detroit Business* that there had been no nuisance complaints or reports of incidents at the station over the past year and that the property was boarded and well maintained.[43] While this assertion is certainly suspect, several accounts suggest that the building was already well looted and stripped of its valuables by the early 1990s.

The station was certainly an irresistible site for explorers, who until the late 1990s could just walk in the front entrance. Even after the depot's new owners, the Detroit International Bridge Company, had secured the property with a chain-link fence, trespassers with wire cutters entered with relative impunity, as did many who later found those holes. When the Bridge Company added security patrols, explorers simply exploited garagelike openings under the vast platform of former tracks, which provided access to the station via a warren of subterranean spaces owned by the city of Detroit. Another entry point was through the Roosevelt Warehouse, aka the Detroit School Book Depository, also a significant urbex site. The Albert Kahn–designed building, which was abandoned after a 1987 fire, was originally a US postal annex that handled mail routed through the station, not unlike the large postal facilities built adjacent to railroad stations of the era in New York, Philadelphia, and Chicago. Once inside the depository, explorers could access a basement passageway that once contained the conveyer belts that moved mail to and from the station, underneath Fifteenth Street and the MCS's former trolley loop.[44]

As a destination for transgression through the 2000s, the station rivaled Packard. While the automobile plant had more buildings and territory for exploration, the MCS was a more exuberantly public complex and perhaps delivered a greater thrill. For many explorers, it evoked the fall of a Rome-like city where the public realm was celebrated, and its splendor was intimately connected to the region's rapid gains in technology, mobility, and wealth. Yet the MCS's office building also set it apart. Well removed from other tall structures, even climbing to the tower's mid floors provided excellent views. For the intrepid, the climb to the roof via the scrapper-compromised and graffiti-covered staircases was a thrilling achievement, and one could enjoy sweeping vistas in all directions. To the southwest was the majestic Ambassador Bridge and beyond that southwestern Ontario, while the downtown skyline stood prominently to the east. A simple Flickr image search (2020) generated many dozens of photos from explorers and thrill seekers who documented their

rooftop exploits, of the twelve-hundred-plus MCS urbex images returned.[45] Kelli Kavanaugh, who assembled the depot's *Images of America* volume, notes that her own rooftop climbs engendered a "sense of quiet and awe," while the *Detroit News* noted that a crowd joined stationmaster Catfish on the roof to watch a Fourth of July fireworks celebration over the river in the late 1990s.[46] Some may have camped on the roof during that evening and others, according to anecdotal sources.

Like the Independence Day celebration, exploration and itinerant gathering among visitors, many who came with their cameras and art projects, was a regular affair, as was savoring the sunset. Sometimes visitors socialized or shared a beer or a joint with the building's resident squatters. The scene during the summer months could be easygoing, with visitors from various walks of life, including international tourists, enjoying or at least tolerating each other's company.[47] And while the media's stereotypical visitor was a suburban youth with neither knowledge of the building's history nor concern for its conservation, astute observers acknowledge that many suburbanites and proper Detroiters alike exercised restraint. By the 2000s, those in the know also brought out-of-town photographers, some of whom did art or fashion photo shoots, or hosted small social events, perhaps with the tacit approval of the building's owner.[48]

Even more than Packard, the MCS stoked the imagination and dreams of photographers, artists, architects, musicians, students, entrepreneurs, rail fans, and others. After abandonment, it became a destination for artistic intervention, contemplation, and dialogue. Aside from copious graffiti, most creative acts were ephemeral or temporary gestures that left little or nothing behind. Many were often cloaked within the interior and largely happened upon by unsuspecting viewers, though in later years their locations were sometimes shared on social media. Among the most prominent works, the debris-strewn waiting room was the setting for Eminem's 2009 video for "Beautiful"—the Detroit rapper's brooding meditation on self-worth and self-acceptance after several years on hiatus to deal with addiction and mental health. "But don't let 'em say you ain't beautiful," he says, with obvious juxtaposition to the video's settings, which also included the Packard Plant and Tiger Stadium, the latter being demolished as the camera rolled. By 2020 the video had garnered over 441 million YouTube views. Somewhat similarly, the station served as a setting for postapocalyptic blockbuster motion pictures *The Transformers* (2005) and *Batman vs. Super Man: Hall of Justice*

(2016), and the not-quite-blockbuster *The Island* (2005), each of which fictionalized the spectacle of the station's decay for a mass audience and arguably drew attention to its potential restoration.[49]

The MCS was not a destination for dance parties, though Kavanaugh documents an overpublicized 1993 rave that police quickly shut down. Unlike Packard, the station's prominence and relatively central location worked against large, loud "underground" events. But it was for decades an inspiration for musicians who recognized its conflicting representations of the great and awful city. As veteran Detroit musician Carl Craig described in the 2014 documentary film *Techno City*:

> It's like Detroit's Grand Central Station, but this is what Detroit thinks of Grand Central Station. I use this building as an inspiration. It comes into my mind when I am at the keyboards, at the drum machines. . . . The lines might be basslines, the curves might be the string lines, and the columns may have more to do with drumbeats, the intricacy of the grooves within the music. I think it comes within the spirit of Detroit and its music. . . . I'm meaning spirit, I'm meaning heart, I'm talkin' about that little *umph* that needs to go into it to make it powerful, to make it definably me, definably Detroit.[50]

During the 1990s, the station was also a regular destination for Wayne State University fine arts students, who sometimes skipped class to explore it. These students found unfenced and unpatrolled access and, once inside, could wander and discover yet-to-be-destroyed or pilfered fixtures like phone booths, benches, and hard-to-remove decorative carvings. While the waiting room's floor was often covered in puddles and debris, the office building's mid-level floors still possessed much of their marble wall sheathing, even as water damage had severely compromised plaster and ceramic-tiled ceilings.[51] In 1995 Wayne State's School of Fine Arts staged *The Cathedral of Time*—a series of multimedia interventions and events, including its opening celebration, which featured a waiting-room string quartet performance. The show's highlights included a hundred-foot-wide window mosaic covering several floors of the office building's exterior, an ice sculpture that melted over the course of the event, and Deborah Riley's ghostly maquettes depicting life-sized travelers.[52] These maquettes, some broken or dismantled into body parts, hauntingly lingered for some time

The Egg by Scott Hocking. (Artist's photo, 2012.)

after. One mostly intact maquette with a bowed head and hands missing survived at least until 1998, when it was photographed by Camilo José Vergara in the station's taxi area, who called it an "anonymous embodiment of defeat."[53]

Long before urbex was a sport and photographs of deteriorating interiors and graffiti tags could be posted online—and over fifteen years before high-art ruins photographers did their Detroit tours—Vergara had been there. Through many visits over the years, Vergara documented the station's decay, finding beauty, poignancy, and irony, and wrestled with its multiple meanings, including those representing decline and human misery. Even as he was "dazzled" by the station's "extraordinary interior" and "awed by its silence," his photographs only reveal themselves in the context of each other and his accompanying textual reflections. And unlike the many urbex documenters he arguably inspired, his photos feel open-ended, part of an evolving and incomplete whole rather than a terse summary of decline as rendered in sensational but static detail. Much like his contemporaneous proposal for Detroit's empty downtown skyscrapers, Vergara also offered outsider reuse concepts for the MCS, including a monastery or agricultural cooperative. At the same time, he made the unfavorable comparison to New York's Grand Central, "the palace of all train stations" and "a triumph of historic preservation."[54]

The interpreters who would follow Vergara included ruins artist Scott Hocking. Over the course of eighteen months in a mid-floor office building hallway, Hocking assembled copious fragments of sheet marble that had been pulled off the walls into a complexly layered egg, delicately balanced on its tapered end. Photographs of *The Egg*, completed in 2012, exhibit an ethereal quality and betray the heaviness and the fragmentary nature of the sheets of broken stone from which it is composed, contrasting with the same material strewn about the floor around the work. *The Egg* also seemed to hint at a potential recovery for destroyed places through painstaking labor and love—at the same time demonstrating how tenuous a recovery might be. Like many of his works, upon completion he would soon dismantle the work by hand, so few people got to see it in person.[55]

In addition to the graffiti and occasional installations, the station was a ruins photography mecca—and like Packard, the Great Recession and the city's bankruptcy period were opportune times for these visits. In the late 2000s and early 2010s, Andrew Moore, Yves Marchand and Romain Mef-

fre, and Julia Taubman all made the rounds. Art historian and Detroit scholar, Doris Apel called Marchand and Meffre's frequently copied, tightly cropped photograph of the exterior taken from Roosevelt Park (thus requiring no trespassing) *the* ruins shot of the MCS. Affording a perspective of the vacuous office building through its grid of broken windows and out the corresponding grid on the opposite side, the photo was featured on a 2012 *New York Times* cover, accompanying a story about the court ruling that made city pensions fair game for cuts in Detroit's bankruptcy settlement. The story's jump-page continuation contained a shot of Detroit's other metonym, the Packard Plant, taken by local photographer Dave Jordano, who also published his own before-and-after abandonment photos of the station's interior, among his many Detroit studies.[56]

Not to be done by his French coconspirators, who had initially invited him to join their Detroit photo adventure, Andrew Moore's interior shot of the adjacent Kahn-designed Book Depository Building is perhaps his most famous Detroit photograph. In a likely unwitting homage to a Vergara photo of the interior of the Camden (New Jersey) Public Library, Moore's image depicts a grove of young birch trees in soft, early autumn colors, rising from a bed of rotting, long-ago burned books through a roof opening created by the 1987 fire. This spot, with its neat rectangular portal to the sky where there was once a roof monitor, was called "the terrarium" by building residents and was well traveled among explorers.[57] In his accompanying essay to Moore's volume, Detroit-native poet Philip Levine notes that the photograph evokes Detroit's motto, coined after the city's 1805 fire, *Speramus Meliora; Resurget Cinerbus* (We hope for better things; it will arise from the ashes).[58] Given Ford's investment in this building—it was the first to be renovated and reopened (April 2023) as part its plan—many Detroiters have now placed its faith in these sentiments. However, other popular interpretations have emphasized the cruel irony of the urban forest growing from rotting books at the same moment the Detroit School District could not afford supplies and reading materials for its students.[59]

Moore's rising-from-the-ashes photograph was taken the autumn before (or after) the most sensational and likely most tragic transgressive incident at the station complex, which also occurred at the Book Depository. In January 2009 *Detroit News* journalist Charlie LeDuff found a dead body entombed in ice in a flooded elevator shaft, with only his feet extending upward above the ice, sneak-

ers intact and laces tied. The deceased, later discovered to be a little-known homeless musician named Johnnie Redding (a second cousin to Otis Redding), lay there in the ice while Canada-versus-USA pickup ice hockey games were played nearby in the flooded basement (the third straight winter for such an improbable activity) and homeless men routinely slept or waited out their time underneath dirty blankets near a continuously tended fire. Some men stayed only until a nearby shelter opened its doors for the evening. While LeDuff broke the story, the question of who first discovered or knew about the body but did not call the police is a matter of dispute. The men apparently knew about Redding's body for at least weeks but were loath to call the police and get kicked out of their encampment. Others who later discovered the body, including a Dutch photographer, also feared getting into trouble for trespassing or something worse. After the body was extracted and the story ran with the headline "Frozen in Indifference"—which quickly became an international spectacle—the hockey ended and the homeless men were kicked out and moved their colony to the abandoned Roosevelt Hotel nearby. The saga of Johnnie Redding's demise cast an awful light upon a city teetering at the edge of bankruptcy, with its now-ex-mayor Kwame Kilpatrick in jail, unemployment at rates not seen since the Depression, and the Big Three automakers also reeling, but it did help publicize the cause of Detroit's homeless.[60]

Surviving the Slumlord and Demolition Calls

Saving the station was never going to be an easy sell in a city hardened by decades of decline, where the grim news of demolitions was often met with a shrug or cheers, and powerful property interests controlled the fate of many of Detroit's most iconic buildings. From 1995 to 2018 the station was owned by billionaire trucking magnet Manuel "Matty" Moroun, who died at age ninety-three in July 2020. The penurious Moroun was a street-smart Detroit native of Lebanese descent who took his father's small trucking company and built it into a billion-dollar enterprise that spanned transportation, real estate, and ownership of the Ambassador Bridge—the only privately owned border crossing between the United States and Canada.[61] Long making the list of richest Americans, in

2010 *Forbes* estimated his family net worth to be $1.6 billion and $2 billion in 2015.[62] Moroun—who apparently possessed fond memories of passing through the MCS while attending college at Notre Dame (South Bend, Indiana) in the late 1940s, often returning home to work at his father's Detroit gas station—was able to wrest ownership of the five-acre core station property and an additional twenty acres around it in 1995, while the station was subject to bankruptcy proceedings. He owned the station, through his company, Control Terminals Inc., a Delaware corporation affiliated with his other corporate entities, the Detroit International Bridge Company and CenTra of Warren, Michigan. Most Detroiters simply say Moroun, the Moroun family, or the Bridge Company when referring to the station's previous owner. Prior to Matty Moroun's death, there had long been questions about who was making the decisions—with his wife, Nora, and son, Matthew, as well as Bridge Company president, Dan Stamper, playing ever larger roles in his businesses as the years advanced—and by most accounts, Matthew engineered the station's sale to Ford.

Moroun had few equals in the region in terms of wealth, land holdings, and controversy, the latter because of his MCS stewardship, his obstruction of a new international bridge that would compete with his own, and poor maintenance practices at his properties. He often sat on idled, deteriorating properties for years. A 2010 *Free Press* analysis found that Moroun owned at least 625 properties within Detroit, many vacant and in quite poor condition. Some were bought out of bankruptcy, often purchased at a sheriff's sale for the five-hundred-dollar minimum bid. Acquired under many different ownership entities, these amassed properties likely made the Morouns the city's largest private landowner. While shrewd, feisty, and litigious—known to use the courts to get what he wanted or prevent others from taking action deemed harmful to his enterprises—Moroun was shy and reclusive and rarely granted interviews or was seen in public (and when in public, was often exceedingly polite). After his father's death in 1992, Moroun spent eight years fighting his sisters in court for complete control of their father's trucking company, eventually buying out their shares for an undisclosed sum. And unlike other prominent Detroit property owners, on balance he wasn't a substantial contributor to charitable causes. In 2004 *Forbes* dubbed him the "troll under the bridge," and many Detroiters have observed that he exhibited a form of avarice and indifference that made likely made him the worst slumlord in a city that has had many.[63]

Of course, Moroun and his family viewed their ownership of the station differently. They considered themselves aggrieved stewards who were "demonized" and "vilified" by local media while trying heroically to keep one of Detroit's icons standing amid the complete deterioration around it, even if the historical record does not well support such a perspective. At the same time, the Morouns—ever concerned about the bottom line—viewed the station as a kind of money pit, which continuously drained resources while generating almost no revenue and a constant stream of headaches. Many wondered why Moroun had bought the station in the first place and held onto it for so long. In 2010, after the dust had settled on a failed city effort to demolish the station using emergency powers and federal money, Moroun was flabbergasted and not sure what to do next. "I can't keep the thieves out of it until I put something in it, but what can I put in it?" he asked a *Free Press* reporter.[64]

Matty Moroun had long thought of the station as linked to his other prominent Detroit property, the nearby Ambassador Bridge, which he had outmaneuvered famed investor Warren Buffett for ownership in 1979. The bridge connecting Detroit with Windsor was privately built in the 1920s and somehow survived the Depression when almost every other privately owned bridge or infrastructure was taken over by government entities. The bridge's traffic flow generates constant revenue from tolls and its duty-free gasoline concession, and is one of only two vehicular crossings between metro Detroit and Canada (the other is the Detroit-Windsor Tunnel). In 2018 Ambassador Bridge traffic was generating an estimated $60 million in tolls a day with over $500 million in trade crossing daily.[65] The family used the great profits it generated to buy additional industrial properties throughout the city and region and across the river in Ontario, including the giant McLouth Steel Plant in Southwest Detroit and the Budd Wheel Plant on the East Side. Some were to provide expanded facilities for his trucking operations while others seemed more speculative. They also spent over a decade fighting the city, state, and Ontario provincial governments' efforts to build a second bridge. Using lawsuits and purchasing key parcels required for the new bridge's landing, they certainly slowed the bridge's development. And even as Michigan and Ontario have begun construction on this span, the Gordie Howe Bridge, every day the Morouns have delayed its completion is a day that the Bridge Company enjoyed or continues to enjoy no competition and collect millions more in revenues.[66]

Moroun's purchase of the station was less of a sentimental trophy of his youth than a vaguely

strategic investment, perhaps to prevent would be competitors from obtaining the property and exploiting the tunnel for border crossing freight, even as under the best of circumstances the tunnel would capture only a small fraction of overall freight and no automobile or truck traffic. The space around the station could have enabled the Bridge Company to create larger areas for customs inspections or duty-free sales, or enable new approaches for a second span, while the MCS itself could have been renovated for use as offices for trucking and logistics companies and associated government functions. The Bridge Company made such a proposal in 2001, and similar reuse schemes were floated over the years, but nothing came of them, some of which would have run into public opposition and required substantial governmental condemnation.[67] Either way, Moroun showed little immediate interest in stabilization or conservation measures and never publicly offered a concrete plan for the station's reuse. His company put up a fence and added security patrols, but the station itself just sat there deteriorating as it had previously.

In 1999 a Bridge Company representative admitted that the company did not have a plan for the station and complained that zoning and the city's lack of a revitalization plan for the area with its "many blighted properties" was clouding its ability to move forward. Still the company had no plans to demolish it, even as calls for such grew louder. Capturing this sentiment, real estate analyst Joel Feldman told *Crain's Detroit Business* that the station was "an eyesore" in a "horribly neglected neighborhood," best suited for an industrial park, low-income housing, and or a neighborhood shopping center. "Any kind of development on that site, by definition, requires demolition," he argued. "It is functionally obsolete, with costs to renovate or repair it so great that you're much better off demolishing it and starting from scratch." While Margaret Garry, a Mexicantown Community Development Corporation manager, called the station a "big white elephant" and said her organization and constituents, "didn't want to take on problems it could not solve."[68]

In addition to the inspection and customs center and the intermodal freight yard, the Morouns and others floated several reuse proposals during their tenure. The casino and hotel complex concept was revived, but state gaming licenses were committed to other Detroit sites. Other schemes involved law enforcement, with the station becoming the Detroit Police Department headquarters or a US Department of Homeland Security complex with a state forensics lab—or a combination

of the two. There were also outlier proposals, including a fish farm and aquarium and a park for extreme sports. Monitoring these proposals from afar, I wondered about the public component, particularly those schemes involving law enforcement or border functions. Would the station's waiting room be renovated and opened to the public again? Law enforcement facilities rarely contain interior public spaces, and it seemed antithetical to the security-obsessed post-9/11 protocols that often make federal facilities into fortresses, including those lacking security functions. Would the MCS become a forbidding compound? And would these tenancies doom the modest groundswell of support for reviving train service and making the station a Midwest high-speed network hub? These questions did not seem up for public discussion.

Of course, the Morouns had little interest in investing their own substantial capital in any of these schemes. The family seemed to be patiently waiting for an eventual but hardly assured payday, no matter how much bad publicity it generated, and rarely shared information with the public, let alone engage in dialogue. While their strategy ultimately provided a great profit, the Morouns were out of sync with the times. From their suburban compound in Grosse Pointe (or other places where they owned properties), their vision of Detroit was one of dysfunction, dereliction, danger, and violent strife. It was the city still living through the aftermath of the 1967 riots, or of bare-knuckled tough guys like Jimmy Hoffa, for whom a young Matty Moroun had waited on as a clerk at his father's gas station, and five-term mayor Coleman Young (Moroun enjoyed relationships with both men). A decade into the twenty-first century, no one would argue that Detroit still had substantial if not existential issues. But the Morouns' perspective failed to recognize genuine improvements in city life, including falling crime rates, renewed demand for downtown office and residential space, and the emergence of institutional development partnerships. Their vision of the city was vastly different than Dan Gilbert's, the Quicken Loans pioneer, whose investments in downtown properties, largely through his development company, Bedrock Detroit, substantially enhanced his wealth but also helped bring activity back to downtown and catalyzed public and other private investments. The Morouns had no interest in partnerships nor Gilbert's brand of placemaking—the "quicker, cheaper, lighter" improvements and public programming, let alone the DIY improvements and events that characterize the iconic sites of Buffalo and metropolitan Pittsburgh documented in previous chapters.[69]

Yet the Morouns were not entirely tone-deaf. Around 2010 the public outcry, the city's on-again-off-again demolition threats, and the thought of the eventual payday motivated them to undertake a stabilization plan (the cost of which was never shared publicly) to make the station presentable and accessible for potential suitors. Some reasoned it was a means to curry favor with state government in an effort to block construction of a new international bridge (or to allow the Bridge Company to build and operate it). Executing the plan developed by the architecture firm Quinn Evans, the company replaced broken windows, cleared interior debris, partially restored electricity, and installed a new freight elevator. It also replaced the station's dilapidated roof and worked to identify and repair other places of water intrusion.[70] The company would also cleanse the station of its asbestos, much of which was insulation for the HVAC system Amtrak installed in the 1970s. The work dragged on for some years, even as the Bridge Company celebrated its progress with dramatic lighting of both the building's interior and exterior beginning in October 2012. While the public appreciated the gesture, some saw it as another ploy to obtain voters' support for a controversial and ultimately unsuccessful ballot proposal, which, if passed, would have required voter approval for any new bridge or tunnel connecting Michigan with Canada, thus slowing or thwarting the proposed Canadian-financed Gordie Howe Bridge.[71]

In 2012 and 2013 I made efforts to interview a Moroun or Bridge Company officer. Eventually I was referred to Elisabeth Knibbe, a preservation architect and principal of Quinn Evans, hired by the company to assess the building's condition and develop plans to replace the windows. Taking issue with media portrayal, she argued that the Morouns "love the building" and noted recent and planned investments. "They are trying to stabilize the building for future uses," she explained, noting the tower was well laid out for a hotel, apartments, or offices but assessed that the market for these uses was at least a decade away. Possessing foresight, Knibbe said the station would make an excellent US headquarters for Chrysler's new parent company, the Italian automaker, Fiat, foreshadowing Ford's purchase six years later.[72] These improvements did help keep the station standing and somewhat watertight for another few years, protecting its value for future sale. When Ford purchased the station for $90 million in 2018, some Detroiters were not happy that the family's long speculative strategy had been validated and paid the family such a handsome windfall, but were relieved that their reign was ending and the station was now in more capable hands.

Of course, the Morouns were not the only party guilty of inertia, neglect, or naked opportunism during the twenty-three years of their ownership. For decades, government officials schemed to bring down the MCS, but demolition costs and the Morouns themselves thwarted these efforts. Yet the Great Recession provided a new opportunity. Hoping to capture federal economic stimulus money, in April 2009 the Detroit City Council hastily passed a resolution to expedite the station's demolition. While Interim Mayor Kenneth Cockrell Jr. offered a variation in which $3.6 million in federal stimulus funding would pay for clearance, but the city would later stick the Morouns with the bill, ultimately enabling it to pursue demolitions of its estimated inventory of forty-five thousand abandoned buildings. At the hearing where the resolution was passed, impatient city council members chastised the mayor's office for not moving fast enough and seemed flabbergasted that the city could not simply demolish the station without due process, including a public hearing and testimony from safety inspectors. The use of federal funds and the structure's listing on the National Historic Register would necessitate additional due diligence and review. "We can't wait any longer," Councilperson Barbara Rose Collins, the measure's sponsor, declared. Council president Monica Conyers, who would later serve twenty-seven months in federal prison for bribery, declared the depot "should've been down years ago." Even local advocates could only offer a meek defense of saving the station. "There are even some preservationists that think it's outlived its usefulness," Preservation Wayne director Karen Nagher explained. "It could be daunting to be restored," but "could be used somehow."[73]

Even as demolition seemed like a dereliction of civic responsibility, the move enjoyed the backing of much of the Detroit media, whose myopic vision is now laughable given Ford's investment. A *Detroit News* editorial accused the Morouns of "hiding behind the building's historic designation" and argued the station was a "public nuisance"—reasoning,

The building may attract out-of-town filmmakers and so-called "urban explorers," but it is also a derelict building—with all of the risks that implies—and a huge blemish on the landscape. It is a constant reminder of the decline of certain parts of the city.[74]

Popular sentiment was mixed, but some residents expressed outrage or sorrow that the city would use public money to demolish an "architectural jewel" and the "shared history of our region" or forgo opportunities to address more critical needs with federal stimulus money.[75]

It's Hard to Be a Preservationist in a Demolition-Obsessed City

One of those outraged was twenty-two-year-old Ashton Parsons, cofounder of the Michigan Central Preservation Society, a nonprofit launched after the city issued its expedited demolition order. In 2009 Detroit was in a "demolition blitz," Parsons argued, and over the previous eighteen months had taken down, by his estimation, ten marquee buildings, including nearby Tiger Stadium:

> It was unreal. They had no vision. They had no understanding of what these buildings meant to the city architecturally. They just wanted to get rid of the eyesores, buildings they perceived as eyesores. And then they set their sights on the train station. And I think that between people being upset by all the destruction lately and the emotional connection to the building, people had had enough.[76]

The preservation society helped coalesce the opposition and provide voice to those who otherwise felt powerless, Parsons argued. His cofounder, John Moyhi, a politically savvy Wayne State undergraduate at the time, made connections in state government, where he helped Senator Cameron Brown draft a response to the city's proposed action. Ultimately the demolition was thwarted when Brown and the group confronted the city, citing the station's listing on the National Historic Register and the due diligence required by the Historic Preservation Act of 1966. The station's cause received additional support from other elected leaders, including city council member Charles Pugh, a supporter of the law enforcement headquarters scheme (Pugh would later be convicted of sexual misconduct for sex with minors and served five years in a Michigan

prison, released in December 2021). At the beginning of 2010, Pugh became council president (for receiving the highest vote total of all council candidates) as Dave Bing became the city's mayor. Neither wanted to see the building demolished, which helped kill the effort. Sensing an opportunity, the Bridge Company did entertain a proposal involving the Department of Homeland Security, but nothing came of it. But even Brown and his coalition's rationale for saving the depot was focused on economic benefits derived from a federal investment rather than broader interest in preservation or enhancing the city's urbanity.[77]

City officials were quite calculated in their attempts to demolish the MCS, whether for the purpose of capturing federal stimulus dollars or ridding the city of an embarrassing icon of decline—or to reuse it in a way that would betray its public nature, historic functions, and connections to the adjacent urban fabric. Their failure to recognize the value of a civic jewel, albeit faded, in an area that was already reviving by the early twenty-first century cannot simply be rationalized by scarce resources, declining tax revenues, or bankruptcy. As Parsons and others have noted, Detroit has failed to retain and preserve many genuine assets, including marquee office towers, hotels, civic buildings, and its flagship Hudson's Department Store. Demolition has also figured prominently into hundreds of millions of public dollars spent on new sports venues, including Ford Field, home of the NFL's Lions and owned by William Ford (the corporation's executive chair who later initiated the station's purchase); and the creation of "the District Detroit" north of downtown, which was condemned and conveyed to the Ilitch family, owner of the Detroit Tigers and Red Wings, for the construction of a hockey and basketball arena.[78] The casualties of this Tax Increment Finance (TIF) district included many solid residential and commercial buildings and the 1924 Park Avenue Hotel (National Historic Register, 2006; contributing structure to a local historic district, 2006), imploded in 2015 to create space for a loading dock for the Little Caesars Arena.[79]

When confronted about the city's weak preservation practices and penchant for demolition, many Detroiters have laughed or rolled their eyes. While a few have been angry enough to act, resistance has rarely been strong enough to stop demolitions or questionable deals. Local advocacy led to the station's inclusion on the National Historic Register in 1975, and later groups, including the "Friends" (1980s) and the "New Friends" (1990s) of the Michigan Central, organized in response

to continued deterioration and demolition threats. The station and its Corktown neighborhood were also the subject of several university architecture and planning studios, as well as a 2001 architect-led investigation and charette facilitated by the Bridge Company.[80] These activities brought attention and helped forestall demolition but fizzled before they could help generate feasible reuse plans. In the late 2000s, the advocacy of the Preservation Society and the Corktown Business Association did help push the Bridge Company to carry out stabilization measures. But the MCS was ultimately saved by dealmaking among very powerful interests well removed from advocates on the ground.

For decades, as the idled station vacillated between eyesore and icon in the region's imagination, many potential preservation advocates acquiesced. The American Institute of Architects did not even include the station in the first edition (1971) of its Detroit architecture guide.[81] The region's most prominent advocacy organization, Preservation Detroit (formerly Preservation Wayne) did not in the last few decades advocate for the station's local landmark designation, even though doing so would have made demolition more difficult and facilitated additional public resources toward restoration. In 2010, when I asked Karen Nagher, the organization's executive director, about advocacy for both the MCS and Packard, she steered our conversation toward residential neighborhood preservation efforts. As they were working with preposterously low funding, I could only conclude that in the organization's estimation, vigorous advocacy for the Michigan Central was not worth the political capital it would require.

In 2016 I continued the conversation with Amy Eliot Bragg, Preservation Detroit's board president, in the organization's small office in a converted Victorian house on Cass Avenue amid the Wayne State University campus. Lacking an executive director and having no paid full-time staff, Bragg was serving as the unofficial executive director and putting in several hours of unpaid work most weeks, while earning a living as a journalist (at that time, she was director of content for a Detroit urban development website). A suburban Detroit native long compelled by local history, Bragg authored the 2011 book *Hidden History of Detroit* and cofounded the Detroit Drunken Historical Society.[82] Although she lacked formal training in planning, preservation, or architecture, in 2013 Preservation Detroit asked her to join the board, and within a few months, she assumed its

presidency—a post she held until 2017. Like Nagher had noted six years earlier, Bragg said that the organization was mostly focused on neighborhoods and on designations with willing owners. "The train station is definitely not one of our advocacy priorities," she said. "But we keep an eye on it, and we listen to how the community is responding to what's going on there."[83]

Bragg provided the organization with youthful energy and a sensibility that would not simply accept Detroit's urban development status quo, which viewed demolition as an inevitable outcome or the price of progress. As board president, she was unafraid to express unpopular positions, sometimes finding herself as a lone voice amid developers and city officials eager to seal a deal or move forward with a demolition or renovation that might jeopardize the integrity of historic structures. Throughout our conversation, she repeated the organization's refrain: "Please, don't tear that down!"[84] Leaders of preservation advocacy organizations across the country could surely commiserate with Bragg; a lack of resources and influence with mayors and developers is close to the rule. Still, Detroit was an exceptional case, which required both fortitude and humor:

I personally find it difficult to not feel like a Debbie Downer all the time. Since I joined the board, one of the struggles that became immediately evident to me was, how do you not just be like the shrill blue-haired lady standing in front of the bulldozer being like, "No, no, no, no, don't tear it down! No!"[85]

The organization was feeling the sting of a decade of lost preservation battles and the resulting demolitions, including the Madison-Lenox and Detroit Statler Hotels (2005), Cass Technical High School (2007), the Lafayette Building with its elegant shopping arcade (2009), and the loss to arson of the Romanesque Revival First Unitarian Church (2014). The previous year, Preservation Detroit had also taken a stand against the TIF district for the Ilitches' arena, but it was not enough to save the Park Avenue Hotel. And its ongoing advocacy to save the Norris House, one of the city's only extant eighteenth-century structures, would be thwarted a year later when the structure burned to the ground in a suspected arson.

The city, she said, almost always capitulated to property interests and did not pursue landmark

designations in the face of uncooperative owners. "We struggle with the mechanisms to hold people accountable," she explained in reference to powerful property owners like the Morouns and Ilitches and Dan Gilbert—all of whom have enjoyed a cozy relationship with Mayor Mike Duggan and his predecessors. Arson of at-risk buildings was also a regular occurrence, but perpetrators were rarely pursued and prosecuted.[86] The city was also not good at code enforcement or the hardball tactics used by advocates in Buffalo, where the Central Terminal's owners were shamed, repeatedly fined for violations and nonpayment of taxes, and then forced to sell. Likewise, Detroit's revitalization by demolition programs have never galvanized the opposition that similar practices have in Buffalo, even if the activists who lead that resistance are a relatively small percentage of all Buffalonians. And as Detroit has invested in demolition and promoted it as a catalyst of renewal, many of its citizens have followed suit. As Bragg explained, Preservation Detroit could not be "paternalistic" and noted,

> If a community or group of people in a neighborhood want to see a building torn down because it's blighted and it's a hazard to their community, it's really hard for us to come in and say, "No, don't tear it down—it's important to you."

Listening to Bragg's lucid analysis of preservation in the city and the limits of advocacy, I couldn't help thinking that demolition had been normalized to the point where bringing down a structure like the train station would be considered an inevitable event. Yet Bragg was optimistic about preserving the MCS and, like others, credited the Morouns for the improvements they had made. Preservation was on an upswing in Detroit, and the renovation of marquee office buildings like the Broderick Tower and the David Whitney Tower (now a hotel) were helping fuel the revival of Downtown and Midtown, and restoring "people's sense of pride in the city," she argued. These activities were now facilitating the train station's cause. Even just five years earlier, Bragg said, it was common for Detroiters to say, "Why don't we tear this down? It's an eyesore. It's blighted. It makes us look bad." Public opinion had now evolved from, "That's got to go," to "Somebody should do something with that."[87]

Growing from Transgression: Sweat-Equity Activism

In the absence of city support and robust preservation advocacy, and long before Ford arrived like a knight in shining armor, some Detroiters were nonetheless compelled to action. Working with limited resources and neither full authorization nor expertise, a range of citizens aimed to save the station and improve its adjacent grounds through sweat-equity improvements, in a manner not so different from their counterparts at Buffalo's Central Terminal and a similar citizen-led effort to recover the neoclassical train station of Gary, Indiana.[88] Their incremental efforts occurred amid a larger atmosphere of transgression and complemented Corktown's emerging reputation as a creative outpost and do-it-yourself haven with the station as its symbolic heart.

As the city directed economic and political capital toward the development of casinos and new baseball and football stadiums in the late 1990s and early 2000s, others were making investments in Detroit's oldest surviving residential neighborhood and its Michigan Avenue commercial spine. Corktown residents and business owners, both long-tenured and new arrivals, helped coalesce interest in the station. Entrepreneur Phil Cooley, who moved to Detroit in the early 2000s and co-opened Slows BBQ in 2005 on Michigan Avenue across from Roosevelt Park, took particular interest. The Marysville, Michigan, native and former model, who had previously lived in Chicago and Paris, proved adept in building local capital. Working with partners, including family members, he launched additional ventures, buying and renovating nearby properties, adapting them as a coffee shop, music studio, light manufacturing, craft, and live-work rental space. Fusing art, music, food, and community development, in 2010 the *New York Times* called him a "de facto spokesman for the now hip revitalization of the city."[89] In 2011 Cooley bought and renovated a former midcentury Corktown office building that once housed a printing press and remade it into Pony Ride, a thirty-thousand-square-foot nonprofit for business start-ups. He has also played a role in several other Detroit organizations, including serving on the board of the Center for Community Based Enterprise

and the local ACLU advisory board, and cochairing the Mayor's Advisory Task Force for the Detroit Works project.[90]

At the MCS, Cooley developed a relationship with the Morouns and was given access. He brought various people in for film and photo shoots and for general admiration and small parties. By the time I met Cooley at a 2010 dinner party he hosted at his above-the-storefront apartment in the Michigan Avenue building he was renovating, he was still on good terms with the Morouns, who had likely recognized his transformational role in neighborhood affairs. He provided the family with a bit of street cred at a time when they were trying to improve their public image. But his access ended when the Bridge Company began their improvements. Elisabeth Knibbe, the preservation architect, said that allowing Cooley and others in the station was too great a liability risk.[91] Cooley also split with the Morouns on a long-term vision for the station, and like many appreciators, desired substantial public uses. At the party, he proposed that the MCS be stabilized and reused as a cultural ruins park similar to Duisburg Nord Landschaftspark and other industrial heritage sites in Germany's Ruhr Valley. It was a monument to the fall of American industrial and corporate capitalism, he argued, an icon that sparked multiple dialogues. "A building like that would not be allowed to deteriorate that way and remain standing in any other city," he told the *New York Times* in a story published a week earlier. "It shows our postindustrial landscape: how nature takes over, what abandonment looks like. There's a lot to be learned from its current state. It needs to be a public space again."[92] Yet the Morouns, as described by Knibbe, had a more corporate vision, something approaching highest and best use that would focus on adapting the tower into new offices, a hotel, or residences, with less concern about public use and access.

By this time, Cooley was focused on reviving the adjacent Roosevelt Park. He could see both the park and the MCS from his apartment window and shared an estimate with the *Times* that some thirty sightseers, including many international tourists, showed up at the park each day to take photos. (It is unclear how he arrived at that estimate and how much time he spent sitting by the window.) Cooley and his neighbors were regularly picking up trash, maintaining or adding plantings (which Cooley often procured through solicited donation), or tackling other tasks—acts of "self-provisioning," which were common in Detroit parks during and after the Great Recession, in response to the

The pedestrian island at Fourteenth Street and Michigan Avenue. (Author, 2012.)

city's failure to provide basic services. But this was no desperate act of "making do," and Cooley was a savvy operator who could also prod the city to mow the grass or address other public realm issues.[93] Likewise, Roosevelt was not a typical neighborhood park; its relative prominence and proximity to local businesses, including Cooley's, in a reviving neighborhood gave these efforts a cultural cachet that eludes parks in outlying areas of the city. With modest support from multiple sources, including the Bridge Company and charitable organizations, Cooley's group and his coalition formalized their efforts into the nonprofit Roosevelt Park Conservancy.

Cooley thought of the station and Roosevelt Park as an ensemble. In its creation, the land for the park was cleared at great effort and expense in the years after the station was completed to give it a proper foreground and facilitate connections to the local business district, of which his own businesses over eighty years later were now part. In 2008 the Greater Corktown Development Corporation approached Cooley about an anticipated grant from Daimler Financial. Each sum-

mer, the financial arm of Chrysler's former parent company engaged in a charitable reclamation, an act of giving back where it would donate money for a public improvement while its employees provided volunteer labor for a day. Cooley suggested that the ten-thousand-dollar grant could be used for Roosevelt Park or in its vicinity. At the same time, Cooley convinced Noah Resnick and Tad Heidgerken of uRbanDetail architects to create a pro bono park master plan. Developed with residents and business owners, their plan (published in 2010) argued that the twelve-acre park was a prominent but neglected public space that "mirrored the abandoned structure that loomed over it," but had the potential to "serve as a centerpiece for the cultural and economic growth of the neighborhood." Written in part to grow the park's coalition and attract resources, it suggested that park design be guided by "flexible parameters" and implemented through an "open framework" that responded to evolving opportunities rather than being determined by "a planned architectural outcome." It envisioned a series of tactical interventions that could be incrementally implemented absent funding and explicit support from city government.[94]

Cooley organized the cleanup event in which a dozen or more Daimler volunteers participated. He used Daimler's grant to leverage in-kind donations to realize the plan's first element, which needed to be economical while providing visual impact that could set the stage for future interventions. The coalition decided to target the traffic island across Michigan Avenue from the park. Using donated materials, volunteers transformed the small triangle-shaped island into a sculptural planted space with native grasses and shrubs. Located at a strategic junction along Michigan Avenue near several lively businesses, including Slows, and possessing road connections to and over the Fisher Freeway (connecting Corktown with long-severed North Corktown), the intervention established pedestrian-oriented territory in former residual space amid a larger environment geared for automobile traffic.

Building on this success, the conservancy convinced Daimler to stage another event the following summer (2009) and increase its donation to thirty thousand dollars. Working with the architects, the group targeted Roosevelt Park's south end, which sat directly underneath the station's north-facing façade, where tourists often stood to admire it. Cooley was able to leverage the Daimler grant to what he estimated was another two hundred thousand dollars of in-kind donations of ma-

LEFT A view from the office building's roof looking northwest while the construction of the Roosevelt Park's Meditation Garden occurs below. (Courtesy of URbAnDetail, 2010.)

ABOVE Architect Noah Resnick shows the author the Meditation Garden that he helped design. The Book Depository Building is in the background. (Author, 2012.)

terials and services. Juxtaposing against vertical geometries of the station's façade, the uRrbanDetail-designed "meditation garden" featured a tableau of segmented areas planted with low-maintenance grasses and wildflowers interspersed with walks and small plazas paved with granite slabs salvaged from a renovation of Hart Plaza (Downtown Detroit) and donated by the city. Yet the garden's planned benches could not be installed; a city representative told the architects that improvements could not be "permanent" or exceed eighteen inches in height. The following year, local businesses donated money for the construction of a fifty-space community parking lot, featuring a bio-swale to capture stormwater runoff and doubling as an event space. In 2011 the Roosevelt Park Conservancy began a campaign and fundraising for a skate plaza and had collected the signatures

of one hundred thousand supporters. In 2012–2013, Cooley was able to obtain a state grant for thirteen thousand dollars and approximately two thousand dollars in private donations to plant allées of trees along park's outer roadways. Cooley's coalition also collected twenty-six thousand dollars in donations (twenty thousand dollars from a Knight Foundation Grant) for repaving these roadways in preparation for the eventual closure of Vernor Highway through the park. And by 2014 Cooley was also working to locate a (never realized) seasonal restaurant fashioned from shipping containers on park grounds. The menu of other improvements offered by the master plan or generated from later public meetings and events included an amphitheater, athletic fields and courts, arts spaces, and children's play spaces.

In May 2012 I toured the park with one of the plan's creators, architect Noah Resnick. The three volunteer-built improvements that had been realized by that time, two of which were not actually on park grounds, were far from prominent. One driving on Michigan Avenue might miss these new features entirely. The meditation garden, which has the most visual impact and sits underneath the station's façade, constitutes only a small part of the total park area. The rest of Roosevelt, which was originally designed as a tree-lined lawn to provide a visual foreground for the station and facilitate vehicular access, was cleaner than it had been in years but still scruffy. This visit and others since confirmed that the park lacks the sustained presence of patrons. Yet local businesses and organizations used Roosevelt for events such as the Corktown Music Festival, the thirty-five-mile Tour de Troit (serving as the starting and ending point), and the annual R. Park Fest with its "Cornhole" tournament and firefighter cookoff, which drew people from the neighborhood, city, and region.

Cooley and Resnick viewed Roosevelt Park as an open community experiment. At the beginning of the 2010s the city lacked both the capacity and political will to carry out improvements. The master plan's suggested improvements could occur as resources and opportunities dictated but was not merely a reflection of scarcity. It was also an incremental operating strategy that allowed for the park's immediate enjoyment while engaging constituencies whose support would be a necessary precursor for comprehensive restoration. The events brought people to Roosevelt while sweat-equity maintenance practices made the park more presentable and usable. And many visitors were indeed moved by being in the presence of Detroit's train station, which helped push the Morouns

to undertake their own improvements. At the same time, the events and volunteer practices served the neighborhood's businesses, including Cooley's expanding constellation of enterprises. Cooley and Resnick both claimed that DIY activities also provided a modest but diverse group of residents with opportunities to impact the built environment in a way that often alludes them, and in some cases, appreciate improvements realized through their own sweat equity.

Yet even as the park improved, these DIY activities were not entirely appreciated by the Bridge Company. I speculate that the Morouns had never given much thought to the park—only that it or a part of it would be available to them if needed for a station redevelopment scheme. In fact, renderings in 2001 of a proposed international trade and customs center show buildings in much of the park's footprint.[95] Planning for the park and station was a study in contrasts. While the scale and ambition of proposals for the MCS over the decades had been out of proportion from what was possible, the Roosevelt Park Conservancy's plans were realizable and their vision in tune with the immediate present and medium term. As the Morouns, as well as city and state agents, waited to do the big development deal, volunteers were on park grounds making improvements with whatever resources were available to them. The difference in approaches was reinforced by Knibbe, who in 2013 worried that the conservancy's more insurgent design programs and events might scare off investors. "They need to think about the long term," she told me, noting that Vernor Highway's closure would hinder vehicular circulation for potential tenants, and a skatepark would not be harmonious with corporate reuse of the station. "The park is the front lawn of the building," she argued. Ironically, Cooley also called the park the station's "front lawn" but asserted that DIY improvements had made the station more valuable. Contrasting their respective approaches in conversation with me in 2013, Cooley observed, "It's absurd to think that we as citizens should just sit and wait for something to happen. The whole community has been working on this [park], and the only people who are not involved are the Morouns."

At the same time as Cooley and his volunteers engaged Roosevelt Park, the Michigan Central Preservation Society was attempting to play a similar role with the station itself. While the group helped prevent the city from executing its demolition order, members were eager to do more. As John Mohyi noted in a 2020 video, "People wanted to be involved rather than just being specta-

tors; they really wanted to take a hand in bringing back the Michigan Central Station."[96] Like Cooley, Mohyi and Ashton Parsons built a modest relationship with the Bridge Company. In 2009 and 2010, the society, with permission, organized and carried out a cleanup of the station's ground floor (including the waiting room), installed holiday lights and decorations on the station's exterior, and built and planted a flower garden underneath its north-facing façade. The cleanup got many nearby residents inside the building for the first time and involved dozens of local youth. Parsons told me that the society took substantial safety precautions, including wearing masks and helmets, but the event triggered an OSHA investigation, which ultimately concluded that there were no significant breaches of volunteer health, but the Bridge Company was made to pay a modest fine.

Parsons was neither a railfan nor an explorer, but he did possess a significant interest in architecture. He called the station a "nerdy passion project," one that had an almost accidental beginning. While a student at Washtenaw Community College in Ann Arbor, a research project about early-twentieth-century ocean liners led him to the neoclassical Pier 54 in New York City, designed by architects Warren and Wetmore, and he discovered that the MCS was among the firm's works. Soon he was devouring the station's history and making it the subject of his film course project. "I had to find out everything I could," he explained. Parsons frequently traveled from his home in the Ypsilanti area southwest of Detroit to admire the MCS, though from the exterior—never once did he enter, at least not without permission. He met other enthusiasts online, including architect and station scholar Garnet Cousins, and the organization's cofounder, Mohyi.[97]

What the society could not do on the ground, it did virtually. Examining the steady stream of MCS images posted to the internet, Parsons identified problem spots where vandalism was occurring or could occur and alerted the Bridge Company. He often recommended protective actions such as boarding up doorways, which the company sometimes but not always carried out. Traveling to the Avery Architectural Archives at Columbia University in New York, Parsons examined Warren and Wetmore holdings and copied historic images and plans, adding to what he obtained from local sources. Photographs, construction drawings, and historic narratives were shared among the group and with the Bridge Company to potentially guide restoration work. The society also surveyed best practices for railroad station preservation and was inspired by the Central Terminal

Restoration Corporation's interim operating model. Parsons tried to convince the Bridge Company to follow the Terminal's lead. As in Buffalo, modest investments would enable fee-generating tours and events, while building credibility for a longer-term plan. But the Morouns were not interested in interim uses, he said.

Parsons expressed mixed feelings about the Morouns and did not principally blame them for the station's decay, which was more the fault of previous owners. At the same time, fifteen years of ownership passed before the Bridge Company did anything to arrest the station's deterioration, and only then did it beef up security measures, he said. Like others, Parsons credited the company's critical improvements, including the roof, windows, new freight elevator, and removal of asbestos. But he explained, "I don't think they ever had a plan to use it for themselves." The Morouns "had made so many enemies with the [Ambassador] Bridge and their slumlord situation" that the station had become another giant headache for them. "They wanted to dump the property [but] wanted somebody to buy it that was going to do something with it," he said.[98] And that somebody was the Ford Motor Company.

A Train Station's Unlikely Savior

On the long approach to Detroit from the airport in October 2019 I chatted with my Lyft driver, Ruby, about regular stuff—travel, weather, Michigan life, and the sadness she feels at this time of year with boating season's end and the onset of cold weather. As we talked I looked out the window at the mostly unremarkable scenery—flat, mostly straight highway with walls or large trees buffering views of the region beyond. Having made the trip many times before, frequently as the driver, I instinctively awaited sight of I-94's landmarks: the eighty-foot-tall Uniroyal Tire, originally made for the 1964 World's Fair in New York, which sits along the freeway in Allen Park, and Ford's River Rouge plant in Dearborn, home to both active and historic factory complexes (or what is left of the historic), the northern edge of which touches the highway. While the tire is a Motor City roadside art icon, the Rouge is much easier to miss and was far more visible from the air an hour earlier. Passing the

Rouge, arguably the most consequential factory complex of the twentieth century, is not very different than passing a generic distribution terminal on the New Jersey Turnpike.

Once in Detroit proper, I-94 becomes the Edsel Ford Freeway, and we exited onto the I-96 southbound ramp and descended into a broad trench unable to see beyond the sloping buffer that separated the freeway from the city. After crossing underneath MLK Boulevard, the interstate abruptly ascended a berm near the core of an expansive highway interchange, and we veered left to merge onto the Fisher Freeway, I-75. Amid the spaghetti of ramps, the Michigan Central Station unexpectedly appeared on my right, the first prominent building we had passed on the entire drive. I felt the adrenaline rush through my body. This was my welcome-to-Detroit moment; I was here to tour the station with Ford representatives. From the backseat, I was quietly savoring the moment when Ruby announced, "I just can't wait to see what they are going to do with that building! I get excited every time I come down here and see it." We hadn't been talking about it and I had not mentioned my trip's agenda, but the MCS is *that* kind of building. I then told her about my upcoming Ford meeting and soon she recalled childhood trips to the station. She was a forty-eight-year-old, Detroit-born African American, and like many of her generation, her family left for the suburbs decades ago, settling in the Ypsilanti area west of the airport. The train station was an icon of the historic city, and she smoothly segued into other defining characteristics of old Detroit, including brick and cobblestone streets, which can still be found around the edges of Downtown and a stretch of Michigan Avenue that leads to the station.

Ruby was one of many in a metropolitan area of nearly five million people for which the station was a touchstone for memories and associations and the physical embodiment of historic Detroit. Many are too young to remember trains at the MCS as Ruby had, or my friend Francis Grunow who embarked on his college visit to Columbia University in New York (where he would soon enroll) via an Amtrak train departing from the station. Of course, many Detroiters hold less fond memories or have an opinion or anecdote about it. In addition to its size and distinctive architecture, its tortured three-decade postabandonment history makes it a region-defining landmark, synonymous with the city in a way that it never was before its abandonment. And unlike the Rouge, where Ford has quietly gone about demolishing nearly every significant historic building, at the MCS the region was

eagerly anticipating Ford's restoration. Of course, the comparison is not entirely fair, as the station has always been a part of the public realm, which the private landscape of Ford's factory has never been. But it's important to note that Ford did not possess a particularly stellar record in urban preservation or revitalization projects.

Soon we arrived at my hotel on Jefferson Avenue, across the street from Ford's last significant Detroit development venture, the Renaissance Center, completed in stages between 1977 and 1981, and now the world headquarters for General Motors. The RenCen required the demolition of the 1882 Brush Street Station, one of the three old stations that had survived into the 1970s (only the MCS is extant today). The John Portman–designed, five-million-square-foot commercial complex was universally panned by critics and others, who noted its fortresslike architecture, with its five cylindrical towers walled off from downtown by their three-story concrete base and land berm. This anti-urban design reflected what a car company thought of the city in the 1970s; and even today, the complex is geared toward suburbanites and visitors who can drive in and out of the megastructure's parking garages without having to set foot on Detroit streets. The RenCen's renovation and redesign that began in the late 1990s with GM's purchase has made it more permeable and welcoming. The winter garden added in 2001 opens directly onto a plaza that connects to a waterfront esplanade and, from there, a ribbon of new parks. Ford's purchase will enable the extension of Detroit's waterfront greenway system and soon one will be able to walk or bike between the RenCen and the MCS along this path. The greenway extension is a relatively minor feature of the plan, but it speaks to Ford's new urban vision and commitment to the city. Yet it does seem counterintuitive that a car company would be encouraging walking, biking, and urban lifestyles that are less automobile-centric. How did we get here?

Apparently, William Ford Jr. had been looking for an opportunity to bring Ford back to Detroit. He and company representatives had been talking to Mayor Duggan, who connected them with the Morouns. Some press about the sale has emphasized the Moroun family's desire, led largely by son, Matthew, to correct their standing in the eyes of public—particularly with the then advanced age of the family's controversial patriarch.[99] Only in Detroit would a real estate deal that yielded $90 million be considered a bequeath potentially worthy of public redemption and repairing one's image.

Yet Bill Ford—whose considerable wealth rivaled Moroun's, and who had been Ford's board chair since 1999 and the corporation's president, CEO, and COO from 1999 to 2006—was looking to shore up his own legacy. Ford, founder Henry Ford's great-grandson, sixty-one years old at the time of the purchase, greatly desired to make a substantial investment in the city where the company bearing his name was born (and apparently possessed ancestral Corktown roots), while placing the corporation on solid footing, prepared for the challenges that will inevitably impact how the world travels and the industries that provide the vehicles.

Ford had been in negotiation with the Bridge Company for some time, some speculate for years—unsurprisingly, the Morouns were tough negotiators. The company had already invested in a former Corktown knitting mill (later dubbed "the Factory") in late 2017 and purchased other properties throughout the neighborhood while rumors of the larger sale circulated. Negotiations dragged on through early 2018, and by the time the big announcement was made that June, few who followed urban development in the city were caught off guard. Yet the news was happily received. Veteran *Detroit Free Press* reporter John Gallagher, who over the past two decades had written more stories about the MCS than anybody, ecstatically noted that "Ford's purchase of the train station shines as a turnaround of miraculous dimensions," and called the deal "the one event in the city's comeback story that outranks all that has gone before."[100] While Dan Austin, a preservationist and founder of HistoricDetroit.org, proclaimed the purchase "will change the narrative of our city," and noted that the station "was plastered on every story about the bankruptcy" but now "almost single-handedly will change the way the world looks at Detroit."[101] At the outdoor press conference in front of the station, Mayor Duggan profusely thanked the Morouns for their "leadership role" and observed that son, Matthew, was "emerging as a leader in this community." In addition to the great payday, the Morouns themselves basked in the glow of adulation and hubristically so. "My father and I believed in this building and Detroit when many others did not," the younger Moroun told reporters (the older Moroun was not present). "My father and I were quite alone, left only with a positive long-term vision that no one else could see," he continued, noting Bridge Company improvements to the building. When asked about the near quarter century of criticism the family received as the station's stewards, Moroun smiled and said, "It's here because we bought it."[102]

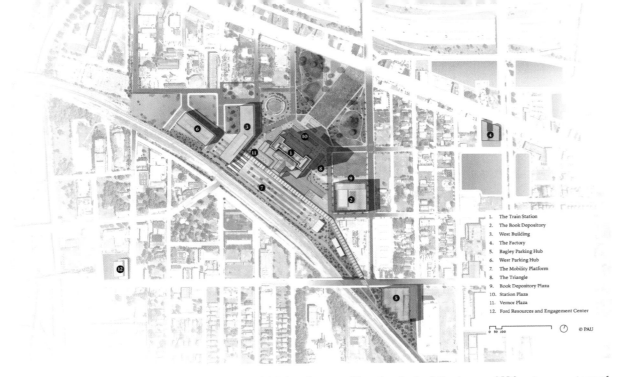

The PAU plan for the station and Ford's Corktown Mobility Campus. (Practice for Architecture and Urbanism courtesy of the Ford Motor Company, 2020.)

Even as many felt the Morouns received the payday they never deserved, most Detroiters were excited if not ecstatic about the deal. Yet I was surprised that even my own discerning and sometimes cynical Detroit informants were also upbeat. Scott Hocking, the artist, said he was "happy that the station was not going to be torn down" and contrasted Ford with previous MCS and Packard owners. "If somebody has the money and they want to get something done, they will go full bore and start cleaning it, fixing it," he explained.[103] "And that's what Ford is doing." Francis Grunow, the consultant and former Preservation Detroit director, said the Ford plan could succeed in a way that would benefit the company and city, emphasizing the station's collective narrative as a place "that touched all people of all social strata" and its potential to provide those public experiences, maybe as a railroad station again, to a generation that had only known it as a ruin. He also emphasized the redemption narrative and noted Ford was making good on previous commitments to Detroit that did not live up to their billing, including the RenCen, even as the corporation was still trying to figure out what mobility was and how it could be made profitable.[104]

With Ford's $90 million purchase, which also included the adjacent Book Depository Building and ancillary properties—about seven and one-half acres total—Detroit's fallen icon (or icon of the fall) was indeed saved, and by a well-capitalized owner eager to be an agent of revival. Its plan will make the station the core of a billion-dollar, 1.2-million-square-foot "mobility campus"—where engineers, programmers, and designers will develop new transportation platforms, and potentially collaborate with tech firms that as tenants will occupy 50 percent of the office space (with other property purchases across the neighborhood, the campus totals thirty acres). While research and development functions will not be entirely relinquished by other Ford technology centers, laboratories, and proving grounds, including the substantial facilities at its Dearborn headquarters, portions of the company's autonomous and electric vehicle divisions will move to and grow at the new Corktown campus. In fact, Ford is developing its Corktown campus in parallel to its ten-year Dearborn Campus Transformation plan, which began in 2016 and aims to create a Southeast Michigan mobility corridor from Ann Arbor to Detroit. When the campus is completed (the company estimates by the end of 2023), Ford expects to have twenty-five hundred employees working in Corktown and another twenty-five hundred employees of other firms working in the same buildings.[105]

Ford's development plan has three substantial elements: the train station itself (approximately 650,000 square feet) with its ground floor restored for retail, dining, entertainment and cultural uses; and its tower, renovated for new offices with the top three floors reserved for hospitality, meetings, and events. The second component is the Kahn-designed 1926 Book Depository (former Roosevelt Warehouse), the first part of which opened in April 2023, provides 280,000 square feet of new office space. The plan's third component is a new office building on the site of the former passenger train yard west of the station. Bookending the campus core, the corporation is building two parking garages. The first, branded the Bagley Mobility Hub—a six-story structure with 1,250 parking spaces and infrastructure to support bicycle, pedestrian, and micromobility travel—opened in 2023 south of the Book Depository. The mobility hub will also connect to the Platform, a mobility technology testing ground and the Detroit River Conservancy's May Creek Greenway. Additionally, the plan includes development beyond the core buildings, including the Factory, a renovated forty-five-thousand-square-foot former knitting mill opened in 2018, housing 250 Ford employees. The

corporation's other scattered Corktown property purchases and leases, including surface parking lots sandwiched between Michigan Avenue and the Fisher Freeway that once served Tiger Stadium, could potentially be developed and incorporated into the campus. Ford estimates that it will spend over $740 million on restoration of existing buildings and the construction of new ones, including $350 million on the station alone, as part of a billion-dollar investment. Yet it will reduce its development costs by taking advantage of some $238.6 million in incentives provided by the local, state, and federal governments (many made possible by the area's inclusion in a Renaissance Zone), including over $103 million from the city, encompassing property tax, corporate income tax, and utility abatements and other programs.[106] While Detroiters have happily told me that Ford would spare no expense in restoring the station to its former grandeur, preservation will not come cheap for taxpayers either.

Ford has emphasized that its MCS vision is indeed urban if not urbane—and that it has learned from both best-development practices and past mistakes made in Detroit, including the Renaissance Center, which to this day, after major GM reconfigurations, still feels like an auto-oriented anathema to the city's reviving downtown. The station will be permeable and welcoming, Ford says. Visitors need not be building employees or their associates to wander the ground floor and enjoy the restored waiting room and passenger concourse; shops, restaurants, exhibitions, and public programs will provide incentives for public entrée. For the rest of the campus—it is really more of a constellation of properties interspersed among everyday fabric—the corporation hopes to blend in rather than take over and wants to maintain Corktown's physical and social authenticity. This, in turn, will satisfy its young, Detroit-based employees, many of whom, Ford anticipates, will want to live in the neighborhood. At the same time, it is eager to be a good corporate citizen and direct resources to residents and businesses made vulnerable to displacement by rising property values, speculation, or direct Ford investments.

To support its vision of inclusiveness and shared prosperity, the corporation assented to a $22 million Community Benefits Agreement (CBA).[107] Kevin Schronce, the Department of Planning and Development's director for the Central Region, which includes the station, called it "the most extensive community benefits agreement the city has negotiated to date" with benefits well exceed-

ing those of the Illitches' TIF-facilitated arena district. The agreement requires Ford contributions to affordable housing development; education, workforce development, and small business initiatives; and public space, mobility, and traffic engineering improvements, including Michigan Avenue streetscape upgrades. Additionally, the CBA requires Ford to contribute funds for displaced residents and businesses and participatory budgeting projects. As part of its open-space commitment, Ford will help fund the May Creek Greenway, which will run along the southern edge of the station complex and contribute to Roosevelt Park's renovation. In addition to funding requirements, Ford has agreed that 51 percent of its Corktown workforce be city residents and 30 percent of the dollar value of all contracts for services or products be from Detroit-headquartered or Detroit-based businesses. All retail and service amenities will be open to the public. Conversely, there will be no private cafeteria—and employees will be expected to patronize local restaurants and businesses for lunch and catering. Finally, through this agreement, Ford has committed to extensive and transparent public engagement practices.[108]

The morning of my station tour, I met K. Venkatesh Presad, a Ford senior technical leader, who invited me for breakfast at a Michigan Avenue café, on the ground floor of a renovated building owned by Phil Cooley, where Cooley once kept his apartment (now a short-term rental unit). A free-thinking engineer originally from Chennai, India, and influenced by time in the tech-saturated Bay Area before his decades with Ford in Michigan, Presad holds a special position and works on projects largely of his choosing. The corporation's website refers to him as Ford's "what's next guy." An ideal liaison to the station restoration and mobility campus development, he understood the station in terms of multiple scales, contexts, and narratives—including the transgressive and DIY ones that I had been documenting. In preparation for my visit, he had watched the YouTube video of my 2018 lecture in Kyiv, Ukraine (and apparently his family watched along with him), where I had outlined ideas for incrementally recovering sites like the MCS.

Over breakfast and throughout the day, Presad and I discussed Ford's Corktown plan and mobility projects. He argued that these investments were critical as Ford shifted from manufacturing vehicles to providing mobility services, even as the mobility concept was still neither fully defined nor fully supported by the technology that will ultimately enable it in whatever form it takes. He also emphasized

that the company's vision was rooted in increasing its competitiveness in a tight global tech labor market. Taking a cue from Richard Florida's creative-class theory, he argued that cities like Detroit with authentic neighborhoods and historic buildings were valued by mobile knowledge-based workers.[109] Likewise, office buildings shared with other companies had the potential to foster collaboration and innovation, ala Silicon Valley or San Francisco. Ford was hoping their own investments would help further catalyze without destroying Corktown's creative and entrepreneurial elements, including artist lofts and gallery spaces, independent businesses, business incubators, and civic actors, like Cooley, who kept the neighborhood on its upward trajectory through recession and bankruptcy.

After breakfast, Presad and I proceeded down Michigan Avenue on foot to Ford's Michigan Central Info Center—a public storefront space filled with handsome displays about the station's history and the corporation's plan for the building and campus. The Info Center occupied the ground floor of the Factory, the renovated 1907 complex where hosiery was once made and where the company's initial Corktown workers were stationed.[110] As we waited to cross the avenue at Rosa Parks Boulevard, one of Ford's self-driving test vehicles, a white Ford Focus with blue accents and company branding and a large cylindrical device attached to its roof, approached the intersection. Traffic was light, and the "driver" brought the car to a stop and exchanged greetings with Presad through the open window. From Rosa Parks, an identical Ford test vehicle waited to make a left onto Michigan. Mobility, though slow moving, had arrived to Corktown in advance of most Ford employees who would be developing it. These vehicles had been on Corktown streets for a few months, Presad said, noting that the neighborhood provided ideal conditions to test autonomous technology, which to date had been primarily limited to more manageable suburban environments and the highway.

Inside the Info Center, we met Rich Bardelli, Ford's MCS construction manager, a Michigan native and Detroit resident, who would be our guide. Once at the station, Bardelli escorted us to a construction trailer to sign a release and receive a safety helmet and reflective vest. From the former passenger train (aka mobility) platforms, we entered the station from a simple door and descended a ramp into the dark and unrenovated basement, then up another ramp into the light-flooded passenger concourse.[111] Open to the sky, the steel roof trusses above us had been stripped, repaired, and cleansed of rust. The concourse's beige brick walls with their pilasters and simple decorative

brick bands and cornice also looked in good shape, even as they were marked in places by faded but distinctive graffiti tags. In midmorning sun, this unfinished room looked great with the trusses creating a lattice pattern shadow on the north wall. Even as I imagined a civilized morning arrival for passengers passing through after making the twenty-one-hour trip from New York many decades ago, the room had already taken on a contemporary feel. With its portals to other parts of the station, I also envisioned a twenty-first-century building lobby and flexible work space with a small café and comfortable chairs and tables scattered about where Ford employees might be working on their laptops or having small meetings.

It was still early in the restoration process, and much of the building's interior was covered in scaffolding—and no going up into the office tower. From the concourse, we walked through the scaffold-covered, colonnaded former ticketing area and paused in front of an easel with a large photograph of this spot from many decades ago, one of several places where such displays had been placed. I wasn't sure to what extent these photos were to guide on-site restoration work or to show to visitors like myself. Either way, the historic images suggested a difficult preservation standard, one that Ford representatives said they are committed to meeting while keeping the vibe contemporary. The corporation had hired the prominent Oslo, Norway, and New York–based design firm, Snøhetta, to be lead architects for the station's restoration and the New York–based Practice for Architecture and Urbanism for its campus plan. Snøhetta's early renderings showed the concourse and waiting room to be lively, programmable spaces filled with people rather than emphasizing exacting historic restoration, even if they show that as well.[112]

From the ticketing hall, Bardelli led us into the waiting room. More than sixteen years after I first stood outside the building thinking about the great space behind the façade, my Baths of Caracalla moment had arrived. The room would be impressive under any condition, and in its mostly unrestored state, it retained primal architectural power. It is a room of exquisite proportion—and what seemed so impressively large from the outside was also intimate and lithe, with its Guastavino vaults (and the musty air they contained) almost floating above me and breaking up the room's great volume into three more discreetly scaled sections. Looking up through a mesh netting, installed to catch falling materials, I admired the herringbone pattern of bricks and the way they formed flawlessly shaped arches,

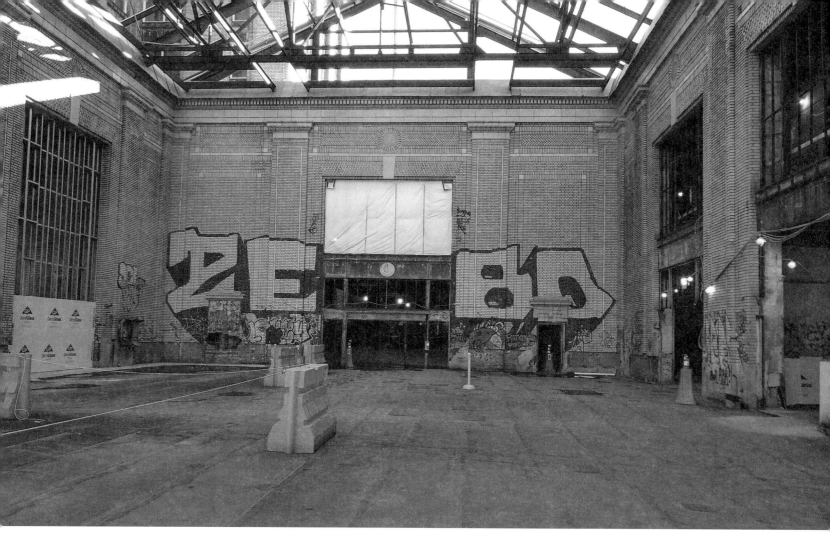

The station's concourse under reconstruction. (Author, 2019.)

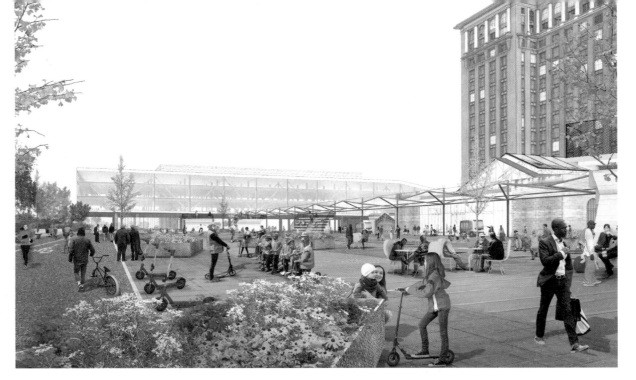

Ford's Mobility Platform on the site of the former tracks and passenger platforms of the station. (PAU, courtesy of the Ford Motor Company, 2020.)

even as some bricks were missing or darkened with grime. While much of the ornament had been destroyed or pilfered over the years, some terra cotta panels that lined the arches between the vaults had survived, and missing ones would be fabricated off-site, Bardelli said. Walls, long stripped of their marble sheathing, exposed an incomplete patchwork of concrete blocks and brick. The room's stately Ionic columns had been cleansed of the grime and graffiti well displayed in the Eminem video, but many were missing their scroll-shaped capitols. Pedimented doorways were covered in wood frames, and partially covered marble floor tiles awaited repair or replacement.

Underneath the center vault, I took stock of this restoration in progress. Some of the window arches were covered in opaque plastic while others were entirely blacked out, but I could imagine returning to discover the room bathed in soft light and people moving about as depicted in the Snøhetta rendering. I also imagined the room just a few years earlier and spotted the hole at the apex of the center vault that once held a large chandelier, where suburban marauders standing

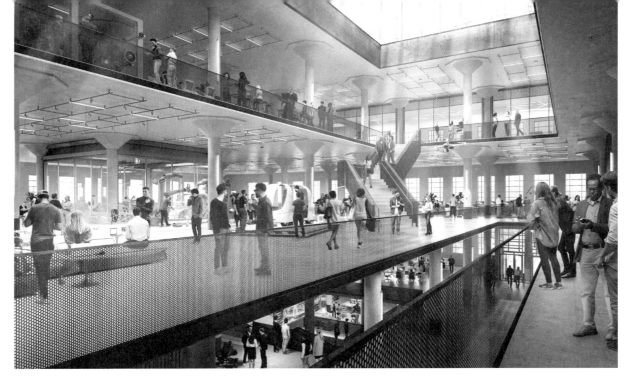

A Gensler rendering of the interior of the Book Depository Building (Gensler, courtesy of the Ford Motor Company, 2020.)

on the roof once dropped chunks of marble. I thought about Vergara's comparison of the formerly deteriorating MCS to Grand Central in New York—Detroit was beginning to catch up. But even if the MCS is restored to the same high standard, it would not share Grand Central's commensurate sense of public purpose, with tens of thousands of railroad passengers passing daily underneath the constellation-dotted, frescoed ceiling of its own restored concourse. Looking around, I felt the acute stress of attempting to maximize my waiting-room experience, including taking photographs, listening to Bardelli's narration and following up with questions, and engaging in quiet contemplation. Between the waiting room and the former Ladies' Reading Room and Men's Smoking Lounge, I had maybe eight minutes. I probably needed eight hours.

Ford's effort to locate original materials had received a boost from donations from people in possession of such items, including the distinctive metal clockface that once hung above the ticketing area. Other returned items include the decorative brass fittings once mounted on staircase posts, elevator push-button panels and light fixtures, a brass fire extinguisher, and an iron mail chute.

Some items were returned by collectors who had been among the building's original explorers (the term not yet invented) after it closed in 1988, including the owner of a nearby Michigan Avenue building, who had been storing fixtures in his suburban basement. Other items including stone and terra cotta pieces awaited authentication and many may not be incorporated into the station's restoration.[113] Ford was also intent on replacing damaged façade panels with limestone sourced from the same pit of the Indiana quarry from which the original panels came. Reopening the quarry for Ford, which, like the station, had been closed for thirty years, required its owners to cut down several mature trees and build a new access road.[114] Significantly damaged or missing decorative panels would be fabricated from fiberglass off-site.[115] Additionally, Ford later committed to replacing the thousand-plus Bridge Company–installed windows, which had drawn the ire of preservationists, with those that are more historically appropriate.

My day with Ford was far from done, and on the ride to Dearborn in the new hybrid SUV that Presad was test driving, we talked more about mobility. Presad described remaking of the vast area that was once the passenger platforms and tracks into a "mobility playground"—where the tools (or toys) of mobility could be tested including A.I.-controlled vehicles, electric scooters, and drones. This "platform," as it was later rebranded by Ford, will connect to the greenway immediately below it, which is adjacent to two Canadian Pacific Railway freight tracks. Could this platform also accommodate trains again? Did Ford's concept of mobility include passenger train service?

Transportation advocates have long argued that the station should anchor intercity service and a revived Detroit–Ann Arbor commuter train with an airport stop. In April 2019 the Detroit/Wayne County Port Authority commissioned a thirty-thousand-dollar feasibility study and was bringing city officials, Amtrak, and Ford together to discuss the matter.[116] When I asked Presad about bringing trains back, he said the company was open to it; other stakeholders provided hopeful but similarly noncommittal replies and noted that the onus was on Amtrak. At an April 2021 public meeting, Michigan Central Initiative director Mary Culler reiterated Ford's position. "We did aid a rail study and we've really tried to advocate for the rail concept but it's a really complicated one. So TBD, but we are definitely protecting for it at this point," she explained.[117] Yet spending time with Ford peo-

ple, it felt like mobility was evolving mostly as personal mobility. And the company's realization of this ideal in Corktown, at least in the immediate future, will still involve space-devouring parking structures enabling Ford employees to drive to work, even if the cars that will get them there might be different than the ones they are presently driving to Dearborn.

Mobility, as envisioned, will also be a collaborative affair, with half the space of the train station and adjacent buildings leased to transportation-focused technology companies or venture capitalists. These other companies could be collaborators or subcontractors—the twenty-first-century equivalent to the supplier factories scattered across Southeast Michigan that fed the plants of the Big Three automakers. While Ford's own industrious past may provide inspiration, Presad and others invoked Silicon Valley. The company hopes to seed and benefit from the start-up and small shop innovation that drove the Valley's explosive growth and compete for the same talent pool.

In Dearborn, I met Paula Roy Carethers, Ford's Detroit project manager, in the corporation's new research center above its proving ground. Carethers had recently moved from New York City to take the position and would leave Ford the following year. While invoking Ford's "we put the world on wheels" mantra, she called the train station's purchase "the first step" toward the company's shift to mobility services. From an upper-floor conference area, I momentarily got lost in thought watching cars circle the test track below. Even a noncar guy like me could feel the excitement of being at a site long connected with advanced automobile research and the weight of Ford's place in history. But as Carethers explained, the corporation could no longer rest on its history or be so suburban in its mindset. To attract talented workers from around the world, Ford had to embrace an urban ideal and innovative real estate practices.[118]

If successful, the Corktown campus will indeed be a shift for the quintessential suburban company. As nice as Ford's Dearborn facilities are, suburban Michigan doesn't quite spell excitement for smart people with choices, many of whom would choose warmer locales closer to the sea or mountains if they opted for the suburbs—or lifestyle cities like Portland, Denver, or Austin for urban living. And for many, the Bay Area still holds considerable cachet even if the Northern California brand has been damaged in recent years by its high cost of living, soaring inequality, and risks of natural or

human-caused disasters. In its Detroit return, Ford understands the station as a cultural asset that cannot be replicated in a Sun Belt locale or even San Francisco. Listening to Carethers, I thought about the broader shift in collective thinking. Just a few years earlier, Detroit leaders were insisting that the only viable alternatives to the station's demolition were adapting it as a casino-hotel or a law enforcement complex.

Ford sees the MCS as an icon of multiple narratives, including those that celebrate its architecture and the days when most Detroit intercity travelers still came through the concourse, and is now co-opting that narrative even as it played an elemental role in the station's demise. But the corporation also valued the station's transgressive history. Well-documented postabandonment countercultures placed the MCS at the "forefront of ruins examples around the world," Carethers argued, and helped build a broad constituency that loved it and advocated for its resurrection, ultimately attracting Ford. The corporation was still considering how to honor this legacy and maintain the vibe, and had conducted walkthroughs with graffiti artists to document and identify the creators of prominent pieces. The graffiti would be difficult to retain and didn't have positive associations for many stakeholders, Carethers acknowledged and noted that the corporation was also engaging the city's creative communities in roundtable discussions. For many, she said, the station had become a "painful piece of Detroit" and that its next chapter would provide unifying symbolic value in addition to tangible benefits both for current and future residents.[119]

A suburban Detroit native, Carethers also described some of her own transgressive history, noting that she and her husband had been among the building's 1990s explorers. For several years, she kept a photograph of them taken on the building's rooftop on her office desk in New York. She became animated as she attempted to describe the condition of the staircase leading to the roof— whole sections had been cut out to harvest the steel from which they were composed. As elsewhere in the station, the stairs had been undermined by scrappers more than thrill-seeking suburbanites, she said. In New York, Carethers worked on several prominent projects at agencies and nonprofit developers, including the rebuilding of Lower Manhattan after 9/11, Brooklyn Bridge Park, and an earlier planning phase of the Domino Sugar Refinery redevelopment on the Brooklyn waterfront. I was intimately familiar with these Bloomberg-era projects and could see the similarities between

them and Ford's MCS plan, including their commitment to broad but often vaguely defined urban ideals including vibrancy, equity, and sustainability. Like Domino and many Brooklyn development projects, real estate best practices had arrived in Detroit, in part because of the transgressive or informal activities that preceded them.

Ford was also playing a supporting role and providing some funding for Roosevelt Park's revival, but the city was leading this effort. Aside from Milliken State Park, almost all of Detroit's twenty-first-century park development projects—including the Campus Martius, Dequindre Cut, the Riverfront and May Creek Greenways, and Ralph Wilson Centennial Park (formerly West Riverfront Park)—are being administered by not-for-profits. Roosevelt will remain a city park. With its increased postbankruptcy planning capacity, the city's Department of Parks and Recreation guided a public engagement process working with the firms Perkins and Will and SCAPE on the redesign. The firms' design builds upon the work of grassroots instigators and uRbanDetail's 2010 master plan, enhancing Roosevelt's capacity for flexible programs and popups and replacing Vernor Highway with a pedestrian promenade. But DIY improvements, like the Meditation Garden, are a casualty of the new plan. Yet the demolished garden's architect, Noah Resnick, was excited to see transformation of the park and station complex. He noted Roosevelt's professional renovation meant that their preceding master plan and corresponding sweat-equity investments had succeeded.[120]

The new park also adds to the city's growing open-space network, and, through its greenway connection, will enable pedestrians, cyclists, and skaters to connect to Detroit's growing ribbon of waterfront green spaces to downtown, and farther east, the Dequindre Cut. The greenway will also extend westward to run underneath the Ambassador Bridge, which was part of the complex sale agreement negotiated by the city, the Morouns, and Ford.

Monitoring Roosevelt Park's renovation from afar during the early 2020s, I recalled, from my first trip to Detroit in 2003, standing in the middle of the empty park awed by the abandoned neoclassical station in front of me. The unlikely history of the ensuing years had brought an icon of both Detroit's rise and fall back from the brink, and the ensemble of train station and park was being reknitted into the physical and mental fabric of the city. For Ford, the restoration of this ensemble, while expensive, was an investment in real estate—a place to keep its urban-oriented engineers

and programmers happy while renting desirable commercial space to other firms. It was also about possessing Detroit's ultimate trophy property and the publicity and branding opportunities that it will generate. If this investment once seemed counterintuitive or risky, the legacy automaker's much larger investment in mobility was far riskier. Well-located, iconic Detroit real estate may well be Ford's hedge.

Detroit Ruins Postscript?

The Michigan Central Station and Packard Plant are icons precisely because their value exceeds simple economic calculation. Even as ruins, they were and are more than just architectural heritage and local history. They stir our souls, inspire us, and connect us to each other and to the collective endeavor of urban life. These places are "collective symbolic capital," or as I have previously argued, regionally distinctive cultural capital—much like Detroit's music, food, and visual arts; its downtown skyline, cultural institutions, and sports teams.[121] But now their fates go in different directions: the MCS returned to a form of its lost grandeur and utility, while the idled Packard Plant is progressively dismantled and cleared. No longer a ruin, the MCS is now an icon of a renewed city of technology and entrepreneurialism, while the Packard Plant (if anything is still left) remains emblematic of the city of dysfunction, apathy, and despair. While moving toward opposite ends of the spectrum, neither is like the other postindustrial icons explored by this book.

At the MCS, guerrilla and DIY practices have reached their end state: the reigns of improvement have been handed off to a better-capitalized and fully legitimate steward. Yet the magnificence and totality of the Ford plan will deny Detroiters the opportunity to play and build in the vast middle ground between complete ruin and restoration. Historic preservation need not be an all-or-nothing proposition. The MCS is being fully reclaimed (except for the trains), as the Central Terminal, Silo City, and the Carrie Furnaces have followed a more incremental recovery, nudged toward high US preservation standards while enjoying a messy and democratic present rife with failure, unrealized

plans, and conflict. Ford's purchase and plan indeed represent a best scenario for a site that had all but been written off. But in the larger landscape of deteriorating Rust Belt icons, the MCS is a singular case. It is hard to imagine another party making a similarly sweeping investment in an abandoned landmark complex and in such a public-oriented scheme. While Ford's plan is transformation rather than recovery, transgression, accident, and DIY did play a role in bringing the company to the table and getting the station miraculously to the present moment. There is much to savor and praise in Ford's plan, and Detroiters rightfully anticipate the station's reuse. Does the final payoff justify thirty years of inactivity and decay? In Detroit it probably does.

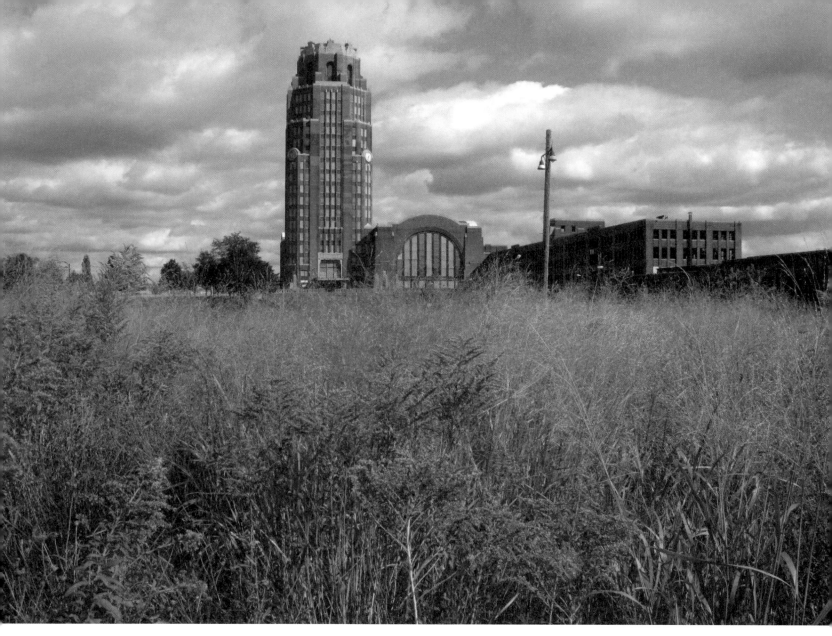

The grounds of Buffalo's Central Terminal, a target of grassroots activities.
(Author, 2015.)

CHAPTER 7

The Beginning or End of Postindustrial DIY?

For too long, former industrial and industrial-era sites, in the Rust Belt and elsewhere, have been treated as tradeable or disposable assets—catalysts of possibility only in their clearance or alignment with the market and politics that propel urban development. Yet the places chronicled in this book—abandoned, deteriorating, and written off as too far gone—speak forcibly to the urban experience. If we value these sites, and others like them, and their architectural heritage, we must have better approaches for engaging and reusing them. We must consider how to encourage and nurture these postindustrial experiments, or facilitate their growth by getting out of the way. It is far from clear that the practices chronicled here can be reconciled with professional notions of legitimacy, safety, or the market-based conventions of urban development, but we must try.

Since the beginning of the twenty-first century, across the United States and elsewhere, there has been a great reconsideration of industrial architecture—in its aesthetic qualities, monumentality, and symbolism; for its ability to help us remember and share the stories of the past; and for its suitability for contemporary adaptations. To these qualities, the postindustrial sites chronicled in this book, add an X-factor—an otherness or separation from the more rationalized or disciplined urban world around us. And in their imperfection and incompleteness, they capture collective imagination, passion, and identity, and bring people together to materially recover, reconstruct and celebrate places that might otherwise be lost. While their origins sometimes

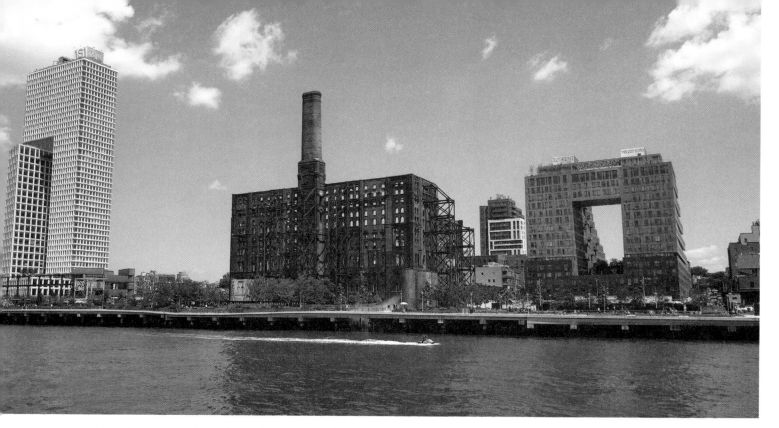

ABOVE A new postindustrial waterfront rises on the site of the former Domino Sugar Refinery in Brooklyn. (Author, 2020.)

RIGHT Chrysler's Jefferson Avenue Assembly Plant in Detroit, a manufacturing complex and logistics landscape entirely insulated from the city around it. (Author, 2010.)

lack cooperative aspiration, they can grow into future-focused collective building projects in environments increasingly dominated by political and economic elites, and hyperrationalized by professional practices.

Yet the moment for play amid iconic twentieth-century ruins is receding, as postindustrial DIY, where it has flourished, is co-opted by professional development or eliminated through demolition. As these postindustrial opportunities become scarce, their playful sense of possibility and capacity for authentic counterculture also vanish. Many prominent sites or landscapes that I studied or enjoyed during the early twenty-first century have been reclaimed, transformed, or erased: the formerly raw banks of the East River in North Brooklyn and its iconic complexes like the Domino Sugar Refinery and Bayside Fuel Depot; the Cramp Shipyard Machine Shop and Gilbert Arts Building in Philadelphia; the former administration building of the Bethlehem Steel Plant in Lackawanna, New York (the site of a spirited winter sit-in among Buffalo preservationists), and the in-progress demolition of Detroit's Packard Plant. For a time, it seemed as if there was always a frontier of *other*—and more forlorn industrial icons awaiting provocative recoveries. North Brooklyn's outsider activity moved from Williamsburg and Greenpoint to the neighborhoods east, DIY in Philadelphia's Northern Liberties moved to Fishtown and farther north, and San Francisco's scene moved across the bay to Oakland, with similar migrations occurring in many other cities. But industrial building stock is finite, and most distinctive sites have already been reclaimed or cleared. And where architecture has been preserved, its essence has often been sanitized or made docile to market forces. The last ebb of the American industrial era is not far off, and soon there may be no industrial fabric for nascent incremental recoveries in both the most and least prosperous cities.

Perhaps the postindustrial experience that I have documented was just temporary, lasting a few decades and concurrently with the devastating economic impacts of deindustrialization. On the balance, I would argue that Philadelphia, Buffalo, Detroit, and metro Pittsburgh are more urbane now than they were at the beginning of the century and their economic prospects stronger, even as some of their most distinctive or magnetic postindustrial places have been lost. Likewise, the conversions of former factories, warehouses, wholesale markets, and some

industrial-era office buildings into loft apartments, offices, flex spaces, restaurants, hotels, and institutional complexes have contributed to the revival of dozens of American cities. We rightly celebrate these projects and the vitality they generate. Yet we must also learn to encourage other uses of industrial places, including those that don't require participants to be consumers—even as sometimes they will be and the general trajectory of successful sites is toward the market.

Maybe the postindustrial frontier lies elsewhere—in the cities of post-Soviet Eastern Europe and those across Latin America and Asia (or in buildings of other eras and typologies). There will *always* be a postindustrial; our cities and lives are filled with the material stuff that was made somewhere, and that somewhere keeps shifting from city to city, continent to continent, from old production facilities to new. Yet contemporary industrial architecture, wherever it is located, often possesses little charm or utility beyond what it is designed for. Predominated by large, single-story metal sheds that spread across large suburban or exurban sites, it is an urban design practice that likely began with Detroit automobile manufacturers in 1920s. Touring the landscape of automobile production today in Southeast Michigan, including Ford's River Rouge complex in Dearborn, Chrysler's Jefferson Avenue Assembly Plant on Detroit's East Side, and GM's Detroit-Hamtramck Assembly Plant (now Factory Zero), these vast sites demonstrate a form of placenessness. They are highly secured, logistics landscapes insulated by fences and land berms, offering little connection to the surrounding urban fabric.[1] The Packard Plant, even as a ruin, possessed more urbanity than any contemporary automobile factory complex. So too did the now demolished plants built through the 1920s that once defined Detroit's first ring and outlying neighborhoods: Cadillac, Lincoln, Chrysler, DeSoto, Hudson, Dodge, Plymouth, and Ford's mostly demolished plant in Highland Park. Across the Rust Belt, the quality of industrial architecture built through the 1920s, before the suburbanization and globalization of industry, was exceptionally high. With these demolitions and many others, opportunities for grassroots and DIY building practices are far fewer and mostly more diminutive. If we value this these places and experiences, we must reconcile them with the professional realm, contradictions and all.

Postindustrial DIY for Professionals?

How do we make sense of the extraordinarily complex and still unfolding case studies of this book and similar sites—and where can we meaningfully connect the dots to professional practices and public policies, and sensibly deal with the contradictions separating formal and informal, legitimate and guerrilla, and market-oriented and grassroots preservation ideals? As I have argued throughout, these places are fluid and their incremental success moves them toward formality, better capitalization, and more conventional approaches to preservation, development, and administration. With growth, postindustrial sites become less *other* and lose some of their wildness, mystery, contradiction, raw beauty, and exhilarating ability to surprise or provoke. As they enter the next phase of recovery, their intimate sense of ownership among pioneering or early protagonists also recedes as capitalized interests and professionalism assert their stakes and the pool of participants expands. But this is not necessarily a cause for lament. The more thorough and longer-term preservation of inspiring structures is often a reasonable trade-off, while a dearth of investment does not at all guarantee the continuation of less formal postindustrial activities. Every decaying factory, warehouse, train station, or institutional complex is a day, month, or year away from an emergency demolition order or the target of an antiblight program, as sites across the Rust Belt show.

In my continued studies and visitation of Rust Belt icons, I have realized that it is vital that we appreciate and use, to the extent possible, these sites in all phases of their life span. Those who traipsed through the ruins of the Carrie Furnaces in their youth or early adulthood can appreciate Rivers of Steel's tours, festivals, and arts programming today as well as tomorrow, when Allegheny County has developed the adjacent parcels and there is more robust urban infrastructure supporting the entire former mill site. Carrie's sense of postindustrial nature may also be diminished by these and other improvements, including restrooms, weatherized spaces, bike and pedestrian paths, a boat dock, and parking facilities. Accessibility has a cost, but riding a bike to Carrie from downtown Pittsburgh would also be a thrill, as would a ferry ride. Likewise, those who were fortunate to have spent time inside and outside of Silo City's

grain elevators during the project's formative period now will have less license and raw terrain to explore. But it's nice to experience live music, spoken word performances, theater, and art, or socialize or partake in seasonal rituals in the shadow of those concrete giants, and sometimes inside of them as well. The adaption of grain complexes for residential and other uses will ensure the endurance of these industrial icons, as the site's bar and cultural arts venue and new landscape-based improvements provide enjoyment for more constituents. And those who explored the Michigan Central Station when it was an open ruin will now be able to return and appreciate the building with so many others who stood outside in Roosevelt Park dreaming of its reuse. Ford's commitment to keeping the station's ground floor public will enable interior access to its restored vaulted waited room.

Making industrial-era sites more vital in their unrecovered states, guerrilla and DIY actors have also helped coalesce broader interest in these places and catalyze their prospects for traditional preservation practices. Yet a form of the corollary should also be true: the legitimate urban development and preservation communities must learn to accept and appreciate some form of postindustrial DIY. While contradictions abound and political hurdles remain substantial, amateur-based and professional practices must coexist—comingle if not collaborate. And there must be a role for DIY protagonists at maturing postindustrial preservation sites, though it will largely be up to these actors to claim and maximize their stake.

Ideally, as the postindustrial projects I have described continue to mature, other sites can be the next guerrilla or grassroots target, even as such practices remain in conflict with urban development and governance. And in larger cities, the next iconic recovery, in whatever form it will take, will surely be more conscribed, precisely because of the success and market discovery of these projects and the attention they have generated both among those responsible for regulation and those seeking investment opportunities. The broader rediscovery of regions like Buffalo and Pittsburgh to live, work, play, or visit has perhaps pushed the frontier to smaller industrial cities: Syracuse, Utica, Erie, Gary, Flint, Akron, Youngstown, Wheeling, Scranton, and Wilkes-Barre. But as I learned in visits to Flint and Youngstown, local politics strongly favor demolition and

clearance over nascent, incremental recovery, particularly when federal- or state-funded brownfields or antiblight programs are present. In these cities and across this vast second tier, many potential postindustrial playgrounds have already been reduced to warehouses, surface parking, meadows, and stormwater retention as their populations continue to decline. Likewise, in many cities, decades of decline have greatly reduced the number of potential local actors ready to be agents of grassroots recovery.

Can we make the organic creation, growth, and maturity of postindustrial projects more frequent and impactful and help foster a sense of belonging, shared culture, well-being, and joy in our cities? Is it possible to nurture and enhance those place of unique cultural, architectural, and natural value, including those possessing little prospect for attracting traditional investment? How can we enable and facilitate the growth of postindustrial projects that are already occurring or are at a nascent stage? I have struggled with these questions for over two decades at the same time that conventional development has assimilated, tamed, or devoured local landmarks and unique cultural spaces. If we are to move forward with any part of this agenda, the allied development community must adopt approaches that do not conform to the economic development model of historic preservation and the high standards of conservation and restoration that accompany it. At the same time, we need to enlarge the pool of historic places, industrial and otherwise, that for a variety of reasons (partial demolition, poor condition or lack of material integrity, environmental hazard, economic infeasibility, etc.) do not fit the US Secretary of the Interior's Standards and Guidelines, and thus are not viable candidates for national or local register listing; or even if they are, their locations make them nonstarters for private investment. And most US incentives don't apply to those projects that lack commercial enterprise or don't immediately have the capacity for revenue generation, like those of this book and many others.

Moving away from the preserve-or-demolish dichotomy, US cities need policies that encourage and nurture bottom-up practices that occur in otherwise idled historic structures and urban landscapes, whether they be regional icons or more diminutive run-of-the-mill sites. Before policies and practices can change, there must be a broader reconception of historic places and ap-

proaches to engage them. Foremost, we must acknowledge that the size and complexity of many historic industrial-era complexes necessitates treating them as places rather than architectural objects. Places suggest ongoing activity, evolution, change, diversity, conflict, and contradiction, while architectural preservation practices push toward stasis and often fail to anticipate or encourage the kind of real-life messiness that occurs in urban places. The great size and multiple meanings of iconic places like the Central Terminal or Silo City's grain elevators should compel us to treat them differently than a museum artifact. We must approach them with greater flexibility than that of a Frank Lloyd Wright home, where painstaking restoration and maintenance of the original design and materials serve a compelling public function but a relatively narrow one. The urge to treat these sites as precious objects and, thus, markers of status or lifestyle must also be resisted. While former industrial buildings have been artfully adapted to serve many functions, whether they be in Brooklyn, Pittsburgh, or Lowell, Massachusetts, they have limitations. Even if we're not bothered by the lack of resident or tenant diversity generated by loft living, these projects don't always create the lively urban activity around and beyond their edges, and in many cases, converted spaces lose their publicness and potential public for functions. Icons belong to everyone.

For multibuilding sites covering several acres or more, why not start from an urban framework? Most professional preservation actors would argue that they already do this, and consider multiple uses, users, and contexts, and acknowledge that the success of most projects often hinge on their connection to their surroundings. But still at the heart of preservation practices and the eligibility standards for public investment in old buildings is the period of significance and focus on those structures that contribute to evoking this period. The projects of this book remind us of the vitality of the present and the excitement of the immediate future, measured in hours, days, and months, rather than the years and decades of the great plan or restoration. All these sites are better treated as cultural landscapes than discreet landmarks. Even in vacancy, their form and use keep evolving with contemporary adaptation and itinerant occupancy—and this is desirable, even as it complicates efforts to preserve our architectural past.[2]

Practices and Policies
to Foster Postindustrial DIY

At a policy level, the reform and diminishment of public urban demolition practices would substantially bolster the cause of postindustrial DIY. Signature or urbane structures and those places of unique cultural value are often at great risk for demolition not because they are dangerous (they often are) or candidates for immediate collapse, but because there is a federal- or state-funded demolition program looking for appropriate targets. Likewise, political actors tend to view these places narrowly as opportunities to demonstrate economic progress and are adept at obtaining external funding to accomplish these goals. Sometimes these demolitions have no particular economic rationale other than to clear nuisance or potentially dangerous structures. Other times they are targets of an economic development scheme, such as the Gilbert Building in Philadelphia, the land for which was desired for a convention center expansion; and Detroit's Clark Street Cadillac Plant, which was cleared for a nonurban industrial park. From a public policy perspective, preserving these structures through mothballing could be a cost-effective way to preserve their nascent value for future urban endeavors. For those sites where guerrilla or grassroots activity is already occurring, it would not at all guarantee their survival but reduce the existential threat of senseless demolition, even as potentially troubling matters concerning legitimacy, public safety, and economic viability would persist and require incremental problem solving. Demolition initiatives have almost always been presented as neat solutions to the vexing issues of the postindustrial city: addressing property blight and hazard, creating space for job creation and economic growth, raising property values, enhancing public safety, and improving sustainability metrics through greening and stormwater control. Yet on the ground, these campaigns have rarely lived up to their billing.[3]

As the realm of public policy actors move from the federal and state levels to the local level, and from legislation and funding to administration and oversight, challenges increase. Public officials

and professionals who can be project advocates should be willing to act accordingly and assume some measure of risk. They will have to act nimbly and use whatever influence they possess to facilitate these unconventional projects, which could mean bucking best practices, prevailing politics, or where the market wants to go. They might also use their discretion on when to look the other way. None of the projects documented in this book could have happened without some deviance from building, fire, environmental, or public assembly codes. There is great need for creative thinking and innovation around interim and incremental compliance mechanisms for postindustrial protagonists and their sites. It is not acceptable for planners, architects, and preservationists who support or enjoy these sites during their leisure time to throw their hands up and invoke adherence to law, public safety, and liability concerns in the professional arena. We must help figure this out and serve as agents of change or assist those who are willing to be those agents.

Government administrators must also contribute to a discussion about how to interpret or reform local or state liability laws and practices. Yes, DIY practices at postindustrial sites are risky, particularly when they experience growth. Yet postindustrial protagonists have often found creative ways to reduce risk and enhance public safety. At the Carrie Furnaces, Rivers of Steel administrators have scrupulously adhered to practices consistent with local and state laws, as well as National Park Service practices, to ensure reasonable levels of public safety while the organization maintains robust general liability policies and requires organizers of activities or rentals to carry their own policies. Assessing risk requires much more local judgment than most people know, even those who are architects and planners. At the same time each of these sites offers unique contexts for assessing risk, and liability codes and case law varies from state to state, while the interpretation and applications of such laws vary among municipalities. Nonetheless, the collected expertise of owners, administrators, and other actors at sites like Carrie Furnaces, Silo City, and the Central Terminal should be considered in the reform of liability policies and practices at all levels of government.

At all the sites of this book, protagonists have expressed admiration for the postindustrial parks of Germany, particularly Emscher Landschaftspark. The stabilization and conversion of these former steel, coal, and gas sites into playful and often spectacular landscapes provide both thrilling

Late afternoon on the runway of the former Tempelhof
Airport in Berlin. (Author, 2013.)

and quotidian leisure, culture, and nature experiences. At these sites, robust public access and use are often more rooted in present and enjoyable use rather than preservation for posterity, even if that too is what they are. Yet a significant part of what makes Emscher parks so compelling is their sense of possibility and permissiveness. You can touch, feel, explore, gather, climb in some places, and move about without too much restriction. Just as our public commitment to funding such projects is not commensurate with the German and European commitment to cultural heritage, our risk-averse culture keeps us from fully realizing the thrilling utility of our own industrial sites. I am not sure our culture and laws will ever evolve to openly permit and encourage the kind of play I have seen at Emscher and at Berlin's decommissioned Tempelhof Airport (site of the Berlin Airlift of 1948–1949, closed in 2008) and other sites across Europe. But surely we can find ways to push the envelope and evolve the way we assess and administer risk.

Where postindustrial DIY projects enjoy some success, growth, and broader public acceptance to the point where they might be legitimate targets for development assistance funding, they will be best supported with incentives that recognize their unique cultural qualities and novel stewardship practices, and correspond to the incremental, grassroots nature of their endeavor. Assistance could come as formative-stage seed funding that recognizes cultural vitality rather than politically recognized determinations of architectural significance and the potential for revenue-generating activities. Such awards would no longer be predicated upon National Register or local listing and determinations of architectural integrity or the potential to invoke the past, though the many languishing sites that are already listed would also be eligible. Available funding could prioritize stabilization efforts or bringing properties up to a minimum standard of safety rather than more ambitious goals of material conservation, restoration, or tasteful, market-embracing adaptation. Because awards would be small, such programs could seed many more projects within a city, county, or metropolitan area, thereby making success and failure a lower-stakes affair.

Some projects will not succeed, or their success will be fleeting, but catalyzing many projects instead of just one or a handful could have on the balance much greater potential. Smaller is often better, and government actors are not always adept in picking winners. New York State's $75 million bet on the adaptation of the Buffalo State Hospital in 2006 and subsequent state and federal

incentives that went to a project whose signature element, a hotel, opened in 2017 and closed in 2021 can be better rationalized as an act of cultural preservation rather than for its per-dollar economic impact. The former psychiatric hospital is arguably the largest and most complete work by one of America's greatest architects, Henry Hobson Richardson. In its transitional state, it remains an exceptional site, one that offers some interior tours in season and whose restored Olmsted-designed campus is open year-round. The hotel was reopened in 2023, and 250 residential apartments will soon be rentable.[4] Yet an alternative engagement strategy (aided by progressive thinking about risk and liability) might have prioritized robust public use and access over income-generating uses. Likewise, a distributed public investment of the same magnitude could potentially support a dozen or more projects in the region.

While Buffalo is a leader for postindustrial preservation activism and experimental practices, it also provides examples of New York State's wasteful largesse (see the state's $750 million subsidy for Elon Musk's Solar City and, most recently, a $600 million contribution to a new National Football League stadium in nearby Orchard Park). Here and across the state, bloated development projects have proceeded at a scale and in a manner that satisfies political objectives rather than offering the most catalytic impact on the ground. The recent state-led investment of over $66 million in the Central Terminal looks economical in comparison, and it makes the evolution of Silo City, which benefited from almost no public subsidies during its first decade, all the more remarkable. Better to seed many projects and let them grow incrementally. Where projects grow toward market orientation and reach a point of maturity, they can then follow more conventional adaptive reuse schemes with larger investments and public incentives. This will instill them with greater capacity to succeed in the long term, while the growth of the market for such adaptations will likely lessen the public funding burden. Most importantly, the public at large will enjoy and benefit from a project's robust formative period, a la Silo City and the Central Terminal.

Part of the issue is that US urban development practices and policies have few practical ways to engage or encourage incrementalism. The vision—for preservation, new development, or a combination—must be complete and rationalized for revenue generation (even if it is just self-sufficiency) for thirty years or more. Public engagement and publicity tend to focus on completed restoration—a

final architectural *product* rather than on the *process of becoming*, even at sites where the ultimate uses have not yet been determined. Supporting small, incremental improvements at large sites is counterintuitive to politicians, many urban professionals and the public at large. Yet this is the direction in which we must move if we value places like those chronicled in this book.

With an incremental approach to preservation and development and support for small or micro-scale endeavors, we must also consider reframing our expectations from profit and prosperity to fostering everyday or utilitarian use, enhancing regional distinctiveness and collective identity, and providing opportunities for unique or exhilarating uses of urban space. And those spaces that have no interior functions or remain inaccessible can still serve as monuments to provoke reflection and awe; anchor our senses of orientation, temporal continuity, and community belonging; and provide fuel for creativity. At the same time, these idled or ruinous historic structures are retained for future endeavors, even if there is no apparent plan for economy-generating reuses. The Ford Motor Company's billion-dollar investment in the Michigan Central Station and its surroundings is not the logical outcome of long-term planning or a prudent public investment strategy; and it was not enabled by the state-led economic development practices and brownfield cleanup programs, which have cleared so many distinctive sites in Michigan and elsewhere. If many public sector actors had had their way, the station would have been demolished decades ago. Can we find a way to better tolerate and live with abandonment, particularly where structures are architecturally distinctive and pregnant with so many collective meanings? Can we accept a new form of urban diversity—where functional and nonfunctional structures exist side by side?

Landscape urbanism practices and the resulting postindustrial parks constructed in the United States in the last few decades—including Gas Light Park in Seattle; the High Line, Brooklyn Bridge Park, and Domino Park in New York; and the postmilitary Presidio in San Francisco—point us toward acceptance of and engagement with ruins. Yet the appropriation of industrial and other ruins long predate the development of both American and European variants of these postindustrial landscape parks. The more economical and incremental design approaches that have been employed at Silo City and the Carrie Furnaces also build around and inside ruins—and provide a kind of authentic indeterminacy lacking at the High Line, a project whose origin is also rooted in informal

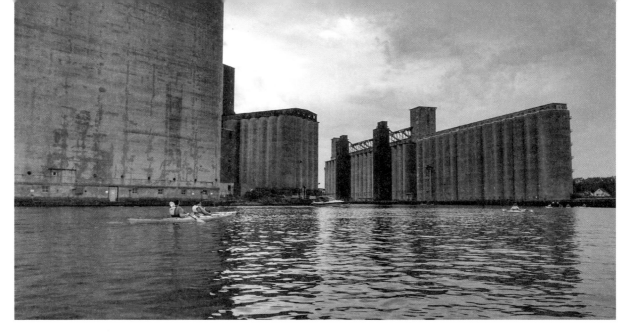

Kayaking through Elevator Alley on the Buffalo River. (Author, 2018.)

use.[5] The constituency of ruins appreciators has grown beyond a critical mass in many cities, and it is time to do more with extant ruins and vacant sites—and for the allied design professions to embrace this messier form of engagement.

Industrial and infrastructural abandonment is no longer the stain of urban decline it once was. Decaying structures and urban ruins' symbolic power to evoke misery, betrayal, corruption, and lost ways of life have not been fully eliminated, but have ebbed with generational succession. Over a dozen years of visiting the Buffalo River have surely confirmed this. The flourishing of Silo City and the RiverWorks recreational complex have brought life back to what was once considered a polluted waterway characterized by derelict structures and urban decline. Yet the great increase in recreational river traffic, of both human-powered and motorized craft, is predicated largely on viewing monumental grain elevators—not merely those of Silo City, RiverWorks, and the few working elevators that store the grain for making breakfast cereals or other purposes. The abandoned, city-owned Concrete Central and Cargill's Superior elevators, having been last used in the 1960s and 1970s, respectively, continue to draw admirers. These concrete icons punctuate the river's unique postindustrial mise-en-scène, with its serpentine curves and both accidental and purposeful ecological restoration sites lining its banks, aided by strategic public investments and a federal-

Icons of the Buffalo River's postindustrial wilds: a view of Cargill's Superior Elevator from the landing of the Concrete Central Elevator. (Author, 2012.)

ly funded cleanup. They suggest leaving economically redundant structures in place and building around them rather than in their place.

The Buffalo River is indeed a singular postindustrial landscape, one whose monumentality and beauty are inspiring and evocative of multiple pasts, including the preindustrial settlements of the Seneca who once lived along its banks. Experiencing the river in a kayak in 2018, these seemingly disparate landscape elements harmoniously came together in a way that seems natural, purposeful, and often sublime. Yet accident has played a large role, as has nonconventional thinking. Likewise, the future of that river, even with the continued success of remediation and restoration activities, and the many recreational boats and small craft that ply it each weekend for half the year, is not fully settled. New projects and constituencies will continue to stake a claim, building upon, colonizing, or destroying the previous postindustrial recovery efforts.

Downriver from Silo City along the Buffalo Ship Canal, food giant Archer Daniels Midland is demolishing the Great Northern Elevator (National Register of Historic Places, 1991) as I finalize this manuscript. The last steel-binned elevator in the city, the Great Northern was the world's largest grain elevator when completed in 1897 and celebrated by the pioneers of twentieth-century architecture and by Reyner Banham decades later, yet the corporation could only see it as a liability. The potential loss of the elevator provoked public outrage, condemnation, and legal action, which temporarily halted ADM's action while potentially workable reuse schemes were generated. Yet the corporation could not be swayed, and city government acquiesced from taking more adversarial actions that might have prevented the elevator's erasure.[6] Today's Buffalo River represents a sea change in the popular perception of what vacant industrial structures are and what they might be. Yet the public sector in Buffalo and across the Rust Belt, can and should do more to support postindustrial preservation projects, including those that are less prominent or significant than the Great Northern.

A Minor Manifesto for Postindustrial Protagonists

While perception has certainly changed, waiting around for those holding power—including property owners, investors, and governments—to facilitate grassroots actions or encourage unconventional urban development practices is generally a bad idea. The most interesting projects will not start with local government or state development incentives. Thus, I aim my concluding thoughts (or minor manifesto) toward protagonists, both amateur and professional, of similarly spirited projects—and those who might continue to draw inspiration or utility from them. None of these ideas or approaches to practice are fully formed and tested. I do expect that postindustrial DIY projects will continue to push the limits and provide fertile ground for future consideration and research, whether they are in the US Rust Belt or elsewhere. Your passionate engagement with a local icon can inspire and bring others forward to join your project.

Do Not Wait; The Agent of Change Is You

There is little permanence in urban environments. And as I have documented, the reasons that the postindustrial sites of this book were not demolished long ago are accidents of fate rather than the product of reasoned practices or policy. Thus, if there is a place that speaks to you, it is incumbent upon you to act. Even if your potential actions do not aim toward lofty goals of recovery or resurrection, it is vital to get started, to do something today and struggle later with troubling questions or contradictions. The window of opportunity is now; tomorrow may bring bulldozers, investors, or the big plan. Be compelled by your own passion, and always enjoy the moment while it lasts. What is here today is precious—enjoy it and share it with others.

Action First, Planning Second

If we wait, the opportunity will be lost. Vacant sites are inherently unstable and subject to impacts delivered by a variety of agents, including government, owners, weather, and other insurgent actors, including those of more nefarious purposes. Sites that have been idle for years can suddenly be transformed by a single event or a reaction to that event; emergency demolition orders are always a possibility. Those compelled to act should act immediately—and not wait for permission, consensus, or a well-considered plan, which can come later. The recovery of all the principal sites in this book involved some activity, practice, or event that occurred without full deliberation or in full accordance with required permitting or owner permission. And taking back mostly happens on the ground rather than in a meeting room or fully sanctioned public forum.

Make the Most of Accidents and Suboptimal Conditions

Every postindustrial site I have ever studied has had an accidental quality, both in terms of its history and the feeling it exudes on the ground—its distinctive *other* and separation from the urban fabric around it. Embrace and exploit the accidental, and don't be afraid that it dents your legitimacy

or claim to action. In urban planning and development, it is often said, *"Don't let perfect be the enemy of the good."* If circumstances were perfect, guerrilla and DIY practices wouldn't stand a chance. Suboptimal characteristics define these sites, and each flaw or problem invites a novel approach, which can potentially grow or open unforeseen possibilities. Garbage- and debris-strewn sites can be cleared; structurally suspect areas can be bypassed; events can happen outside or in the vicinity of a suspect or inaccessible building instead of in it. Problem solving and the tackling of straightforward, formative tasks, such as organizing a cleanup, can provide the opportunity to engage others and build momentum for future and more complex endeavors. Additionally, every mistake, stumble, or missed opportunity can be the seed of some unexpected and ultimately rewarding idea, plan, or practice. Mistakes provide space and time for reconsideration and help push a project in unforeseen directions. When later plans materialize and grow, they are often better for having these preliminary if flawed experiences precede them.

Start Small; Embrace Incrementalism

One of the principal failures of urban planning and preservation is the inability to act in accordance with scale, context, and available resources. The same preservation and adaptive reuse practices that work on a discreet building on a regular city block are often useless on a sprawling multibuilding complex. Similarly, those strategies that work in Manhattan, Center City Philadelphia, or San Francisco will likely be ineffective in most of North Philadelphia, to say nothing of the peripheries of Detroit and Cleveland. While elected officials and most urban professionals wait for the stars to align around the big plan and the emergence of deep-pocketed investors, sites lay fallow for years if not decades. The big plan is the opposite of postindustrial DIY. It does not take a professional graduate degree to understand that many parts of the Rust Belt will not support grand restorations or adaptations, even as those formal agents of development attempt to do exactly that or wait for the public funding to clear historic places entirely. Their waiting provides opportunities for insurgent or do-it-yourself agents, who can act on something discreet—in extent or time (temporary is often ideal) and without the weight of the future. The long-term architectural

stabilization and restoration, revenue generation and profitability, or fiscal self-sufficiency are all important but can come later.

Many vacated Rust Belt sites, even those of great extent or those of high architectural value, should not be treated only as a planning-scale dilemma. No matter what previous uses were, or proposed uses can be—and whether the site exists as mostly buildings or landscape—these spaces can be recovered incrementally by local actors rather than all at once by well-funded development interests. Partial recovery could be a community garden, a social gathering, a play space, renegade art, or a one-off event. If these small, temporary, or itinerant actions are successful, then they can grow on their own accord. Occupation of urban space is an ideal springboard for future actions.

Emphasize Ad Hoc Fun Rather Than Process and Immediate Inclusivity

Some projects are simply too small, too local—even after they have grown—to enable effective outreach and public deliberation. Attempting to collect broad and representative perspectives at an early stage can kill a project before it has a chance to form or grow beyond its infancy. Likewise, the realm of public planning is risk averse. We must demonstrate that a project has legs, that the ship can sail, before we try to sell it or share it beyond those who are compelled simply out of self-interest or curiosity. And if the immediate principals are not having fun or finding intrinsic value in this endeavor, how will others, and why even do it at all? Yet at the same time, it is vital that projects that aim to be public, provide engaging activity that attracts others.

To plan, design, or build inclusively is an explicit goal of nearly every public project and rightly so. But inclusiveness is difficult to define and achieve and, at many industrial-era sites, is often invoked as a vague proposition or platitude by more powerful interests to rationalize their plan or actions. I would argue that most postindustrial DIY projects are inclusive but not in a way that it is typically defined and measured in the arena of planning and urban development. The scale and resources of these incremental endeavors and their organic growth do not lend themselves to com-

munity meetings, surveys, and discussions with local stakeholders. Rather, their inclusiveness is more ad hoc; it's about being open to proposals and new participants and allowing a project to grow accordingly. Additionally, a lack of immediate or sustained engagement of residents living around or near a particular project should not immediately doom it. Diversity and the formalization of participatory mechanisms can grow as projects grow.

Diversity and inclusion must be taken seriously if projects are to develop legs and garner necessary political support—and they will be more vital and enduring projects for it. While being inclusive sometimes cuts against the very quality that makes them compelling—their hidden or underground atmosphere—postindustrial DIY should not only be the realm of subculture, for those in the know. Lower the barrier of entry; sharing makes things better. Of course, diversity is challenging, and stewards and protagonists must gauge when and how to diversify beyond formative or early-stage participants.

Be Open to the Ideas of Others

The greatest error of any place-based undertaking is to shoulder too much of the responsibility yourself. Even the most dynamic people must depend on collaborators and partners in urban development, including those of the informal variety. You don't need to have all the answers or the ability to solve every problem, or know where to draw the line between itinerant use and that which might need a permit or an insurance policy. Share the burden, the assumption of risk, and the opportunity to be creative. Devise ways to reach out to a larger pool of collaborators, and let them propose ideas and carry out programs. Allowing others to orchestrate programs also enables sharing the burden of administration, including obtaining permits if necessary, procuring and transporting equipment or infrastructure, and dealing with security issues and many other concerns. But most importantly, sharing opportunities greatly expands the realm of possibilities and offers the greatest chance of the larger endeavor to succeed and grow. And sharing is its own reward.

Recognize and Embrace Risk; Sometimes Rules Must Be Finessed

I have already discussed liability and risk in the previous section aimed at professionals and urban leadership. The same guiding principles apply at the site level. Protagonists must have some confidence that things will work out. Those looking to grow their activities, in extent or impact, should look for sympathetic public actors who can help them shoulder the responsibility and problem solve before someone calls in a potential code violation. As projects scale upward and the need to consider risk grows, protagonists should take the responsibility very seriously. At the same time, there is no way to have a feasible contingency for every potential problem or liability.

ACKNOWLEDGMENTS

This book represents many years of work and the contributions of numerous individuals. Foremost, I thank my wife, Anne Leonard. I could never have completed this project without Anne's love, patience, enthusiasm, and practical support. Fantastic to have shared some of these experiences with her as well. I also thank my great friend Brent Ryan, who brought me to Detroit in 2003 and to Buffalo in 2009. These formative experiences helped propel this project, as did our critical dialogue that began decades ago and continues to take me in unexpected directions.

It was again a great pleasure to work with my editor, Fred Nachbaur, and the Fordham University Press staff, including Eric Newman, Kem Crimmins, John Garza, Kate O'Brien-Nicholson, Katie Sweeney Parmiter, and Will Cerbone. I acknowledge Fred's belief in the value of my work and his willingness to dedicate the Press's resources toward this book's realization. Mark Lerner and adam bohannon were responsible for the excellent cover and book design. The work of my copy editor, Bob Land, was similarly praiseworthy. Special thanks to Jeremy Wang-Iverson for helping me bring this work to a larger audience. The insightful commentary of my esteemed peer reviewers, Bob Fishman and Lynda Schneekloth, helped guide the manuscript revision. Receiving their thoughtful feedback and endorsement was one of my highlights of 2022. Special thanks to Lynda for introducing me to Silo City. Also thanks to Mike McGandy, who took a great interest in this work and reviewed some early chapter drafts.

I also acknowledge the generous support of the Smart Family Foundation, which funded much of my research travel and contributed to production expenses. Special thanks to Mary Smart, who has long been a champion of my work. I began work on what would eventually become *Postindustrial DIY* as I was finishing my first book, *The Accidental Playground*, and, thus, this project also benefited from the resources generated by the National Endowment of the Humanities research fellowship I enjoyed during that period.

At Morgan State University, I enjoyed excellent research support. I thank my colleagues Mary-

ACKNOWLEDGMENTS

Anne Akers and Siddhartha Sen, who encouraged me to prioritize this project over others and provided often-scarce administrative resources and release time. Over the course of a decade, I worked with three ace research assistants: Megan Oliver, Conley Kinkead, and Ethan McLeod. Special thanks to Ethan for helping me tie up many loose ends and bring this project across the finish line. Thanks to Lucas Rogers, who helped me piece together a long-unfinished Philadelphia investigation; and to Shahrouz Ghani Ghaishghourshagh, who created the detailed site maps found throughout the book. Other student contributors included Karolina Tittel, Larry Jenkins, Gladys Hurwitz, Kshitiz Gurung, and Laura Bianca-Pruett. University staff who supported this research included Salimah Hashim, Julianita Alexander, Lavon Wright, and Felomina Johnson.

I thank all the people who supported, facilitated, and advanced my field studies and helped me make connections on the ground. In Buffalo my investigations were facilitated by Dave Franczyk, Caitlin Boyle, Jason Wilson, Dana Saylor, Christina Lincoln, Rick Smith, Swannie Jim Watkins, Paul Lang, Monica Pellegrino Faix, Carl Skompinski, Tim Tielman, Dan Shanahan, Noah Falck, and Lesley Maia. My Detroit studies were aided by Karen Gage, Francis Grunow, Patrick Cooper-McCann, Liz Beale, K. Venkatesh Presad, Garnet Cousins, Ashton Parsons, Kevin Schronce, Kirk Pinho, Nailhed, and the late Dave Biskner. In addition to his insightful commentary, Scott Hocking shared striking Detroit photographs. In metropolitan Pittsburgh my work was generously facilitated by Ron Baraff and benefited from the assistance of Tim Kaulen, Katy Sawyer, Jim Kapusta, and Morton Brown. Also thanks to my good friend Ray Gastil for taking me on some Pittsburgh-area adventures and for our ongoing discourse about the fate of the American city.

Additional thanks to Steve Zachs, Anne Raines, Adam Krom, Becky Bradley, Ron Unger, John McNally, Deborah Flora, Conrad Kickert, Jason Knight, Peter Brown, Jason Brody, Scott Campbell, Camilo Vergara, Elihu Rubin, Terry Schwarz, and Kate Daly. During the pandemic I was desperate to find a New York City–based place to work, and the now defunct Brooklyn Writers Space came through (thanks to Scott Adkins and Bailey Williams). Finally, thanks to all who participated in my investigations, including those whose dialogue with me did not make it into the final manuscript.

NOTES

PROLOGUE: A POSTINDUSTRIAL VIEW FROM THE NORTHEAST CORRIDOR

1 Federal Writers' Project (FWP), Works Progress Administration for the Commonwealth of Pennsylvania, *Philadelphia: A Guide to the Nation's Birthplace* (1937; repr. Harrisburg, PA: Telegraph Press, 1988); Philip Scranton and Walter Licht, *Work Sights: Industrial Philadelphia 1890–1950* (Philadelphia: Temple University Press, 1986).

2 My tours of the monuments of industrial Philadelphia were documented in Daniel Campo, "In the Footsteps of the Federal Writers' Project: Revisiting the Workshop of the World," *Landscape Journal* 29, no. 2 (2010): 179–198.

3 The city of Philadelphia's Neighborhood Transformation Initiative is well described by Jon Kromer, *Fixing Broken Cities: The Implementation of Urban Development Strategies* (New York: Routledge University Press, 2010), and Brent D. Ryan, *Design after Decline: How America Rebuilds Shrinking Cities* (Philadelphia: University of Pennsylvania Press, 2012).

4 Richard Florida, *The Rise of the Creative Class: And How It's Transforming Work, Leisure, Community and Everyday Life* (New York: Basic Books, 2002); see also Elizabeth Currid-Halkett, *The Warhol Economy: How Fashion, Art, and Music Drive New York City* (Princeton, NJ: Princeton University Press, 2009).

5 See Harvey Molotch, "The City as a Growth Machine: Toward a Political Economy of Place," *American Journal of Sociology* 82, no. 2 (September 1976): 309–332.

6 Heywood T. Sanders, *Convention Center Follies: Politics, Power, and Public Investment in American Cities* (Philadelphia: University of Pennsylvania Press, 2014).

7 Tom Belden, "A Plan for bigger Convention Center; Pa. Has a Big Role in Paying the Tab," *Philadelphia Inquirer*, June 12, 2007.

8 Daniel Campo, "Relocation Blues: The Convention Center Expansion Plan Costs Arts Groups More Than a Home," *Philadelphia City Paper*, March 14, 2007.

9 Demolition analysis performed by Lucas Rogers (2021) using newspaper and internet media articles and satellite imagery. In author's possession.

10 While some of the buildings were already owned by the city, state, or a public authority and were likely being kept vacant to facilitate their eventual demolition, the 1893 Odd Fellows Hall at 121 North Broad Street, converted to an office building in the 1920s, had tenants and an owner eager to make further investments in the building. See Inga Saffron, "A Building to Save for the Block's Sake: An Unpaid Plug for a Building," *Philadelphia Inquirer*, September 24, 2004.

11 Jessica Pressler, "Philadelphia Story: The Next Borough," *New York Times*, August 14, 2005.

12 Robin Pogrebin, "Brooklyn Waterfront Called Endangered Site," *New York Times*, June 14, 2007.

13 During its two-month run, Kara Walker's *A Subtlety, or the Marvelous Sugar Baby* drew tremendous crowds, who

awaited entry standing in lines that often ran for blocks along the waterfront, and garnered popular and critical applause. The *New York Times* called the installation "a defining work" of the 2010s. See Roberta Smith, "The Decade in Culture: A Sea Change in the Art World, Made by Black Creators," *New York Times*, November 24, 2019.

14 Daniel Campo, *The Accidental Playground: Brooklyn Waterfront Narratives of the Undesigned and Unplanned* (New York: Fordham University Press, 2013).

15 Neil Smith, *The New Urban Frontier: Gentrification and the Revanchist City* (New York: Routledge University Press, 1996); Julian Brash, *Bloomberg's New York: Class and Governance in the Luxury City* (Athens: University of Georgia Press, 2011); Sharon Zukin, *Loft Living: Culture and Capital in Urban Change—Special Edition* (New York: Rutgers University Press, 2014); Tom Angotti and Sylvia Morse, *Zoned Out!: Race, Displacement, and City Planning in New York City* (New York: UR Books, 2017); Samuel Stein, *Capital City: Gentrification and the Real Estate State* (New York: Verso, 2019).

16 The role of artists and the arts in property development practices and gentrification is and continues to be a prominent issue in US cities and among scholars. In addition to the formative works of Sharon Zukin and Neil Smith acknowledged in the previous note, see Richard Lloyd, *Neo-Bohemia: Art and Commerce in the Postindustrial City* (New York: Routledge University Press, 2006); Vanessa Mathews, "Aestheticizing Space: Art, Gentrification and the City," *Geography Compass* 4 (2010): 660–675; Meghan Ashlin Rich and William Tsitsos, "Avoiding the 'SoHo Effect' in Baltimore: Neighborhood Revitalization and Arts and Entertainment Districts," *International Journal of Urban and Regional Research* 40, no. 4 (July 2016): 736–756; Chiara Valli, "Artistic Careers in the Cyclicality of Art Scenes and Gentrification: Symbolic Capital Accumulation through Space in Bushwick, NYC," *Urban Geography 43, no. 8 (2022): 1176–1198.*

17 Campo, "In the Footsteps of the Federal Writers Project."

CHAPTER ONE: RECOVERING POSTINDUSTRIAL PLACES

1 Historic American Engineering Record, "Perot Malting Elevator" (No. NY-250) prepared by Thomas Leary, John Healy and Elizabeth Sholes (1990–1991).

2 US National Park Service, "Secretary of the Interior's Standards for the Treatment of Historic Properties," accessed March 28, 2022, https://www.nps.gov. See also Charles Birnbaum and Christine Capella Peters, the Secretary of the Interior's Standards for the Treatment of Historic Properties with Guidelines for the Treatment of Cultural Landscapes (Washington, DC: US Department of the Interior, 1996).

3 U.S. National Park Service—National Register Regulations, accessed March 28, 2022, https://www.nps.gov.

4 Reyner Banham, *A Concrete Atlantis: U.S. Industrial Buildings and European Modern Architecture 1900–1925* (Cambridge, MA: MIT Press, 1986).

5 See John Chase, Margaret Crawford and John Kaliski, eds., *Everyday Urbanism* (New York: Monacelli Press, 2008); Donavan Finn, "DIY Urbanism: Implications for Cities," *Journal of Urbanism* 10, no. 2 (2014): 391–398; Mike Lydon and Anthony Garcia, *Tactical Urbanism: Short-term Action for Long-term Change* (Washington, DC: Island Press, 2015);

Gordon Douglas, *The Help-Yourself City: Legitimacy & Inequality in DIY Urbanism* (New York: Oxford University Press, 2018).

6 Duncan Hay, "Preserving Industrial Heritage: Challenges, Options, and Priorities," *Forum Journal* 2, no. 3 (Spring 2011): 11–24.

7 See Barry Bluestone and Bennett Harrison, *The Deindustrialization of America: Plant Closings, Community Abandonment, and the Dismantling of Basic Industry* (New York: Basic Books, 1982); Jon Teaford, *Cities of the Heartland: The Rise and Fall of the Industrial Midwest* (Bloomington: Indiana University Press, 1993); Steven High, *Industrial Sunset: The Making of North America's Rust Belt, 1969–1984* (Toronto: University of Toronto Press, 2003).

8 Philipp Oswalt, *Shrinking Cities* (Ostfildern-Ruit, Germany: Hatje Cantz, 2005); Brent Ryan, *Design after Decline: How America Rebuilds Shrinking Cities* (Philadelphia: University of Pennsylvania Press, 2012).

9 See Jefferson Cowie and Joseph Heathcott, eds., *Beyond the Ruins: The Meanings of Deindustrialization* (Ithaca, NY: Cornell University Press, 2003); Stephen High and David Lewis, *Corporate Wasteland: The Landscape and Memory of Deindustrialization* (Ithaca, NY: Cornell University Press, 2007); Anne Trubek, ed., *Voices from the Rust Belt* (New York: Picador, 2018).

10 Rust Belts outside the United States are documented by Philip Cooke, ed., *The Rise of the Rustbelt: Revitalizing Older Industrial Regions* (London: Routledge, 1996).

11 Conor Dougherty, "Oakland Fire Leads to Crackdown on Illegal Warehouses Nationwide," *New York Times*, December 8, 2016; August Brown, "After Ghost Ship and a Crackdown, L.A.'s DIY Music Scene Plans Its Response," *Los Angeles Times, December 17, 2016*; Bree Davies, "Denver: Quit Kicking Your Artists Out," *Westword*, December 26, 2016; Rebekah Kirkman and Brandon Soderberg, "Delineate It Yourself: After the Bell Foundry, Mayor's Safe Arts Space Task Force Is Formed," *Baltimore City Paper*, January 18, 2017; August Brown, "The L.A. DIY Community Contemplates a Post–Ghost Ship Life," *Los Angeles Times*, January 21, 2017; Blair Murphy, "From Texas to DC, Artists and DIY Spaces Struggle with Permits and Trolls," *Hyperallergic*, February 1, 2017; Karen Kucher, "Artists' Studios Shut Down," *San Diego Union Tribune,* September 8, 2017; Kaila Philo, "Is Baltimore's DIY Art Scene Being Killed Off?," *Vice*, September 15, 2017; Elizabeth Weil, "In the Ashes of Ghost Ship," *New York Times Magazine*, December 16, 2018.

12 Daniel Campo, *The Accidental Playground: Brooklyn Waterfront of the Undesigned and Unplanned* (New York: Fordham University Press, 2013); Daniel Campo, "A New Postindustrial Nature: Remembering the Wild Waterfront of Hunters Point," *Streetnotes* 25 (2016): 212–230; Daniel Campo, "Rustbelt Insurgency and Cultural Preservation: How Guerrilla Practices Saved the Blast Furnaces and the Automobile Factory," *Urban Design International* 25, no. 2 (2020): 165–178.

13 Doris Apel, *Beautiful Terrible Ruins: Detroit and the Anxiety of Decline* (New Brunswick, NJ: Rutgers University Press, 2015).

14 Detroit has served as a laboratory for practices that occur in abandoned places. For an academic perspective see Andrew Herscher, "Detroit Art City: Urban Decline, Aesthetic Production, Public Interest," in Margaret Dewar and June Manning Thomas, ed., *The City after Abandonment* (Philadelphia: University of Pennsylvania Press, 2012), 117–149; Apel, *Beautiful Terrible Ruins.* For a journalistic perspective, see Charlie LeDuff, *Detroit: An American Autopsy* (New York: Penguin, 2013).

15 Sherry Linkon and John Russo, *Steeltown U.S.A.* (Lawrence: University of Kansas Press, 2002), 182–183; Jefferson Cowie and Joseph Heathcott, *Beyond the Ruins: The Meanings of Deindustrialization* (Ithaca, NY: Cornell University Press, 2003); Steve Mellon, *After the Smoke Clears: Struggling to Get By in Rustbelt America* (Pittsburgh: University of Pittsburgh Press, 2006); Stephen High and David W. Lewis, *Corporate Wasteland: The Landscape and Memory of Deindustrialization* (Ithaca, NY: Cornell University Press, 2007).

16 For Pittsburgh examples, see Tracy Neumann, *Remaking the Rust Belt: The Postindustrial Transformation of North America* (Philadelphia: University of Pennsylvania Press, 2016); Allen Dieterich-Ward, *Beyond Rust: Metropolitan Pittsburgh and the Fate of Industrial America* (Philadelphia: University of Pennsylvania Press, 2017).

17 See Camilo José Vergara's seminal photo documentation of Detroit in *New American Ghetto* (New Brunswick, NJ: Rutgers University Press, 1995), *American Ruins* (New York: Monacelli, 1999), and *Detroit Is No Dry Bones: The Eternal City of the Industrial Age* (Ann Arbor: University of Michigan Press, 2016).

18 See Richard Moe and Carter Wilkie, *Changing Places: Rebuilding Community in the Age of Sprawl* (New York: Holt, 1999); Donovan Rypkema, *The Economics of Historic Preservation: A Community Leaders' Guide* (Washington, DC: National Trust for Historic Preservation, 2005); Stephanie Ryberg-Webster and Kelly L. Kinahan, "Historic Preservation and Urban Revitalization in the Twenty-First Century," *Journal of Planning Literature* 29, no. 2 (2014): 119–139; Stephanie Meeks, *The Past and Future City: How Historic Preservation Is Reviving America's Communities* (Washington, DC: Island Press, 2016).

19 Mark Sommer, "2,500 Preservationists Came to Buffalo 10 Years Ago. It Was a Turning Point for the City," *Buffalo News*, November 6, 2021.

20 Recent conversions of Buffalo industrial complexes include the residential Pierce-Arrow Lofts (former Administration Building of the eponymous automobile factory), the Northland Training Center, a workforce training and startup hub in the former Niagara Machine & Tool Works, and the adaptation of a pair of former factories at 27-37 Chandler Street into an incubator for food-based businesses.

21 Mark Sommer, "Landmark Status Is Not Enough to Save City's Endangered Buildings," *Buffalo News*, February 16, 2022.

22 Hay, "Preserving Industrial Heritage." Federal tax credits and preservation incentives are discussed in William Murtaugh, *Keeping Time: The History and Theory of Historic Preservation*, 3rd ed. (New York: John Wiley, 2005), 58–60. A summary and assessment of all US federal historic preservation legislation can be found in David Listokin, Barbara Listokin, and Michael Lahr, "The Contributions of Historic Preservation to the Housing and Economic Development," *Housing Policy Debate* 9, no. 3 (1998): 431–478. For state tax credit programs, see Harry Schwartz and Renee Kuhlman, "State Tax Credits for Historic Preservation," National Trust for Historic Preservation, 2016, https://www.landmarks.org.

23 See US National Park Service, "Federal Historic Preservation Tax Incentives Generated $7 Billion in GDP and 122,000 Jobs in 2020," news release, December 22, 2021, https://www.nps.gov/.

24 Hay previously made this observation in "Preserving Industrial Heritage."

25 Federal eligibility standards for incentives are guided by the US Secretary of the Interior's "Standards for Rehabilitation," accessed April 10, 2022, https://www.nps.gov. For criticism concerning these standards and associated industrial preservation practices, see Thomas Leary and Elizabeth Sholes, "Fragments Shored against the Ruins: Industrial Archeology and Heritage Preservation," *IA, The Journal of the Society for Industrial Archeology* 26, no. 1 (2000): n.p.; Constance Bodurow, "A Vehicle for Interpreting and Preserving Our Recent Industrial Heritage," *The George Wright Forum* 20, no. 2 (2003): 68–88; Hay, "Preserving Industrial Heritage."

26 Brent D. Ryan and Daniel Campo, "Autopia's End: The Decline and Fall of Detroit's Automotive Manufacturing Landscape," *Journal of Planning History* 12, no. 2 (2013): 95–132.

27 US Environmental Protection Agency, "Anatomy of Brownfields Redevelopment," June 2019, https://www.epa.gov.

28 Charles Hyde, *Detroit: An Industrial History Guide* (Detroit: Detroit Historical Society, 1980); Motor Cities National Heritage Area, accessed February 5, 2022, https://www.motorcities.org.

29 See Justin Hollander, Niall Kirkwood, and Julia Gold, *Principles of Brownfield Regeneration: Cleanup, Design, and Reuse of Derelict Land* (Washington, DC: Island Press, 2013); US Environmental Protection Agency, "Anatomy of Brownfields Redevelopment," June 2019, https://www.epa.gov.

30 Christina Lincoln, "City of Might," in Terry Schwarz, ed., *Historic Preservation and Urban Change, Urban Infill 7* (Cleveland: Kent State University, 2014), 45.

31 Jane Jacobs, *The Death and Life of Great American Cities* (New York: Random House, 1961).

32 J. B. Jackson, "The Necessity for Ruins," in *The Necessity for Ruins and Other Topics* (Amherst: University of Massachusetts Press, 1980), 102.

33 Andrew Hurley, *Beyond Preservation: Using Public History to Revitalize Inner Cities* (Philadelphia: Temple University Press, 2010). See also Kevin Lynch, *What Time Is This Place* (Cambridge, MA: MIT Press, 1972); Sharon Zukin, *Landscapes of Power from Detroit to Disney World* (Berkeley: University of California Press. 1991); Dolores Hayden, *The Power of Place: Urban Landscapes as Public History* (Cambridge, MA: MIT Press, 1995); Max Page and Randall Mason, eds., *Giving Preservation a History: Histories of Historic Preservation in the United States* (New York: Routledge, 2004).

34 Judith Stilgenbauer, "Landschaftspark Duisburg Nord—Duisburg, Germany (2005 EDRA/Places Award—Design)," *Places* 17, no. 3 (2005): 6–9; Anneliese Latz, "Regenerative Landscapes—Remediating Places," in Lisa Tilder and Beth Blostein, eds., *Design Ecologies: Essays on the Nature of Design* (New York: Princeton Architectural Press, 2010); Anne Raines, "Ruhrgebiet," *Planning Perspectives* 26, no. 2 (2011): 183–207.

35 See Kelly Shannon, "From Theory to Resistance: Landscape Urbanism in Europe," in Charles Waldheim, ed., *The Landscape Urbanism Reader* (New York: Princeton Architectural Press, 2006), 141–161, for a sampling of these projects.

36 Daniel Campo, "Iconic Eyesores," *Journal of Urbanism* 7, no. 4 (2014): 351–380.

37 Campo, *The Accidental Playground*, 246–247; Similarly, Ann Deslandes notes that "DIY urbanists mark themselves as non-expert citizens smuggling themselves into a professionalized structure and making it work for them." Deslandes, "Exemplary Amateurism: Thoughts on DIY Urbanism." *Cultural Studies Review* 19, no. 1 (2013): 216–227. See also Campo, "Iconic Eyesores."

38 For DIY urbanism project documentation (and variants including everyday, informal, guerrilla, and tactical urbanisms), see John Chase, Margaret Crawford, and John Kaliski, eds., *Everyday Urbanism* (New York: Monacelli Press, 2008); Jeffrey Hou, ed., *Insurgent Public Space: Guerrilla Urbanism and the Remaking of Contemporary Cities* (New York: Routledge, 2010); Vinit Mukhija and Anastasia Loukaitou-Sideris, *The Informal American City: Beyond Taco Trucks and Day Labor* (Cambridge, MA: MIT Press, 2014); Lydon and Garcia, *Tactical Urbanism;* and Douglas, *The Help-Yourself City.*

39 Kimberly Kinder, *DIY Detroit: Making Do in a City without Services* (Minneapolis: University of Minnesota Press, 2016); Fran Tonkiss, "Austerity Urbanism and the Makeshift City," *City* 17, no. 3 (2013): 312–324. See also Claire Herbert, *A Detroit Story: Urban Decline and the Rise of Property Informality* (Berkeley: University of California Press, 2021).

CHAPTER TWO: BUFFALO'S CENTRAL TERMINAL

1 Ada Louise Huxtable, "Last Rites for Railroad Stations?," *Detroit Free Press,* December 9, 1972.

2 Ibid.

3 US Department of the Interior, National Park Service, "National Register of Historic Places Nomination Form—New York Central Terminal," September 7, 1984.

4 Milton Rogovin, *The Forgotten Ones* (New York: Quantuck Lane Press, 2003).

5 Gregory Gilmartin, *Shaping the City: New York and Municipal Art Society* (New York: Clarkson Potter, 1995); Hilary Ballon and Norman McGrath, *New York's Pennsylvania Stations* (New York: Norton, 2002).

6 Garnet Cousins, "Beacon at Mile 435.9 (Part I): A Station Too Late, Too Far," *Trains,* September 1985, 20–33.

7 Ibid.

8 Ibid.

9 Joan E. Given, "'Empire Express' Leaves Central, Grand Era Fades," *Buffalo Courier Express,* October 28, 1979; US Department of Interior, "National Register of Historic Places Nomination Form."

10 Buffalo's postwar decline is well captured by Mark Goldman, *City on the Edge: Buffalo, New York* (Amherst, NY: Prometheus Books, 2007).

11 US Department of the Interior, "National Register of Historic Places Nomination Form"; Garnet Cousins, "Beacon at Mile 435.9 (Part II): Dedication to Dethronement," *Trains,* October 1985, 40–49; "Anthony Fedele, Owned Central Terminal," *Buffalo News,* May 24, 1995.

12 Given, "'Empire Express' Leaves Central"; Thomas J. Dolan, "Buffalo Central Terminal Auctioned for $100,000," *Buffalo News,* October 29, 1986.

13 Dave Franczyk, interview with author, Buffalo, October 15, 2015.

14 US Department of Interior, "National Register of Historic Places Nomination Form"; Cousins, "Beacon at Mile 435.9 (Part II)"; Dolan, "Buffalo Central Terminal Auctioned for $100,000; Franczyk, interview with author.

15 Franczyk, interview with author.

16 Dolan, "Buffalo Central Terminal Auctioned."

17 "Terminal Owner on Schedule with Redevelopment," *Preservation Report* (of the Preservation Coalition of Erie County) 10, no. 1 (January/February 1988): 2; Franczyk, interview with author; Tim Tielman, interview with author, Buffalo, February 12, 2016.

18 *Carl M. Cole, as Escrow Agent, Respondent, v. Telesco Leasing Company, Inc., Appellant, and Samuel M. Tuchman et al., Respondents* (no number in original), Supreme Court of New York Appellate Division, Fourth Department 177 A.D.2d 1038; 578 N.Y.S.2d 51; 1991 N.Y. App. Div., LEXIS 15835, November 15, 1991, Decided; November 15, 1991, Filed; Len Delmar, "Derailed at Buffalo Central Terminal, Tuchman Sets Sights on Falls Housing," *Buffalo News*, December 4, 1994, 5.

19 "Station Has Seen Last Train but Not Last Chance," *New York Times*, October 14, 1992, B6.

20 "Buffalo Central Terminal Tour Part II," Buffalo Ghost Tour, YouTube, accessed December 26, 2020 (footage likely shot July 30, 1992). See accompanying *Buffalo News* story.

21 "Station Has Seen Last Train but Not Last Chance"; Susan Schulman, "Owner of Station Faces Fine, Jail Term," *Buffalo News*, December 31, 1992; Sharon Lindstedt, "City Urged to Protect Rail Terminal; Task Force Asks for Help for Historic Landmark," *Buffalo News*, January 22, 1993.

22 Lindstedt, "City Urged to Protect Rail Terminal."

23 Schulman, "Owner of Terminal Faces Fine, Jail Term."

24 Lindstedt, "City Urged to Protect Rail Terminal."

25 Franczyk, interview with author.

26 Joseph H. Radder, "A Glorious Revival Looms for Central Terminal," *Buffalo News*, April 23, 1993, 3.

27 Stephan Koenig, "Government Should Restore Terminal," *Buffalo* News, January 9, 1993, 2.

28 Marquette Law School, "Sports Facility Reports (Vol. 14)—National Hockey League," 2014.

29 James Fink, "New Owners Take Title to the Central Terminal," *Business First of Buffalo*, August 13, 1990; Len Delmar, "Derailed at Buffalo Central Terminal: Tuchman Sets Sights on Falls Housing," *Buffalo News*, December 4, 2004; *Buffalo Central Terminal, Ltd., Plaintiff v. United States of America, Donald Eigendorff, in His Capacity as Contracting Officer, General Services Administration, Lorraine Aives, in Her Capacity as Contracting Officer, General Services Administration, Defendants*; 90-CV-1295S United States District Court for the Western District of New York, 886 F. Supp. 1031; 1995 U.S. Dist. LEXIS 6416; 40 Cont. Cas. Fed. (CCH) P76,826, January 27, 1995, Decided; January 27, 1995, Filed.

30 Molly McCarthy, "Railroad Buffs Urge Action on Central Terminal," *Buffalo News*, September 1, 1994.

31 Harold McNeil, "Acquisition of Central Terminal Proposed," *Buffalo News*, November 5, 1996, 1B.

32 Douglas Turner, "'Pig Book' Assails $6 Million in Aid to Area; Congressional Funding for WNY Projects Is Wasteful, Anti-Spending Group Says," *Buffalo News*, February 16, 1995, 1.

33 Ibid.

34 Harold McNeil, "Franczyk Vows to Fight for Terminal Funds; Assails Mayor's Office for Pressing to Redirect U.S. Aid to Shea's," *Buffalo News*, February 20, 1995, 5.

35 Mark Kohan and Timothy Tielman, "We'll Take That $1.5 Million, Senator; Moynihan's Rescue Attempt Brings Joy to the East Side but Will the Mayor's Reluctance Scuttle Both the Grant and the Terminal?," *Buffalo Preservation Report* (April/May 1995), 1.

36 McNeil, "Franczyk Vows to Fight for Terminal Funds."

37 "This Pig Really Was Pork; Central Terminal Too Far Gone for Public Funds," *Buffalo News*, 8.

38 Kohan and Tielman, "We'll Take That $1.5 Million, Senator."

39 Gregory N. Racz, "Past Perfect? Preservationists Made Buffalo Appreciate Its History, but Do We Have to Save It All?," *Buffalo News, August 20,* 1995, 7M.

40 Marge Thielman Hastreiter, "Citizens Vow to Fight for Terminal; A Landmark Now and Forever," *Buffalo Preservation Report* 18, no. 3 (June/July 1995): 1; Harold McNeil, "Acquisition of Central Terminal Proposed," *Buffalo News*, November 5, 1996, 1B.

41 McNeil, "Acquisition of Central Terminal Proposed."

42 Scott Field, "Save Central Terminal: Wishes Made Known at Fillmore District 'Summit,'" *Buffalo Preservation Report* 20, no. 1 (February/March 1996): 1.

43 Tim Tielman and Chris Hawley, interview with author, Buffalo, February 12, 2016.

44 McNeil, "Acquisition of Central Terminal Proposed."

45 Tielman and Hawley, interview with author.

46 Rick Stouffer, "Non-Profit Firm Buys Central Terminal, Has Refurbishing Plans," *Buffalo News*, August 29, 1997, 1B.

47 Ibid.

48 Mike Vogel, "Clock Grant Helps Terminal Bide Its Time," *Buffalo News,* August 31, 1998; Mark Sommer and Tom Buckham, "Clock Lighting May Brighten Future," *Buffalo News,* October 1, 1999; Tielman and Hawley, interview with author.

49 Vogel, "Clock Grant Helps Terminal Bide Its Time"; Gene Warner, "Landmark's Admirers Make Tracks for the Central Terminal," *Buffalo News*, May 9, 1999.

50 Tielman and Hawley, interview with author.

51 Ibid.

52 See "Don't Waste Any More Money on the Terminal," *Buffalo News*, May 23, 1999; "Preservationists Must Learn to Be More Selective," *Buffalo News*, December 28, 1999; and "Terminal Restoration Is a Waste of Effort," *Buffalo News*, May 30, 2000.

53 Henry Davis and Karen Brady, "Terminal's 75th Birthday Will Mark Its Rebirth," *Buffalo News*, November 13, 2000.

54 Brian Meyer, "Central Terminal Proposed as Site for Casino," *Buffalo News*, August 8, 2001; Brian Meyer, "Common Council Pleads for a City-Owned Casino," *Buffalo News*, May 15, 2002; Mark Sommer, "A Landmark's Struggle—A Recent Surge of Interest Has Raised Hopes—However Faint—for the Art Deco Train Station," *Buffalo News*, September 9, 2003; "Picnic Planned at Central Terminal," *Buffalo News*, September 18, 2003; "A Passage to the Past," *Buffalo News*, September 21, 2003; Melinda Miller, "Seneca Buffalo Creek Casino Wows at Grand Opening," *Buffalo News*, August 27, 2013.

55 Dan Shanahan, email to author, September 18, 2022.

56 Patrick Mullin, "Model Planes, Art Deco and Dream Days," *Globe and Mail (Toronto),* June 8, 2005; Patrick Mullin, "Paddling, Punk Rock and Photos," *Globe and Mail (Toronto),* June 21, 2006; Jana Eisenberg, "Central Location Group Uses Vintage Terminal for Art's Sake," *Buffalo News*, August 11, 2006; Central Terminal Restoration Corporation, "History and Restoration," accessed March 18, 2023, https://buffalocentralterminal.org; Shanahan, email to author.

57 Central Terminal Restoration Corporation, "History and Restoration."

58 Logan Ward, "Reinventing Buffalo," *Preservation Magazine*, July/August 2011, 26–33.

59 Travel Channel, "Off Limits" (March 2011) via Forgotten Buffalo Facebook page, accessed December 25, 2020, https://www.facebook.com/ForgottenBuffalo/videos/2293273414297992, accessed December 25.

60 Central Terminal Restoration Corporation, "Buffalo Central Terminal Master Plan 2011" (in author's possession).

61 Open Data Buffalo, accessed February 20, 2021, https://data.buffalony.gov.

62 Charlotte Keith, "A Terminal Case," *Artvoice* 14, no. 20 (May 20, 2015): 8–9.

63 Ibid.

64 Mark Sommer, "Commercial Grade Lighting Restored to Central Terminal," *Buffalo News*, December 20, 2019.

65 Karl Skompinski, interview with author, via remote video, September 6, 2022.

66 Mark Sommer, "Cuomo Challenge Puts Buffalo Train Station on a Deadline," *Buffalo News*, October 26, 2016.

67 Mark Sommer, "Cost Estimates Favor Downtown Train Station over Central Terminal," *Buffalo News*, March 22, 2017; News Editorial Board, "The New Amtrak Station Belongs Downtown," *Buffalo News*, April 13, 2020; Mark Sommer, "Train Station Panel Expected to Recommend Downtown Site," *Buffalo News*, April 19, 2017; Mark Sommer, "Panel OKs Downtown Train Station in 11-4 Vote," *Buffalo News*, April 20, 2017.

68 Sommer, "Cost Estimates Favor Downtown Train Station over Central Terminal"; Sommer, "Train Station Panel Expected to Recommend Downtown Site"; Sommer, "Panel OKs Downtown Train Station in 11-4 Vote"; Karl Skompinski, interview with author, Cheektowaga, NY, October 27, 2018.

69 Thomas Prohaska, "New Amtrak Station Opens Downtown, Handling Curtailed Runs amid Pandemic," *Buffalo News*, November 8, 2020; Mark Sommer, "Buffalo's New Downtown Train Station Draws Rave Reviews: 'It's Gorgeous,'" *Buffalo News,* November 28, 2020.

70 Skompinski, interview with author, via remote video, September 6, 2022.

71 Mark Sommer, "Developer Looks to Larkinville for Central Terminal Inspiration," *Buffalo News,* December 6, 2015; "Developer's Plan Offers at Least a Hope of Repurposing the Central Terminal," *Buffalo News*, December 10, 2015; "Ambitious—and Challenging—Proposals Would Breathe Life into 2 Iconic Buildings," *Buffalo News*, May 31, 2016; "Latest Proposal for the Central Terminal Makes New Housing a Major Component," *Buffalo News*, December 13, 2016.

72 Susan Schulman and Jonathan Epstein, "Master Plan for Buffalo's Central Terminal Includes Townhouses," *Buffalo News*, May 25, 2016; Mark Sommer, "Plans for Central Terminal Hinge on Residents as Much as Rail Traffic," *Buffalo News*, December 3, 2016.

73 Jessica Marinelli, "A Spotlight Shines on Buffalo's Central Terminal," Buffalo Rising, May 16, 2017

74 Mark Sommer, "Developer Dropped from Central Terminal Project Says He Was 'Blindsided,'" *Buffalo News, May 5,* 2017.

75 Michael Mroziak, "Urban Land Institute to Study Central Terminal Next Week," WBFO—Buffalo Toronto Public Media, June 20, 2017, https://news.wbfo.org; "Getting Adaptive Use Right—ULI's Final Report on Central Terminal," *Buffalo Rising*, January 9, 2018, www.buffalorising.com.

76 "Getting Adaptive Use Right."

77 New York State Press Release, "Governor Cuomo Announces $5 Million Investment Marking Major Milestone at Buffalo's Historic Central Terminal," April 13, 2018, https://www.governor.ny.gov; Empire State Development, "The Buffalo Billion II: East Side Corridor Economic Development Fund," Spring 2019, https://esd.ny.gov.

78 Buffalo Architecture Guidebook Corporation, *Buffalo Architecture: A Guide* (Cambridge, MA: MIT Press, 1981).

79 Franczyk, interview with author; Tielman, interview with author.

80 Richardson Center Corporation, accessed January 13, 2021, https://richardson-olmsted.com.

81 Monica Pellegrino Faix, interviews with author: Buffalo, October 24, 2020, and via remote video, September 15, 2022.

82 Andrew Galarneau and Mark Sommer, "Hotel Henry Will Close, the Victim of a 'Pandemic Body Blow,'" *Buffalo News*, February 16, 2021.

83 Mark Sommer, "Douglas Jemal Hoping to Open Hotel in June at Richardson Olmsted Campus," *Buffalo News*, April 16, 2022.

84 Mike Baggerman, "Renewed Push to Revitalize Buffalo's Central Terminal," *Buffalo News,* October 8, 2020.

85 Empire State Development, "The Buffalo Billion II"; East Side Avenues, accessed April 3, 2023, https://eastsideavenues.org/.

86 Smith Group, "Central Terminal Master Plan—Public Engagement Meeting #1 Recap Summary," October 8, 2020; Smith Group, "Central Terminal Master Plan—Public Engagement Meeting #2 Recap Summary," December 9, 2020 (in author's possession).

87 Smith Group and the Central Terminal Restoration Corporation, "Buffalo Central Terminal Master Plan," August 2021 (in author's possession).

88 Karl Skompinski, interview with author, via remote video, September 6, 2022.

89 Mark Sommer, "Hochul: Central Terminal Revival to Get 'Transformational' $61M Boost," *Buffalo News,* June 1, 2022.

90 Pellegrino Faix, interview with author, via remote video, September 15, 2022.

91 Mark Sommer, "Developer Sought for Central Terminal: 'This Is the Right Time,'" *Buffalo News*, July 27, 2022.

92 Smith Group, "Central Terminal Master Plan."

CHAPTER THREE: SILO CITY

1 Buffalo Architectural Guidebook Corporation, *Buffalo Architecture: A Guide* (Cambridge, MA: MIT Press, 1981).

2 Lynda Schneekloth, "Unruly and Robust: An Abandoned Industrial River," in Karen Franck and Quentin Stevens, *Loose Space: Possibility and Diversity in Urban Life* (London: Routledge, 2007), 256–257.

3 The architects for the American Elevator and the Perot Malting Elevator are the James Stewart Company and H. R. Wait (later additions); for the Lake and Rail Elevator, the Jones-Hettelslatter Company; for the Marine A Elevator, the James Stewart Company and the A. E. Baxter Engineering Company, see Lynda Schneekloth, ed., *Reconsidering Concrete Atlantis: Buffalo Grain Elevators (Buffalo: Urban Design Project, University at Buffalo, 2006)*, 14 (in author's possession).

4 The city's one steel-binned elevator, the Great Northern (owned by Archer Daniels Midland), the largest grain elevator in the world at the time of its completion in 1897, is being demolished as this chapter is being finalized in January 2023.

5 Schneekloth, *Reconsidering Concrete Atlantis,* and author observations.

6 David Tarbet, *Grain Dust Dreams* (Albany: State University of New York Press, 2015).

7 Tracey Drury, "High-Energy Partnership Fuels City Ethanol Project," *Buffalo Business First*, August 7, 2006; Sharon Linstedt, "Lake & Rail Grain Elevator Purchased by Minnesota Firm; Former Con Agra Site Sold by RiverWright," *Buffalo News,* June 13, 2008, https://buffalonews.com.

8 Sharon Linstedt, "Ethanol Plant to Open on Buffalo River," *Buffalo News*, July 30, 2006); Drury, "High-Energy Partnership Fuels City Ethanol Project."

9 "Buffalo's Grain Elevators: Inspiration or a Blight?," *New York Times,* August 24, 1984; Linstedt, "Ethanol Plant to Open on Buffalo River"; "ECIDA Approves Tax Credits for Three Buffalo Projects," *Buffalo News*, November 11, 2008; Matt Gryta, "Ethanol Plant Gets Green Light from Judge; Old First Ward Residents Fought $80 Million Plan," *Buffalo News*, December 19, 2007, https://buffalonews.com.

10 Sharon Linstedt, "Grain Elevator Returns to Life," *Buffalo Spree*, September 6, 2008.

11 Esther Miller and Sharon Linstedt, "Grain Elevator Returns to Life; Complex on Buffalo River Received a 400,000-Bushel Shipment on Monday—the Site's First Delivery in over Ten Years," *Buffalo News*, September 23, 2008.

12 Trading Economics, "Ethanol," accessed September 13, 2019, https://tradingeconomics.com/commodity/ethanol.

13 Jonathan Epstein, "Plug Pulled on Planned Buffalo, New York, Ethanol Plant," *Buffalo News*, October 18, 2011.

14 "Erie County Real Estate Transactions," *Buffalo News*, November 20, 2011; City of Buffalo Online Assessment Roll System (OARS), accessed September 15, 2019, www.buffalo.oarsystem.com; Erie County, N.Y. Real Property Tax Services (subset of the New York State Real Property System), accessed September 15, 2019, http://www2.erie.gov.

15 Rick Smith, interview with author, Buffalo, March 23, 2012; Lynda Schneekloth, Kerry Traynor, and Beth Tauke (UB faculty members), interview with author, Buffalo, March 23, 2012.

16 Department of the Interior, Historic American Engineering Record, "Buffalo Grain Elevators," HAER No. NY-239 (n.d.), 53; Kowsky, "Monuments of a Vanished Prosperity," in Schneekloth, *Reconsidering Concrete Atlantis*, 40.

17 Though "material integrity" is not an explicit requirement for National Register listing, many commentators have argued that it is a de facto requirement and implicit in Department of Interior standards for determining "significance," and is ill-suited for cultural landscapes, which, by definition, are constantly changing. See Catherine Howett, "Integrity as a Value in Cultural Landscape Preservation," in Robert Alanen and Robert

Melnick, eds., *Preserving Cultural Landscapes in America* (Baltimore: Johns Hopkins University Press, 2000); Randall Mason, "Fixing Historic Preservation: A Constructive Critique of 'Significance' [Research and Debate]," *Places* 16, no. 1 (2004): 64–71; Julie Riesenweber, "Landscape Preservation and Cultural Geography," in Richard Longstreth, ed., *Cultural Landscapes: Balancing Nature and Heritage* (Minneapolis: University of Minnesota Press, 2008).

18 According to ELAB organizers, City of Night drew twelve thousand people in 2013 and sixteen thousand in 2014.

19 Heart bombings consist of affixing a cutout paper heart on the entrance of a threatened building.

20 The collective action of Buffalo Young Preservationists, Preservation Buffalo Niagara, and the Campaign for Greater Buffalo helped stall the medical center's demolition effort, and as of early 2022 Trico was to be adapted as a mixed-use complex with 243 residential apartments. See James Fink, "Trico Project Still a Go as Development Costs Approach $108 Million," *Buffalo Business First*, January 27, 2022.

21 Christina Lincoln, interview with author, Buffalo, September 11, 2014.

22 The Wildroot complex was designated a city landmark in 2018. See Mark Sommer, "2018 Was a Landmark Year for Landmarks in the City of Buffalo," *Buffalo News*, December 29, 2018.

23 Dana Salyor, interview with author, Buffalo, September 14, 2014.

24 Stephen High and David Lewis, *Corporate Wasteland: The Landscape and Memory of Deindustrialization* (Ithaca, NY: Cornell University Press, 2007), 8–9. See also Camilo José Vergara, *American Ruins* (New York: Monacelli Press, 1999), and Tim Edensor, *Industrial Ruins: Space, Aesthetics and Materiality* (Oxford: Berg Publishers, 2005).

25 Chris Clements, "Explore Buffalo's 'Silo City: Vertical' Tour—Buffalo, NY," Exploring Upstate, October 15, 2014, http://exploringupstate.com.

26 Reyner Banham, *A Concrete Atlantis: U.S. Industrial Buildings and European Modern Architecture 1900–1925* (Cambridge, MA: MIT Press, 1986), 19–20, 166.

27 See Mark Sommer, "'Nature as a Refuge': Final Design for the Riverline Is Unveiled," *Buffalo News*, July 19, 2021.

28 Logan Ward, "Reinventing Buffalo," *Preservation Magazine*, July/August 2011, 26–33; Mark Sommer, "2,500 Preservationists Came to Buffalo 10 Years Ago. It Was a Turning Point for the City," *Buffalo News*, November 6, 2021.

29 Buffalo Architectural Guidebook Corporation, *Buffalo Architecture*.

30 See Mark Goldman, *City on the Edge: Buffalo, New York* (Amherst, NY: Prometheus Books, 2007).

31 "Buffalo's Grain Elevators."

32 Buffalo Niagara Cultural Tourism Initiative, "A Cultural Tourism Strategy: Enriching Culture and Building Tourism in Buffalo Niagara," January 2005; Ward, "Reinventing Buffalo"; Mike Vogel, "Running in Place," *Buffalo News*, October 16, 2011.

33 Banham, *A Concrete Atlantis*, 20.

34 Banham, *A Concrete Atlantis*; Le Corbusier, *Towards a New Architecture*, trans. Frederick Etchells (London: Architectural Press, 1927), 33. Also see Tricia Vita, "Can Buffalo, N.Y., Woo Tourists with Its Grain Elevators?," *Preservation*, June 20, 2003; http://www.preservationnation.org/magazine/story-of-the-week/2004/

Against-the-Grain.html; Michael Frisch, "Where Is the Fun in a Grain Elevator?," in Schneekloth, *Reconsidering Concrete Atlantis*, 123–132.

35 "Buffalo's Grain Elevators."

36 "The Grain Elevators Grew with Buffalo, but It's Not Practical Now to Save Them All," *Buffalo News*, October 13, 1996.

37 Mark Sommer, "Fire Loss of Historic Grain Elevator Is Called Another Case of City Neglect," *Buffalo News,* October 4, 2006; Ivonne Jaeger, "The Grand Ladies of the Lake," in Schneekloth, *Reconsidering Concrete Atlantis*, 63.

38 See Lynda Schneekloth, "Introduction," in Schneekloth, *Reconsidering Concrete Atlantis*, 13–17, and Frisch, "Where Is the Fun in a Grain Elevator?"

39 Editorial Board, "Judge in Great Northern Case Needs to Allow for an Appeal," *Buffalo News*, September 13, 2022; "Complete Coverage: The Great Northern Grain Elevator Controversy," *Buffalo News,* November 12, 2022.

40 Schneekloth, *Reconsidering Concrete Atlantis*, 13.

41 Ibid., 9.

42 Judith Stilgenbauer, "Landschaftspark Duisburg North—Duisburg, Germany (2005 EDRA/Places Award—Design)," *Places* 17, no. 3 (2005): 6–9; Anne Raines, "Ruhrgebiet," *Planning Perspectives* 26, no. 2 (2011): 183–207.

43 IBA Emscher Park, https://www.internationale-bauausstellungen.de.

44 See Brent Ryan, *Design after Decline: How America Rebuilds Shrinking Cities* (Philadelphia: University of Pennsylvania Press, 2012), 212–220.

45 See Charles Waldheim, *The Landscape Urbanism Reader* (New York: Princeton Architectural Press, 2006).

46 See Buffalo Niagara Cultural Tourism Initiative, "A Cultural Tourism Strategy," University at Buffalo Regional Institute, 2005, http://ubwp.buffalo.edu/ubri/project/buffalo-niagara-cultural-tourism-initiative/; City of Buffalo, "Queen City Waterfront," University at Buffalo Regional Institute, 2007, https://regional-institute.buffalo.edu/work/queen-city-planning/.

47 Mark Sommer, "Backers Want Historic Grain Elevators Turned into National Park," *Buffalo News*, May 15, 2017.

48 Jim Watkins, interview with author, Buffalo, September 12, 2014.

49 Rick Smith, interview with author, March 23, 2012.

50 Watkins, interview with author, September 12, 2014.

51 Smith, interview with author, March 23, 2012.

52 Buffalo Rising, "Buffalo's 2nd Skyline: Silo City and Elevator Alley," October 4, 2011, www.buffalorising.com; Mark Sommer, "Sky-High Views among Ideas Pitched for Light-Show Grain Elevator," *Buffalo News*, December 11, 2018.

53 The Buffalo River Restoration Partnership is funded through the Great Lakes Legacy Act administered by the US Environmental Protection Agency. See Congressman Brian Higgins, "Buffalo River Remarkable Recovery Continues with $44 Million Sediment Cleanup," press release, September 24, 2013, http://higgins.house.gov. See also New York State Department of Environmental Conservation and the Erie County Department of Environment and Planning, "Buffalo River Urban Canoe Trail Guide" (n.d.).

54 Buffalo Rising, "Elevator B @ Hive City," June 8, 2012, www.buffalorising.com.

55 See plusFARM's Spring 2014 Studio "Kissing Sparrows" project, www.plusfarm.org.

56 Rick Smith, email to author, July 29, 2014; Rick Smith, interview with author, September 12, 2014; Josh Smith, interview with author, Buffalo, October 23, 2020.

57 Jim Watkins, interview with author, Buffalo, September 12, 2014.

58 Watkins, email to author, July 30, 2014; Watkins, interviews with author, September 12, 2014, and October 16, 2015.

59 Noah Falck, interview with author, Buffalo, October 23, 2020; Silo City, Silo Sessions, accessed January 5, 2023, www.silo.city.

60 Erich Mendelsohn, *Erich Mendelsohn's Amerika, trans.* Stanley Applebaum (1926 [published in German]; New York: Dover Publications, 1993); Banham, *A Concrete Atlantis*; Historic American Engineering Record, "Buffalo Grain Elevators"; Lisa Mahar-Keplinger, *Grain Elevators* (New York: Princeton Architectural Press, 1993); Gerrit Engel and Winfried Nerdinger, *Buffalo Grain Elevators* (Berlin: Nova-Concept, 1997); Bernd and Hilla Becher, *Grain Elevators* (Cambridge, MA: MIT Press, 2006); Schneekloth, *Reconsidering Concrete Atlantis;* Tarbet, *Grain Dust Dreams;* Bruce Jackson, *American Chartes: Buffalo's Waterfront Grain Elevators* (Albany: State University of New York Press, 2016). For an example of Ralston Crawford's work, see "Buffalo Grain Elevators" (1937), Smithsonian American Art Museum, accessed January 30, 2014, http://americanart.si.edu.

61 Anthony Chase, "Silo City Show," *Artvoice* 11, no. 33 (August 16, 2012), https://artvoice.com/.

62 Watkins, interview with author, September 12, 2014.

63 Dany Saylor, interview with author, September 14, 2014.

64 Valery Lyman, "Breaking Ground," artist statement, 2019, www.breakinggroundexhibit.com.

65 Dan Shanahan, interview with author, via remote video, May 11, 2022.

66 Chase, "Silo City Show."

67 Terry Gibson and Ella Hilsenrath, "Reinventing Dead Space: Torn Space Theater," *Chance Magazine* 6, accessed September 14, 2019, https://chance-magazine.com.

68 Lynn Freehill-Maye, "The Trouble with Owning a Grain Elevator," *New Yorker,* July 31, 2016.

69 Rick Smith, interview with author, September 12, 2014.

70 "Silo City Phase 1 Project—Public Access Dock and Basic Amenities," project submission to the Niagara River Greenway Commission, November 20, 2012.

71 Rick Smith, interview with author, Buffalo, October 16, 2015.

72 Ibid.

73 Ibid.

74 Rick Smith, interview with author, September 12, 2014.

75 Rick Smith and Watkins, interviews with author, September 12, 2014; Rick Smith email to author, July 29, 2014. Silo City LLC was registered in New York State in 2011; Riversullivan Inc. holds the US trademark to "Silo City" (registered in 2014).

76 Rick Smith, interviews with author, March 23, 2012; September 12, 2014; and October 16, 2015; City of Buffalo Online

Assessment Roll System (OARS), accessed September 15, 2019, www.buffalo.oarsystem.com; Erie County, NY, Real Property Tax Services (subset of the New York State Real Property System), accessed September 15, 2019, http://www2.erie.gov.

77 Watkins, interview with author, October 25, 2018.

78 Caitlin Desilvey, *Curated Decay: Heritage beyond Saving* (Minneapolis: University of Minnesota Press, 2017), 11.

79 Conor Dougherty, "Oakland Fire Leads to Crackdown on Illegal Warehouses Nationwide," *New York Times,* December 8, 2016; August Brown, "After Ghost Ship and a Crackdown, L.A.'s DIY Music Scene Plans Its Response," *Los Angeles Times*, December 17, 2016); Bree Davies, "Denver: Quit Kicking Your Artists Out," *Westword*, December 26, 2016; Rebekah Kirkman and Brandon Soderberg, "Delineate It Yourself: After the Bell Foundry, Mayor's Safe Arts Space Task Force Is Formed," *Baltimore City Paper*, January 18, 2017; August Brown, "The L.A. DIY Community Contemplates a Post–Ghost Ship Life," *Los Angeles Times*, January 21, 2017; Blair Murphy, "From Texas to DC, Artists and DIY Spaces Struggle with Permits and Trolls," *Hyperallergic*, February 1, 2017; Karen Kucher, "Artists' Studios Shut Down," *San Diego Union Tribune*, September 8, 2017; Kaila Philo, "Is Baltimore's DIY Art Scene Being Killed Off?," *Vice*, September 15, 2017.

80 Watkins, interview with author, October 25, 2018.

81 Ibid.

82 Schneekloth, "Unruly and Robust," 259.

83 Lynda Schneekloth, interview with author, Buffalo, September 7, 2012.

84 Rick Smith and Watkins, interviews with author, Buffalo, September 12, 2014; October 16 and 17, 2015; October 25, 2018.

85 Mark Sommer, "Grain Elevator Could Become Brewery, Entertainment, Recreation Complex," *Buffalo News,* October 31, 2013; James Fink, "Entertainment, Sports Drive RiverWorks Project," *Buffalo Business First*, November 1, 2013; Mark Sommer, "Buffalo RiverWorks Opens Today for Hockey and Curling, with More to Come," *Buffalo News*, December 1, 2014.

86 Buffalo River Landing, accessed October 7, 2019, https://buffaloriverlanding.com/.

87 Rick Smith, interview with author, September 12, 2014.

88 Ibid.

89 Rick Smith, interview with author, October 17, 2015.

90 Successful grain elevator adaptations are discussed by Tom Yots, "Challenging the Imagination" in Schneekloth, *Reconsidering Concrete Atlantis*, 114–122.

91 Lorraine Mirabella, "Lower-Cost Luxury: Sales of New Condos in the Baltimore Area Are on the Rise as Prices Drop, but the Recovery Still Has a Ways to Go," *Baltimore Sun*, July 12, 2009; Silo Point, accessed December 2013, http://silopoint.com.

92 Minnesota Historical Society, accessed December 2015, https://www.mnhs.org/millcity.

93 Heritage Montreal, "Silo No. 5," May 3, 2016, https://memento.heritagemontreal.org; André Dubuk, "Devimco

convertira le Silo n° 5," *La Presse* (Montreal), June 1, 2022; Inerjys, "Devimco and Inerjys to Rebuild Silo No. 5," press release, June 16, 2022, https://www.inerjys.com.

94 Watkins, interview with author, October 25, 2018.

95 Jonathan Epstein, "Silo City Reimagined as a Place for Artists to Live, Work," *Buffalo News, June* 3, 2019.

96 "Going with the Grain at Silo City," *Buffalo News*, June 6, 2019.

97 Jonathan Epstein, "Silo City Developers Seek Adaptive Reuse Permit," *Buffalo News,* July 1, 2019.

98 James Fink, "Silo City Conversion Work to Start This Summer," *Buffalo Business First,* December 18, 2019; Jonathan Epstein, "Developers Kick Off Project to Bring Historic Silo City Back to Life," *Buffalo News*, November 17, 2020; New York Homes and Community Renewal, Board Meetings Minutes, February 9, 2023, https://hcr.ny.gov/.

99 Jonathan Epstein, "Planning Board Backs More Than $121 Million in Adaptive-Reuse Projects," *Buffalo News*, April 20, 2021.

100 Rick Smith, interview with author, Buffalo, October 23, 2020.

101 Daniel Campo, *The Accidental Playground: Brooklyn Waterfront Narratives of the Undesigned and Unplanned* (New York: Fordham University Press, 2013); Daniel Campo, "Iconic Eyesores: Exploring Do-It-Yourself Development at Abandoned Train Stations in Buffalo and Detroit," *Journal of Urbanism* 10 no. 2 (2014): 351–380.

102 Jonathan Epstein, "Silo City Project Caught Up in Acrimonious Dispute," *Buffalo News*, September 1, 2022.

CHAPTER FOUR: THE CARRIE BLAST FURNACES

1 U.S. Steel mostly ran six furnaces through 1971. Two were shut down and razed by the mid-1970s; two others were running until 1982 and were torn down shortly after the Park Corporation bought Carrie in 1988. The two extant furnaces, #6 and #7, were decommissioned in 1978. Ron Baraff, interview with author, via remote video, December 15, 2021.

2 Baraff, interview with author, December 15, 2021, based on 1951 U.S. Steel pamphlet. This source also notes that total employment spanning both plants was approximately eight thousand during the mid-1960s.

3 Kenneth Warren, *Big Steel: The First Century of the United States Steel Corporation, 1901–2001* (Pittsburgh: University of Pittsburgh Press, 2001); Steve Mellon, *After the Smoke Clears: Struggling to Get By in Rustbelt America* (Pittsburgh: University of Pittsburgh Press, 2002); Michael Bennet, National Historic Landmark Nomination—"Carrie Blast Furnaces Number 6 and 7," Washington, DC: U.S. Department of the Interior, 2006; Kirsten Paine, "Carrie Clark: She Who Lit the Fires," Rivers of Steel (blog), March 9, 2023, https://riversofsteel.com.

4 Warren, *Big Steel,* 335–336.

5 Tim Kaulen, interview with author, Pittsburgh, May 29, 2015.

6 Industrial Arts Co-op, "Space Monkey," accessed March 19, 2023, http://iaco-op.net/spacemonkey.htm.

7 Kaulen, interview with author.

8 The development of Southside Works is documented in Allen Dieterich-Ward, *Beyond Rust: Metropolitan Pittsburgh and the Fate of Industrial America* (Philadelphia: University of Pennsylvania Press, 2016).

9 Jim McKinnon, "Reports of Cult Led to Ranking Shooting," *Pittsburgh Post-Gazette, May 12, 1994.*

10 Industrial Arts Co-op, "Attack of the Giant Woolly Millipede," accessed March 19, 2023, http://iaco-op.net/millipede.htm.

11 Kaulen, interview with author.

12 Liz Hammond, interview with author, Pittsburgh, June 12, 2017.

13 Ibid.

14 Ibid.

15 Kaulen, interview with author.

16 Anne Raines, "Ruhrgebiet," *Planning Perspectives* 26, no. 2 (2011): 183–207; IBA Emscher Park, https://www.internationale-bauausstellungen.de.

17 Jan Ackerman, "A Place for Steel? Steel Making Is Central to the History of the Region, and a Local Group Hopes to Honor the Legacy," *Pittsburgh Post-Gazette*, March 12, 2000.

18 P. Krause, *The Battle for Homestead, 1880–1892: Politics, Culture and Steel* (Pittsburgh: University of Pittsburgh Press, 1992).

19 Bohdan Hodiak, "Pending Land Sale Gives New Life to Steel Museum," *Pittsburgh Post-Gazette*, November 3, 1993.

20 Linda Wilson Fuoco, "Kelly C. Park Says His Company Is Impatient with Holding Sites for a Steel Heritage Museum without Being Paid for Them," *Pittsburgh Post-Gazette*, February 23, 1994.

21 Dieterich-Ward, *Beyond Rust*, 275.

22 Fuoco, "Kelly C. Park."

23 Ackerman, "A Place for Steel?"

24 Ibid.

25 Dieterich-Ward, *Beyond Rust*, 280.

26 See also ibid., 275–276.

27 Ann Belser, "County Trying to Buy Carrie Furnace Site," *Pittsburgh Post-Gazette*, September 1, 2004.

28 Joe Grata, "Hot Metal Bridge Opens: Span Links Past, Future," *Pittsburgh Post-Gazette*, June 24, 2000.

29 Ron Baraff, interview with author, Swissvale, PA, May 28, 2015; August Carlino, interview with author, Homestead, PA, June 12, 2017.

30 Belser, "County Trying to Buy Carrie Furnace Site."

31 Ann Belser, "At Last! Plans for Carrie Furnace Site Can Proceed," *Pittsburgh Post-Gazette*, September 1, 2005.

32 August Carlino, interview with author, Homestead, PA, June 12, 2017.

33 Ed Blazina, "Construction to Begin on Apartments," *Pittsburgh Post-Gazette,* May 15, 2008.

34 Karamagi Rujumba, "Redevelopment of Carrie Furnace Site to Begin This Year," *Pittsburgh Post-Gazette*, May 18, 2009.

35 Ed Blazina, "Last Piece of the Carrie Puzzle in Place; Redevelopment of Former Steel Mill Site along Waterfront to Begin," *Pittsburgh Post-Gazette*, December 13, 2011.

36 Ackerman, "A Place for Steel?"; Belser, "At Last!"

37 Blazina, "Construction to Begin on Apartments."

38 Len Barcousky, "Carrie Furnace, UPMC-Braddock Site Redevelopments March On," *Pittsburgh Post-Gazette*, June 30, 2012.

39 Belser, "At Last!"

40 Annie Siebert, "Locals Work to Restore Furnace; Goal Is to Turn Carrie Site into Park, Museum," *Pittsburgh Post-Gazette, August* 16, 2012.

41 Barcousky, "Carrie Furnace."

42 Jim Kapusta, tour of Carrie Blast Furnaces and interview with author, Swissvale, PA, September 27, 2019.

43 Ron Baraff, interview with author, May 28, 2015.

44 Kevin Kirkland, "Marks of Time; Rust Isn't the Only Thing Covering Abandoned Carrie Furnaces, and Today, You Can Take a Closer Look," *Pittsburgh Post-Gazette*, July 6, 2013.

45 Baraff, interview with author, May 28, 2015.

46 Joanne Klimovich Harrop, "Experience 'King Lear' at the Carrie Furnace," TribLIVE May 9, 2019, https://triblive.com.

47 Siebert, "Locals Work to Restore Furnace."

48 Baraff, interview with author, June 13, 2017.

49 Baraff, interview with author, April 29, 2016.

50 See National Park Service, Historic Preservation Standards and Guidelines, https://www.nps.gov/. Also Charles Birnbaum and Christine Capella Peters, *The Secretary of the Interior's Standards for the Treatment of Historic Properties (Washington, DC: U.S. Department of the Interior, 1996);* Norman Tyler, Ilene Tyler, and Ted Ligibel, *Historic Preservation: An Introduction to Its History, Principles and Practice*, 3rd ed. (New York: W. W. Norton and Company, 2018).

51 See Constance Bodurow, "A Vehicle for Interpreting and Preserving Our Recent Industrial Heritage," *The George Wright Forum* 20, no. 2 (June 2003): 83; Daniel Campo, "Historic Preservation in an Economic Void: Reviving Buffalo's Concrete Atlantis," *Journal of Planning History* 15, no. 4 (2016): 314–345.

52 Bennett, National Historic Landmark Nomination.

53 Baraff, interview with author, May 28, 2015.

54 See *The Domino Effect*, documentary by Daniel Phelps, Megan Sperry and Brian Paul. Produced by The Domino Effect Movie LLC, 2012.

55 Baraff, interview with author, May 28, 2015.

56 See Bennett, National Historic Landmark Nomination, 13–14.

57 Baraff, interview with author, June 13, 2017.

58 Ibid.

59 Songer Services, "Stack Preservation Project for Historic Carrie Blast Furnace near Pittsburgh Connects Big Steel History to a Promising Future at Songer Services," PR Newswire, September 21, 2017, https://www.prnewswire.com.

60 Baraff, interview with author, June 13, 2017.

61 Rivers of Steel, "The Historic Preservation of the Carrie Blast Furnaces" (blog), January 13, 2023, http://riversofsteel.com.

62 Baraff, interview with author, via remote video, December 15, 2021.

63 Kirckstarter, Save the Carrie Deer, accessed March 19, 2023, https://www.kickstarter.com.

64 Baraff, interview with author, April 29, 2016.

65 Ibid.

66 See Joshua David and Robert Hammond, *High Line: The Inside Story of New York City's Park in the Sky* (New York, Farrar, Straus and Giroux, 2011).

67 Ibid.

68 Ibid.

69 Rivers of Steel Heritage Corporation, "Rivers of Steel Announces the Acquisition of RiverQuest," press release, August 31, 2016, http://riverquest.org.

70 Baraff, interview with author, via remote video, December 15, 2021.

71 Ibid.

72 Carlino, interview with author.

73 Baraff, interview with author, May 28, 2015.

74 Bodurow, "A Vehicle for Interpreting and Preserving Our Recent Industrial Heritage;" 72.

75 Thomas Leary and Elizabeth Sholes, "Authenticity of Place and Voice: Examples of Industrial Heritage Preservation and Interpretation in the US and Europe," *The Public Historian* 22, no. 3 (2000): 49–66; Bodurow, "A Vehicle for Interpreting and Preserving Our Recent Industrial Heritage"; Andrew Hurley, *Beyond Preservation: Using Public History to Revitalize Inner Cities* (Philadelphia: Temple University Press, 2010).

76 See Sherry Linkon and John Russo, *Steeltown U.S.A.* (Lawrence: University of Kansas Press, 2002); Deborah Rudacille, *Roots of Steel: Boom and Bust in an American Mill Town* (New York: Anchor Books, 2011).

77 Mellon, *After the Smoke Clears; See also Steven High, Industrial Sunset: The Making of North America's Rustbelt, 1969–1984 (Toronto: University of Toronto Press, 2003).*

78 Linkon and Russo, *Steeltown U.S.A.*; Bodurow, "A Vehicle for Interpreting and Preserving Our Recent Industrial Heritage"; Kirk Savage, "Monuments to a Lost Cause," in Jefferson Cowie and Joseph Heathcott, eds., *Beyond the Ruins* (Ithaca, NY: Cornell University Press), 237–256; Kari Lydersen, "Chicago Steelmaking: Dead but Not Forgotten: Activists Want to Turn Old Plant into a Museum," *Washington Post*, December 27, 2004; Lee Bay, "What Ruins of a Former Chicago Steel Plant Say about Our Past and Future," WBEZ FM (blog), January 7, 2013, http://www.wbez.org.

79 Linkon and Russo, *Steeltown U.S.A.*, 182–183.

80 Pamela Wood, "Sign of the Times: Sparrows Point Blast Furnace Demolished," *Baltimore Sun*, January 28, 2015.

81 Pamela Wood, "Former Sparrows Point Steel Mill Gets New Name," *Baltimore Sun*, January 12, 2016.

82 Jeffrey A. Parks, *Stronger Than Steel: Forging a Rust Belt Renaissance* (Bethlehem, PA: Rocky Rapids Press, 2018).

83 Lynn Olanoff, "Bethlehem Steel Corp. Blast Furnaces Are Now Center Stage in City's Redevelopment," Lehigh Valley

Live, June 27, 2011, www.lehighvalleylive.com; Steel Stacks, accessed March 19, 2023, www.steelstacks.org.

84 Parks, *Stronger Than Steel*.

85 Baraff, interview with author, May 28, 2015.

86 M. Belko, "Amazon Appears to Find Strip District Appealing," *Pittsburgh Post-Gazette, May* 15, 2018.

87 Regional Industrial Development Corporation, "Construction Underway at Historic Carrie Furnace Site," *Pittsburgh Business Times*, March 3, 2023, https://www.bizjournals.com/pittsburgh/news/2023/03/03/construction-underway-at-carrie-furnace-site.html; Maria Sciullo, "How Pittsburgh Really Will Be Hollywood on the Mon in a Couple of Years," *Pittsburgh Magazine*, March 16, 2023, http://www.pittsburghmagazine.com.

88 Jim Kapusta tour and interview.

89 Ibid.

90 I also draw upon the documentation and statistics of Bennett's "Carrie Blast Furnaces National Historic Landmark Nomination" in this paragraph.

91 Jim Katusta tour and interview.

92 Recent histories focusing on the aftermath of steel plant closures provide extensive documentation concerning injury, disease, and death among steelworkers and retirees. See Linkon and Russo, *Steeltown U.S.A.; High, Industrial Sunset;* Rudacille, *Roots of Steel*, and Dieterich-Ward, *Beyond Rust*.

93 See American Lung Association, "State of the Air—2023 Report," https://www.lung.org/research/sota.

CHAPTER FIVE: THE PACKARD AUTOMOTIVE PLANT

1 W. Hawkins Ferry, *The Buildings of Detroit: A History* (Detroit: Wayne State University Press, 1968); James Ward, *The Fall of the Packard Motor Car Company* (Stanford, CA: Stanford University Press, 1995).

2 Jim Suhr, "Fighting to Save the Packard Plant—And He Won't Leave," Associated Press, January 30, 1999; Camilo Vergara, *American Ruins* (New York: Monacelli Press, 1999).

3 Brent D. Ryan and Daniel Campo, "Autopia's End: The Decline and Fall of Detroit's Automotive Manufacturing Landscape," *Journal of Planning History* 12, no. 2 (2013): 95–132.

4 Daniel Okrent, "The Tragedy of Detroit: How a Great City Fell and How It Can Rise Again," *Time,* October 5, 2009. *Time*'s editors were perhaps unaware of an earlier *New York Times Magazine* story on Detroit-region race relations with the same title: Ze'Ev Chafets, "The Tragedy of Detroit," *New York Times Magazine, July* 29, 1990.

5 Jonathan Mahler, "G.M., Detroit and the Fall of the Black Middle Class," *New York Times*, June 24, 2009.

6 Bill Vlasic, "Derelict in Detroit, and Hard to Sell," *New York Times*, November 21, 2013.

7 A. Kellogg, "How Do You Put the Dump into Dump Truck? Push It off the Fourth Floor: Detroit's Abandoned Industrial Landscape Has Become a Playground for Pranksters," *Wall Street Journal*, November 6, 2009, www.wsj.com.

8 Ferry, *The Buildings of Detroit*.

9 See Charlie LeDuff, *Detroit: An American Autopsy* (New York: Penguin Press, 2013).

10 *The Telegraph* (UK), "Freeskiers Perform Tricks in Detroit's Derelict Buildings," YouTube, January 14, 2014, www. youtube.com.

11 J. Hinds, "Even in Ruin, Detroit's Packard Plant Inspires Artists," *USA Today*, March 20, 2014, www.usatoday.com.

12 Charles Waldheim, "Detroit *Disabitato* and the Origins of Landscape," in Julia Czerniak, ed., *Formerly Urban: Projecting Rustbelt Futures* (Barcelona: Actar, 2013), 170.

13 Camilo José Vergara, *The New American Ghetto* (New Brunswick, NJ: Rutgers University Press, 1995), 202.

14 J. C. Reindl, "Packard Plant Rehab Project Breaks Ground," *Detroit Free Press*, May 16, 2017.

15 John Gallagher, "Venice Biennale Focuses on Detroit of the Imagination," *Detroit Free Press*, May 21, 2016.

16 J. C. Reindl, "Packard Plant Owner Vows to Pay $185,000 Tax Bill to Avoid Foreclosure," *Detroit Free Press*, February 8, 2019.

17 Vergara, *American Ruins;* Carolyn Geck, email to author, October 20, 2017.

18 Adriel Thornton, interviews with author, via remote video, September 28 and October 14, 2022.

19 Ibid.

20 Geck, email to author; Thornton, interview with author, September 28, 2022.

21 Thornton, interview with author, September 28 , 2022.

22 Vergara, *American Ruins.*

23 Thornton, interviews with author, September 28 and October 14, 2022.

24 Joshua Glazer, "Craving the Rave: Detroit's Electronic Music Scene in the '90s," Red Bull Music Academy, May 21, 2014, https://daily.redbullmusicacademy.com; Geck, email to author; Thornton, interview with author.

25 Elizabeth Beale, interview with author, October 17, 2019; Carolyn Geck, interview with author, September 8, 2017; Geck, email to author.

26 Patrick Gallagher, "My Life as a Kid: A Nostalgic Look Back on Raves in the 1990s," Mr. Beller's Neighborhood—New York Stories (blog), July 7, 2005, https://mrbellersneighborhood.com.

27 Thornton, interviews with author, September 28 and October 14, 2022.

28 Glazer, "Craving the Rave."

29 Adam Graham, "Plastikman Brings Bold Sounds to Detroit," *Detroit News*, May 27, 2010.

30 Richard Pope, "Hooked on an Affect: Detroit Techno and Dystopian Digital Culture," *Dancecult: Journal of Electronic Dance Music Culture* 2, no. 1 (2011): 24–44.

31 Jon Savage, "Machine Soul: A History of Techno," *Village Voice,* Rock and Roll Quarterly, Summer 1993; Pope, "Hooked on an Affect"; Dan Sicko, *Techno Rebels: The Renegades of Electronic Funk*, 2nd ed. (Detroit: Wayne State University Press, 2014).

32 Christoph Schaub, "Beyond the Hood? Detroit Techno, Underground Resistance, and African American Metropolitan Identity Politics," fiar (Forum for Inter-American Research), accessed November 7, 2019, http://interamerica.de.

33 Savage, "Machine Soul"; Sicko, *Techno Rebels.*

34 Katie Trexler, "Crave the Rave," Fox 2 News Detroit Special Report, YouTube, August 5, 2014, posted on www.youtube.com.

35 "Police Warn of 'Rave' Risks: Many Dangers Lurk for Kids Drawn to Late Night Parties," *Detroit News*, June 29, 1999.

36 "The Battle for the Packard Plant: Bloomfield Hills Company, Detroit, Tenants Square Off," *Detroit News, May 5*, 1999.

37 Brent D. Ryan, *Design after Decline: How America Rebuilds Shrinking Cities* (Philadelphia: University of Pennsylvania Press, 2012); Jason Hackworth, "Demolition as Urban Policy in the American Rust Belt," *Environment and Planning A* 48, no. 11 (2016): 2201–2222; Alan Mallach, *The Empty House Next Door: Understanding and Reducing Hypervacancy in the United States* (Cambridge, MA: Lincoln Institute of Land Policy, 2019).

38 Hackworth, "Demolition as Urban Policy"; Jason Hackworth, *Manufacturing Decline: How Racism and the Conservative Movement Crush the American Rust Belt* (New York: Columbia University Press, 2019).

39 Hackworth, "Demolition as Urban Policy."

40 Ryan and Campo, "Autopia's End."

41 Collins George, "Detroit Calls Economic Doctors: Seeks Cure for Disease Causing Flight of Industry," *Detroit Free Press, June 23*, 1957.

42 Charles Hyde, *Detroit: An Industrial History Guide* (Detroit: Detroit Historical Society, 1980); Detroit Historical Museum, *Milwaukee Junction: Cradle of Detroit's Automobile Industry*, booklet, Detroit Historical Museum, 2005.

43 Collins George, "Test Suit Weighed: City May Try to Condemn Site," *Detroit Free Press*, June 12, 1957.

44 Ward, *The Fall of the Packard Motor Car Company*.

45 "As We See It: A Second Front Opens on the War on Blight," *Detroit Free Press*, June 15, 1957.

46 "Where Are Packard's 4,000?," *Detroit Free Press*, January 24, 1960.

47 "Old Packard Plant Bought for a Million-Plus," *Detroit Free Press, February* 11, 1958.

48 *Detroit Free Press*, May 29, 1958, 3 (photo published with caption only).

49 Susan Watson, "The Story of the Boulevard They Called Grand," *Detroit Free Press Sunday Magazine*, April 27, 1975.

50 Louis Cook, "The Packard Plant Still Gets Good Mileage," *Detroit Free Press,* February 19, 1981.

51 Dorothy Weddell, "Developer Buys Packard Site," *Detroit Free Press,* December 16, 1983.

52 Jennifer Dixon, "The Packard Plant: Why It Has to Go," *Detroit Free Press* (special full-section feature on Packard), December 2, 2012.

53 Ibid.

54 Jennifer Dixon, "Management Firm for Packard Sues the City," *Detroit Free Press*, November 24, 1998.

55 Helen F. Ladd, "Spatially Targeted Economic Development Strategies: Do They Work?" *Cityscape* 1, no. 1 (1994): 193–218; Audrey McFarland, "Race, Space, and Place: The Geography of Economic Development," *San Diego Law Review* 36 (1999): 295–394; Alan Peters and Peter Fisher, "The Failures of Economic Development Incentives," *Journal of the American Planning Association* 70, no. 1 (2004): 27–37; Timothy Bartik, *Making Sense of Incentives: Taming Business Incentives to Promote Prosperity* (Kalamazoo, MI: W. E. Upjohn Institute for Employment Research, 2019).

56 Ryan and Campo, "Autopia's End."

57 Jennifer Dixon and Joel Thurtell, "City Takes over Packard Plant," *Detroit Free Press,* November 21, 1998; Dixon,

"The Packard Plant."

58 Nailhed, "Packard 2003–2005" (blog), accessed September 29, 2021, http://www.nailhed.com.

59 Dixon, "Management Firm for Packard Sues the City"; Jennifer Dixon and M. L. Erick, "More Fights Loom over Packard Plant," *Detroit Free Press*, November 12, 2010.

60 "Packard Plant Managers Win Ruling, Question Police Presence at Site," Associated Press, November 24, 1998; "The Battle for the Packard Plant," *Detroit News*, May 5, 1999; George Hunterland, "Tax Payment Ends Dispute in Detroit; Former Packard Plant Was Scene of Standoff between Owner, City," *Detroit News, October* 9, 2000; George Hunterland and Christine MacDonald, "Owner Confusion Stalls Progress: City Officials, Alleged Title Holder at Odds over Eyesore," *Detroit News, November* 15, 2010.

61 "The Battle for the Packard Plant."

62 "Packard Plant Managers Win Ruling, Question Police Presence at Site," Associated Press, November 24, 1998; "The Battle for the Packard Plant"; Hunterland, "Tax Payment Ends Dispute in Detroit"; Hunterland and MacDonald, "Owner Confusion Stalls Progress."

63 Stuart Blond, "The Packard Plant Is Saved," *Society of Automotive History Journal* 188 (September–October 2000): 5–6; Dixon, "The Packard Plant."

64 Hunterland and MacDonald, "Owner Confusion Stalls Progress"; Nailhed, "Packard 2003–2005"; author's analysis of Google Earth satellite photographs taken March 27, 1999, and July 17, 2001.

65 Robert Ankeny, "Group Proposes Car Museum at Old Packard Site," *Crain's Detroit Business, January* 24, 2000.

66 "The Battle for the Packard Plant."

67 Blond, "The Packard Plant Is Saved."

68 Ibid.; Dixon, "The Packard Plant."

69 Blond, "The Packard Plant Is Saved."

70 Hunterland, "Tax Payment Ends Dispute in Detroit."

71 Dixon and Erick, "More Fights Loom over Packard Plant."

72 Vergara, *American Ruins;* Charles Waldheim, *Stalking Detroit* (Barcelona: Actar, 2001); Mark Binelli, *Detroit City Is the Place to Be* (New York: Metropolitan Books, 2012); Doris Apel, *Beautiful Terrible Ruins: Detroit and the Anxiety of Decline* (New Brunswick, NJ: Rutgers University Press, 2015). In contrast to those who invoke the ruins of antiquity or the Middle Ages, historian Nick Yablon notes that industrial ruins at sites like Packard and elsewhere are "untimely" as they arose unpredictably and have not been around long enough to or disappear before they have accrued the aura of age that develops over centuries. See Nick Yablon, *Untimely Ruins: An Archaeology of American Urban Modernity, 1819–1919* (Chicago: University of Chicago Press, 2010).

73 Steven High and David Lewis, *Corporate Wasteland: The Landscape and Memory of Deindustrialization* (Ithaca, NY: Cornell University Press, 2007); Apel, *Beautiful Terrible Ruins.*

74 "Packard: Ruins of Detroit, Matterhorn of Michigan," American Peyote (blog), December 5, 2010, http://blog.americanpeyote.com.

75 Packard explorer Nailhed provides documentation of several rooftop exploits. See "Packard: 2006, Part A," and other entries in his "Packard Plant Portal," http://www.nailhed.com.

76 Kimberly Kinder, *Detroit DIY: Making Do in a City without Services* (Minneapolis: University of Minneapolis Press, 2016), 29–30.

77 Daniel Campo, *The Accidental Playground: Brooklyn Waterfront Narratives of the Undesigned and Unplanned* (New York: Fordham University Press, 2013); Daniel Campo, "Historic Preservation in an Economic Void: Reviving Buffalo's Concrete Atlantis," *Journal of Planning History* 15, no. 4 (2016): 314–345.

78 For looseness in urban space, see Karen Franck and Quentin Stevens, eds., *Loose Space: Possibility and Diversity in Urban Life* (London: Routledge, 2007).

79 A Flickr search for "Packard" and "Urbex" produced 4,779 images with very few false positives (www.flickr.com, accessed and tallied by author, November 13, 2019).

80 Donna Terek, "The Packard Plant: Life in the Ruins," *Detroit News,* March 28, 2011.

81 Theresa Welsh and David Welsh, *A Guide to Postindustrial Detroit: Unconventional Tours of an Urban Landscape,* Seeker Books (revised through 2018), www.theseekerbooks.com, 16.

82 Theresa Welsh and David Welsh, *Detroit's Spectacular Ruin: The Packard Plant* (n.p.: Seeker Books, 2013–15), 9.

83 John Metcalfe, "Hunting Detroit's Masterworks of Architecture before They Go Extinct," CityLab, October 11, 2013, www.citylab.com.

84 Austan Goolsbee and Alan Krueger, "A Retrospective Look at Rescuing and Restructuring General Motors and Chrysler," *Journal of Economic Perspectives* 29, no. 2 (Spring 2015): 3–24; Mahler, "G.M., Detroit and the Fall of the Black Middle Class."

85 David Segel, "A Missionary's Quest to Remake Motor City," *New York Times*, April 14, 2013.

86 Stephen Lowman, "The Impulsive Traveler: In Detroit, Ruins Porn and an Incipient Renaissance," *Washington Post,* July 6, 2011.

87 "Detroit's Faded Beauty," *Washington Post*, June 6, 2014, www.washingtonpost.com.

88 "Detroit's Cityscape Attracts Fans of Techno Music," *Detroit News, November* 9, 1999); G. Newkirk, "Urban Exploration Tours Bringing Droves of Tourists to Detroit Ruins," *Roadtrippers Magazine*, January 1, 2014, https://roadtrippers.com/.

89 "Packard Plant Continues to Smolder after Monday Fire," *Detroit News, June* 10, 2009.

90 "Firefighters Work to Control Packard Plant Blaze," *Detroit News, June* 29, 2009.

91 LeDuff, *Detroit,* 52.

92 Dixon, "The Packard Plant."

93 Vergara, *American Ruins*; Camilo Vergara, "How to Destroy an American Landmark: The Slow Death of Detroit's Famous Packard Automotive Plant," *The Nation*, February 25, 2019, www.thenation.com.

94 Andrew Moore, *Detroit Disassembled (Akron, OH: Akron Art Museum, 2010)*; Y. Marchand and R. Meffre, *The Ruins of Detroit* (London: Steidl, 2011).

95 Moore, *Detroit Disassembled,* 119.

96 Detroit Future City, *2012 Detroit Strategic Framework Plan* (Detroit: Inland Press, 2012), 258–263.

97 See Bill McGraw, "Redesigning Detroit: Mayor Mike Duggan's Blueprint Unveiled," MLive Michigan, August 18, 2015, www.mlive.com.

98 See note 81.

99 Apel, *Beautiful Terrible Ruins,* 3.

100 Tim Edensor, *Industrial Ruins* (Oxford: Berg Publishers, 2005); Bradley Garrett, *Explore Everything: Place-Hacking the City* (London: Verso, 2014).

101 LeDuff, *Detroit,* 80.

102 See Nick Yablon, "Epilogue to Posthuman Ruin," in Nick Yablon, *Untimely Ruins*, 289–294.

103 LeDuff, *Detroit,* 120.

104 See Brian Doucet and Drew Philp, "In Detroit 'Ruin Porn' Ignores the Voices of Those Who Still Call the City Home," *The Guardian,* February 15, 2016. See also Alice Mah, *Industrial Ruination, Community, and Place: Landscapes and Legacies of Urban Decline* (Toronto: University of Toronto Press, 2013).

105 Willy Staley, "What's Really Pornographic? The Point of Documenting Detroit," *The Awl,* September 1, 2011, www.theawl.com.

106 Welsh and Welsh, *A Guide to Postindustrial Detroit,* 16.

107 Apel, *Beautiful Terrible Ruins,* 10; see also Andrew Herscher, *The Unreal Estate Guide to Detroit* (Ann Arbor: University of Michigan Press, 2012).

108 See Mark Lemley, "The Myth of the Sole Inventor," *Michigan Law Review* 110, no. 5 (2012): 709–760.

109 Melena Ryzik, "Wringing Art out of the Rubble in Detroit," *New York Times, August 3,* 2010.

110 See Richard Florida, "Detroit Rising," Citylab (2012–2013), essays and videos at www.citylab.com. Videos produced by Rana Florida.

111 Kilpatrick was convicted of federal and state corruption charges and other misdeeds three separate times and is now serving a long sentence in federal prison. See LeDuff, *Detroit.*

112 Christine MacDonald, "City Seeks Owner of Packard Ruins," *Detroit News,* July 9, 2010.

113 Dixon and Erick, "More Fights Loom over Packard Plant."

114 Hunterland and MacDonald, "Owner Confusion Stalls Progress."

115 Mary M. Chapman, "The Packard Plant, a Symbol of Bygone Detroit, May Soon Be Demolished," *New York Times,* March 2, 2012.

116 L. DiVito, "Your Guide to Detroit's Ruins," *Detroit Metro Times,* February 25, 2014, www.metrotimes.com.

117 Billy Voo, interview with author, via phone, October 11, 2019.

118 Mark Stryker, "Graffiti Artist Banksy Leaves Mark on Detroit and Ignites Firestorm," *Detroit Free Press,* May 15, 2010.

119 Dixon, "The Packard Plant"; Mark Stryker, "Banksy Mural from Detroit Sells for $137,500," *Detroit Free Press,* September 30, 2015; Erick Trickey, "The Fight over Graffiti: Banksy in Detroit," Belt, October 13, 2015, https://beltmag.

com; Voo, interview with author.

120 Scott Hocking, interview with author, Detroit, September 9, 2017.

121 Ibid.

122 See Nailhed, "Packard 2003–2005."

123 Catherine Elton, "From Barcelona to Lima, He's Breathing New Life into Empty Buildings," Ozy, January 20, 2019, www.ozy.com.

124 Kari Smith, interview with author, Detroit, March 16, 2016; M. Davey, B. Vlasic, and M. Williams, "Detroit Ruling Lifts a Shield on Pensions," *New York Times* (Packard photograph appeared in the print edition on A1), December 3, 2013.

125 Smith, interview with author.

126 Vlasic, "Derelict in Detroit, and Hard to Sell"; Bill Vlasic, "Developer from Peru Has Eye on Detroit," *New York Times,* February 4, 2014.

127 *The Architectural Imagination,* an exhibition staged in the U.S. Pavilion at the 15th Venice Architecture Biennale, 2016, curated by Cynthia Davidson and Monica Ponce de Leon, accessed November 25, 2019, www.thearchitecturalimagination.org.

128 Smith, interview with author. The Kahn system or Kahn-bar system of reinforced concrete beam construction is discussed in Ferry, *The Buildings of Detroit,* 180–182.

129 Smith, interview with author.

130 Reindl, "Packard Plant Rehab Project Breaks Ground"; Jennifer Chambers, "Packard Plant Renovation Finally Springs into Action," *Detroit News, May* 16, 2017.

131 J. C. Reindl, "A Piece of the Packard Plant Is Back in Business," *Detroit Free Press,* April 23, 2015.

132 Steven Lewis, interview with author, via phone, September 8, 2017.

133 Francis Grunow, interview with author, Detroit, September 8, 2017.

134 Ryan Felton, "Tiger on the Loose in Detroit Building Ends Photo Shoot Early," *The Guardian,* August 17, 2015.

135 Candice Williams, "'I Haven't Had My Day in Court': Packard Plant's Resident Leaves after Eviction," *Detroit News, October* 1, 2019.

136 Allan Hill and Connie, interview with author, Detroit, October 17, 2019.

137 Ibid.

138 See George Hunter, "Hide-and-Seek Accident not at Packard Plant, *Detroit News,* January 15, 2019.

139 Ward, *The Fall of the Packard Motor Car Company.*

140 Ferry, *Buildings of Detroit;* Hyde, *Detroit.*

141 Ferry, *Buildings of Detroit.*

142 Hyde, *Detroit.*

143 Ibid.

144 Kirk Pinho, "Plans Scrapped for Automotive Heritage Museum at Old Ford Highland Park Plant Office Building," *Crain's Detroit Business,* October 18, 2016.

145 Nancy Darga, interview with author, Detroit, March 16, 2016. The author also toured the Ford Piquette Avenue Plant in 2012, 2016, and 2019. Also see Ford Piquette Avenue Plant, www.fordpiquetteplant.org.

146 Detroit's Russell Industrial Center (former Murray Body complex), represents an alternative approach to industrial adaptation. Under for-profit ownership, the over two-million-square-foot, Kahn-designed plant leases spaces to artists and small businesses, hosts events, and has been incrementally renovated in response to demand. See Russell Industrial Center, http://russellindustrialcenter.com/.

147 Sarah Cox, "American Beauty Building Gets a Dumpster and a Demo Crew," *Curbed Detroit*, July 23, 2021, https://detroit.curbed.com.

148 Kirk Pinho, "Packard Plant Owner Owes Nearly $774,000 in Property Taxes, Other Fees, plus $6,250 in Rent," *Crain's Business Detroit, October* 2, 2020; Breana Noble, "Grand Plan to Redevelop Packard Plant Is Scrapped; Eyesore Goes Back on Market," *Detroit News*, October 29, 2020; "Newmark Listing Detroit's Iconic Packard Plant," *RE Journals*, November 12, November; Newmark Packard / Arte Express Prospectus (n.d.) (downloaded from https://www.loopnet.com/Listing/1580-E-Grand-Blvd-Detroit-MI/21333601/?stid=ngkf, n.d., in author's possession).

149 J. C. Reindl, "Packard Plant Owner Misses Key Deadline for Demolition Permit," *Detroit Free Press,* April 21, 2021.

150 Miriam Marini, "Detroit City Council Approves $1.7 Million Contract to Demolish Portion of Packard Plant," *Detroit Free Press, July* 7, 2022.

151 Dana Afana, "Crews Begin Demolition of a Portion of Detroit's Packard Plant," *Detroit Free Press, September* 29, 2022.

152 Adriel Thornton, interview with author, via remote video, September 28, 2022.

CHAPTER SIX: MICHIGAN CENTRAL STATION

1 Camilo José Vergara, *New American Ghetto* (New Brunswick, NJ: Rutgers University Press, 1994), 214.

2 Vergara, *New American Ghetto*; Camilo José Vergara, *American Ruins* (New York: Monacelli Press, 1999).

3 The Michigan Central Station or Depot has been frequently called a "temple of transportation" and a "cathedral of transportation." See Robert Benson, "Michigan Central: Will Anybody Save This Station?," *Detroit Free Press, December* 5, 1982.

4 Nathan Silver, *Lost New York* (Boston: Houghton Mifflin, 1967); Ada Louise Huxtable, *Will They Ever Finish Bruckner Boulevard: A Primer on Urbicide* (New York: Macmillan/Collier, 1972); Hilary Ballon and Normal McGrath, *New York's Pennsylvania Stations* (New York: Norton, 2002).

5 Garnet Cousins and Paul Maximuke, "Detroit's Last Depot, Part II: The Ceremony That Was 61 Years Late," *Trains*, September 1978, 44–51.

6 Garnet Cousins and Paul Maximuke, "Detroit's Last Depot, Part I: The Station That Looks Like a Hotel," *Trains*, August 1978, 40–48; Emily Moser, "Michigan Central Station, Part I," *Railroad and Railfan* 38, no. 12 (December 2019): 30–37.

7 Benson, "Michigan Central."

8 "Whitney Warren, Vanderbilt Mansion National Historic Site," National Park Service, accessed October 26, 2021, www.nps.gov; "Warren & Wetmore Architectural Drawings and Photographs, 1889–1938," Columbia University

Libraries Archival Collections, accessed October 26, 2021, www.columbia.edu.

9 Cousins and Maximuke, "Detroit's Last Depot, Part I."

10 W. Hawkins Ferry, *The Buildings of Detroit* (Detroit: Wayne State University Press, 1968); Cousins and Maximuke, "Detroit's Last Depot, Part I."

11 Cousins and Maximuke, "Detroit's Last Depot, Part I"; Charles Hyde, *Detroit: An Industrial Architecture Guide* (Detroit: Detroit Historical Society, 1980); Dan Austin, "Michigan Central Railroad Depot," Historic Detroit, June 2018, https://historicdetroit.org.

12 Cousins and Maximuke, "Detroit's Last Depot, Part I."

13 Austin, "Michigan Central Station."

14 Cousins and Maximuke, "Detroit's Last Depot, Part II."

15 Cousins and Maximuke, "Detroit's Last Depot, Part I"; Cousins and Maximuke, "Detroit's Last Depot, Part II."

16 Hyde, *Detroit;* George Galster, *Driving Detroit: The Quest for Respect in the Motor City* (Philadelphia: University of Pennsylvania Press, 2014).

17 US Department of the Interior—National Park Service, National Register of Historic Places Inventory—Nomination Form—"Penn Central Station," prepared by Leonard Kniffel of the Detroit Historical Museum, April 16, 1975; Cousins and Maximuke, "Detroit's Last Depot, Part II"; Emily Moser, "Michigan Central Station, Part II: Rebirth of Detroit's Elegant Gateway," *Railfan and Railroad* 39, no. 1 (January 2020): 50–57.

18 US Department of the Interior, Nomination Form—"Penn Central Station."

19 Cousins and Maximuke, "Detroit's Last Depot, Part I"; Candice Williams, "105 Years at the Station," *Detroit Free Press*, March 20, 2018.

20 Billy Bowles, "Amtrak Is Going Places in Michigan," *Detroit Free Press,* April 20, 1975.

21 Ibid.

22 Sylvia Porter, "The Positive Side of Amtrak," *Detroit Free Press,* March 23, 1972; Bowles, "Amtrak Is Going Places in Michigan"; Louis Cook, "Fighting the Disappearin' Railroad Blues," *Detroit Free Press,* October 20, 1977.

23 US Department of the Interior, National Register of Historic Places Nomination Form—"Penn Central Station."

24 Garnet Cousins, interview with author, via phone, May 31, 2020.

25 Cousins and Maximuke, "Detroit's Last Depot, Part II"; Moser, "Michigan Central Station, Part II."

26 Cousins, interview with author.

27 "Roosevelt Park," Corktown History, April 19, 2012, https://corktownhistory.blogspot.com.

28 Cousins and Maximuke, "Detroit's Last Depot, Part I."

29 Neal Rubin, "Rubin: CPA Building Is Doomed—But Who's to Blame?," *Detroit News*, November 16, 2016; Robin Runyan, "Update: The CPA Building Is Safe from Demolition. For Now," Curbed Detroit, November 23, 2016.

30 Cousins and Maximuke, "Detroit's Last Depot, Part I"; Cousins and Maximuke, "Detroit's Last Depot, Part II"; Moser, "Michigan Central Station, Part II."

31 Ibid.

32 W. Kim Heron, "End of the Line? Amtrak and Conrail May Leave Michigan Central," *Detroit Free Press*, April 11, 1985.

33 Associated Press, "75-Year-Old Central Depot Closing Next Week," *Business News*, January 1, 1988.

34 Ibid.

35 Patricia Chargot, "A Golden Age Rolls to an End as Train Depot Shuts Its Doors," *Detroit Free Press,* December 31, 1987.

36 John Gallagher, "Michigan Central Owner Wants Depot Bustling Again," *Detroit Free Press*, November 9, 1990; "U.S. Report: Auction Postponed," *Globe and Mail* (Toronto), August 14, 1991; Robert Ankeny and Terry Kosdrosky, "Depot Can't Get on Track," *Crain's Detroit Business*, March 1, 1999; Dan Austin, "Michigan Central Station," Historic Detroit, June 2018, https://historicdetroit.org.

37 "U.S. Report: Auction Postponed"; Kelli Kavanaugh, *Detroit's Michigan Central Station*, Images of America (Charleston, SC: Arcadia Publishing, 2001).

38 Ankeny and Kosdrosky, "Depot Can't Get Back on Track."

39 National Rail Passengers Association, Hotline 702, accessed May 30, 2020, www.railpassengers.org; National Rail Passengers Association, Hotline 759, accessed May 30, 2020, www.railpassengers.org.

40 Kavanaugh, *Detroit's Michigan Central Station*; Ashton Parsons, interview with author, via phone, July 26, 2020.

41 Cousins, interview with author.

42 "The Last Stationmaster: Eleven Years after the Final Train Pulled Out, the Michigan Central Depot and Its Unofficial Guardian Are Both Shells of Their Former Selves," *Detroit News*, March 2, 1999.

43 Ankeny and Kosdrosky, "Depot Can't Get Back on Track."

44 Jeff Rice, *Digital Detroit: Rhetoric and Space in the Age of the Network* (Carbondale: Southern Illinois University Press, 2012), 152; Charlie LeDuff, "From the Archives: Frozen in Indifference," *Detroit News*, January 29, 2009.

45 Flickr.com image search for "Michigan Central Station urbex," by author, June 18, 2020.

46 "The Last Stationmaster"; Kavanaugh, *Detroit's Michigan Central Station* (see photograph on 120).

47 "The Last Stationmaster."

48 Mark Binelli, *Detroit City Is the Place to Be: The Afterlife of an American Metropolis (New York: Metropolitan Books, 2012)*; Dora Apel, *Beautiful Terrible Ruins: Detroit and the Agony of Anxiety of Decline* (New Brunswick, NJ: Rutgers University Press, 2015), 76–79.

49 Kavanaugh, *Detroit's Michigan Central Station*; Bill McGraw, "Historian in the Streets: Life in the Ruins of Detroit," *History Workshop Journal* 63, no. 1 (2007): 288–302; Andrew Moore, *Detroit Disassembled* (Akron, OH: Akron Art Museum, 2010); Yves Marchand and Romain Meffre, *The Ruins of Detroit* (London: Steidl, 2011).

50 *Techno City: What Is Detroit Techno?*, film produced and directed by Ben Cohen, Third Ear Productions, 2014, www.youtube.com.

51 Debora Hendren, "Michigan Central Station: A Beautiful Detroit Treasure," The Orange Door (blog), July 14, 2013, http://theorangedoor-debrasdish.blogspot.com.

52 Kavanaugh, *Detroit's Michigan Central Station*.

53 Vergara, *American Ruins*.

54 Ibid., 56–57.

55 Scott Hocking, interview with author, Detroit, September 7, 2017; see also Scott Hocking, accessed June 18, 2020, https://scotthocking.com.

56 Monica Davy, Bill Vlasic, and Mary Williams Walsh, "Detroit Ruling Lifts a Shield on Pensions," *New York Times,* December 4, 2013; Apel, *Beautiful Terrible Ruins,* 76–79; Dave Jordano Photography, "Detroit Unbroken Down," accessed August 13, 2020, https://davejordano.com.

57 Nailhed (blog), "Fahrenheit 313," accessed August 13, 2020, www.nailhed.com.

58 Philip Levine, "Nobody's Detroit," in Moore, *Detroit Disassembled,* 114.

59 Jennifer Chambers, "Court Weighs Detroit Literacy Battle: 'Is This Really Education?," *Detroit News*, October 22, 2019.

60 Curt Guyette, "Anatomy of a Story," *Detroit Metro Times*, February 25, 2009; Charlie LeDuff, *Detroit: An American Autopsy* (New York: Penguin Press, 2013); "Detrospect: Five Years after Johnnie Redding (RIP)," Nailhed (blog), February 2014, www.nailhed.com.

61 John Gallagher, "Moroun's Property Falls into 3 Main Areas, Some Blighted," *Detroit Free Press,* April 11, 2010; John Gallagher, "He Bridged Nations, Sparked Fury, Steered Detroit's Future," *Detroit Free Press*, July 14, 2020.

62 Luisa Kroll, "The Forbes 400: Billionaires 200–299," *Forbes*, October 11, 2010; Forbes Staff, "The Forbes 400 List," *Forbes*, October 19, 2015.

63 Stephane Fitch and Joann Muller, "The Troll under the Bridge," *Forbes*, November 15, 2004; Susan Berfield, "Matty Moroun: Detroit's Border Baron," *Bloomberg Businessweek, May* 3, 2012; Charlie LeDuff, "There Are Only Two Fights Left for Matty Moroun: Death and Legacy," *Detroit News,* March 22, 2018; Francis Grunow, interview with author, Detroit, October 17, 2019; Gallagher, "He Bridged Nations."

64 John Gallagher, "Moroun Defends His Motives," *Detroit Free Press*, April 11, 2010; Gallagher, "He Bridged Nations."

65 LeDuff, "There Are Only Two Fights Left."

66 Chad Livengood, "State Attorneys Accuse Moroun of Stalling Tactics over Bridge Project," *Crain's Detroit Business*, January 31, 2017; LeDuff, "There Are Only Two Fights Left."

67 "US-Canada Bridge Owner Proposes 100-Acre Customs Center," Associated Press, June 15, 2001; Darren Nichols, "Freight Depot Plan Comments Sought; Four Sites in Running for Detroit Terminal," *Detroit News*, August 16, 2005.

68 Ankeny and Kosdrosky, "Depot Can't Get Back on Track."

69 Ben Austin, "Detroit through Rose-Colored Glasses," *New York Times,* July 13, 2014.

70 Louis Aguilar, "Moroun Spending Money on Central Depot," *Detroit News*, November 3, 2011; Tom Greenwood and Candice Williams, "Lights Illuminate Work to Be Done at Mich. Train Station," *Detroit News,* October 2, 2012; John Gallagher, "Cleanup of Depot Continues: Ultimate Fate of Station Unclear," *Detroit Free Press,* November 12, 2011; Elizabeth Knibbe, interview with author, via phone, July 31, 2013.

71 Greenwood and Williams, "Lights Illuminate Work to Be Done at Mich. Train Station"; Sonja Puzic, "Michigan Voters

Reject Roadblock to New U.S.-Canada Bridge," CTV News, November 6, 2012, www.ctvnews.ca; Scott Hocking, interview with author, Detroit, October 18, 2019.

72 Knibbe, interview with author.

73 David Josar, "Council: Demolish Train Depot on Owner's Dime," *Detroit News*, April 8, 2009.

74 "Train Wreck," *Detroit News*, April 9, 2009.

75 "Letters to the Editor," *Detroit News,* April 15, 2009.

76 Ashton Parsons, interviews with author, via phone, June 12 and July 29, 2020.

77 Cameron S. Brown, Michigan state senator, Sixteenth District, letter to Dan Stamper, president, Detroit International Bridge Company, May 20, 2009; Christine MacDonald, "Bing Vows to Recover Demolition Expenses," *Detroit News,* January 18, 2010; Susan Saulny, "Seeking a Future for a Symbol of a Grander Past," *New York Times*, March 6, 2010.

78 The development of Ford Field (1999–2002) necessitated the partial demolition of the Hudson Warehouse, a part of which was incorporated into the stadium complex. See Don Muret, "Ford Field One of NFL's Most Versatile Stadiums," *Street and Smith's Sports Business Journal,* August 6, 2012.

79 Nichole Christian, "Detroit Sees Park as Star Player in Redevelopment," *New York Times,* April 11, 2000; Kat Stafford and Joe Guillen, "Lawsuit Seeking to Block Little Caesars Arena Public Funding Moves Forward," *Detroit Free Press*, June 6, 2017; Sarah Rahal, "Rally Planned Thursday to Prevent Demolition near New Arena," *Detroit News*, August 23, 2017; Louis Aguilar, "Former Gold Dollar, Legendary Detroit Cass Corridor Bar, Being Demolished," *Detroit News*, August 12, 2019.

80 Kavanaugh, *Detroit's Michigan Central Station*.

81 Katharine Mattingly Meyer, ed., *Detroit Architecture: A.I.A. Guide* (Detroit: Wayne State University Press, 1971).

82 Amy Elliot Bragg, *Hidden History of Detroit* (Charleston, SC: History Press, 2011).

83 Amy Elliot Bragg, interview with author, Detroit, March 18, 2016.

84 Ibid.

85 Ibid.

86 Ibid.

87 Ibid.

88 Mitch Smith, "Grimy, Glorious, Gone. The Divergent Paths of 7 Train Stations," *New York Times,* September 29, 2018.

89 Melena Ryzick, "Detroit's Renewal: Slow Cooked," *New York Times,* October 20, 2010.

90 "Philip Cooley," Playground Detroit, August 26, 2011, https://playgrounddetroit.com.

91 Knibbe, interview with author.

92 Susan Saulny, "Seeking a Future for a Symbol of a Grander Past," *New York Times*, March 6, 2010.

93 Kimberly Kinder, *DIY Detroit: Making Do in a City without Services* (Minneapolis: University of Minnesota Press, 2016).

94 uRbanDetail, Roosevelt Park Master Plan, 2010, 4, 6, 7 (in author's possession).

95 Kavanaugh, *Detroit's Michigan Central Station,* 124–125.

96 Michigan Central, "Thank You to the Michigan Central Preservation Society," Facebook (video post), June 25, 2020, www.facebook.com.

97 Ashton Parsons, interview with author, via phone, June 12, 2020.

98 Ibid.

99 John Gallagher, "Station Deal Helps the Morouns' Image," *Detroit Free Press, June* 12, 2018).

100 John Gallagher, "Detroit's Comeback Looks to Be More of a Sure Thing," *Detroit Free Press*, June 17, 2018.

101 Ian Thibodeau and Louis Aguilar, "Ford Purchase Sets Depot on New Track; Michigan Central Depot Sold by Moroun Family," *Detroit News, June 12,* 2018.

102 Gallagher, "Station Deal Helps the Morouns' Image."

103 Scott Hocking, interview with author, Detroit, October 18, 2019.

104 Francis Grunow, interview with author, Detroit, October 17, 2019.

105 Ford Motor Company, "Ford Acquires Iconic Michigan Central Station as a Centerpiece of New Detroit Campus to Usher in Ford's Smart, Connected Future," media release, June 19, 2018, https://media.ford.com; Ford Motor Company, "Ford Update 6.26 (2020)," public meeting presentation; Michigan Central, accessed May 1, 2023, https://michigancentral.com/.

106 Allie Gross, "Ford Asks Detroit for $100M as Part of Bigger Train Station Incentives Package," *Detroit Free Press*, September 11, 2018; Michigan Central, accessed May 1, 2023, https://michigancentral.com/.

107 Since 2016 the Detroit city code requires that all Tier 1 Projects—those that involve an investment of at least $75 million and the abatement of more than $1 million in city taxes—are subject to the Community Benefits Ordinance, as negotiated between the developer and the city.

108 "Community Benefits Provision for Tier 1 Development (Corktown Area Projects)" (Community Benefits Agreement for Ford's Corktown development projects), October 10, 2018, https://detroitmi.gov.

109 Richard Florida, *The Rise of the Creative Class* (New York: Perseus Book Group, 2002).

110 Robin Runyan, "220+ Ford Employees to Move Offices to The Factory in Corktown," Curbed Detroit, December 15, 2017, https://detroit.curbed.com; Robin Runyan, "Ford Previews New Corktown Offices," Curbed Detroit, May 24, 2018, https://detroit.curbed.com.

111 These ramps were part of the legacy of design innovations of architect Allan Stem (see Cousins and Maximuke, "Detroit's Last Depot, Part I"; Cousins and Maximuke, "Detroit's Last Depot, Part II").

112 Selina Cheah, "Snøhetta to Design Ford's Research Campuses in Detroit and Dearborn, Including Michigan Central Station," *Architect's Newspaper, June* 19, 2018.

113 Phoebe Wall Howard, "Ford Receiving Calls to Return Stolen Detroit Train Station Property," *Detroit Free Press,* June 27, 2018; Phoebe Wall Howard, "Ford to Host 10-Day Winter Festival at Detroit Train Station," *Detroit Free Press,* January 10, 2019.

114 John Gallagher, "Things Are Still Raw inside the Michigan Central Station," *Detroit Free Press,* November 18, 2018.

115 Ford Motor Company, "A Century Later, Same Indiana Quarry Again Provides Limestone for Michigan Central

Station," media release, November 13, 2019, https://media.ford.com.

116 Joel Kurth and Chastity Pratt, "Detroit Studies Restoring Passenger Trains to Michigan Central Station," Bridge, April 3, 2019, www.bridgemi.com.

117 John Bozick, "Michigan Central Stays on Track. Latest Community Meeting Provides Progress Update from Ford," Detroit Is It, April 23, 2021, https://detroitisit.com.

118 Paula Roy Carethers and K. Venkatesh Presad, interview with author, Dearborn, Michigan, October 18, 2019.

119 Ibid.

120 Noah Resnick, email correspondence with author, January 25, 2023.

121 Apel, *Beautiful Terrible Ruins*, 34–35.

CHAPTER SEVEN: THE BEGINNING OR END OF POSTINDUSTRIAL DIY?

1 Brent D. Ryan and Daniel Campo, "Autopia's End: The Decline and Fall of Detroit's Automotive Manufacturing Landscape," *Journal of Planning History* 12, no. 2 (2013): 95–132.

2 Kevin Lynch, *What Time Is This Place?* (Cambridge, MA: MIT Press, 1972); John Brinckerhoff Jackson, *Discovering the Vernacular Landscape* (New Haven, CT: Yale University Press, 1984); *Arnold Alanen and Robert Melnick, Preserving Cultural Landscapes in America* (Baltimore: Johns Hopkins University Press, 2000).

3 Even those scholars in favor of urban demolition practices have acknowledged the many shortcoming or detrimental impacts of these programs. Buffalo's "5 in 5," which aimed to demolish five thousand vacant houses in five years, serves as an example. See Amy E. Frazier, Sharmistha Bagchi-Sen, and Jason Knight "The Spatio-Temporal Impacts of Demolition Land Use Policy and Crime in a Shrinking City," *Applied Geography* 41 (2013), 55–64; Russell Weaver and Jason Knight, "Can Shrinking Cities Demolish Vacancy? An Empirical Evaluation of a Demolition-First Approach to Vacancy Management in Buffalo, NY, USA," *Urban Science* 2, no. 3 (2018): 69, https://doi.org/10.3390/urbansci2030069. See also Alan Mallach, *The Empty House Next Door: Understanding and Reducing Hypervacancy in the United States* (Cambridge, MA: Lincoln Institute of Land Policy, 2018).

4 Mark Sommer, "Jemal's Planned Redevelopment of Richardson Olmsted Campus to Include 250 Apartments, Reopened Hotel," *Buffalo News*, December 2, 2022.

5 See Joshua David and Robert Hammond, *High Line: The Inside Story of New York City's Park in the Sky* (New York: Farrar, Straus and Giroux, 2011).

6 Mark Sommer, "Emergency Demolition Ordered for ADM Elevator," *Buffalo News*, December 18, 2021; "With Jemal's Interest in City's Damaged Grain Elevator, Demolition Is Unthinkable," *Buffalo News,* December 20, 2021.

INDEX

Abdurraqib, Hanif, *147*
ADM. *See* Archer Daniels Midland (ADM)
Ambassador Bridge, Detroit, 310, 315, 321, 323, 357
American Beauty Iron Works, Detroit, 291
American Can Company, Baltimore, 48
American Manufacturing Company, Brooklyn, 16
American Ninja Warrior competition, *203,* 204
American Rescue Plan Act, 292
Apel, Doris, 262–264, 320
Archer Daniels Midland (ADM), 128, 140, 377, 395n4
art, 58, 90, 95, 270–273, *271. See also* Carrie Deer, Pittsburgh;
 graffiti; photography
Art Deco, 19, 47, 63, 65, 70, *71,* 72, 80–81, 91
Arte Express Detroit, 237–238, 254, 266, 272, 275, 278–279,
 281–282, 284, 291–293
ArtsQuest, 220
Asian Arts Initiative, 9
Atlanta, 48
Austin, Dan, 344
Austin Nichols Warehouse, Brooklyn, 17
automobile plants, 247–248. *See also* Packard Automotive
 Plant

Bagley Mobility Hub, 346–347
Baltimore, 48, 165, 219
Banham, Reyner, 18, 119, 121, 135–136, 148, 377
Banksy, 267, *268,* 269
Baraff, Ron, 190–191, *191,* 197, 200, 204–205, 210, 213, 215, 217,
 222, 224
Bardelli, Rich, 349, 352
Beale, Elizabeth, 262–263, 282–285
Becher, Bernd, 148
Becher, Hilla, 148
Belgium, 38, 244
Belleville Three, 243
Bennett, Michael G., 208
Benson, Robert, 300

Bethlehem, Pennsylvania, 205, *221*
Bethlehem Steel, 205, 208, 218, 220, *221*
Bing, Dave, 329
Biniasz, Marty, 95–96, *96,* 97
Bioresource, 250–251, 254, 264–265, 269
Biskner, Dave, 260
Bloomberg, Michael, 14, 16, 356
Blumenthal Brothers Chocolate Works, Philadelphia, 4
BMT Power Station, Brooklyn, 16
Boderow, Constance, 217–218
Bone Black (Hocking), 272–273
Braddock, Pennsylvania, 198
Bragg, Amy Eliot, 330–331, 334
Breaking Ground, 204–205
Brier Hill iron mill, Youngstown, 187, 219–220
Brooklyn, New York, 14–21, 48, 56, 356, *362, 363*
Brooklyn Bridge Park, 56, 142
Brooklyn Grange, 205
Brown, Byron, 101–102, 127
Brown, Sharron, 187–188
BUDCO, 229
Buffalo, New York, *14,* 15–25, *17, 20, 22, 24–25, 40–41,* 46–47,
 51–53, 57, 417n3. *See also* Central Terminal, Buffalo; Silo
 City, Buffalo
Buffalo Creek Casino, 136
Buffalo Savings Bank, 85
Buffalo State Hospital, 87, 107–110, 136–137, 372–373,
 396n20
Buffalo Young Preservationists (BYP), 133
Burns, Dylan, 175
Burroughs Adding Machine buildings, Detroit, 51, 291
Bushwick, Brooklyn, 17
BYP. *See* Buffalo Young Preservationists (BYP)

Cadillac Plant, Detroit, 50–51, 251
Cain, Kevin, 148
Carethers, Paula Roy, 355

Carlino, Augie, 193, 204, 217, 224

Carnegie, Andrew, 177, 194

Carrie Blast Furnaces, Pittsburgh, 34–35, 37, 50, 53, 57, *176*, 177–229, *178–179, 181, 185–186, 189, 191, 194, 200, 203, 212, 223, 225, 228–229*, 365, 370, 374, 400n1

Carrie Deer, Pittsburgh, *23*, 181–182, 185–193, *189, 191*, 200, 202, 211–213, 229

Casab, Romel, 254, 265, 269

Casey, Bob, 198–199

casinos, 90, 136, 139, 220

Cathedral of Time, The, 317–319

Central Terminal, Buffalo, 29, *30*, 31–32, 34, 47, 53, 57, *62, 63–117, 64, 66–67, 69, 71, 73, 76, 93, 96–97, 99, 103, 111, 115, 118*, 343–344, *360*

Central Terminal Restoration Corporation (CTRC), 67, 70–71, 87–88, 90, 92–93, 99–100, 104–105, 116

Centro Historico, Lima, 274

Ceroy, Anthony, 169

citizen ownership, 86–91

City Hall, Buffalo, 47

Clark, Carrie, 177

Clark Street Technology Park, Detroit, 50

Cockrell, Kenneth, Jr., 327

Collins, Barbara Rose, 327

Columbia (steamship), *151*, 153–154

concert venue, 220

Concrete Atlantis, A (Banham), 119

Concrete Central Grain Elevator, Buffalo, *40–41*, 52

Connecticut Street Armory, Buffalo, 85

Conyers, Monica, 327

Cooley, Phil, 333–336, 338, 348–349

Corktown, Detroit, 297, 303, 330, 333, 335, 338, 344, *345, 346–349*

Cousins, Garnet, 305, 307

Craig, Carl, 317

Cramp Shipyard, Philadelphia, 4–5, *5, 9*

Cranbrook Art Museum, 273

Crane Arts Building, Philadelphia, 7–8

Crawford, Ralson, 148

Cristini, Dominic, 246, 251–252, 254, 264–265

Cristini, Robin, 246, 251, 253–254

CTRC. *See* Central Terminal Restoration Corporation (CTRC)

Culler, Mary, 354–355

Cuomo, Andrew, 92, 101, 105–106

Darke, Rick, 215

Darwin Martin House, Buffalo, 87, 91, 137

Death and Life of Great American Cities, The (Jacobs), 53

DeLisle, Alan, 84

demolition paradigm, 247

Demuth, Charles, 148

Design 99, Detroit, 52

Detroit, 21–22, 24, 40, *43*, 46, 50–51, 55, *56–57*, 57, 65, 233–235. *See also* Michigan Central Station, Detroit; Packard Automotive Plant

Detroit School Book Depository, 315, 320, *353*

Disston saw works, Philadelphia, 4

DIY: as building practice, 38; fostering, practices and policies for, 369–382; joys of, 91–100; landscape design, 213–217; limits of, 91–100; outside Rust Belt, 57–58; place of, in Rust Belt, 35–42; range of, 39–40; restoration and, 22; role of, 24; tension between, and building practices, 39; ubiquity of, 58

Dobosiewicz, Eddy, 97

Domino Park, 16

Domino Sugar Refinery, Brooklyn, *15*, 16, 206, 356, *362*, 363

Doyle, Mike, 198–199

Duende, 155, 158, *168*, 169, 174

Duggan, Mike, 281, 292, *292*, 332, 344

Duisburg Nord Landschaftspark, *55*, 56, 141, 222, 334

Dumbo, Brooklyn, 48

Duquesne Brewing Company, 184

Dyngus Day, Buffalo, 21, 79, 91, 93–95, *97*, 100

Eberhard-Faber Pencil Factory, Brooklyn, 17

ecological restoration, 142–145

Edgar Thomson Steel Works, 199

Egg, The (Hocking), *318*, 319

Elevator Alley, Buffalo, *27*, 28, 119, *375*. *See also* Silo City, Buffalo

Eminem, 316

Emscher Park, Germany, 55–56, 141, 193, 370, 372
Energy Policy Act, 127
Erie Canal, 75
ethanol, 127–128
Exchange Street Station, Buffalo, 78, 101, 103, *103*

Fabric Workshop, 9
Falck, Noah, 147, 173
Fedele, Anthony, 79
Feldman, Joel, 324
Fellheimer, Alfred, 75
Festival of Combustion, 224–225, *228,* 229, *229*
Field, Scott, 86–87
Fisher, Jessie, 160
Fisher Body #21, Detroit, 258, 270, 278
Florida, Richard, 264
Ford, Henry, 264, 288
Ford, William, 329
Ford, William, Jr., 343–344, 353–355
Ford Field, Detroit, 415n78
Ford Piquette National Heritage Site, *56–57, 57,* 288, 290
Fort Wayne Railroad Bridge, 185
Franczyk, Dave, 67, 72–73, *73,* 80–87, 90, 100, 102, 119
Freshkills Park, Staten Island, 142, 214

Garcia Lorca, Federico, 155
Garden of the Gods (Hocking), 270–273, *271,* 275
Garry, Margaret, 324
Gas Light Park, Seattle, 56, 374
Geck, Carolyn, 240, 242, 246
Germany, 38, *53,* 55–56, 141, 193, 218, 222, 334, 370, *371,* 372
Ghost Ship Warehouse fire, 39, 160
Giant Woolly Millipede, 187, 219
Gilbert, Dan, 258, 325, 332
Gilbert Building, Philadelphia, 9–14, *10–11,* 19–20, 369
Goldman, Mark, 149–150
Gorski, Dennis, 89
Governors Island, New York, 142
graffiti, *129,* 201–202, 204, 210, *212, 261,* 266–267, *268, 277, 311,* 319, 350, *351,* 356
Grain Elevator Project, 140–141, 165

Grand Trunk Warehouse, 284–285
Great Allegheny Passage, 216
Greenpoint, Brooklyn, 14, 17, 363
Gretsch Musical Instrument Factory, Brooklyn, 17
Griffin, James D., 80
Gropius, Walter, 121
Grunow, Francis, 281, 342, 345
Guarantee Building, Buffalo, 91, 137–138

Hackworth, Jason, 247
Hallwalls Contemporary Arts Center, Buffalo, 52
Hammond, Liz, 187–188, 192, 227
Hamtramck Disneyland, 52
Hawkins, W. Ferry, 286
Hawtin, Richie, 243
Hegemann, Dmitri, 278
Heidelberg Project, Detroit, 52
Heidgerken, Tad, 336
Helsinki Central Station, 75
Higgins, Brian, 102
High Line, New York, 56, 142, 214, 221
High Wire Gallery, 9
Hill, Allan, 279–280, 282–284, *283,* 285–288
historic preservation. *See* preservation
Historic Preservation Act, 48, 53, 75, 328
Hochul, Kathy, 116
Hocking, Scott, 269–270, *270,* 270–273, *318,* 319, 345
Hoffa, Jimmy, 325
Homestead Steel Plant, Pittsburgh, *42, 49,* 50, 179–180, 193–194, *194,* 219
Hoover-Mason Trestle, 220–221, *221*
Hudson Warehouse, Detroit, 415n78
Hults, Bill, 274
Huxtable, Ada Louise, 63

incentives, for preservation, 48–50. *See also* tax credits
incrementalism, 379–380
industrial heritage preservation, 48–51
Industry City, Brooklyn, 48
integrity, material, in historic status designation, 209–210, 395n17

investigative methods, 59–61
Iron Eden, Pittsburgh, 52

Jackson, J. B., 53
Jacobs, Jane, 53
Jeannette Blast Furnace, 219
Jefferson Avenue Shul, Buffalo, 52
Jemal, Douglas, 112–113, 117
Jones and Laughlin Pittsburgh Steel Works, 185, 219
Joy, Henry B., 286

Kahn, Albert, 231, 285–286, 291
Kahn, Julius, 235, 286, 288
Kapusta, Jim, 224–225, 225, 229
Kaulen, Tim, 184–185, 185, 187, 190, 192, 227
Kavanaugh, Kelli, 316
Khondker, Aziz, 250–251
Kilpatrick, Kwame, 264, 321, 407n72
Kinder, Kimberly, 257
Knibbe, Elisabeth, 326, 334
Kowsky, Frank, 140

Land, Edward, 253
landscape design, 213–217
Lang, Paul, 93–95, 100, 105, 109, 173
Larkin Soap Factory, Buffalo, 51, 137, 140
Le Corbusier, 121, 139
LeDuff, Charlie, 260, 263, 321
Leland, Henry, 264
Levine, Philip, 320
Lewandowski, Mark, 95, 96, 96–97, 100
Lima, 274
Lincoln, Christina, 52, 134
Locust Point Grain Elevator, 165
Longton, Mark, Jr., 310
Los Angeles, 57
Lowell, Massachusetts, 48, 142
Lyman, Valery, 146, 149, 204

Marchand, Yves, 262, 320
Marren, Patrick M., 139

Masiello, Anthony, 84, 86
Mason, George, 288
material integrity, in historic status designation, 209–210, 395n17
Maurer, Paul, 100
Maximuke, Paul, 307
McCartney, Sue, 87
Meffre, Romain, 262, 320
Mendelsohn, Erich, 121
Meola, Melissa, 148
Michigan Central Preservation Society, 328
Michigan Central Station, Detroit, 40, 43, 45, 65, 294, 295–359, 296, 306, 311, 314, 318, 335, 337, 345, 351–353, 366, 374, 411n3
Midlands, 38, 244
Miller, Aaron, 91
Minier, Andrew, 133
Minneapolis, 165
modernism, 121, 148–149, 243
Mohyi, John, 339–340
Monongahela River Valley. See Pittsburgh
Montreal, 165
Moore, Andrew, 262, 285, 320–321
Moroun, Manuel "Matty," 310, 321–322, 324–327, 332, 334, 339, 341
Moroun, Matthew, 344
Motor City Industrial Park, 233, 238
Moyhi, John, 328
Moynihan, Daniel Patrick, 84
Murphy, Russ, 254
Murray Body complex, Detroit, 411n146

Nagher, Karen, 330–331
National Heritage Area (NHA) program, 217–218
National Park Service (NPS), 16, 141, 158, 167, 194, 199, 207–208, 217–218
National Register of Historic Places, 16, 19, 79, 109, 130, 329, 395n17
National Trust for Historic Preservation, 47
New York City, 3, 14–21, 38, 56, 74, 84, 214, 298, 356
NHA. See National Heritage Area (NHA) program

Norry, Irving, 253
Northeast Corridor, 3–21
Nowak, Henry J., 139
NPS. *See* National Park Service (NPS)

Oakland, California, 39, 57, 160
Occupational Safety and Health Act (OSHA), 227
Odd Fellows Hall, Philadelphia, 363n10
Old Dutch Mustard Company, Brooklyn, 16
Olds, Ransom, 264
Onorato, Don, 196–197
OSHA. *See* Occupational Safety and Health Act (OSHA)
Owl, The, 186, 186–187

Packard Automotive Plant, 34, 40, 55, *230,* 231–293, *234, 242, 256, 261, 268, 270, 274, 276–277, 280, 283, 287, 289–290, 292,* 320, 364, 407n72
Palazuelo, Fernando, 237, 266, 274, *274,* 275, 279–280, 291–292
Palms Apartment Building, Detroit, 288
Paradowski, Mark, 134
Park, Ray, 196
Parsons, Ashton, 328, 340–341
parties, 238–246, 267
Pataki, George, 109
Pawlak, Russell, 90
PCC. *See* Pennsylvania Convention Center (PCC)
PCVB. *See* Pennsylvania Convention and Visitors Bureau (PCVB)
Peace Bridge, Buffalo, 52
Pellegrino-Faix, Monica, 109, *109,* 110, 112–114, 116
Pennsylvania Convention and Visitors Bureau (PCVB), 12–13
Pennsylvania Convention Center (PCC), 12–13
Pennsylvania Station, Manhattan, 84, 298
Peoples-Stokes, Crystal, 100, 102
Perret, Auguste, 288
Philadelphia, *2,* 3–14, *5–6,* 7–12, *11,* 14, 21, 363, 385n10
Philadelphia Fringe Festival, 8
Philco Television and Radio Works, Philadelphia, 4, 7
Phillips Paint Varnish Factory, 184
photography, 40, 204, 235, 255, 262–263, 319–321

Pittsburgh, 22, *32–33,* 34–35, 46, *49,* 52–53, 57. *See also* Carrie Blast Furnaces, Pittsburgh
Plastikman, 243
Pope, Richard, 243
Portman, John, 343
Portwood, Edward, 251
postindustrial, defined, 37
Presad, K. Venkatesh, 348–349
preservation, 16: approaches, 207–213; criticism of practices in, 49–50; incentives, 48–50; industrial heritage preservation, 48–51, 192–199; private ownership and, 16; tax credits, 19, 48
Preservation Buffalo Niagara, 133–134, 160–161, 396n20
preservationist groups, 52, 133, 328–332
Presidio, San Francisco, 56, 142, 374
Pridgen, Darius, 102
Providence, Rhode Island, 37
Pugh, Charles, 328

Quantum Theatre Company, 204

raves, 221, 238–242, 244–245, 267
Reading Railroad Ore Pier, Philadelphia, *6,* 8
recovery, as term, 45
Redding, Johnnie, 321
Reed, Charles, 75
Renaissance Zone, 251
Rendell, Ed, 197
Resnick, Noah, 336, *337,* 338
Revere Sugar Refinery, Boston, 9
Richardson, H. H., 47, 87, 107, 137–138, 373
Richardson, The, Buffalo, 107–110, 136–137
Ridgewood, Queens, 17
Riley, Deborah, 319
RiverQuest, 216
Riverscape Lighting Project, 143–144, 152, 222
Rivers of Steel Corporation, 183, 208–209, 217–218
Rivers of Steel (ROS) National Heritage Area, 180, 192, 197. *See also* Carrie Blast Furnaces, Pittsburgh
RiverWright, 143
RiverWright Energy, 127

Roosevelt Park, Detroit, *296, 297,* 304, 308, 320, 333–337, *337,* 339
Rosenwach Water Tank Factory, Brooklyn, 16
Ruhr Valley, 38, *54,* 55–56, 141, 193, 222, 334, 370
Russell Industrial Center, Detroit, 411n146
Rust Belt: culture, urbanism and, 51–59; defined, 37–38; icons, 42–46; in other countries, 38; place of postindustrial DIY in, 35–42
Ryan, Sean, 102

Saarinen, Eliel, 75
San Francisco, 56, 142, 374
Saylor, Dana, 136, 148
Schaeffer Brewery, 16
Schlichter Jute Cordage Works, Philadelphia, 4
Schmidt's Brewery complex, 9
Schneekloth, Lynda, 124, *124,* 140, 161
Schronce, Kevin, 347
Scott, Brenda, 252
Seattle, 56, 374
Shanahan, Dan, 91, *148,* 149
Shelton, Jerry, 155
SIHC. *See* Steel Industry Heritage Corporation (SIHC)
Silo City, Buffalo, *24,* 25–29, *27,* 53, *118,* 119–175, *120, 122, 124, 129, 131, 144, 146–149, 151, 162–163, 165, 168, 170–172,* 365–366, *375,* 375–376, 395n4
Skompinski, Carl, 102, 110, 114
Smith, Josh, *170,* 175
Smith, Kari, 275
Smith, Rick, 29, 123, *124,* 126–128, 130–131, 134, 136, 142–143, 146, *148,* 150–151, 153–155, 157–161, 165, 167, 169, 174–175
"Space Monkey" figures, 184–185
Sparrows Point steel plant, 219
Spencer, William, 309
Stamper, Dan, 322
Steel Industry Heritage Corporation (SIHC), 183, 193–195, 197
Steel Industry Heritage Task Force, 183
steel plants, 218. *See also* Bethlehem Steel; Carrie Blast Furnaces, Pittsburgh; Homestead Steel Plant, Pittsburgh; Jones and Laughlin Pittsburgh Steel Works; Thyssen Steel Plant, Germany
Steel Stacks, Pittsburgh, 208, 220–222
Steel Yard, Providence, 37
Stetson factory, Philadelphia, 4
Stinson, Harry, 104–105
Subtlety, A, or the Marvelous Sugar Baby (Walker), *15,* 16–17
Sugar House Casino, 9
Sullivan, Louis, 47, 91, 137–138
Summer, Don, 252–254
Swimmer, The, 184

Taubman, Julia, 320
Tauke, Beth, *124,* 125
Tax Acts, 48
tax credits, 19, 47–48, 105, 117, 127, 167
Taylor, Martin, 99
techno music, 243–245
Tech Town, Detroit, 51
TechTown, Detroit, 291
Telephone Company Building, Buffalo, 85
Telesco, Thomas, 80–83
Thornton, Adriel, 239–242, 244–246, 292–293
Thyssen Steel Plant, Germany, *54–55,* 56, 141, 193, 222
Tielman, Tim, 82, 85–88, 102, 108
Torn Space Theater, 91, *148–149,* 149–150, 154, 167, *172,* 174
tourism, 47, 92, 98, 116, 138, 141–142, 199–207
Townsell, Kevin, 126
T-Plex. *See* Ford Piquette National Heritage Site
transgressive acts, 39, 45, 161, 180, 183, 236, 238, 246, 255, 257, 259, 263, 266–267, 278, 293, 295, 312–321, 333–341
Traynor, Kerry, *124,* 125, 130–132
Trentham, Gerry, 125
Tribe 9, 239, 243
Tuchman, Bernard, 83, 87
Tuchman, Samuel, 81–83, 85, 87, 89
Tunick, Spencer, 90

ULI. *See* Urban Land Institute (ULI)
urban exploitation, 255–266

urbanism: architecture and, 51–59; austerity, 59; DIY, 35, 58; guerrilla, 35, 40, 182–185, 236, 257; postindustrial, 32; Rust Belt culture and, 51–59; traditional, 10
Urban Land Institute (ULI), 47, 106–107, 112
urbex, 255–266

Van Horn, Jill, 74
Vergara, Camilo José, 237, 261–262, 295, 298, 319–320, 353
Voo, Billy, 266–267, 269
Vox Populi, 9, *10*

Wagner, Steward, 75
Walker, Kara, *15,* 16–17
Wallonia, 38
Warren, Whitney, 301
Washburn Crosby Elevator, 165
Watkins, Swannie Jim, *124,* 125, 143, 146–147, 150, 152, 154, 156–160, 165, *165,* 168–169
Wetmore, Charles D., 301
Wildroot Hair Tonic Factory, Buffalo, 52
Willert Park Public Housing complex, Buffalo, 52
Williamsburg, Brooklyn, 14, 17, 19, 363
Wilmoth, Marvin, 169
Woodward, Augustus, 300
Workers, The, 185
Wright, Frank Lloyd, 47, 49, 87, 91, 137–138, 143

Yablon, Nick, 407n72
Young, Coleman, 250, 325
young preservationists, 52, 133
Youngstown, Ohio, 187, 219

Zemsky, Howard, 102

Daniel Campo, Ph.D., is an urbanist and Associate Professor and Chair of the Department of Graduate Built Environment Studies in the School of Architecture and Planning at Morgan State University. He is the author of *The Accidental Playground: Brooklyn Waterfront Narratives of the Undesigned and Unplanned*. He was previously a planner for the New York City Department of City Planning.

POLIS: Fordham Series in Urban Studies

Edited by Daniel J. Monti, Saint Louis University

Tom Hare, *Zonas Peligrosas: The Challenge of Creating Safe Neighborhoods in Central America*

Maria Francesca Piazzoni, *The Real Fake: Authenticity and the Production of Space*

David Faflik, *Urban Formalism: The Work of City Reading*

Ron Nerio and Jean Halley, *The Roads to Hillbrow: Making Life in South Africa's Community of Migrants*

Christopher Prener, *Medicine at the Margins: EMS Workers in Urban America*

Sharon Egretta Sutton, *Pedagogy of a Beloved Commons: Pursuing Democracy's Promise through Place-Based Activism*

Daniel Campo, *Postindustrial DIY: Recovering American Rust Belt Icons*